The Keepers
of Light

The Keepers of Light

A History
& Working
Guide
To Early
Photographic
Processes

William Crawford

MORGAN & MORGAN
Dobbs Ferry, New York

Published by Morgan & Morgan, Inc.
145 Palisade Street
Dobbs Ferry, New York 10522

International Standard Book Number 87100-158-6

Library of Congress Catalog Card Number 79-88815

Cover photograph: French hand-colored stereoscopic
daguerreotype, early 1850's. International Museum of
Photography/George Eastman House.

Book design: John Alcorn
Color sections printed by Morgan Press, Inc.

Printed in U.S.A.

Dedication

For Francine and Charlie

Acknowledgments

Richard Benson taught me how to look closely at prints. I still see only half of what Benson sees. James Borcoman cleared up my misconceptions about early printmaking and, through his writings, showed me how a scholar operates. Dennis Bookstaber is a dynamite ambrotypist. Bill Broecker, my first editor, remained encouraging and helpful even after I failed to arrive for our appointment one cold and rainy day on the corner of 48th and Fifth. Liz Burpee, my final editor, taught me that the least words say the most. Elliot Glickler made sense of ancient and obscure writings. Dr. Robert Green reintroduced a long-lost art and keeps it going strong. Robert Gumpper jovially instructed me in oil printing after I failed to instruct myself. Reg Heron sent voluminous, helpful letters on cyanotype. John Hill molded an innocent mind and frequently paid for dinner. Martha Jenks and her staff at IMP/GEH make Rochester a city one actually wants to visit.

David Kolody, my mentor in conservation and restoration techniques, suffered numerous questions and successfully predicted the sex of my then-unborn child. Rodger Kingston, with sure taste, put together a collection of photographs that made me stop and think again. Yong-Hee Last read and commented and then took me to some great parties. Ron MacNeil got me started in gravure and showed gentlemanly restraint when I popped the bearings on his press. Weston Naef was open and kind and guided me on a microscopic tour of Edward Steichen's prints. Robert Sagerman was a pillar of advice. Jim Stone, who keeps a loaded revolver next to his enlarger, was an invaluable co-experimenter. Stanley Triggs gave me a delightful time in the Notman Archive, and Bill Baker made it possible. Todd Walker launched me as a collotypist and can expect to get his slides back very soon. Everyone else is still on probation.

Table of Contents

Part I

Part II

Part III

Introduction

This is a book about photographic technique. It is theoretical at the start, becomes historical, and then gets down to the practical. Briefly, this is how it came to be.

The original idea had been to publish a collection of instructions on the use of certain photographic printing processes popular in the 19th and early 20th centuries: processes photographers have attempted to revive in recent years but for which there existed no comprehensive, up-to-date reference source. With this practical goal in mind, the how-to technical chapters, which make up the second part of this book, were written first.

When I set out to describe the various processes, I also set out to describe the history behind them. As I worked, something unexpected happened. I began to realize that I was looking at the history of photography in a manner different from the one I had been taught. I was not looking at it solely from the usual vantage point of the art historian—from above, as it were, predominantly in visual or formalist terms—but equally from below, from the point of view of the evolving technology that had made photography possible. I was thinking about technology more than most art historians usually do. And yet, even though I was fairly bubbling over with technical information, I discovered there was something about photographic technology that I was still a long way from figuring out. I knew photography has to depend on technology to a far greater degree than do other visual arts (at least traditional ones); but if you asked me what this dependence was all about, if you wanted to know what special things have to happen when you start using a machine to make pictures instead of making them by hand, I could not give much of an answer. I could not put my finger on the underlying relationship between technology and the images technology can be coaxed to produce. There was no model that could help me define the relationship historically, no model I could use as a guide to understanding at least some of the changes that have taken place in photography during its—to date—140 years.

In trying to come up with a model I fumbled for a while, but then I happened to reread a book I had come across but not quite digested earlier. It was William M. Ivins's *Prints and Visual Communication.* On reading it again, I found the starting point for my model: Ivins's concept of *pictorial syntax.* Ivins's *syntax* led me to an analogy between technology and language, an analogy that underscores the rules that lie behind photographic images.

Of course, talking about syntax is not the usual way to start a how-to book on photography. Readers who prefer to do things themselves, instead of reading about what others have done or thought, might want to skip Part I and go directly to the how-to chapters, taking a look first at the introductory technical chapters at the beginning of Part II. Those in less of a hurry, or whose interests are chiefly historical, or who are just afraid of missing something, should read on here.

Part I

Photographic Syntax

William M. Ivins was Curator of Prints at the Metropolitan Museum of Art in New York from 1916 until 1946. His *Prints and Visual Communication* was published in 1953. Its general subject was the relationship between the traditional techniques of hand-drawn printmaking (principally the woodcut, metal engraving, etching, mezzotint, wood engraving, and lithograph) and photography. Ivins pointed out that, historically, printmaking had not been practiced as an art form entirely for its own sake, as the traditional techniques of printmaking have come to be practiced today, but as a way of distributing visual information.

Art historians tend not to stress this, but when people looked at prints it was usually to gain information about things they did not have the opportunity to see firsthand. In general, looking at prints was thought to be more a substitute for direct experience than an aesthetic experience complete in itself: Such self-sufficient masterprieces as Rembrandt's etchings were not the norm. Sometimes the subject of the print was an event or an actual place or object. Sometimes the subject was a painting, which in turn may have represented a famous person or a purely imaginary scene. Looking at the print was a substitute for looking at the painting.

Although they were expected to act as transmitters of visual information, traditional printmakers were remarkably casual about pictorial accuracy. Instead of working from their subject directly, they usually worked from a drawing made by someone else or even from another print. More often than not the person who actually engraved or prepared the plate had never seen the thing he was trying to represent. His job was not to check the facts but to translate his secondhand copy into a form that would permit reproduction. To the printmaker, the point-by-point resemblance between the final print and the thing represented was not essential. Technologically—at least until photography came along—a high level of resemblance was impossible, anyway.

And so prints were by nature suggestive and schematic rather than optically precise. Looking at them, you could only get an indication of what the subject was really like. Consequently, looking at prints tended to call for a temporary suspension of credulity. The picture on the page was not to be taken literally. This act of suspension is something that persons who have been brought up on photography—and who take the density of information contained in photographs for granted—know little, if anything, about. Photographs may indeed sometimes make us incredulous, but not often about the basic accuracy of their surface details.

Ivins's definition of printmaking was strictly functional: The function of printmaking was the creation of "exactly repeatable pictorial statements"—meaning identical pictures that could be produced in quantity and distributed at large; the same pictorial information placed in many hands. This seems a lean definition, trimmed of the usual notions of "art" and "beauty." It may not satisfy the aesthete, yet it is perfect for the historian of ideas. It describes what prints *do*: They allow us to share the knowledge of what things look like. Their greatest utility is not decorative but intellectual.

Ivins argued that once you begin to examine prints in these functional terms you discover that "without prints we should have very few of our

modern sciences, technologies, archaeologies, or ethnologies—for all of these are dependent, first or last, upon information conveyed by exactly repeatable pictorial statements." Take prints away and hearsay and rumor will spread; science will sink back into magic.

The thesis in *Prints and Visual Communication* involves a concept of pictorial *syntax,* which Ivins

defined as the "conventions or systems of linear structure" used in the preparation of a drawn image. In other words, syntax is the system of organization used in putting lines together to form pictures that can stand as representations of particular objects. The terms *draftsmanship* or *pictorial style* might also describe this, but Ivins used *syntax* because he wanted to establish a clear

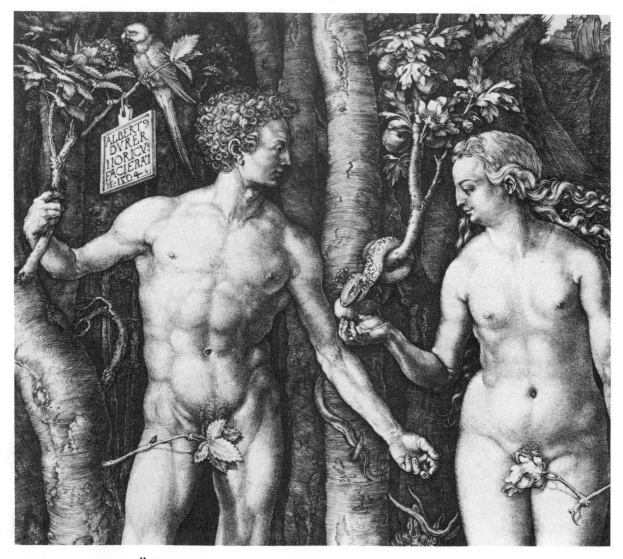

FIG. 1. ALBRECHT DÜRER, *Adam and Eve* (detail), early 16th century.
Dürer's syntactical system in this engraving consists of lines that follow the contours of the forms they represent. Dürer's perspective is flat, but the print ripples with texture.
(Courtesy of the Museum of Fine Arts, Boston, Centennial Gift of Landon Clay)

association between the linear structure of prints and the linguistic structure that makes verbal communication possible.

Ivins showed that the syntax of printmaking must operate within the physical limits of the print-making process used: Certain processes can allow only certain kinds of lines or tones built from lines.

Yet process is not the only determinant. During the Renaissance, for example, German print-makers and Italian printmakers tended to use quite different syntaxes, even though they employed the same engraving processes. Each approached his work according to the syntactical preferences of his culture. The Germans filled their pictures with indications of surface texture, often with a dutiful singlemindedness that sacri-ficed the illusion of volume beneath the surface. The Italians did the opposite. They sacrificed tex-ture while achieving the illusion of volume by stressing outline and contour, using simple lines.

Such syntactical choices tended to restrict what printmakers could communicate through their work. If the printmaker's syntax could not effec-tively represent specific features of the original subject, in the print those features would be lost, or at least transformed by the printmaker into something his chosen syntax could comprehend

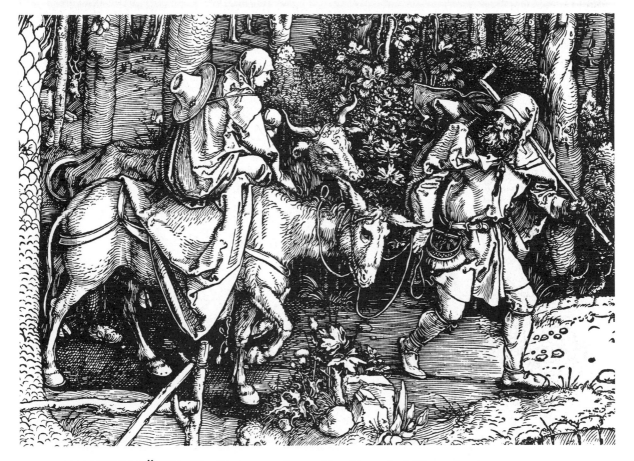

FIG. 2. ALBRECHT DÜRER, *The Flight into Egypt* (detail), early 16th century.
The same syntactical system as Fig. 1, but this time in a woodcut, a process that does not permit lines nearly as fine as those in a metal-plate engraving.
(Museum of Fine Arts, Boston, Maria Antoinette Evans Fund)

and convey. When the syntax was inadequate, the specific features slipped away. To find a metaphor for this, compare the linear structure of pictorial syntax to the linear structure of a fisherman's net. Unless the fisherman's net is fine enough, the little fish will swim right through. Unless the syntax net is fine enough, and made for the task, the specifics will slip through: Only the general outlines will be caught. The difference between fishermen and traditional printmakers is that the latter were more reluctant to change their nets, no matter how poor the catch. Traditional printmakers were usually syntactical traditionalists.

In actual practice, linear syntax was never quite able to represent visual facts accurately. No matter how faithful the printmaker's intentions, his syntax net was inevitably full of gaps, and inevitably something slipped through. The result was that the *picture* of objects and of the world at large given in prints could never entirely coincide with reality. Ivins was especially interested in these gaps because he realized (and was one of the first to point out) that the defects in syntax limited the information men could communicate with one another through pictures, and thus limited what could be achieved by science and technology and civilization as a whole.

The final chapters of *Prints and Visual Com-*

FIG. 3. SCHOOL OF MANTEGNA, *Four Women Dancing* (detail), early 16th century.
Here the syntax consists almost entirely of straight lines, applied after the outlines of the figures were drawn. The effect is one of bas relief. The syntax describes volume but not surface texture.
(Museum of Fine Arts, Boston, Francis Draper Colburn Fund)

munication have to do with photography. Ivins's technical and historical information on photography was not always correct, and he left some important things out; yet he provided an interpretation of photography that is of great value because he saw it as part of the history of printmaking and visual communication as a whole. He showed that one could never hope to understand the significance of photography until one understood the nature of the problem photography solved. The problem was accurate visual communication, a problem generations had struggled with but without much success. According to Ivins, photography's great achievement was to make possible communication through "exactly repeatable pictorial statements" without the distortions of linear syntax. The firsthand optical image produced by the camera took over from the secondhand print made manually. In effect, the gaps in the net suddenly became smaller, and the result was a spectacular jump in the quality of pictorial reports. The specifics caught up with the generalities.

By itself, the above observation may seem a mere truism, just a fancy way of saying that photographs are more accurate than traditional prints. On one level, that is all it amounts to. The interesting part comes in tracing the implications of the truism. When you do, you discover that photography was a "breakthrough" in the most complete sense of that overused but undervalued word because it lead to a breakthrough in consciousness. And this is something far more important than any of photography's periodic artistic achievements. Photography broke through the shell in which *credible* visual experience until then had always been confined. The circumference of the shell was only the distance the eyes could actually see from any given place at any given moment. It still is. Look up, right now, and you will see the shell around you. It is the limit of your visual field. You can climb to the roof and make the shell expand by miles. You can *stretch* it and change its shape as you move through the world, but you cannot *crack* it. Only photography can crack it. Through the cracks made by photography it becomes possible to look out on the most

remote places, far beyond the physical field of view, and even see past moments frozen in time, all presented without the distortion of linear syntax. Our photographic power over space and time makes us fundamentally different, in the scope of our consciousness, from our prephotographic ancestors, whose visual horizon was locked inside the shell and whose moments past were forever lost from sight.

I have presented Ivins according to my own purposes, and the reader familiar with him may already have had occasion to wince. Ivins talked about nets, but differently. I do not recall his mentioning cracks in shells. It would be safer to read Ivins for yourself. My only concern is with the basic idea of syntax and its possible application to photography.

Ivins thought that photography and the photomechanical processes had no syntax. This is a conclusion some photographic historians find hard to accept, because the differences among photographic and photomechanical prints are actually as great as the differences among the various sorts of prints made before photography began. For example, a daguerreotype is quite different from an ambrotype—even when produced using the same camera and showing the same subject. And both are unlike a print of the same subject made from a collodion negative. The differences, in fact, are more easily noticeable than those between etchings and engravings. Photographic and photomechanical prints have different characteristic "looks" as objects in themselves and thus different ways of communicating information. Because these differences affect communication, they would seem to qualify as *syntactical.* Yet if we label them *syntax* we make the term mean more than Ivins intended.

By *syntax* Ivins only had in mind conventions or systems of *drawing,* and from this definition it simply follows that photography is nonsyntactical because photography makes drawing unnecessary. Ivins had keen eyes, and he was undoubtedly more aware of the different looks produced by the various photographic processes and their different capabilities for communication than most

photographers were, but by and large he chose to ignore them. By limiting the idea of syntax to drawing he was able to show how photography *as a whole* was different from what had gone before, and this was his main purpose.

Although Ivins ignored it, photography does have a syntactical basis, one that has evolved and broadened during photography's existence.

Photographic Syntax

In lingusitics, *syntax* is the name for the rules of structure that make meaning possible. We have to follow *syntactical* rules in order to turn our concepts into statements. For example, if you saw someone stealing your camera you might justifiably scream, "That person is stealing my camera!" If you ignored the rules and screamed, "That camera is stealing my person," the metaphor might be interesting, but the thief would doubtless escape.

The current theory in modern linguistics is that syntactical rules are inherent in human consciousness and are passed along as part of our common genetic equipment. This has replaced the earlier theory that these rules are the product of social convention and are passed along through learning. According to the modern view, when children learn to speak they do not have to learn rules of structure. Instead, they learn to apply rules already in their posseison. These innate rules work whether the child is learning English or Urdu. No matter what our language, when we speak, we all reach down and touch the wellspring, common to us all, from which language flows.

When we use words to describe an object the possibilities are infinite; there is no restriction on the number of statements we can make. We can say of a building, "It is a big building," or, more learnedly, "It is a neo-Baroque structure of substantial dimension." On the surface the two statements are different, but beneath the surface both follow the same syntactical rules. All the other infinitely possible statements about the building must also follow the rules. Because of this, the statements are infinite only in the same qualified sense as are the points on a line segment running from *A* to *B*—there may be an infinite number of points in between, but the line itself is finite.

When we photograph an object, again our possibilities are infinite. We can spend a lifetime devotedly photographing the building from different angles and in different lights, and the pictures we make can be as different as the statements we speak. Given this, is there any useful analogy we can discover between talking about the building and photographing it? Are there "syntactical" rules of structure for the way we turn objects into photographs, rules that compel the infinite possibilities to fall along a finite line, just as there are rules for the way we turn concepts into statements? How you answer this question tends to determine how you approach the study of the history of photography.

My answer is that there is a syntactical structure for the "language" of photography and that it comes, not from the photographer, but from the chemical, optical, and mechanical relationships that make photography possible. My argument is that *the photographer can only do what the technology available at the time permits him to do.* All sorts of artistic conventions and personal yearnings may influence a photographer—but only as far as the technology allows. At bottom, photography is a running battle between vision and technology. Genius is constantly frustrated—and tempered—by the machine.

Contemporary sensibility puts so much emphasis on photography as a "creative" activity that we can forget that what photographers really do—whether creative or not—is contend with a medium that forces them to look, to respond, and to record the world in a technologically structured and restricted way. I think that this point is essential to an understanding of photography. You simply cannot look at photographs as if they were ends without means. Each is the culmination of a process in which the photographer makes his decisions and discoveries within a technological framework. The camera not only allows him to take pictures; in a general sense it also tells him what pictures to take and how to go about it. It does this by restricting the field of view. The

technology itself has blind spots and often stumbles through the dark. It is ornery and obstinate and sees only what it will. As a result, human experiences and natural wonders that the technology is not yet able to see go unrecorded— and even unnoticed. Each time the technology enlarges *its* sight, our eyes grow wider with surprise.

Here is a definition of photographic syntax. **In photography, the syntax is technology. It is whatever combination of technical elements is in use. The combination determines how well the technology can see and thus sets the limits on what photographers can communicate through their work.**

This definition will be fleshed out as we go. It is the complement of what Ivins was talking about when he described the *linear syntax* of traditional prints. In traditional printmaking, the syntactical way of putting down lines produces both a characteristic look and a definite range of possibilities for communication. In photography, the combination of syntactical elements—camera, sensitive film or plate, printing method— also produces a characteristic look and a definite range of possibilities for communication. And the metaphor of the net applies to photographic syntax as much as to linear syntax. Photographic syntax is a more effective net of vision, but one that can catch only certain kinds of fish.

The elements of photographic syntax begin to come together as soon as the photographer pulls his camera out of the case. Even the amount of time necessary to fiddle with a tripod or screw on a lens is a part of syntax if it means that when the photographer has finally set up his gear the thing that intrigued his eye has already disappeared, moved down the street, or been transformed by the passage of light into something not so special after all. The choice of lens is part of syntax because it influences how perspective is "drawn" in the image and whether the image is clear or diffuse. The sensitive film or plate has one of the principal roles in syntax because its characteristics determine both the exposure time necessary in the light available and the way colors are reproduced or translated into a scheme of black-and-white

values. The printing method introduces the final elements of syntax: It determines the form the image takes as a tangible object and the way tonal values recorded in the negative are presented. Even the texture of the printing material is part of syntax, because its reflective qualities affect our perception of image tones.

Each step in the photographic process plays a syntactical role to the degree that it affects the way the information, the sentiments, the surprises, and the frozen moments found in photographs actually meet the eye. Together, these elements make up the syntax net. The choice of subject is up to the photographer, but he can only haul his subject in according to the capacity of the net.

For example, most photographs taken between roughly 1855 and 1880 were made with the wet-plate collodion process (discussed more thoroughly later on). The photographer using this process had to sensitize his glass plate and then expose and develop it while it was still damp. To do

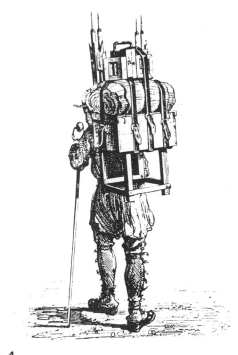

FIG. 4
A wet-plate photographer carrying his syntax on his back.

this out-of-doors, he had to endure the torment of carrying all his supplies and some sort of dark-room along with him (Fig. 4). It was like dragging an anchor. The wet plate was over-sensitive to blue light, compared with its sensitivity to the other colors of the visible spectrum. It was also relatively slow and so, unless the light was particularly strong, exposures of at least several seconds—often minutes—were necessary. Since enlarging, though possible, was more or less impractical, large negatives the size of the final print had to be made. The need for large negatives, together with long exposure times, made a tripod necessary.

All these syntactical elements restricted what a photographer could do. Unless the thing he wished to photograph could be represented using the available syntax—immobile camera, long exposure, blue-sensitive plate—the photographer was simply out of luck. These three basic features of the wet-plate syntax were also basic features of the daguerrean syntax of the 1840's, although in some significant ways the wet plate and the daguerreotype were quite different.

The Effects of Syntax

The syntactical limitations of photography have an importance that goes far beyond the narrow interests of academic study. They are important because they limit our perceptions of the world. They especially limit our perceptions of history. The syntaxes that have existed at various stages in photography shape the world we see when we look at photographs from earlier times. I think we are only beginning to notice the relationship that exists between our ancestors' technology and *our* idea of their world. The photographs they made give us only a version of the truth, one restricted by the technology then at hand. The farther we go back in time, the more restricted the photographic version becomes. If you had the power to run time backward and to hold photographs up beside the events they pretend to mirror, you would see the resemblance become increasingly faulty and dim. It is not that the details become lost—photography has always been good at recording the

stitching of buttonholes—what goes dim is the reflection of what it was really like to have been alive.

Consequently, photographs can be a reliable testimony of how things once were only if looked at in terms of the technical syntax in which they were made. Unless we do our looking with this in mind, photographs will give us an idea of history that is bound to be in some degree wrong, an idea forced out of its rightful shape by a technology that operates selectively, that must discriminate and distort before it can reveal.

One of the things people immediately began to regret when photography was invented was that it had not been invented earlier, that there was no accurate visual record of the great men and women who had come before. Because of photography, our image of what the 19th century was like is considerably more vivid than was the 19th century's image of the preceding ages. Photography, of course, is not our only source of visual information about the 19th century. There are innumerable paintings, wood engravings, lithographs, and other prephotographic prints; but for us they lack the apparent credibility of photographs. (Does anyone except a politician on the Fourth of July really believe that the America of a Currier & Ives lithograph ever existed?) As a result, when we visualize the past back to 1839, when photography became publicly known, we visualize mostly in terms of what we have seen in photographs.

At 1839 there is a barricade that obstructs our view into the deeper past. History seems to fade from sight as we shift our means of visualization. Paintings and prints can help us see into the pre-1839 depths, but not clearly. Yet the view on the photographic, post-1839 side of the barricade consists only of what could be caught in the net of the available syntax—and equally important: it bears the imprint of the photographic medium, of the net itself.

Syntactical Imprints

The syntax available during the first decades of photography left imprints that are easy to see.

This is especially noticeable in daguerrean portraiture. Long exposure times were needed and poses had to be held, sometimes for uncomfortable periods. In the studio this heroic immobility was usually encouraged by clamping the subject's head from behind with an iron brace out of sight of the camera. Subjects in early daguerreotypes frequently sit with one hand supporting the chin. They look like deep thinkers: They were actually concentrating on not moving their heads. Anyone who could manage to look pleasant in these circumstances was either indomitably good-natured or an accomplished hypocrite. I am overstating the case, but the general solemnity of daguerrean portraiture is undeniable. The subject may smile, yet the posture that supports the smile is usually rigid, and more often than not the underlying rigidity can be read across the face. The psychological unreality this could produce was widely recognized and made fun of at the time. Ralph Waldo Emerson saw its imprint:

> Were you ever daguerreotyped, O immortal man? And did you look with all vigor at the lens of the camera, or rather, by the direction of the operator, at the brass peg a little below it, to give the picture the full benefit of your expanded and flashing eye? And in your zeal not to blur the image, did you keep every finger in its place with such energy that your hands became clenched as for fight or despair, and in your resolution to keep your face still, did you feel every muscle becoming every moment more rigid; the brows contracted into a Tartarean frown, and the eyes fixed as they are fixed in a fit, in madness, or in death? And when, at last you are relieved of your dismal duties, did you find the curtain drawn perfectly, and the coat perfectly, and the hands true, clenched for combat, and the shape of the face and head?—but, unhappily, the total expression escaped from the face and the portrait of a mask instead of a man? Could you not by grasping it very tight hold the stream of a river, or of a small brook, and prevent it from flowing?[1]

Part of what bothered Emerson (aside from his own aversion to having his picture taken) was simply the newness of the thing. Human faces had rarely been fixed in such an uncompromising way before, at least not in commissioned portraits by trained painters. One might think an American familiar with the brutalities of Colonial portraiture would have been ready for anything; but in fact no one could have been prepared for what happens when the flow of life is immobilized and an individual is summed up in an isolated instant. It would have been fascinating to have been there to see the reactions of Europeans and Americans to their first daguerrean portraits. Carl Dauthendey, who became a professional daguerreotypist in 1843, described a response verging on paranoia: "People were afraid at first to look for any length of time at the pictures [the daguerreotypist] produced. They were embarrassed by the clarity of these figures and believed that the little, tiny faces of the people in the pictures could see out at them . . ."[2]

And yet, aside from its fundamental newness —its optical truth coupled with its dependence on the expression of the moment—daguerrean portraiture fell like a soldier right into line. Its compositional formulas are the standard ones of 19th-

FIG. 5
SARAH GOODRIDGE, *The Rev. Henry Ware, Jr.,* 19th century minature.
(Museum of Fine Arts, Boston, Emma F. Monroe Fund)

FIG. 6
WILLIAM M.S. DOYLE, *Samuel Stockwell,*
miniature, no date.
(Museum of Fine Arts, Boston)

At this stage of the available syntax, snapshot or candid portraits—which by their nature tend to break almost automatically with traditional compositional portrait structure—were not possible. Everyone had to oblige and be still, just as everyone had to be still when painted by an artist. The early syntax thus tended to ensure a continuity between traditional portraiture and the new photographic portraiture. As a result, the composite image of man that we are given in daguerreotypes is overwhelmingly restricted to a studio version—just as it was in prephotographic portraiture. Very few daguerreotypes were taken out in the field, and even those that were did not shake the studio problem of having to hold a pose.

When we look at daguerreotypes it is often impossible to distinguish between poses and personalities, or between the fashionable affectations of the time (the ways people wanted to look) and the affectations syntactically encouraged by the act of being daguerreotyped (Fig. 8). A whole

century portrait painting in general and especially of painted miniatures (small portraits that became popular in the 18th century and remained so until photography drove the miniaturists out of business). The portrait subject is set within the frame and presented in the same general ways. Compared with the already available types of portraiture, daguerreotypes rarely display any startlingly new formal arrangements. (There are exceptions—see Figure 7—but here we are speaking in statistical terms.) One way to interpret this uniformity is to say that the conventions of portrait painting were so well established that they were automatically taken over by daguerreotypists as being *ipso facto* the only way to proceed. This partly states the case, but if you look at it in terms of syntax you see that no other approach would have been as practical. The traditional portrait formalism was simply the easiest response to the syntactical problem of long exposure with a stationary camera.

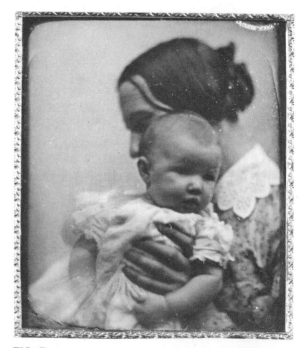

FIG. 7
SOUTHWORTH & HAWES, *Mrs. J.J. Hawes, and Alice,* daguerreotype, no date.
(Museum of Fine Arts, Boston)

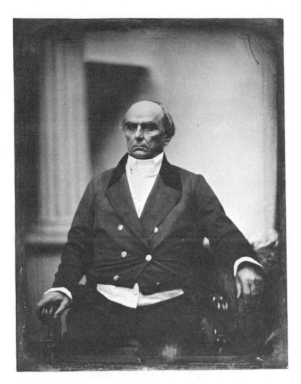

FIG. 8

JOSIAH JOHNSON HAWES, *Daniel Webster,*
daguerreotype, 1850.

(Museum of Fine Arts, Boston, Gift of Edward Southworth
Hawes)

Another result of the long exposures necessary with the syntax of daguerreotypes and early wet-plate photographs is that the urban world comes to us virtually depopulated. We are shown very little of the normal activity of the streets. The people we do see had either taken the time to pose or mug for the camera or had remained motionless by chance. Often we see only the semitransparent ghosts of persons who moved too fast to be caught whole, but not fast enough to escape altogether. The same goes for moving vehicles. If the photographer tried to capture the unposed activity of the street the result was usually an image forlorn, like the paintings of the *Scuola Metafisica,* with only an occasional lonely figure or two. In 1823, sixteen years before the announcement of photography, Daguerre's Diorama, the spiritual ancestor of the daguerreotype, was described as producing an impression "of a world deserted; of living nature at an end; of the last day past and over."[3] For all its painstaking realism, the painted Diorama suf-

catalog of human emotions can be found in daguerreotypes, but not one that we can be sure is genuine and untainted—the technology was virtually blind to any human response other than those stimulated by its own presence. The conclusion is that daguerrean portraiture gives an incomplete and untrustworthy image of man. It suffers under too many impositions. We do not see activities—as we do in later photography—but only arrangements. The necessary formalism reduces things to a single dimension. Perhaps the best way to convey what this implies is to ask you to imagine what our "image of man" would be today if ninety-nine percent of all contemporary photographs showing the human body were studio portraits. There is no doubt that we would think of ourselves differently and in narrower terms.

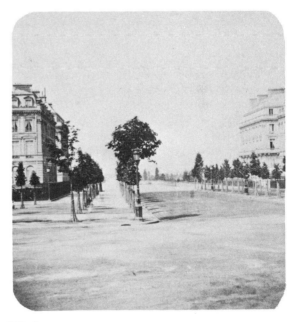

FIG. 9

Half of a stereoscopic slide, French, 1850's, street depopulated by a long exposure time.
(Collection of David Kolody)

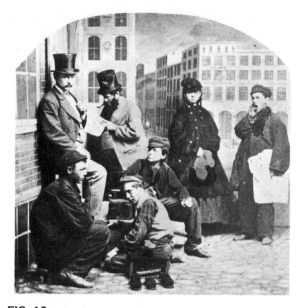

FIG. 10
LONDON STEREOSCOPIC COMPANY. *A street scene posed in a studio, 1850's, half of a stereo.*
(Collection of Rick Russack)

fered, the critic said, from "a stillness which is the stillness of the grave." The same complaint was often leveled against photography during the 1840's and 1850's.

The first "instantaneous" street photographs, which were made sporadically through the 1850's but only in quantities beginning in 1859, were greeted with amazement and even relief. They signaled a quantum jump in the syntactical capabilities of photography because they began to show what the city looked like *in use,* something that pre-1859 photography nearly always failed to do. In 1861, Oliver Wendell Holmes said that if a philosopher from a strange planet were to ask to see the most remarkable product of human skill he should be handed an instanteous stereoscopic photograph showing the view down New York's Broadway.[4]

Before instantaneous exposures (roughly one-tenth of a second according to 19th-century reckoning) became practical, if one wanted to

photograph the action of the streets it was necessary to pose figures in motion, as Charles Nègre did in 1851 (Plate 4). Photographers in the 1850's who undertook street scenes frequently did them entirely in the studio, with figures posed against painted backgrounds. These scenes were often photographed in the sugary style of genre paintings—a style to which the British, under the influence of the paintings of Sir David Wilkie, were particularly vulnerable.

The instantaneous street photographs made from the 1850's through the 1870's were almost always taken from a second story or higher, with the camera pointed down the street rather than across it. This camera direction allowed more of the street to be shown, but with the slow wet-plate it was also syntactically necessary. It was far easier to freeze the image of figures moving directly away from or toward the camera than across its field of view. This is because the shifting of the image on a plate is at a minimum when the movement of the figure is along the line of the optical axis. Unless the figure is a considerable distance

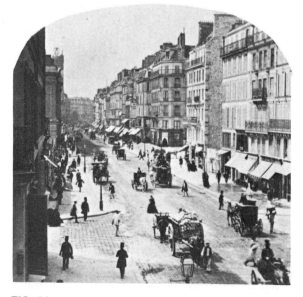

FIG. 11
WILLIAM ENGLAND, *Rue De Rivoli, a Paris—Vue Instantanée (No. 3). Half of an "instantaneous" stereograph taken in 1861.*
(Collection of Rick Russack)

from the camera, lateral movement at low shutter speed tends to come out as a blur. The circa-1859 instantaneous street photographs made by Henry Anthony (in New York), George Washington Wilson (in Edinburgh), and William England (in Paris) were uniformly from high up, looking down the length of the street.

If the photographer wanted to get closer to the action—if he wanted to photograph from street level or straight across the street—the syntactical problems became much greater. Street activity involving motion could be taken unposed if far away but had to be posed when close up. Consequently, the "long shots" and the "close-ups" from this period do not quite mesh. The closer one gets to the action, the more artificial the action becomes. It was not until the 1880's and 1890's, with the introduction of the hand camera, that photographers were able to get down to street level and successfully stalk the action around them. The historian who wants to use photographs to gain an idea of what 19th-century urban life was like can draw from this his own conclusions about the syntactical limitations of the record.

Syntax and Time

The relationship between photographic syntax and our visual sense of history deserves careful study. I could only start on it here. Before dropping it to look at some other aspects of syntax, there is one more thing to add. Over the years, as the technology of photography advanced, it became able to see more of life and thus to communicate more. (The advantage photographic syntax has over linguistic syntax is that it can change practically overnight.) These advances in syntax have a remarkable effect on later generations. The syntactical advances compress the sense of historical time; they draw the past closer.

We can see this happening when we look back at those periods when the photographic syntax made a jump ahead: The outstanding examples are the introduction of the collodion process in the early 1850's and of the hand camera in the 1880's. In photographs taken after, the world appears as if abruptly changed—the past seems somehow a nearer thing. The world was indeed changing, but not as rapidly as photography itself. The jump in the syntax, in its capacity for information, gives us the odd illusion that the world suddenly jumped, too. The past does not recede from us at a stately, steady pace, but in sudden syntactical fits. Photographically recorded, history has the jitters. Film and television, the syntactical descendants of photography, have greatly accelerated this compression of the sense of historical time. Despite the inevitable differences, when people a century from now look back on our era they will certainly feel much closer to us than we feel toward our ancestors of a century ago.

Camera Syntax and Printmaking Syntax

The emphasis so far has been on the elements of syntax that have to do with the act of taking a photograph. We can call these camera syntax. *Camera syntax consists of the technical elements that set the limits on what can be recorded on the sensitive surface of a film or plate.* The camera syntax available to the photographer determines the extent to which he or she must specially select or arrange subjects in order to overcome the technology's blind spots.

Once the exposure is made, the latent or negative image must be transformed into a positive one. *The syntactical elements that determine how the image finally appears can be called printmaking syntax.* If we print the same negative on albumen paper, on platinum paper, and on modern resin-coated paper, we will end up with three distinctly different objects. This is because each of these printing processes has a printmaking syntax of its own, with its own characteristic look.

Admittedly, a clear-cut technical division between camera syntax and printmaking syntax is not always possible. Any experienced photographer knows that printmaking actually begins with the exposure and development of the negative. In the case of direct-positive processes—such as the daguerreotype, the tintype, or the modern Polaroid and Kodak one-step pro-

cesses—strictly speaking, no printing takes place. Therefore the division is necessarily a general one. *Camera syntax* refers to the making of a record and to its technological limitations. *Printmaking syntax* has to do with the manner in which the record is *presented.*

Printmaking syntax can alter information. When we print our negative on various papers or in various ways we retain the same basic information but we inevitably modify it to a certain degree. Printmaking syntax—image color, surface texture and surface optics, and above all the way the tonal scale is presented (contrast)—affects the way content comes across.

Artistic Syntaxes

So far I have not said much about the contributions of the photographer. I have talked as if photography were entirely an exercise in technique. This emphasis is lopsided but worth risking to make the point that every time a photographer solves an aesthetic problem he has to solve an underlying technical problem. One solution supports and influences the other. Granted, the photographer is infinitely more interesting than the photographic machine, and so are the things the photographer uses the machine to capture. But unless you understand the ways the machine cajoles and begrudges you will never know how truly interesting the photographer is. You will not see the compromises he had to make in order to put his vision on paper.

In the 19th century the products of the machine were often made to look like art (that is why cast-iron bathtubs had claw-and-ball feet). In the present century it is just the reverse. Modern art has repeatedly derived both formal qualities and subject matter from the machine. In painting, this imitation of machine-produced forms has long since become old-hat. Ironically, in serious photography the medium's own unique capacity for machine-produced form has until recently been largely suppressed. Some of the most interesting work today—for example the 35mm work of photographers like Robert Frank, Lee Friedlander, Tod Papageorge, and Garry Winogrand—finally

shows us what it means to give in to the photographic machine. Instead of making photographs that have the preconceived artistic balance for which 19th-century photograpers struggled, today's avant-garde takes its cue from the amateur's haphazard snapshot. The photograper does not deliberately guide the camera; instead, it is almost the other way around. The photographer reacts spontaneously and does not know the result until he comes out of the darkroom. Formal order is not imposed but discovered. The images that result often have, by traditional standards, a wildly unbalanced, sometimes chaotic or apparently nihilistic look. The look comes from allowing the machine to do the seeing. The photographer's genius at least partly consists of making sure that the machine has plenty of good opportunities.

This willingness to give in to the machine and to allow the syntax to dictate formal qualities is something that would have appalled 19th-century art photographers. Of course, their technology was more static and consequently more rigid in its preferences than modern equipment—it offered fewer surprises. Even so, 19th-century photographers would admit to its influence about as eagerly as they would to the possession in the nursery of a bastard son. Nineteenth-century critics tended to play the spoilsport by overemphasizing the machine. Believing that the camera, like most machines, was only capable of producing standardized and often imperfect results, many critics rejected the idea that it could produce artistic results: Communication of information was one thing, but artistic expression was quite another.

Just what it was that artistic expression required depended on your school of thought. Some felt it had to be visionary; that it had to make visible the objects of the imagination. But photographers were stuck with the objects of sense. Others felt that artistic expression required the ability to record the world exactly as the eye sees it. This held out more promise—until it was discovered that the world does not appear the same in photographs as it does to the naked eye. Photographers thus had to contend with criticism from both sides, criticism that said their

machine had neither the imaginative nor the realistic capabilities needed to produce "art." In a conscious attempt to prove the critics wrong, a number of photographers, starting as early as the 1840's, tried to develop special "artistic syntaxes." This will be one of the topics in the pages that follow.

Printmaking Syntax and the Problem of Reproduction

For the most part, the historical portion of this book will deal with printmaking syntax. I want to show how photographs have evolved as physical objects and how different printmaking syntaxes have produced different looks. This is not easy to do in a book illustrated with offset reproductions instead of actual prints. The linear syntax Ivins spoke of in connection with prephotographic prints can be shown without much trouble in offset reproductions. But when it is applied to the reproduction of original photographs, offset printing, like any other photomechanical reproduction process, tends to make everything it touches come out looking alike. It imposes its own printmaking syntax and largely ignores that of the original. For example, an offset reproduction of a daguerreotype looks much the same as an offset reproduction of an albumen print, even though in reality the printmaking syntaxes of the originals produce visual sensations that are very different. Without using actual prints it is extremely difficult to show the various ways printmaking syntax can affect the look of photographs. Verbal descriptions can help, but they always seem to fall short. I would prefer to reach into a drawer, pull out some prints, and let the reader see things firsthand.

The inadequacies of photomechanical reproduction become particularly frustrating when one studies the work of the so-called Pictorialist photographers busy at the turn of the century. The Pictorialists were especially conscious of the physical qualities of their prints, and they expended an enormous amount of energy searching for ways to give their prints maximum surface beauty. They tried to make beautiful images also be beautiful objects. To an extent this has always

been a part of careful photographic printmaking, but in Pictorialism it became an outright obsession. While the camera syntax of Pictorialist work can be reproduced photomechanically, the surface qualities of its printmaking syntax usually cannot be reproduced to any significant degree. With the exception of the plates in the recent book *Georgia O'Keeffe, A Portrait* (Metropolitan Museum of Art, New York, 1979), there has rarely been a reproduction of an Alfred Stieglitz platinum or palladium print, to give an example, that comes even close to conveying the special *presence* of the original. As a consequence, the impression one gains of Stieglitz's work through reproductions is remarkably different from the impression gained from original prints. Stieglitz complained about this himself in regard to the reproduction of his own work, but the complaint can be extended to photographic reproductions as a whole.

The moral is that the student of the history of photography who relies on photomechanical reproductions operates under the same disadvantage as does the student of the history of painting who leans back and relies on the slides his lecturer flashes on the screen. Both miss the experience of the original in itself. This experience is as necessary in photography as in any other art, although its importance in photography is less generally understood.

The difficulty of reproducing printmaking syntax has tended to ensure that books on the history of photography tell certain lies. Both the Newhall and Gernsheim versions of *The History of Photography* are excellent works, but when you flip through the illustrations you are constantly misled. You are led to believe, among other things, in the existence of black-and-white photography. The four-color reproductions in this book should remind you that there is rarely such a creature as a black-and-white print, because nearly all photographic printing is printing in color. It may only be monochromatic color, or a delicate shift from cool blacks to warm ones, or color applied by hand, but color—in any form—has to be reckoned with because it is of real consequence in the way an image does its work. A tonal value

printed in brown will not look the same as when printed in another color, and the image of which it is a part will change accordingly. Nineteenth-century photographs—far more than 20th-century ones—have a surprising range of colors. The color loosely known as *sepia* is only one example. The four-color reproductions here will at least suggest the color differences among the various 19th-century printmaking syntaxes. While this is better than picking out one "antique" color and foisting it on all the images, we are still telling lies—only more subtle ones: Even if you get the color right in an offset reproduction you will rarely get the tactile qualities right, and yet the underlying tactility plays a large role in determining how color is perceived.

Although the problems involved in reproduction are considerable, there is one way to turn them to advantage. If you bring a reproduction along when you look at an original print and then settle down and compare the two as carefully as if you were Sherlock Holmes searching for clues, you will give your eyes some valuable training. Any number of tiny events occur on the surface of a print or reproduction, but the first time out all you notice is the gross activity. You have to learn how to see the characteristics of printmaking syntax, and comparison of two versions of the same image is the best way.

☆ ☆ ☆ ☆

In the following pages I have tried to do two things. The first is to give fairly detailed technical information on certain historical photographic processes by describing the experiments that led up to them and the problems their inventors hoped to solve. The reader who is interested in the technical history of the calotype or of the gum print, for example, or who wants to know how to identify prints by process, can find information here. But beyond simply describing processes, I have tried, secondly, to present at least the beginnings of an account of the syntactical relationship between images and technology. I have narrowed this down considerably by emphasizing printmaking, particularly the processes that contributed to major changes in styles of photographic printing. Because of this emphasis, much has been left out—such as the various contending claims to the priority of the invention of photography on paper, full-color photography, and literally hundreds of miscellaneous little-used processes and formulas.

The reader will find that in concentrating on printmaking, and especially on printmaking done in the pursuit of "artistic" results, I have largely ignored the broader problems of syntax-and-communication discussed above. This is one of those cases where an author covers his retreat by explaining that handling the subject in the manner it deserves would take a book in itself. (One of the things that book would contain is a detailed account of the effects the gelatin dry plate and the hand-held camera had on camera syntax, an account absent here.)

Those who already have a background in the history of photography will discover that the text refers almost entirely to well-known photographers and may groan and wonder, "Do we really have to hear about *them* again?" I wondered about that myself. I tried to justify it by concentrating on how these photographers responded to the syntactical problems they faced, and how their work reflects certain ideas concerning what photographs should be like as physical, as well as visual, objects.

Photographic printmaking really started with Fox Talbot. Accordingly, so will we.

The First Processes

William Henry Fox Talbot, photography's first completely successful printmaker, was born in 1800. Although by formal training a classicist and mathematician—he was elected a Fellow of the Royal Society in 1831 on the strength of his work in mathematics—Talbot was also interested in chemistry, botany, astronomy, and a great many other studies. When he was seven years old he decided to estimate the number of miles he had already traveled in his life. The figure came to 2,717.[5] This is just a story about a boy, but it describes the character of the man. Throughout his life, Talbot had to scramble to keep up with his almost whimsical curiosity: The man who was a pioneer in the development of photography was also a pioneer in the translation of ancient cuneiform writing. On top of this, Talbot was an inveterate tourist. Oddly enough, his addiction to

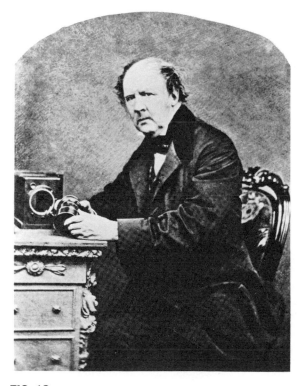

FIG. 12
Portrait of Talbot taken 1864 by John Moffat.
(Science Museum, London)

FIG. 13
Wood engraving from volume three of Louis Figuier's Les Merveilles de la Science, *1867.*

the pleasures of travel led to his experiments in photography.

Talbot was elected as the Chippenham representative to the House of Commons on December 19, 1832. (He recorded in his letters that his constituents celebrated the victory by drinking four guineas' worth of ale and spirits at the local pubs at his expense.[6]) The following June, in 1833, Talbot and his wife, Constance, began a six-month tour of the Continent. They traveled from London to Paris and on to Berne, wandered at a leisurely pace through Switzerland, and then, by September, headed south for Italy. As Talbot later wrote in *The Pencil of Nature,* it was in October of 1833, while he was trying to make *camera lucida* sketches of the picturesque scenes along the shores of Lake Como, in the Italian lake district at the foot of the Alps, that the idea of photography first came to him.

The camera lucida Talbot carried on his travels was an optical aid to drawing invented in 1807 by William Hyde Wollaston, the chemist and physicist. It consisted of a prism that could be adjusted to allow an artist to look at a distant scene and simultaneously at a sheet of drawing paper. The image of the scene appeared superimposed over the paper, and all the artist had to do was trace its outlines. Talbot's problem was that he could not draw, at least not to his own satisfaction, even with the help of the camera lucida. He decided that what he really needed was a *camera obscura,* a device he had taken on earlier trips abroad and one which had been used since the Renaissance, in one form or another, as an aid to drawing and to the study of perspective.

In its most common form in the 1830's, the camera obscura was simply a box with a lens at one end. The lens projected an image onto a mirror, which in turn reflected it onto a ground-glass screen—the same principle used in reflex cameras today. The image could then be traced on translucent paper laid over the glass. But even with the camera obscura there still remained the need to draw. Talbot wondered if perhaps by using the optics of the camera there might be a way to imprint the image on paper entirely by the chemical action of light. On his return to England

FIG. 14
A lithograph of the camera lucida in use.
(Gernsheim Collection, Humanities Research Center, University of Texas at Austin)

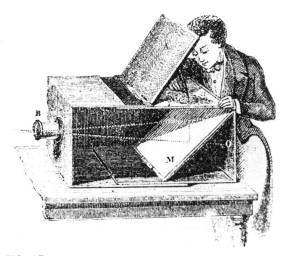

FIG. 15
Wood engraving showing the principle of the camera obscura.

in January of 1834, Talbot set to work to find a means to capture the "fairy pictures, creations of a moment," which passed so temptingly across the screen of the camera obscura.

Talbot did not know of the experiments along the same lines that had been undertaken earlier by Nicéphore Niépce in France, which at that very moment were being continued by Louis Daguerre. Nevertheless, he did not have to start from scratch. He was able to base his work on studies made as far back as 1725 by Johann Heinrich Schulze on the effect of light on silver nitrate, and on research on silver chloride done by the Swedish chemist Carl Wilhelm Scheele in 1777.

While trying to prepare phosphorus with chalk and nitric acid, Schulze had accidentally discovered the light-sensitivity of silver nitrate. He found that his chalk-and-acid combination turned purple when exposed to light, and discovered that this was due to traces of silver in the nitric acid. Scheele confirmed Schulze's experiments and also demonstrated that a precipitate of metallic silver results when silver chloride is exposed to light. Scheele found that this reaction occurred most rapidly when the silver chloride was exposed to light from the violet end of the spectrum.

In Britain at the beginning of the 19th century, Thomas Wedgwood and Humphry Davy had also experimented with silver nitrate. Thomas Wedgwood was the youngest son of Josiah Wedgwood, the potter and porcelain maker. Josiah had used the camera obscura in preparing a china table service depicting British mansions for Catherine the Great of Russia. He was a member of a group of scientific men who called themselves the Lunar Society, a name they took because they met monthly on evenings when the moon was full. Another member of the Lunar Society was Dr. Joseph Priestly, who knew of Schulze's and Scheele's experiments. Probably Thomas Wedgwood learned about them through Priestly. Wedgwood began experimenting some time at the close of the 1790's, and Davy later joined him. Humphry Davy was a chemist who became director of the chemical laboratory of the Royal Institution in 1801. He was co-editor of the

Journal of the Royal Institution, and it was in that journal, in 1802, that he described the experiments he and Thomas Wedgwood had conducted.[7]

Wedgwood had tried to form an image using a solution of silver nitrate spread on various surfaces and placed in a camera obscura. He failed because the low sensitivity of the silver nitrate made necessary a longer exposure time in the camera than he realized. He abandoned the camera and turned to making contact prints by coating paper or white leather with the silver nitrate solution, then placing opaque or semi-transparent objects on top and leaving it out in the sun. Davy later repeated these experiments but used silver chloride, finding it more sensitive than the nitrate. Wedgwood and Davy were successful in making images by contact printing. Yet their process had a crucial drawback: The image, once produced, stayed sensitive to light. It had to be viewed in dim light, and only for brief periods, or the previously unexposed portions would darken and the image would disappear. They did not know how to "fix" it.

Although the studies by Schulze and Scheele were well known to scientific men in the early 19th century, including Talbot, the work of Wedgwood and Davy was not. Talbot was to write in 1839 that he was not familiar with the latter when he started his experiments, although he mentioned that he did come across it later, *after* he had discovered a method of fixing the image.[8]

Like the predecessors, Talbot coated paper with a solution of silver nitrate. His first experiment was to place the paper in a window in such a manner that the shadow of an object fell across its surface.[9] Later, he placed flowers, leaves, lace, and other objects directly on the paper. Talbot was disappointed with the low sensitivity of the silver nitrate and switched to a solution of silver chloride. At first he found no improvement in the sensitivity. Then, instead of brushing on an already prepared solution of silver chloride, Talbot tried brushing on a solution of salt (sodium chloride) and following that, after the paper had dried, with a solution of silver nitrate—thus forming the silver chloride on the paper itself. The sen-

sitivity proved no greater than before, but now Talbot noticed that the paper tended to darken faster at the edges of the coating than at the center. He wondered if this might be because the edges had received less salt than the center. In the spring of 1834, he tested this idea by coating paper with a weaker solution of salt while keeping the strength of the silver nitrate solution the same. The paper now darkened far more rapidly upon exposure than the earlier sheets had.

In this way Talbot found that the sensitivity of silver chloride was greatly increased in the presence of an *excess* of silver nitrate. This also led to the corollary discovery that an excess of salt

diminished the sensitivity of the silver to the point where a solution of salt could actually be used to fix the image and prevent it from darkening on further exposure to light.[10] That autumn Talbot found that a solution of potassium iodide could also be used to fix the image. Later, however, he learned that neither the salt solution nor the iodide could make images truly permanent, the effect of both being only to reduce, but not totally eliminate, sensitivity.

Once he had determined the correct chemical proportions for the sensitizer, Talbot had no trouble obtaining "very pleasing images of such things as leaves, lace, and other flat objects of complicated forms and outlines" placed over his sensitive paper and pressed down tightly with a sheet of glass.[11] But when he placed the paper in a camera obscura and focused it on his home, Lacock Abbey, leaving it for exposures of an hour and more, he found that it was only sensitive enough to record (in negative) the outlines of the roof and chimneys, not the details of the architecture. According to Talbot's book *The Pencil of Nature*, this was in the spring of 1834.

By the summer of the following year he had learned to increase the sensitivity of the paper by giving it alternate and repeated brushings of the salt and the silver solutions and exposing it while still wet. Apparently he discovered this while experimenting with the images produced by a device called a *solar microscope*, which was in essence a kind of enlarging camera designed to project magnified silhouette images of tiny objects. Talbot reported that he had success in enlarging the image of objects on his sensitive paper more than seventeen times their actual linear diameter.[12] Using paper prepared in this fashion, he also had better results with the camera obscura. With tiny cameras equipped with lenses of short focal length and relatively large aperture, Talbot was able to reduce the exposure time on a bright day to ten minutes. Talbot noted that he was aided in his work by the unusually good summer weather of 1835.

Talbot Gets a Surprise. This was about the stage at which Talbot's experiments stood when, on January 7, 1839, the illustrious French scien-

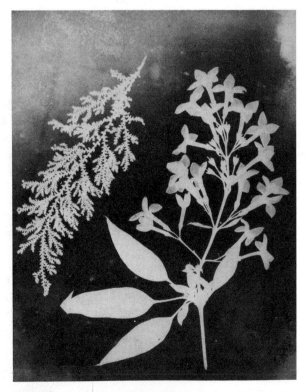

FIG. 16
Photogenic drawing by Talbot of jasmine and fern, 1839.
(Gernsheim Collection, Humanities Research Center, University of Texas at Austin)

tist François Arago, acting on behalf of Louis Daguerre, announced the results of Daguerre's photographic experiments to the Academy of Sciences in Paris. Arago did not give the working details of Daguerre's process, however, and when Talbot learned of the announcement he realized that if he acted quickly he could still establish his priority as the inventor, in the event that Daguerre's process and his own turned out to be the same. And so on January 25 he exhibited a number of what he called *photogenic drawings* at the Royal Institution in London. They were prints of flowers and leaves, a lace pattern, a print (or prints) made by exposing through painted glass, a view of Venice printed from an engraving, at least two images made using the solar microscope, and a number of negative camera obscura pictures of Lacock Abbey.[13] Six days later, Talbot took these to the Royal Society and there read a paper entitled, "Some Account of the Art of Photogenic Drawing, or the process by which natural objects may be made to delineate themselves without the aid of the artist's pencil." The paper described the process in general and gave some thoughts about its future applications, but it did not reveal the details or the method of fixing the image. On February 21, a letter from Talbot was read before the Society, this time giving working details. Daguerre's method of working was not revealed until six months later, on August 19, 1839.[14]

Long before then, however, it had become clear that the two techniques were significantly different.

The most obvious difference was that, while the daguerreotype image was positive, Talbot's images, at least at this early state, were negative— reversed in tone. In "Some Account of the Art of Photogenic Drawing" Talbot described how a photogenic copy of an engraving, made by printing *through* the engraving and therefore a reversed-tone image, could be corrected in tone if the copy were itself printed through (having first been fixed, of course). But this printing method was mentioned only in connection with engravings. It is difficult to imagine why positive copies from camera negatives, had they existed, would not have received the principal attention. Ap-

parently there were none at this time.

On February 1, 1839, Talbot visited Sir John Herschel, the astronomer, and eleven days later Herschel wrote Talbot suggesting he try varnishing the back of engravings with mastic in order to improve their translucency and thus facilitate the printing of copies. No specific mention was made of applying this to negatives made in the camera. Exactly when camera negatives were first printed to make positive copies is not known, but in August of 1839 Talbot showed ninety-five photogenic drawings at a meeting of the British Association in Birmingham, and among them were positives printed from camera negatives.[15]

Hypo. Herschel was the one to discover the best method for fixing the images. Twenty years earlier, in 1819, he had found that sodium thiosulfate (which until 1869 was—incorrectly— called *hyposulphite of soda,* whence the name still used today, *hypo*) had the power to "dissolve" certain silver salts. Herschel learned of Daguerre's process in a letter dated January 22, 1839, sent to him by a Captain Francis Beaufort, and immediately began experiments of his own. Although he had no knowledge of the details of either Daguerre's or Talbot's methods, by January 29 Herschel had managed to print images using silver chloride, silver nitrate, silver carbonate, and silver acetate, and to fix them in sodium thiosulfate.[16] Herschel's images, as he later admitted, were not equal to Talbot's but his method of fixing was far superior. The thiosulfate did not actually dissolve the unexposed silver salts, as Herschel stated, but produced a soluble compound that could be washed away. It left unchanged the reduced, metallic silver formed in the image areas during exposure.

During Talbot's visit to Herschel on February 1, Herschel told him about the thiosulfate technique. Daguerre learned of it through a letter—dated March 1, 1839— that Talbot sent to the French physicist Jean Baptiste Biot, in which he listed the known fixing methods and called thiosulfate the best.[17] Daguerre immediately abandoned salt as his fixer (he had discovered its use independently of Talbot) and took up thiosulfate.

The Calotype

On September 20 and 21, 1840, Talbot was experimenting with papers prepared in various ways, giving them short exposures in order to determine which was the most sensitive.[18] He happened to observe that a sheet of paper sensitized with a solution of gallic acid and silver nitrate and exposed in the camera while still moist—exposed too briefly to give an immediate image—produced an image when left for a time in the dark. This gave Talbot the idea of exposing paper prepared in the same way but used dry, and then developing the image out with the gallic-and-nitrate solution. The experiment was a success and led Talbot to the technique he called *calotype*, from the Greek word for "beautiful." Later the process also became known as the *Talbotype.*

Talbot patented the calotype on February 8, 1841 (British Patent No. 8842). According to the patent specification, he first coated paper by brushing it with a solution of silver nitrate, which he allowed to dry. Next he dipped the paper for a minute or two in a solution of potassium iodide, then rinsed it in water and dried it again. Talbot stored this "iodized paper" in the dark until needed. He sensitized the paper by brushing it with a solution of silver nitrate, acetic acid, and gallic acid, a solution he referred to as *gallo-nitrate of silver.* After brushing he allowed thirty seconds for the sensitizer to sink in, then dipped the paper in water, dried it, and placed it in the camera for exposure. He developed the image by brushing it with the same gallo-nitrate solution, and fixed it in a salt solution or with potassium bromide. The patent did not mention sodium thiosulfate as a fixer for the calotype negative, apparently because potassium bromide gave better transparency. Talbot described the use of sodium thiosulfate in a second patent (No. 9753) in 1843.

Developing the image out made much shorter exposure times possible. Talbot said that in October of 1840 he succeeded in taking portraits in direct sunlight in half a minute, and in open shade in four or five minutes.[19] For printing, Talbot generally waxed the back of the paper calotype negative and printed it in contact with the salted photogenic paper introduced earlier.

Calotype Prints. The technique for making a salted-paper print from a calotype negative was refined during the 1840's by Talbot and others. The printer first "salted" paper by brushing it with, or dipping it in, a solution of sodium chloride or

FIG. 17 and FIG. 18
Calotypes by Talbot or associated, mid-1840's.
(International Museum of Photography/George Eastman House)

ammonium chloride, or a combination of both chemicals. If the paper lacked sizing (see Part II), the salting solution was combined with a sizing agent—such as arrowroot, starch, or gelatin—to keep the sensitive coating from sinking too far into its surface, a situation that might flatten the contrast of the image. The printer sensitized the paper, as needed, by brushing it over with silver nitrate, then let it dry before use. After the image had printed-out to a sufficient density during the sunlight exposure beneath the negative, the printer rinsed it in water to remove the excess silver nitrate. Next, he toned the image in a solution of gold chloride (gold-toning was introduced for prints in 1847,[20] but was not used regularly until the 1850's), fixed it in sodium thiosulfate, and washed it in several changes of water.

The resulting matte-surfaced prints were usually reddish brown or, if toned with gold, anywhere from reddish brown to purplish brown. Generally, the longer the print remained in the toning bath, the "colder" its final color (gold-toning did not turn prints golden in tone).

Many color variations were possible, even before gold-toning was introduced. The color depended on the sizing and on any chemically active trace materials present in the paper (British papermakers usually sized with gelatin, and their papers gave cooler tones than French papers, which were usually sized with starch or resin) and especially on the composition of the sensitizer and the fixing bath. "Exhausted" fixers—that is, baths containing an excess of dissolved silver, either from previous prints or from the deliberate addition of silver nitrate—were used to tone prints through the formation of dark silver sulfide. Unfortunately, this treatment eventually causes prints to discolor and fade. Another way to modify the color was to wash the print only briefly after fixing and then dry it with heat. The method produced what was described as a "purple or deep tinge" and was used in printing Talbot's book *The Pencil of Nature*.[21] The paper generally considered best for printing—Talbot's favorite—was Whatman's Turkey Mill. It was a handmade rag paper, tub-sized in gelatin, the sizing then hardened with alum (these details are important for paper conservators).

Many salted-paper prints have faded, generally to tones of green-brown or yellow-brown, for the most part because of having been fixed with an exhausted fixer or not sufficiently washed. During the 1840's, on Herschel's advice, washing was generally considered complete when the drippings from the print no longer tasted sweet. This turned out to be a regrettably invalid test. Some earlier prints fixed with salt instead of with thiosulfate have been observed to have faded to pink and mauve colors, and some fixed with potassium bromide to have taken on a yellow color in the highlights.[22] Talbot noted that images fixed with potassium iodide would slowly begin to fade on subsequent exposure to light until "obliterated . . . to the appearance of a pale yellow sheet of paper."[23] Developed-out calotype negatives, and positives printed on calotype paper and developed, usually have a slate-gray color in the dense areas, while the light areas may have turned gray-green or yellow-brown.

Although largely supplanted by albumen papers during the 1850's, salted-paper prints were made at least through the early 1860's, often from collodion negatives (albumen and collodion are described farther on). The Pictorialists revived the process in 1890's.

The Daguerreotype

Talbot's technique was the first successful negative/positive method of photography, but for more than a decade this approach to image-making took a back seat to the far more popular direct-positive daguerreotype introduced by Louis Jacques Mandé Daguerre. Daguerre had already become famous in Paris and London back in the early 1820's as the creator, along with his partner, Charles Bouton, of the Diorama, a kind of highly illusional picture theater. The partners produced Diorama pictures by a technique of painting on both sides of a large transparent screen in such a way that the appearance of the painted image could change in front of the viewer's eyes, depending on whether the screen was illuminated

FIG. 19
An early lithograph of Louis Jacques Mandé Daguerre.

from the front or from behind. In preparing his Dioramas, Daguerre sometimes made use of the camera obscura.

Daguerre's interest in photography began as early as 1826, but he was unsuccessful in producing any images until after 1829, the year he formed a partnership with Joseph Nicéphore Niépce. In certain of its details the daguerreotype technique was based on information Daguerre had received from Niépce, but it was Daguerre's discovery of the possibility of forming a latent image on iodized silver, and bringing it out by development, that made the daguerreotype a reality.

Niépce's process involved the use of bitumen, a substance that becomes insoluble on exposure to light. Niépce experimented with bitumen coatings on a variety of surfaces, among them silver-plated copper. In 1829, Niépce found that he could darken the silver plating by exposing it to the vapor of iodine and in this way increase the contrast of his images (see page 235 for more details about Niépce's work).

After hearing about this, Daguerre began experimenting with iodized silver and found that it was sensitive to light (Figure 21). He then attempted to use it as a photosensitive material in place of Niépce's bitumen. The undocumented story is that one day Daguerre happened to place an iodized silver plate in a cupboard used for storing chemicals. The plate had been exposed but had produced no visible image. On opening the cupboard a few days later, Daguerre was surprised to find that the plate now bore an image. To learn how this had come about, he exposed a series of plates and systematically placed them in the cupboard while removing the chemicals one by one. Eventually this process of elimination revealed that the fumes from a few drops of mercury from a broken thermometer had brought out the image. This probably occurred in 1835. In 1837, Daguerre discovered that he could fix the image

FIG. 20
View of Diorama showing the method of changing the illumination from front to back.

FIG. 21
Daguerre lifts the spoon. According to Louis Figuier (Les Merveilles de la Science), *Daguerre discovered the light sensitivity of silver iodide by accidentally leaving a spoon on the surface of an iodized plate. This was in the spring of 1831.*

FIG. 22
François Arago revealed the working details of the daguerreotype at a joint public meeting of the French Academies of Art and Sciences on August 19, 1839. The process was not actually demonstrated at the meeting, however. Because of a sore throat, Daguerre did not speak.

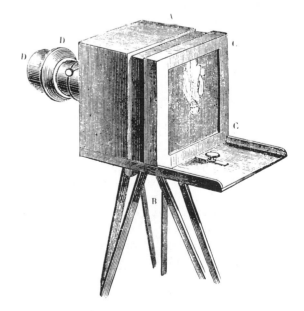
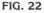

FIG. 23
A daguerreotype camera.

produced by the action of mercury on iodized silver by treating the plate afterward in a salt solution. Talbot had made the same discovery three years earlier in connection with his photogenic drawings.

At the first public demonstration of the daguerreotype process—in Paris on September 17, 1839, nine months after Arago's original announcement—Daguerre proceeded as follows:

Taking a copper plate coated on one side with silver, Daguerre first cleaned it by buffing its surface with pumice, using cotton balls. He then rinsed it in a dilute solution of nitric acid, for further cleaning and also to remove any superficial traces of copper from the silver surface. After

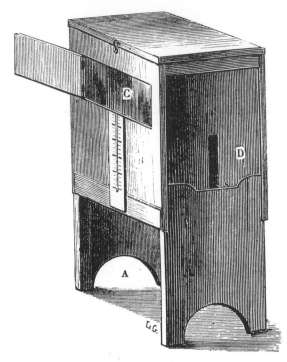

FIG. 24
Mercury box for developing the image.

FIG. 25
A stand for warming the plate during toning with gold chloride.

darkening the room, he sensitized the plate by placing it silver-side-down over an opening in a box containing iodine. Inside the box, about halfway down, was a sheet of muslin stretched across so that the vapors of iodine rising from below would be distributed evenly over the surface of the plate. Gradually the silver took on a yellow color, similar to that of brass. A contemporary estimate stated that the yellow coating of silver iodide thus formed was no thicker than one millionth of a millimeter. Daguerre placed the sensitized plate in a camera, made the exposure (which on this particular day, because of the dull light, was fifteen minutes), and then placed it in a box at the bottom of which was a pool of mercury. (If the image was intended to be viewed directly, the plate was suspended over the mercury at an angle of 45 degrees; but if it was intended to be viewed at a 45-degree angle, it was placed horizontally over the mercury.) Daguerre heated the mercury from below with a spirit lamp, causing it to vaporize. The vapor reacted with the exposed areas of the silver iodide and created a whitish mercury amalgam, which brought out in positive form the until-then-invisible latent image. Finally, Daguerre fixed the image in a hot sodium thiosulfate solution and passed it around for the general admiration.[24]

FIG. 26
A human eye from a daguerreotype portrait, shown under 250X magnification. The white dots are the mercury amalgam; the dark areas are the silver plate.

The Daguerrean Look. The highlights in a daguerreotype consist of a whitish deposit, which under magnification looks like a field of tiny white dots. The shadows are mirrorlike silver, toned with gold. The practice of toning daguerreotypes in a solution of gold chloride was introduced in 1840 by Hippolyte Fizeau and it was soon universally followed. Sometimes the gold chloride was added to the fixing bath, sometimes it was used afterwards; either way, the reaction was helped along by heating the bath or the plate itself. Toning helped to prevent oxidation (tarnishing) of the silver, but today, unless the image has been properly restored, most daguerreotypes will show discoloration due to oxidation. The difference between a discolored and a restored daguerreotype can be considerable.

When you look at a daguerreotype you find that the shadows reflect light back to you, reversing the tones of the image, unless you hold the plate at an angle to a sufficiently dark surface. Usually daguerreotypes were kept under glass (with a cutout metal overmat between the plate and the glass) to protect the delicate surface and to seal it against oxidation, and placed in a small, hinged case for further protection. The inside of the case's cover, when opened, provided the surface necessary to prevent the distracting reflections mentioned above.

When the daguerreotype is held at the correct angle for viewing, the shadows appear to recede slightly. This happens because the shadows, acting as a mirror, reflect a "virtual image": an image that appears to come from behind the plane of the reflecting surface. This gives the daguerreotype the appearance of slight three-dimensional relief. The shadows also take on a slight tint from the color of the reflected surface. These peculiar optical qualities cannot be illustrated through conventional methods of reproduction. They have no antecedent in earlier pictorial media, nor any real offspring. They are unique to the daguerreotype.

The daguerreotype image, like the reflection in a mirror, is horizontally reversed: It reads backwards. This was often corrected by placing a mirror at a 45-degree angle in front of the lens and daguerreotyping the reflection of the subject, rather than the subject itself.

Daguerre's technique was used at first almost exclusively for landscape, architecture, or still-life scenes. The plates were not sensitive enough for portraits unless the sitter could be persuaded to remain motionless in bright light for many minutes. But by late in 1840, it was discovered that "accelerators" or "quickstuff" such as bromine and chlorine, fumed onto the plate in addition to the iodine, increased the sensitivity of daguerreotypes many times over. Together with the introduction of larger, faster lenses, this made portraits possible. Millions of daguerreotype portraits were made during the less than two decades the process remained in vogue.

Some First Reactions: Reality and Representation. Although photogenic drawing and the calotype have come first in this account, it was actually the daguerreotype that gave the public its initial idea of photography. Until the introduction of the calotype at the end of 1840, photography on paper was, in Herschel's words, "child's play" compared to the daguerreotype. Daguerreotypes

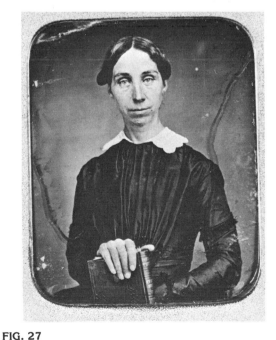

FIG. 27
Daguerreotype with overmat and glass removed.
(Courtesy, David Kolody)

could give a much clearer, more detailed imitation of reality. Even after the calotype came into use, many more daguerreotypes than calotypes were made. Consequently, the public's first reaction to photography was mostly in terms of the daguerrean image.

To the degree that initial reactions tend to set patterns for what follows, this sequence was important. For both photographers and the public, the daguerrean syntax established certain assumptions about what photographic images were or even should be like. Even though photography soon began to evolve away from the daguerreotype, these assumptions persisted and influenced the course that evolution took.

Persons seeing a daguerreotype for the first time commonly reacted with a mixture of confusion and disbelief. This is a common theme in the earliest published reports. The precise and seemingly inexhaustible detail was too perfect to have been the work of an artist's hand—but how else could it have been produced? Daguerre encouraged people to look at daguerreotypes under magnification. It was only by coming this close to the image that one could accept its origin. A correspondent for *Le Commerce* wrote:

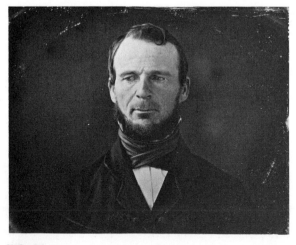

FIG. 28
Daguerrean portrait. It is rare to find a daguerreotype portrait showing the eyes looking down.
(Rodger Kingston Collection)

All this [the daguerreotype] is wonderful. But who will say that it is not the work of some able draughtsman? Who will assure us that they are not drawings in bistre or sepia? M. Daguerre answers by putting an eyeglass into our hand. Then we perceive the smallest folds of a piece of drapery; the lines of a landscape invisible to the naked eye. With the aid of a spying-glass we bring the distances near. In the mass of buildings, of accessories, of imperceptible traits which compose a view of Paris taken from the *Pont des Arts,* we distinguish the smallest details; we count the paving-stones; we see the humidity caused by the rain; we read the inscription on a shop sign.[25]

Under examination, the details in traditional prints dissolved into their separate units of linear syntax. Paintings dissolved into the contours of brush strokes. But the daguerreotype remained pure image. None of the previously known elements of syntax could be found. Such a thing was unprecedented. No one described this characteristic of the daguerreotype more succinctly than Edgar Allan Poe, who wrote in 1840:

If we examine a work of ordinary art by means of a powerful microscope, all traces of resemblance to nature will disappear—but the closest scrutiny of the photographic drawing [given the date and his American vantage point, Poe must have meant the daguerreotype] discloses only a more absolute truth, more perfect identity of aspect with the thing represented.[26]

In the presence of this "more perfect identity of aspect with the thing represented," what had always been thought of as the fundamental distinction between representation and reality was suddenly blown away. Before, there had always been an obvious dividing line between a picture and the object the picture was meant to represent. One merely had to approach closely enough to identify the marks of the hand, and even the best illusion fell apart. But, within the limits of two-dimensional representation, in the daguerreotype no clear-cut point could be found where the image might be severed from its represented object.

H. Gaucheraud described the daguerreotype as appearing "as if it were nature itself."[27] The correspondent for *Le Commerce,* already quoted,

said, ". . . it is nature itself." The London *Spectator* called it "Nature herself reflecting her own face."[28] On April 24, 1840, Samuel Morse, at the annual dinner of The National Academy of Design in New York, stated that daguerreotypes "cannot be called copies of nature, but portions of nature herself."[29] These statements, with their various degrees of hyperbole, have in common the idea that in creating the inseparable connection between image and object Nature is the active force. This reverses the traditional order of things. Instead of pictures coming from Mankind, and thus inevitably being distinct from Nature, pictures now come from Nature itself and are identical with it. To the men and women of 1839, what incredible magic this must have seemed!

The romantic idea that Nature was the active force in photography was soon replaced by the more prosaic one that the Machine did all the work, yet in either case the assumed conclusions were the same: that the human role was minimal and that the process was essentially automatic. After the initial shock, people began to realize that photographs were far from perfect reflections of nature, let alone actual "portions of it." But the correlative idea that the photographic process was essentially automatic was not as easy to shake. Much of the trouble later generations had in accepting the idea that a photograph could be a work of art can be traced to this original misconception. Those photographers who tried to come up with "artistic syntaxes" took pains to show how unautomatic photography could be.

Legal Matters

One of the reasons the daguerreotype was far more in evidence than Talbot's calotype during the 1840's was that Talbot placed legal restrictions on the use of his technique. At the urging of Arago and others, the French government agreed in the summer of 1839 to purchase Daguerre's invention and grant the inventor an annuity of 6,000 francs (as well as one of 4,000 francs to Isidore Niépce, son of Joseph Nicéphore Niépce, who on his father's death had become Daguerre's partner). On August 19, when he announced the

details of the process, Arago stated that it had been purchased by France with the intention of donating it to "the entire world" [*le monde entier*]. As it happened, in this transaction *le monde entier* did not include England, where Daguerre had an agent, Miles Berry, take out a patent (No. 8194), dated August 14, 1839.

Talbot apparently asked nothing from the British government, but, to establish his claim as inventor and to realize a profit, he obtained British patents (which covered England and Wales) and French patents for the calotype, and later a patent in the United States. He left the technique of printing on salted paper unpatented.

Talbot limited the use of the calotype to licensed operators. During the 1840's and early 1850's he repeatedly became involved in licensing and patent disputes as he tried to retain control over his invention and its subsequent improvements, including those introduced by others. For example, in his 1843 patent (No. 9753) Talbot included Herschel's method of fixing with sodium thiosulfate, which had been made public, without restrictions, four years earlier. Talbot admitted that the use of thiosulfate was not new, but claimed it in the patent as part of an overall "system." When the collodion process came into use in 1851, Talbot asserted that it was covered by his patents, although he had nothing to do with its discovery.

Bayard's Process

Unlike calotype prints, each direct-positive daguerreotype was a one-of-a-kind image that could not be reproduced unless it was itself photographed. But despite the difficulty of reproduction, during the early years of photography the direct-positive method seemed to many the most logical way to create an image. In 1839, a French civil servant named Hippolyte Bayard developed a direct-positive paper process and disclosed it to Arago in May of that year, four months after Arago's announcement of the daguerreotype.[30] Bayard had, in fact, succeeded in producing negative images on silver chloride paper even before Talbot revealed the details of

the photogenic process. But Arago, not wishing to draw attention away from Daguerre's process, managed to persuade Bayard to delay in announcing the details of his technique. Bayard agreed, rather foolishly as it turned out, and his technique did not become known until early in 1840. It consisted of preparing a paper similar to Talbot's salted photogenic paper, darkening it by exposure to light, and then dipping it in a potassium iodide solution. The paper was placed in a camera, where the exposed areas bleached out as the action of the light released iodine. The image was fixed in sodium thiosulfate.

During the next few years several other inventors also disclosed direct-positive paper techniques, and even Talbot included some fairly half-hearted directions for a direct-positive modification of the calotype in his 1841 patent.

The various direct-positive paper processes never became as practical or as popular as the daguerreotype. Their sensitivity was much lower than that of either the daguerreotype or the calotype, and the permanency of the image was suspect.[31] Bayard appears to have been the only one who succeeded in using them in a pictorially interesting manner.

Artistic Preferences

The difficulty of reproducing the daguerreotype was the process's greatest technical disadvantage. Its greatest technical advantage, compared with the calotype, was its ability to render incredible detail. The irregular paper surface of the calotype negative simply could not record as minutely detailed an image as was possible on the smooth surface of the daguerreotype plate, and the need for printing *through* the fibers of the paper negative in order to produce the positive reduced detail even more. This characteristic of the calotype probably would not have caused much comment, or even been immediately noticed, if the daguerreotype had not already established such a high standard for detail. But, while the daguerreotype was unassailable from this technical point-of-view, from an artistic point-of-view its standard was open to attack. To one way of thinking, the daguerreotype was actually too detailed, too full of information. As a result, a certain group of photographers came to reject the daguerrean standard and to prefer the calotype—over and above its reproduction capability—because they believed its technical "defects" could be turned to artistic advantage.

The Problem of Effect

As the photographic historian James Borcoman has pointed out, one important reason for the artistic rejection of the daguerreotype was the concept of *effect*, a concept that all Academically trained 19th-century painters learned, in one form or another, in the course of their studies.[32] It had a considerable influence on attitudes toward photography, as did Academic training in general.

At the start of his training the art student was given the task of copying engravings. The first examples he worked with were simple renderings of contour. Later the student copied more complicated engravings, in which cross-hatched lines were used for shading and relief. In essence, the student was learning linear syntax. The next step was to copy engravings of individual anatomical features. First the student separately copied eyes, noses, lips, and so on, and then combinations of these features. Gradually, by copying parts and then combinations, the student learned the normative ways of drawing the human figure. Throughout these exercises the student was taught to make a light outline sketch first and then fill in the details. The practice of beginning with the outlines was followed throughout all stages of the student's training. In the artist's mind, details, or *finish*, came last.

When the student graduated from copying engravings he began to draw from plaster casts of classical sculpture, and now became involved with the problem of *effect (effet)*.

In English, the noun "effect" generally means "result" or "outcome." But in French 19th-century Academic practice the world *effet,* which we translate as "effect," has a more technical meaning, one that has to do with the way tonal values are handled in a work of art. Taught that *effect* (we will stick to English) was created through the expressive juxtaposition of light areas and dark areas, the student would make an outline sketch of the cast and then define the *effect* by establishing where the most important lights and darks were to be. Next, he began to connect these areas of opposite tones by adding passages of halftone. The student was told that the nature of

the *effect* depended on how the halftones were handled: With a simple, generalized halftone treatment the *effect* gained from the juxtaposition of lights and darks remained strong and dramatic; but as more halftones were added, linking the lights and darks, the *effect* receded while the halftones gained prominence. The point was not to reduce the drawing to starkly contrasting areas of light and dark, but rather to find a balance between the contrast necessary for *effect* and the halftones necessary for modeling. Too great an emphasis on halftones could flatten out the tonality of the drawing and sacrifice the pictorial benefits of *effect.*

After the students had become experienced in drawing casts they began to draw from live figure models. Finally, they began to paint. Here the student again started with an outline sketch showing the general relationships of light areas and dark areas. Over the sketch he then made an underpainting (an *ébauche*), using broad washes of transparent pigment, working first in the dark areas. Next he used an opaque white pigment to indicate the highlights, then linked the lights and darks by washing in a series of halftone tints. The *ébauche* was done in earth tones, nearly monochromatic, and it served as the basis over which, if desired, a finished work could be completed. In making the *ébauche* the student was encouraged to work spontaneously and to concentrate on the relationship of masses and on *effect.* Refinements of detail could come later.

This description of academic practice is taken from Albert Boime's *The Academy and French Painting in the Nineteenth Century* (1971). The idea that *effect* and embellished halftones were somehow at odds was not peculiar to France, however. It had roots in standard Neoclassic doctrine. In Britain, Sir Joshua Reynolds discussed the problem in his *Discourses on Art.* The *Discourses* were delivered as lectures at the Royal Academy during the last quarter of the 18th-century and were later translated into French, German, and Italian. They were widely read. For Reynolds, the word "effect" did not carry as specific a technical meaning as that described above. It meant something more like "general

result." Yet the idea behind his use of the word is similar to *effet* in the sense that success depended, not on elaborate detail, but on the ability to produce a unified, total composition. In Neoclassical terms, it meant the ability to fix the attention on the universal and the ideal. Undue emphasis on "finish" was discouraged. In 1782, in "Discourse Eleven," Reynolds wrote:

> Excellence in every part, and in every province of our art, from the highest style of history [history painting] down to the resemblances of still-life, will depend on this power of extending the attention at once to the whole, without which the greatest diligence is vain . . .
>
> We may extend these observations even to what seems to have but a single, and that an individual, object. The excellences of portrait-painting, and we

FIG. 29
SIR JOSHUA REYNOLDS, *Portrait of Mrs. Mary Robinson as Contemplation,* circa 1785.
(Museum of Fine Arts, Boston)

FIG. 30 JEAN-AUGUST-DOMINIQUE INGRES, *Odalisque With a Slave*, circa 1839-40. (Fogg Art Museum, Harvard University)

Both these paintings are idealized representations, but there the resemblance ends. They are op- posites in terms of technical handling and illustrate opposite ideas of how a painting should look, regardless of subject. Working in the "grand manner," Reynolds stressed general composition and the relationship of light and dark. The details are not "minutely discriminated" and not allowed to distract the eye from the picture as a whole. Ingres cared far more for draftsmanship than Reynolds ever did. His details are "finished" and demand attention. Ingres was not afraid to sacrifice strength of effect *to halftone and detail. His painting is harder to look at because there is more to look at.*

Artists and critics responded to the daguerreotype, and to later processes, according to where they stood on the prephotographic issue of effect *versus halftone and detail. The issue was not restricted to painting; it was picked up and echoed by photographers themselves. Until as late as the 1930's the recurrent aesthetic debate among photographers was in large part a continuation of the much older debate among painters: What should the artist-photographer emphasize: general relationships or specific details?*

may add even the likeness, the character, and countenance, as I have observed in another place, depend more upon the general effect produced by the painter, than on the exact expression of the peculiarities, or minute discrimination of parts. The chief attention of the artist is therefore employed in planting the features in their proper places, which so much contributes to giving the effect and true impression of the whole. The very peculiarities may be reduced to classes and general descriptions; and there are therefore large ideas to be found even in this contracted subject [portraits]. He may afterwards labour single features to what degree he thinks proper, but let him not forget continually to examine *whether in finishing the parts he is not destroying the general effect.* [Italics—W.E.C.]

Although the notion that *effet* or "general effect" should have precedence over fully rendered halftone and finish was frequently challenged from the 1840's on, it remained important in the minds of many critics and painters (Boime points out that Impressionism is partly an outgrowth of the concern for *effet*). As a result, there existed a built-in resistance to the idea that the daguerreotype, with its abundance of halftone and detail, could be an aesthetically acceptable medium. The daguerrean syntax showed too much. It did not lend itself to the elimination of detail for the sake of general effect. It gave the important and the irrelevant equal weight—something that artists usually were trained not to do.

But there was another side to this, because the argument over the aesthetic value of the daguerreotype reflected the larger 19th-century debate over what a work of art should be like. In this debate the earlier tendency toward painterly generalization found itself at odds with a growing appetite for realistic detail, for "truth to Nature." Not surprisingly, painters who already valued detailed finish tended to be receptive to the daguerreotype. The French painter (Hippolyte) Paul Delaroche saw no essential conflict between the daguerrean image and the standards of art. When Arago asked him for a statement to submit to the French Government in support of the proposal for purchase of the process, Delaroche quickly obliged. He wrote about the potential value of the daguerreotype to the artist. As if he were lecturing to his students, Delaroche automatically reverted to the language of the Academy. He tried to reconcile the opposite points of view:

> Nature is reproduced in them [daguerreotypes] not only with truth, but with art. The correctness of line, the precision of form, is as complete as possible, and yet, at the same time, broad, energetic modeling is to be found in them, as well as a total impression equally rich in tone and in effect ... No doubt he [the engraver who will copy daguerreotypes for reproduction] will admire the inconceivably rich finish, which in no way interferes with the composure of the masses, nor does it at all impair the general effect.[33]

Samuel F. B. Morse, the American painter and inventor, felt the same way. He had visited Daguerre on March 8, 1839, the day the Diorama burned down, and later that year wrote to his own mentor, Washington Allston:

> [The daguerreotype will] banish the sketchy, slovenly daubs that pass for spirited and learned; those works which possess mere general effect without detail, because, forsooth, detail destroys general effect. Nature, in the results of Daguerre's process, has taken the pencil into her own hands, and she shows that the minutest detail disturbs not the general respose.[34]

Another argument against the daguerreotype was that the sharp, detailed image was not consistent with the way the world actually appears to the human eye. This was frequently brought up in discussions of *effect*. We will return to this idea in examining the theories of Peter Henry Emerson.

Artistic Syntax: The Calotype

The state of mind adverse to the daguerreotype was more favorable to the calotype. In addition to its tendency to subdue detail, the calotype, as an object, simply looked more like a work of art. Its characteristics were more familiar. According to a contemporary account: "Instead of the cold, metallic surface, on which the Daguerreotype raises its slight film of ghostly white, we have here the usual paper ground of an ordinary water-color drawing, with the figure standing out in a deep

brown, somewhat resembling sepia."[35] The calotype also allowed a variety of controlled pictorial effects, far more than the daguerreotype. Talbot recognized this potential very early, and he was the first to use it (or at least hint at its use) as an argument for photography as an art. It was a type of argument photographers were later to fall back on many times.

Talbot wrote in a letter to the editor of *The Philosophical Magazine* in February of 1841:

> I remember it was said by many persons, at the time when photogenic drawing was first spoken of, that it was likely to prove injurious to art, as substituting mere mechanical labour in lieu of talent and experience. Now, so far from this being the case, I find that in this, as in most other things, there is ample room for the exercise of skill and judgement. It would hardly be believed how different an effect is produced by a longer or shorter exposure to the light, and, also, by mere variations in the fixing process, by means of which almost any tint, cold or warm, may be thrown over the picture, and the effect of bright or gloomy weather may be imitated at pleasure. All this falls within the artist's province to combine and to regulate; and if, in the course of these manipulations, he, *nolens volens,* becomes a chemist and an optician, I feel confident that such an alliance of science and art will prove conducive to the improvement of both.[36]

Hill and Adamson

The first to take full advantage of the artistic features of the calotype were David Octavius Hill, a Scottish landscape painter and lithographer, and Robert Adamson, the first professional calotypist in Scotland. Together, Hill and Adamson produced a remarkably beautiful series of calotypes.

Adamson had learned the calotype process from his brother, Dr. John Adamson, who had taken it up in 1841 at the suggestion of Sir David Brewster. In 1843, Hill undertook to paint a group portrait of the some 450 churchmen who had participated at the founding of the Free Church of Scotland in May of that year. Brewster persuaded Hill to join forces with Adamson in order to produce calotypes from which the proposed painting might be copied. Brewster's meeting with Hill must have taken place by the middle of June 1843, since the Hill-Adamson collaboration is mentioned in the June 24 issue of *The Witness.* The same article indicates, if obliquely, that Hill first had a few daguerreotypes made, but on seeing Adamson's calotypes decided on the latter process (this story has never been substantiated).

The new partners quickly began taking individual and group portraits of the Free Church participants. By July they had already decided that they would expand their subject matter beyond the Free Church painting, and their work eventually came to include pictures of country people, sailors, craftsmen, notables from society, science, and the arts, and also landscape and architectual views. Generally, Hill directed the composition of the subjects while Adamson handled the chemical manipulations. The degree to which they may have come to share these functions is not known, although it is known that Adamson was not without artistic skill of his own. Hugh Miller, the Scottish naturalist and popular essayist, saw in their calotypes a striking resemblance to the works of the Scottish painter Sir Henry Raeburn. Miller wrote about this in an article in an issue of *The Witness* dated July 12, 1843. The date is significant because it shows how quickly Hill and Adamson established an artistically successful method of working. In Miller's words:

> Here, for instance, is a portrait exactly after the manner of Raeburn. There is the same broad freedom of touch; no nice miniature stipplings, as if laid on by the point of a needle—no sharp-edged strokes; all is solid, massy, broad; more distinct at a distance than when viewed near at hand. The arrangement of the lights and shadows seems rather the result of a happy haste, in which half the effect was produced by design, half by accident, than of great labour and care; and yet how exquisitely true the general aspect! Every stroke tells, and serves, as in the portraits of Raeburn, to do more than relieve the features: it serves also to indicate the prevailing mood and predominant power to the mind.[37]

This statement could not have been made if the images had been daguerreotypes. Miller makes Hill and Adamson's calotypes sound like illustrations out of Sir Joshua's *Discourses.*

FIG. 31
SIR HENRY RAEBURN, *The Right Honorable Charles Hope.*
(Museum of Fine Arts, Boston)

Hill and Adamson remained in partnership until Adamson's death at the age of twenty-seven in 1848. In that year, Hill wrote of the calotype.

> The rough surface, and unequal texture throughout of the paper is the main cause of the Calotype failing in details, before the process of Daguerreotypy— and this is the very life of it. They look like the imperfect work of man—and not the much diminished perfect work of God.[38]

The compositional style Hill and Adamson achieved in their portraits clearly owes much to the English and Scottish portrait tradition, but it was also a response to the syntactical problems they faced. The light-sensitive characteristics of the calotype made a certain approach necessary. All Hill and Adamson's single portraits and groups were taken in direct sunlight. This was done to keep exposure times reasonable; even so, they were generally at least a minute long. Because the calotype softened the edges of shadows, and because many of the original prints are now faded, the harsh lighting is not always immediately apparent until you take a more careful look —for instance, at the shadows under the eyebrows or the shadow of the nose across the upper lip.

When Hill began to work with the calotype he had to learn that its syntax could not accommodate the same range of contrasts that his eyes could. As he stood before his subjects in the sunlight, he could see separate tones in both the highlights and deep shadows, but the calotype could not. Its "exposure latitude" was too narrow. The calotype was slower than the daguerreotype;

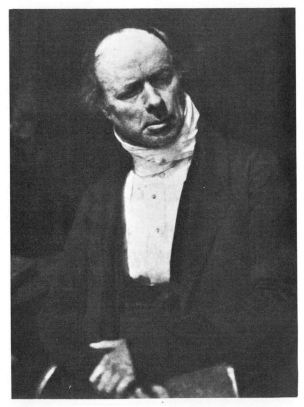

FIG. 32
HILL and ADAMSON, *Rev. Thomas Henshaw Jones,* calotype negative/salted-paper print, circa 1845.
(International Musuem of Photography/George Eastman House)

FIG. 33

HILL and ADAMSON, calotype negative/salted-paper print.

(International Musuem of Photography/George Eastman House)

and, as a general rule in photographic sensitometry, the slower the sensitive material, the narrower its latitude. The calotype could register tones either in the highlights or in the deep shadows, but not fully in both at the same time. Hill had to adjust his own vision accordingly, and had to be constantly aware of how the shadows fell on and around his subjects. Miller was dead wrong in suggesting that the arrangement of the lights and shadows could be the result of a "happy haste." Because the narrow latitude of the calotype amplified contrasts, the shadows had to be carefully placed in order not to cut the picture apart with empty areas of darkness. Sometimes a mirror was used to reflect light back into the shadows. In his finest work Hill used the harsh contrasts as the key to the structure of the composition. He often placed portrait subjects against a dark background, such as an open door leading into a darkened room, in this way exaggerating the contrast even more but simplifying the composition at the same time. The contrast threw the highlights into relief, making them seem to emerge from the surrounding darkness. In view of their tonal qualities it was repeatedly said that Hill and Adamson's calotypes "looked like Rembrandts." Given the limitations of the available

syntax—mainly its inability to handle both ends of the tonal scale in bright light—that was about the only way they could look.

Pencil Work. The calotype negative had another artistic advantage over the daguerreotype: It could be altered inconspicuously by pencil shading in order to lighten selected areas in the print. The texture of the paper effectively hid the evidence. Hill and Adamson used this capability to adjust the relationship of tonal values, separate figure from ground, accent highlights, add details (Hill once drew in a waterfall), or simply touch out the immobilizing head brace. They did it far more than is generally realized. In fact, much of what is usually taken in Hill and Adamson's work as a local fuzziness characteristic of the early paper negative is actually the result of deliberate manipulation.

Improvements in the Paper-Negative Process

The amateurs and the few licensed professionals in Britain who practiced the calotype felt little incentive to work out major improvements as long as the basic process remained under Talbot's control. It was In France, where Talbot apparently did little to enforce his local patent, that the most important technical improvements in the paper negative originated.

One of the leading French experimenters, in stature second only to Daguerre and Niépce, was Louis-Désiré Blanquart-Evrard. Blanquart-Evrard learned the calotype process in 1844. Three years later he introduced an improved method. When he first described it he neglected to give Talbot credit for the original invention (Talbot had spent several weeks in Paris in 1843 lecturing on and demonstrating the calotype, but the process was still not well known in France in 1847). At a meeting of the British Association in June of 1847 Talbot called this an "act of scientific piracy," although he apparently took no legal action against the Frenchman.

Blanquart-Evrard's process was different from Talbot's in that he floated the paper on or immersed it in baths of potassium iodide and then silver nitrate in a way that allowed the chemical

solutions to soak into the paper. This made it possible to produce a better tonal scale in the negative, and consequentally in the print, than could be obtained when only the surface of the paper was brushed with the solutions, as described in Talbot's calotype patent of 1841. Blanquart-Evrard's paper could be stored in the dark until needed. Just before use it was dampened with an acid solution of silver nitrate, laid face up over a backing sheet of damp paper, and the whole sandwiched between two sheets of glass to seal in the moisture. The combination was placed in the camera for exposure—which took about a quarter of the time needed for a calotype. It was developed in a solution of gallic acid and fixed in thiosulfate.[39] Eliminating the gallic acid from the sensitizer made the shorter exposure possible and left a cleaner image. One of the first to use the new process was Maxime du Camp, who photographed with it in Egypt from 1849 to 1851.

While Talbot's calotype paper could be exposed either dry or moist, in Blanquart-Evrard's technique the paper had to be damp. To get around this inconvenience the inventor worked out a process in which paper was coated with whey and egg albumen and could then be used dry. He described it in 1850.[40] It was slower than his earlier paper, but it could be prepared ahead of time, a definite advantage for the photographer traveling far from the studio.

The Waxed-Paper Process

The last major improvement in the paper negative was the waxed-paper process invented by another Frenchman, Gustave Le Gray. After exposure and processing, paper negatives were usually coated with wax to make them more transparent for printing. In Le Gray's process, the paper was waxed *before* sensitizing. After waxing, it was immersed in a solution of rice water, sugar of milk, potassium or ammonium iodide, and potassium bromide, then dried, and finally sensitized in a bath of silver nitrate and acetic acid.[41] It could either be sandwiched between two sheets of glass and exposed in the camera while still moist,

or allowed to dry for use later.

Its keeping properties—up to about two weeks —were much better than those of the earlier calotype, which Talbot had suggested should be exposed within a few hours after sensitizing. The wax had a preservative effect.

After exposure, the paper could be developed right away in a solution of alcohol, gallic acid, and silver nitrate, or development could be postponed, with less excellent results, for as much as a week. With the calotype it was necessary to develop the image as soon after the exposure as possible. Developing the wax-paper negative took from thirty minutes to several hours, depending on the exposure.

Paper prepared in this way had about the same sensitivity as the calotype, but its other advantages and its superior rendering of detail caused it to become almost universally adopted by photographers working on paper, after it was published in December of 1851. Roger Fenton used the process in 1852 to photograph architectural scenes in England and Russia before he switched to the new collodion technique.

French Paper-Negative Work

In 1851, writing in the first issue of the newly-founded *Société Héliographique*'s publication, *La Lumière*, Francis Wey compared the daguerreotype with the paper photograph in order to determine which produced a result closer to "art." He gave the advantage to the paper print because it permitted detail to be made secondary to the general effects created by the opposition of masses and tonal values. Yet Wey doubted that photography could actually reach the level of art, "since the artist must not only translate nature, he must interpret it as well." Looking at a print by Charles Nègre some three months later, Wey was surprised to see evidence of how much interpretive control actually was available to the paper photographer.[42] To Wey, Nègre's print *The Little Rag Picker*, was comparable in its expressiveness and tonal quality to a swiftly-done *ébauche*.

In 1852, in the preface to his textbook, *Photographie, Traité Nouveau sur Papier et sur*

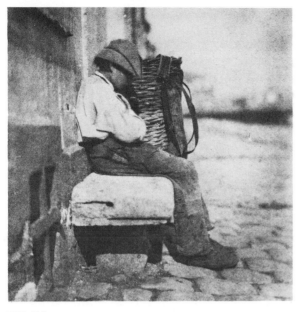

FIG. 34
CHARLES NÈGRE, *The Little Rag Picker,* calo-
type or variant process/salted-paper print. The
negative was made sometime before May 1851.
(Courtesy, André Jammes, Paris)

Verre, Gustave Le Gray acknowledged the con-
flict between effect and detail and, as if directly
answering Wey's earlier doubts, insisted that in-
terpretation was possible in photography: The
means were available.

> In my point of view, the artistic beauty of a
> photographic print consists . . . almost always in
> the sacrifice of certain details in such a manner as to
> produce an effect [*une mise à l'effet*] which some-
> times attains to the sublime in art.
>
> It is also especially in the hands of artists that
> Daguerre's instrument can arrive at giving finished
> results [*des résultats complets*]. By varying the
> focus, the exposure, the artist can highlight or
> sacrifice such and such a part, produce a strong ef-
> fect of shades and lights, or else an effect of extreme
> gentleness and softness, and that while copying the
> same sight, the same model.
>
> There is, thus, only the artist or the man of taste
> who can surely obtain a perfect work with the aid of
> an instrument capable of rendering the same object
> with an infinite variety of interpretations, because he
> alone has the intuition of the effect which best suits
> the subject which he is reproducing.

Although Le Gray refers to "Daguerre's instru-
ment," there is little doubt from the context that he
means the camera and not the daguerreotype
proper. These paragraphs recall Talbot's remarks
to the editor of *The Literary Gazette* some eleven
years earlier. They represent, however, an in-
sider's point of view. The general public persisted
in believing that photography was essentially
mechanical and nonvolitional, and thus by defini-
tion *inartistic.*

Le Gray had been trained as a painter in Paul
Delaroche's *atelier.* About 1848 he gave up paint-
ing for photography. With the financial help of the
Comte de Briges he opened a portrait studio in
Paris. Le Gray was an important teacher of pho-
tography, and many of his students became
prominent photographers. Among them were the
painters Charles Nègre, who had been a student of
both Ingres and Delaroche, and Henri Le Secq,
also one of Delaroche's students. Of the French
photographers who used the paper process,
Nègre and Le Secq are perhaps the most in-
teresting. Their work demonstrates the claims
made for photography by Le Gray in the preface
of his textbook.

Nègre and Le Secq. Charles Nègre began
making daguerreotypes around 1844. Just when
he took up work with paper photography is
unknown, though it was definitely by the spring of
1850. Like Hill, he used his photographs as
studies for paintings. Nègre's initial emphasis was
painterly genre. Later he switched to forthright
documentation. In portraiture he never came
close to Hill's achievement; but, like Hill, he found
in the syntax of photography a means of exploring
pictorial effect.

Chimney Sweeps Walking (Plate 4) was one of
a series of at least four photographs Nègre made
using the same models on a day in the au-
tumn of 1851. In three of the four extant images
the figures were posed "in motion." In the one
reproduced here, the photographer used pencil
shadings on the negative to lighten the buildings
in the background, concentrating on the center of
the image. In this way he enhanced the aerial
perspective (haze) and threw the foreground
figures into relief. His earlier *Little Rag Picker,*

which Wey had found so admirable, had also benefited from pencil work on the negative.

Nègre's best-known photograph, *The Vampire,* shows Henri Le Secq in a dapper top hat standing on a balcony of the Cathedral of Notre-Dame. Nègre opaqued the sky in the negative to create a uniform white in the print. He pencil-shaded along the horizon on the left to suggest aerial perspective. He also used the pencil to emphasize the highlights on the buildings in the distance, on the gargoyle, on the shoulder, forearm, brow, and top of the vampire's head, and on the architectural details of the cathedral. The balustrade on the lower right was lightened to balance it against the sky in the upper left corner.[43]

Nègre's handwork adds tremendously to the quality of his images. The adjustments in tonality give them a pictorial equilibrium and coherence they would otherwise have lacked.

By the summer of 1852, Nègre's concentration

FIG. 35
CHARLES NÈGRE, *The Vampire,* waxed-paper negative/salted-paper print, circa 1853.

This is truly one of the splendid photographs from the early 1850's. Notice that its composition mirrors that of The Little Rag Picker.
(Courtesy, André Jammes, Paris)

on producing photographs for use as painting studies began to give way to other interests. He set out to record the great architectural monuments of Paris and the landscape and architecture of the Midi region of France. As his attention turned from making photographs for his private use to more marketable work, his style also changed. His prints became more specific, more "daguerrean" in their emphasis on information. The deliberate tonal modifications of the earlier photographs were replaced by a concern for the surface details of the subject in front of the camera.

Henri Le Secq, Nègre's friend, was one of several photographers commissioned by the French Government in 1851 to document historic buildings and monuments. Using the waxed-paper process, Le Secq photographed the cathedrals of Amiens, Strasbourg, Beauvais, Chartres, and Rheims. The style of these images tends to be in keeping with their purpose: They are forthright and detailed.

In remarkable contrast to this documentary work are Le Secq's later still lifes—his *Fantaisies Photographiques*—and his landscapes, which take advantage of the hazy and "mysterious" look possible with paper negatives (Plate 5). This quality, in combination with Le Secq's highly individualistic handling of composition, resulted in some extraordinary images of great ambiguity. As a master of pictorial effect, Le Secq was more than Nègre's equal.

What set Nègre and Le Secq apart as photographers and photographic printmakers was their ability to make the paper-negative process serve a variety of purposes. Their training as painters made them resist the notion that the paper negative should necessarily be used in a manner imitative of the daguerreotype. Instead, they drew from the syntax of the paper negative a whole range of visual possibilities. They exploited whichever characteristics of the paper negative the situation seemed to warrant. Sometimes the results were "daguerrean" in the careful preservation of detail, at other times the expressive, more painterly qualities of the printmaking syntax were given center stage. In the latter cases their work anticipates that of the Pictorialists years later.

The Syntax Takes Shape

As a general principle in the evolution of print-making, the process that can present more information in the same space at competitive cost wins out over its rivals. The principle applies to both prephotographic and photographic processes, at least when information is the paramount thing. During the first two decades of photography, most experimental work concentrated on finding a convenient and practical way to convey information. For this, what was needed was a process that could combine the optical precision of the daguerreotype with the reproducibility of the calotype. The solution was to stop using paper as the base for the negative and instead use glass.

Albumen Negatives

Claude Félix Abel Niépce de St. Victor was a cousin of Daguerre's original photographic partner (although in some earlier histories of photography he is demoted to the rank of nephew). Niépce de St. Victor introduced albumen glass-plate negatives in 1847. Negatives on glass had been tried before, by Herschel and others, but without practical success. What was needed was a substance that could hold the silver salts firmly to the smooth surface of the glass without inhibiting the photochemical reaction or the development of the image.

To prepare his plate, Niépce de St. Victor first beat egg whites to a froth together with potassium iodide and sodium chloride, and left the mixture to stand. A clear liquid settled out, which he strained and then poured over the glass and left to dry to a thin, smooth, transparent coating. He sensitized the plate by dipping it in a bath of silver nitrate. This formed light-sensitive silver-chloro-iodide and coagulated the albumen. After exposure, he developed the image in a solution of gallic acid. These albumen plates had lower sensitivity than calotypes and were too slow for portraits, but because they were on glass and did not have the interfering texture of a paper negative they produced much sharper prints. The plates could be prepared up to two weeks before use and developed any time up to two weeks afterwards.

The method attracted followers when Niépce de St. Victor released the details in June of 1848,[44] but it never became widely adopted as a negative process. The reasons were that Talbot soon covered a similar process with patents[45] and that the more sensitive collodion process appeared three years later.

FIG. 36
Niépce de St. Victor was a lieutenant in the municipal guard in the Paris suburb of St. Martin. In 1848 his photographic laboratory was the guardroom of the barracks, as shown in this wood engraving from Figuier's Les Merveilles de la Science.

Albumen was widely used during the 1850's and for some time after, however, to produce positive glass lantern slides and glass stereo slides. Albumen turned out to be excellent for work of this sort. Albumen lantern slides and stereoscopic slides made by C.M. Ferrier and his various associates were famous from the early 1850's on—and rightly so, since in sharpness and tonality they are nothing short of resplendent.

Collodion

In 1846, a Swiss chemist, C.F. Schönbein, discovered an explosive substance that came to be known as *guncotton,* and the following year Ménard and Domonte together showed that when guncotton was dissolved in alcohol and ether it formed a viscid fluid, which they named *collodion*, a word derived from the Greek for "glue." Poured over a surface, collodion dries to a tough, transparent, colorless film. It was originally used as a means of covering and drawing together wounds and surgical incisions. The suggestion soon followed that collodion might have a use in photography as a medium for the sensitive coating. In 1850, Le Gray and Robert Bingham separately published this idea and made vague mentions of experiments,[46] but the first to come

FIG. 37
The aftermath of an explosion in a French guncotton factory on July 17, 1848 (Figuier's Les Merveilles de la Science).

up with a workable process involving collodion was Frederick Scott Archer.

Archer was a sculptor who had learned the calotype process in 1847. He began experimenting with collodion in the autumn of 1848. He first tried to use it as a coating material for paper negatives, to give the paper a more uniform surface; but he found that when he then processed the negative the collodion tended to wash off. By June of 1849 Archer had turned his attention to the possibility of using a film of collodion as a *substitute* for paper.[47] He prepared the film by flowing collodion over glass plates. These experiments eventually led to the collodion process, which Archer published in March 1851 in *The Chemist.*

The first step in the collodion process was to coat a glass plate with collodion containing potassium iodide (later, potassium bromide was included in the formula). After the collodion had set, but well before it actually dried, Archer sensitized the plate in a bath of silver nitrate, in this way forming light-sensitive silver iodide. He then put the glass plate in a holder, inserted it in the camera, and made the exposure. Before the collodion had a chance to dry, Archer developed the image in pyrogallic acid. Finally, he fixed it in sodium thiosulfate, followed by a wash in water.

When the process came into general use, ferrous sulfate became the standard developer because it was found to give the plate about three times greater sensitivity than did pyrogallic acid. Likewise, potassium cyanide was often used as the fixer because it was faster acting, could be washed out of the plate more quickly afterwards, and helped produce the whitish image desired in certain modifications of the process (described below). Archer originally recommended that the collodion film be stripped from the glass in one piece before the image was fixed. In this way, one sheet of glass could be used to produce any number of negatives. When the process came into general use, however, this stripping step was omitted and each negative was made and kept on a separate sheet of glass.

Collodion plates became insensitive if the silver iodide formed during sensitizing was allowed to

dry in contact with the excess silver nitrate left on the plate from the sensitizer bath. In addition, the silver nitrate would crystallize as it dried, forming a netlike pattern that would show up distinctly in a print.[48] This is why the plate had to be sensitized, exposed, and processed *before the collodion dried,* and consequently why the technique became known as the *wet-plate* process. By mid-19th-century standards it was convenient enough for studio work with a darkroom nearby. Fieldwork with wet plates was another story. In addition to his camera and tripod, the photographer had to equip a wagon darkroom or carry along a tent darkroom with trays, sensitizing bath, collodion, glass plates, all the processing chemicals, and a supply of water. Wet-plate work could not be done in cold weather because the collodion might freeze before the process was completed. In very hot weather it could be difficult to get the collodion to set firmly enough to stay on the plate. If the light were weak and the exposure long the plate could dry out, spoiling the image.

As early as 1854 various "dry" collodion processes began to be introduced in the hope of overcoming the drawbacks of the wet plate. "Dry" is a misnomer since the processes generally involved the use of a hygroscopic ingredient, such

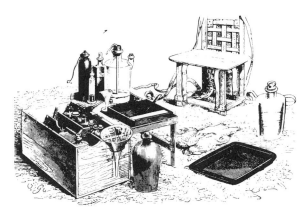

FIG. 39
A traveling wet-plate outfit (Fig. 4 shows what it looked like packed up).

as honey, grape sugar, treacle, albumen, or gelatin, to keep the plate in a moist state.[49] Results with these processes were often uncertain, and exposures were usually longer than with regular wet plates. Most collodion negatives were therefore made using the "wet" process.

Because of their transparent base, collodion negatives (like albumen negatives) were much faster to print than paper negatives, and prints from them had better reproduction of tone, especially in the shadows and highlights, and sharper detail. More will be said about prints from collodion negatives further on.

Ambrotype and Tintype

Two direct-positive modifications of the collodion process became very popular. If mercuric chloride or nitric acid were added to the developer, the wet-plate image became a grayish white, and could be viewed as a positive simply by backing it with a dark material or by painting either of the sides of the glass black. When this was done, the grayish white image took on the appearance of highlights and the black backing filled in the shadows. The idea of transforming the negative image into a positive one was originally suggested by Archer, but it was patented only in 1854, by a Bostonian named James Ambrose Cutting. It be-

FIG. 38
Processing a collodion plate under light filtered through a yellow pane of glass.

came known, courtesy of Cutting's middle name, as the *ambrotype*. It was followed two years later by the famous *tintype*, invented by another American, Hannibal L. Smith. For the tintype (*tintype* was actually a later name, originally it was *melainotype* or *ferrotype*), the collodion was coated on a thin metal plate which had first been japanned (lacquered black).

Both the glass ambrotype and the metal tintype have a characteristic gray and often rather dingy appearance, and this makes them easy to distinguish from shiny daguerreotypes. Like daguerreotypes, tintypes have reversed images, but ambrotypes can "read" correctly if blackened on the collodion side. Both processes enjoyed a considerable popularity during the 1850's as an inexpensive alternative to the daguerreotype, and tintypes continued to be made throughout the 19th-century.

When trying to come to a qualitative judgment about ambrotypes and tintypes it is important to

FIG. 41
American tintype (Courtesy, David Miller, Montreal).

examine as many as possible. Many seem to have been indifferently made, but occasionally examples pop up that show the processes were capable of considerable physical beauty. On the other hand, the more usual slightly grubby quality of these images often enhances their charm as folk art: The primitiveness of the surface can be an effective accent to a simple, stark image.

Like the daguerreotype, the ambrotype and tintype were dead ends from the standpoint of reproduction. Though ambrotypes without the black backing are nothing more than collodion negatives, their density range (see page 119) is too limited to produce acceptable prints on salted or albumen paper. Collodion's most important contribution was to lie not in these direct-positive

FIG. 40
An American ambrotype (Rodger Kingston Collection).

modifications but in its use as a negative material in combination with the albumen paper introduced in France in 1850.

Albumen Printing Paper

Soon after its introduction, Louis Blanquart-Evrard took up Niépce de St. Victor's albumen glass-plate negative process. He experimented with albumen coatings in connection with his improvements to Talbot's calotype (described above), and he also adapted it to the purpose of making prints. Albumen-coated printing paper had in fact been tried as early as 1839, but not followed up.[50] Blanquart-Evrard described his albumen printing paper to the French Academy of Sciences on May 27, 1850, and Le Gray included it in his textbook of 1852. The first English description was published in Robert Hunt's *A Manual of Photography* in 1853.

Albumen paper was coated with egg albumen mixed with ammonium or sodium chloride. The photographer could coat the paper himself or, by the mid-1850's—once the process had become popular and commercial production had begun—purchase it already coated. It was stored in this form and sensitized ("silvered") by being floated albumen side down on a solution of silver nitrate in a tray for several minutes and then hung in the dark to dry.

Like the earlier plain salted paper, to which it was in principle more or less identical except for the presence of albumen, the paper gave a printing-out image in sunlight. The exposure was simply continued as long as necessary for the im-

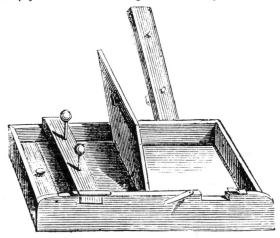

FIG. 43
A contact-printing frame. The design allowed the frame to be opened part way to check the progress of printing, without disturbing the registration of negative and print.

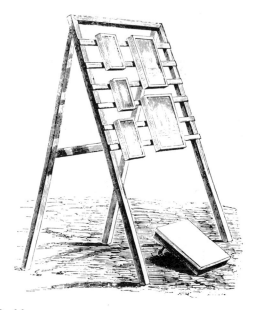

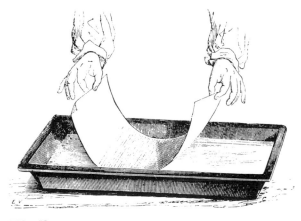

FIG. 42
Sensitizing albumen paper by floating it on a solution of silver nitrate.

FIG. 44
A portable rack for holding printing frames in the sunlight.

age to achieve the required depth. Actually, as with salted paper, it was necessary to overprint because the image lightened in processing. After exposure, the print was rinsed in water, toned in a solution of gold chloride, fixed in sodium thiosulfate, and washed. All except the earliest albumen prints were toned with gold. Unless toned, albumen prints, unlike plain salted prints, took on an unattractive color that was due to the reaction between the albumen and silver—the color was described historically as "cheesy."

The earliest albumen prints had matte surfaces, but by the mid-1850's glossy-surfaced papers ap-

peared. The glossy albumen coating had the effect of lifting the image above the fibers of the paper. In combination with the glass-plate negative, this made it possible for prints on paper to have crispness and detail until then never attainable with a negative-positive process. The albumen gloss gave the shadows a depth and tonal separation that also had been impossible on the earlier matte-surface papers. Together, the introduction of collodion negatives and of albumen paper brought an end to the daguerrean era, an end to the paper negative, and the beginning of a new dominant syntax.

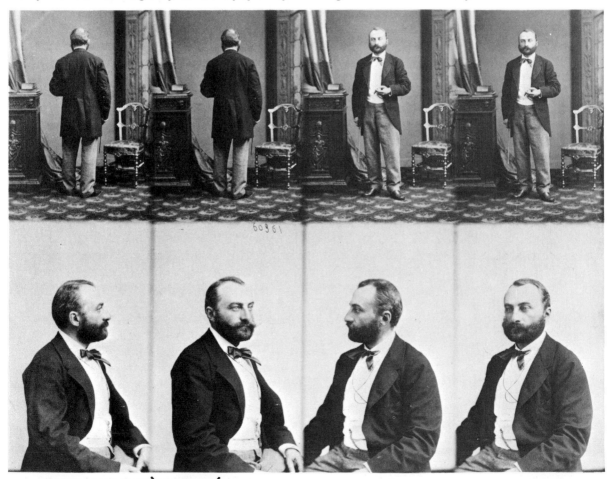

FIG. 45 ADOLPHE-EUGÈNE DISDÉRI, uncut *cartes de visite,* 1850's.

The upper left and upper right pairs were each taken simultaneously and can be viewed stereoscopically.

(International Musuem of Photography/George Eastman House)

Albumen paper caught on dramatically with the introduction of stereoscopic photography and then the *carte de visite*. Collodion negatives and albumen paper permitted prints to be mass-produced on a scale that made possible the tremendous fad for stereoscopic pictures that began in the mid-1850's. By the end of that decade, more stereos on paper had been produced than any other kind of paper photograph. In the 1860's the *carte de visite* overtook the stereo in popularity.

The *carte de visite* portraits, the "card photographs," were patented in 1854 in France by Adolphe-Eugène Disdéri. These small (about 2⅛ inches by 3½ inches) photographs were made by the wet-plate collodion process, using special cameras equipped with several lenses and often with movable plates so that a dozen or more separate or duplicate poses could be made on one negative. The entire negative was printed on glossy albumen paper, which was then cut into separate prints, which in turn were pasted on mounts only slightly larger than the normal calling, or visiting, cards of that era. Although he ended up as a beach photographer in Nice and died in poverty, Disdéri in his prime was an excellent promoter and the *carte de visite* system became the rage. It spread to Britain and by the end of the 1850's had crossed to America.

Until the early 1890's, the overwhelming majority of photographs printed on paper were

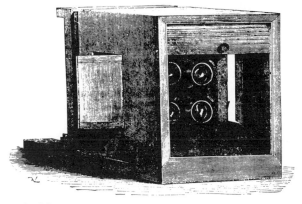

FIG. 46
Carte de visite camera with four lenses.

printed by the albumen process. The strain on the chickens was phenomenal. The *British Quarterly Review* of October 1866 estimated that six million egg whites were used annually in England to supply albumen for coating paper. At the height of its operation in the late 1880's, the Dresden Albumenizing Company in Germany used 60,000 eggs per day. In America, according to an *Atlantic Monthly* article written by Oliver Wendell Holmes after visiting the E. and H.T. Anthony Company in 1863, fifteen thousand reams of albumen paper were imported from Europe annually, where in turn "Ten thousand . . . native partlets cackle over the promise of their inchoate offspring, doomed to perish unfeathered, before fate has decided whether they shall cluck or crow, for the sole use of the minions of the sun."[51]

The Albumen Look. Albumen prints can be found in a variety of colors, from reddish brown to an almost blue gray, depending on the original method of toning and on any later chemical deterioration the print in question may have suffered. All too often there will be signs of fading. There will be some gloss—the degree varies—and often on close examination the surface of earlier prints will look minutely cracked. The paper is usually very thin, but dense. Unmounted prints have a tendency to curl or wrinkle. Prints are usually found trimmed right to the edge of the image—even unmounted ones. This was done to conserve gold in the toning bath.

It is difficult to talk about the albumen-paper-collodion negative combination in terms of the work of particular photographers—work that might be taken as epitomizing the process. No one photographer can be said to stand out as a master of albumen/collodion, simply because there was a veritable horde of masters. But some general remarks about albumen syntax can be made (and the reader can test these against his or her own observations).

For one thing, albumen paper has a very long exposure scale, and this gives albumen images a characteristic progression of tones. How the image looks of course depends on how carefully the negative and print were made, but, with a negative

of a density range matching the exposure scale of the paper, the result can be a wonderfully rich print. (For an explanation of exposure scale and density range see page 121.) The long-scale tonality of a good albumen print does not easily survive offset reproduction, and the look is difficult to put into words, yet it is distinctive. Not every albumen print has it to an equal degree because not every print or negative was a technical success. This is especially true of those made early in the 1850's, when the kinks in negative-making and printing were still being worked out.

In albumen prints there is in general a very full rendering of tones, and the transition from one tone to the next is gradual, even when the overall range of *reflection density* (the difference between the deepest shadow and the brightest highlight in the print) is great: There are no quick jumps between tones except between those that represent considerable contrast in the original scene. The long-scale tonality characteristically enhances highlight detail, giving the highlights a subtlety that modern papers are hard pressed to match. The beauty of an albumen print is rarely the sort that draws attention away from the image. Instead of casting a veil over the image, it enhances its presentation.

If you were to see an exhibition of well-preserved albumen prints, where you could examine twenty or so in one sweep, you would probably notice a definite uniformity in their tonal quality, as if they were all humming their different melodies in the same key. The main reason for this is that the chemistry of the process did not permit much variation in the tonal scale. Printing-out papers like albumen could not be modified in contrast as easily as modern developing-out papers can; hence, their tendency to produce a standard result. Another reason is that it was far more difficult to retouch a glass-plate negative in order to modify *general* tonality than, for instance, to retouch a paper negative. If Charles Nègre had photographed the *Vampire* of Notre-Dame with a collodion plate he would have had problems altering his image with pencil shadings as inconspicuously as he did. But *local* retouching of portrait negatives was frequent, and photographers often opaqued the entire sky area in their negatives in order to eliminate uneven tones. Francis Bedford, one of England's leading landscape photographers in the 1860's, took the opposite approach and often painted clouds in.

Early Developing-Out Paper

Blanquart-Evrard is given credit for inventing albumen printing, but during the 1850's he actually preferred to print on a matte paper similiar to that prepared for calotype negatives. In its advanced form, the paper he used was soaked in a solution of gelatin, potassium bromide, and potassium iodide, and dried. Before printing it was exposed to the fumes of hydrochloric acid, then sensitized with silver nitrate. The fuming gave the final image a redder tone; without it the result would be gray. Exposure, in contact with a negative, lasted only a few seconds in sunlight, even in the dull light of winter. Afterwards, the print was developed with gallic acid.[52] More than two hundred prints could be made from a single negative in the course of a day—an amazing rate for the 1850's. With a printing-out process on a clear day the maximum from a single negative was about a dozen.

In his 1841 calotype patent, Talbot had mentioned printing negatives *by development* on calotype paper, but he recommended that the simple printing-out salted paper be used instead. He said that the "tints of the copy are generally more harmonious and agreeable" when salted paper was used. Hill and Adamson may have experimented with developed prints: The slate color of certain of their prints (the color of a calotype negative) suggests this, though the color could be produced in other ways.[53] With the exception of Blanquart-Evrard, however, printing by developing-out did not become common practice until the 1880's, even though it was sometimes used for printing in the winter when the light was poor; for printing weak (low-density range) negatives which needed developed prints for sufficient contrast; or for making prints in the solar enlarger.

Blanquart-Evrard set up a printing establishment near Lille in July of 1851 and later, in partnership with Thomas Sutton, on the Isle of Jersey

from 1855 to 1857. Using the developing-out process, Blanquart-Evrard produced what must have been hundreds of thousands of prints for portfolios and books. The first set was issued in September 1851, a portfolio of five prints reproducing works of art, titled *Album photographique de l'artiste et de l'amateur*. His developed-out prints have shown great permanence. This is due in part to the chemistry of development, which tends to produce a more permanent image than printing-out, and in part to his care in fixing, toning, and washing. The earlier prints produced by Blanquart-Evrard were usually gray and look like gray platinum prints. Later prints were often warmer in tone.

Blanquart-Evrard kept the details of his process secret, revealing them to Thomas Sutton under the promise of secrecy only after Sutton had published a pamphlet describing a similar method. Prince Albert, Queen Victoria's husband, offered to purchase the secret with the intention of publishing it for the benefit of the entire photographic world. Blanquart-Evrard turned him down.

FIG. 47 LOUIS DÉSIRÉ BLANQUART-EVRARD, developed-out print from *Etudes Photographique*. 1850's. (International Museum of Photography/George Eastman House)

Syntactical Corrections: Combination Printing

A tremendous advance in the capabilities of the photographic syntax occurred during the 1850's. Nevertheless, the "gaps" or "blind spots" in the syntax remained considerable. Writing in the *London Quarterly Review* in 1857, Lady Elizabeth Eastlake presented a list of some of the things photography still could not do.[54]

To begin with, photography could not give an accurate monochromatic rendering of color. The sensitive materials were more receptive to the blue-and-violet end of the spectrum than to the yellow-and-red end. "Thus it is," she wrote, "that the relation of one colour to another is found changed and often reversed, the deepest blue being altered from a dark mass into a light one, and the most golden yellow from a light body into a dark."

Photography was also unable to record fully both the shadows and the highlights of a contrasty subject, and the way it reproduced tonal relationships was often far from what people thought they had seen. Photography could not record both the landscape and the sky in the same exposure: An exposure sufficient for the former meant overexposure for the latter.

Lady Eastlake apparently did not have unlimited faith in technological progress, and she concluded that nothing could remedy the technical defects she listed. She also concluded that the more science was able to improve photography's tractable defects, the more obvious the intractable ones would become.

The technical problems Lady Eastlake—and many others—complained about were problems of (in our terminology) camera syntax. The consensus was that, because of them, the photographic image could not represent nature in a way that compared to normal visual experience. The photograph distorted some things; others it left out completely. Lady Eastlake's pessimism about the chances of an improved state of affairs was at least partly warranted: It was a long time before methods of emulsion-making were advanced enough to overcome the principal defects of camera syntax. But Lady Eastlake did not mention (or did not know) that photographers were beginning to use the manipulations available in printmaking syntax to bridge the gaps in camera syntax. One manipulation was combination printing.

Possibly the earliest record of combination printing is the description in the February 23, 1851, issue of *La Lumière* of Hippolyte Bayard's method for adding clouds to landscape scenes.[55] Bayard printed his landscape negative and then cut the print apart along the line where sky and land met. He then made another print from the negative. Next, he covered the lower portion of the new print with the same portion cut from the first print, leaving the sky area exposed. He placed a paper mask cut into the shape of a cloud over the sky area and printed again. During this second stage of printing he constantly shifted the cloud mask just enough to blur the outline. Bayard used similar masking and burning-in techniques to create tonal gradations in skies or in the backgrounds of studio portraits. He said he had used these methods for several years and had shown them to other photographers.

The following month a method was described in *La Lumière* for combining in one print portraits made on separate paper negatives.[56] This involved cutting the figures out of the negatives and assembling the cutouts and printing them

1. TALBOT. *Photogenic Drawing.* Contact print from a woodcut or engraving, probably 1839 or earlier. National Gallery of Canada, Ottawa. *(See pages 17-21.)*

2. TALBOT. *Haystack at Lacock.* From *The Pencil of Nature,* 1844. The print is tipped by its corners into a volume at the National Gallery of Canada, Ottawa. *(See pages 22-23.)*

3. HILL and ADAMSON. *The Monk.* Salted-paper print from a calotype negative, circa 1843. The National Gallery of Canada, Ottawa.

It appears that the negative was worked over in pencil to bring out the highlights in the print. The edges of the print have begun to fade. *(See page 37.)*

4. CHARLES NÈGRE. *The Three Sweeps.* Salted-paper print from a calotype or early waxed-paper negative taken in 1851. The National Gallery of Canada, Ottawa. (Courtesy of André Jammes)

Nègre posed the figures "in motion." He worked over the negative in pencil to lighten the background. This and the two previous plates show the variety of color possible even before gold-toning of prints was introduced. *(See page 39.)*

5. HENRI LE SECQ. *Rustic Scene.* A cyanotype from a waxed-paper negative. Probably mid-1850's. International Museum of Photography/George Eastman House. *(See pages 39-40.)*

6. ANONYMOUS. Hand-colored stereoscopic daguerreotype, French, circa 1852. International Museum of Photography/George Eastman House.

The illusion of physical substance in carefully colored stereo daguerreotypes is remarkable.

7. J.J.E. MAYALL. *Man Reading.* Hand-colored daguerreotype, circa 1853. Ralph Greenhill Collection, National Gallery of Canada, Ottawa.

8. ANONYMOUS. Hand-colored tintype, 1850's or 1860's. International Museum of Photography/George Eastman House.

The color on this tintype is far more primitive than on the daguerreotypes opposite, but in its way more evocative.

9. ANONYMOUS. *Gargoyles.* Albumen print from a collodion negative, French, probably 1860's. Rodger Kingston Collection.

The highlights of this print have begun to yellow.

10. JULIA MARGARET CAMERON. Albumen print from collodion negative, late 1860's. International Museum of Photography/George Eastman House.

11. WILLIAM NOTMAN STUDIOS. *Master William Benson and Mother, 1863.* Badly faded albumen *carte-de-viste.* The Notman Archives, Montreal.

12. The same negative enlarged by sunlight onto albumen paper. Hand-colored with water colors and much imagination by John Fraser, who was in charge of the Notman art department. The original is mounted beneath a circular mat, removed here to show the underlying print. The Notman Archives, Montreal. *(See page 61.)*

13. WILLIAM NOTMAN STUDIOS. Hand-colored albumen composite, early 1870's. The Notman Archives, Montreal.

A re-creation of the ice carnival held in 1870 in Montreal honoring the visit of Prince Arthur. The Prince is the sixth figure, top row from the left. Individual figures and groups were photographed in the studio, following a sketch made beforehand. The separate prints were then pasted together and rephotographed. The coloring was done over a print made from the resulting master negative.

14-34. THE PHOTO-CLUB DE PARIS. These plates are from the splendid photogravure albums published by the Club to commemorate its annual salons. The dates refer to the year of exhibition. Courtesy, *Ars Libri,* Boston. *(See page 251.)*

ROBERT DEMACHY: **14.** *Etude de Femme,* 1894; **15.** *Etude,* 1895; **16.** *Coin de rue à Menton,* 1896.

ALFRED STIEGLITZ: **17.** *The Cardplayers,* 1894; **18.** *A Rainy Day on the Boulevard,* 1895; **19.** *Winter, Fifth Avenue,* 1896/**20.** F. Boissonas, *Les Troglodytes,* 1894; **21.** Dresser, *Nettoyage,* 1894; **22.** E.H. de Saint-Senoch, *Vieux Pont de Quimperlé,* 1895.

HUGO HENNEBERG: **23.** *En Eté,* 1894; **24.** *Novembre,* 1895; **25.** *Le Pont,* 1896; **26.** *Sur la route,* 1897.

HANS WATZEK: **27.** *Un Tyrolien,* 1894; **28.** *Michel,* 1895; **29.** *Soir d'automne,* 1896/ **30.** Achille Darnis, *La berge inondée,* 1897; **31.** *Tête d' Etude,* 1895; **32.** G.J. Engleberts, *Dans les Dunes de Kalwyck,* 1895; **33.** E.J.C. Puyo, *Sommeil,* 1896; **34.** Heinrich Kuhn, *Crépuscule,* 1897.

35. ALFRED STIEGLITZ. *A Bit of Venice,* 1894. Photogravure printed by the Photochrome Engraving Company, New York. Private Collection.

36. ALFRED STIEGLITZ. *Watching for the Return,* 1894. Photogravure printed by E.C. Meinecke & Co., New York. Private Collection

Stieglitz made both negatives during a European tour in 1894. The gravures, printed under his direction, have far greater clarity than those of the *Camera Work* period later on. *(See pages 105-107.)*

37. EDWARD STEICHEN. *The Pond—Moonrise,* 1903. Platinum print, tinted by hand, probably also an over-printing in gum. The Alfred Stieglitz Collection/The Metropolitan Museum of Art, New York. (33.43.40)

38. EDWARD STEICHEN. *The Flatiron Building,* 1909 print from a 1904 negative. Gum dichromate over platinum. The Alfred Stieglitz Collection/The Metropolitan Museum of Art, New York. (33.43.39)

Both these prints are quite dark, with details that emerge from the shadows only after patient looking. The platinum printing, done first, supplied the initial density and detail. The gum printing and tinting gave color and additional depth. While making these prints Steichen could not have been certain of the result: He had to play with the printing technique and accept its suggestions. The prints evolved in layers and stages.

39. JOSEPH KEILEY. *Indian Head,* 1898. Platinum print developed with glycerin. The Alfred Stieglitz Collection/The Metropolitan Museum of Art, New York. (33.43.187)

Keiley was the Photo-Secession's chief proponent of the glycerin method. He first covered the exposed print with a layer of glycerin, then brought out the image using brushes dipped in different developers—each produced a different color. *(See page 77.)*

1

Talbot, photogenic drawing, 1830's.

2

Talbot, salted paper, 1844.

3

Hill and Adamson, salted paper, circa 1843.

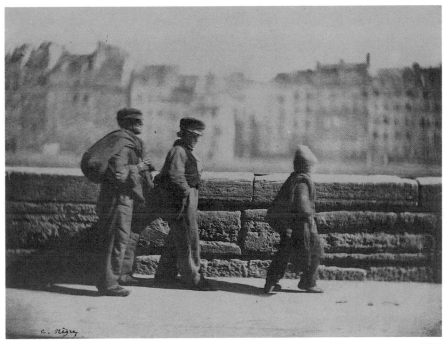

4

Charles Nègre, salted paper, 1851.

5

Henri Le Secq, cyanotype, 1850's.

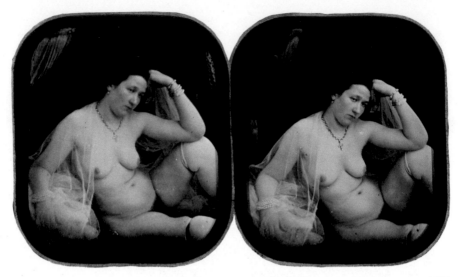

6

Anonymous, hand-colored stereo daguerreotype, circa 1852.

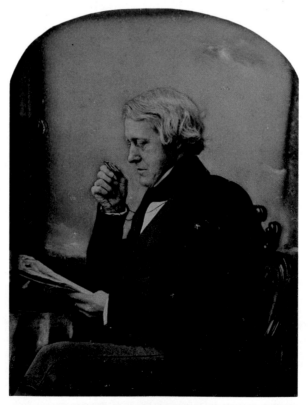

7

J.J.E. Mayall, hand-colored daguerreotype, circa 1843.

8

Anonymous, hand-colored tintype, 1850's or 1860's.

Anonymous, albumen, 1860's.

10

Julia Margaret Cameron, albumen, 1860's.

11

William Notman Studios, albumen, 1863.

12

William Notman Studios, hand-colored albumen, 1863.

William Notman Studios, hand-colored albumen composite, early 1870's.

ROBERT DEMACHY

Etude de Femme, 1894

Etude, 1895

Coin de rue à Menton, 1896

ALFRED STIEGLITZ

The Cardplayers, 1894

A Rainy Day on the Boulevard, 1895

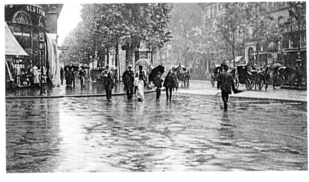

Winter, 5th Ave., 1896

F. BOISSONAS

DRESSER

E.H. de SAINT-SENOCH

Les Troglodytes, 1894

Nettoyage, 1894

Vieux Pont de Quimperle, 1895

HUGO HENNEBERG

En Eté, 1894

Novembre, 1895

Le Pont, 1896

Sur la route, 1897

HANS WATZIK

ACHILLE DARNIS

Un Tyrolien, 1894

Michel, 1895

Soir d'automne, 1896

La berge inondée, 1897

ACHILLE DARNIS

G.J. ENGLEBERTS

E.J.C. PUYO

HEINRICH KÜHN

Tête d'Etude, 1895

Dans les Dunes de Kalwyck, 1895

Sommeil, 1896

Crepuscule, 1897

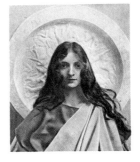
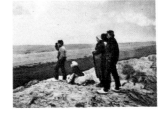
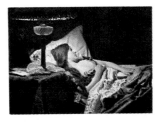

Alfred Stieglitz, photogravure, 1894.

Alfred Stieglitz, photogravure, 1894.

Edward Steichen, platinum print with overprinting. 1903.

Edward Steichen, gum over platinum, 1909.

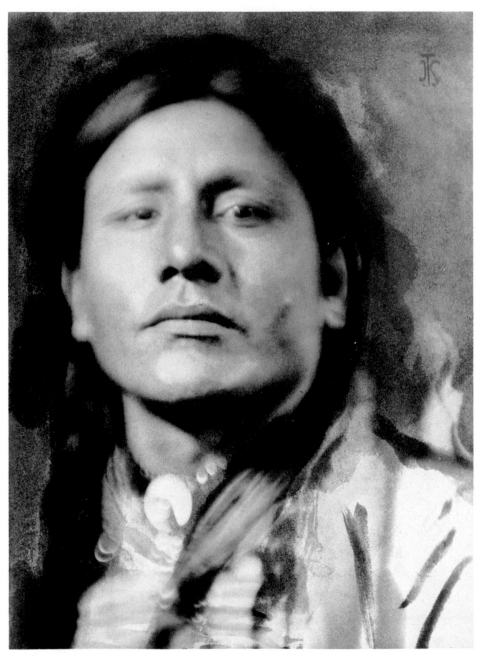

Joseph Keiley, glycerin-developed platinum, 1898.

together, the background being protected by a mask. The background was then printed while the figures were masked.

In 1852, the August 7 edition of *La Lumière* carried a description by Ernest Lacan, who had become the publication's editor, of a new technique used by Bayard to print in skies. Bayard now made glass-plate negatives (apparently collodion) in which the sky was correctly exposed. He could use them to add skies to landscape negatives in which the land portion had been correctly exposed. He first printed the landscape negative while protecting its sky area with a mask. Then he removed the landscape negative, replaced it with the sky negative, and made a second printing exposure, this time protecting the land portion with a mask.

Lacan was especially enthusiastic about Bayard's method because it allowed the photographer to select a sky appropriate to the mood of the landscape. He believed this freedom to combine parts gave photography a new status:

> ... But how many times does it happen that when a landscape or a monument is lighted so as to give a beautiful print the sky is perfectly blank and consequently will only be rendered by a flat tone, or present an aspect which is not in harmony with the rest of the view? By means of M. Bayard's technique, on the contrary, the photographer, as the painter, can match the sky with the view that he is representing
>
> The same negative can furnish very different effects; it is the intelligence and the sentiment of the artist which will indicate to him the one that he has to choose for such and such a subject. He will truly have to compose his sky.
>
> Thanks to the clever idea of M. Bayard, one will be able less than ever to reproach photography for being only a mechanical reproduction of nature. By means of this new procedure it enters into the domain of art.[57]

Bayard's technique for printing skies in from second negatives was used extensively in the following decades, though not always with the sensibility Lacan had hoped for. Instead of matching appropriate skies to landscapes, many photographers simply used the same sky negative over and over.

Although the documents suggest that combination printing started on the Continent, the most famous combination prints were made in England. The leaders in this were Oscar Gustave Rejlander and Henry Peach Robinson.

Rejlander and Robinson

Rejlander was born in Sweden and had been a portrait painter before learning photography in the early 1850's. He made his first combination print in 1855. According to A.H. Wall, Rejlander turned to combination printing—Rejlander called it "composition photography"—when, "vexed and despairing, he found that, after arranging three figures for a portrait group, his lens would not give sufficient sharpness to the male subject, who stood behind a couch, on which two ladies were seated." To solve the problem, Rejlander made a combination print. The picture was exhibited in 1855 and was described in the exhibition catalog as "a group printed from three negatives."[58]

Rejlander produced his most spectacular combination print, *The Two Ways of Life* (Figure 48) in 1857 specifically for the Art Treasures Exhibition held in Manchester that year. *The Two Ways of Life* is probably the most famous photograph of the decade; it is certainly the strangest. It was printed from more than thirty negatives and was 36 inches wide by 16 inches high, requiring two sheets of albumen paper joined together. Rejlander made at least four prints in at least two versions. He started by making preliminary sketches and took six weeks to photograph and complete the composition. He described his methods at a meeting of the Photographic Society of London in 1858:

> I began with the foreground figures, and finished with those farthest off. After having fixed upon the size of most of the nearest figures, I proceeded with those in the second plane. With a pair of compasses I measured on the focusing glass the proportionate size according to the sketch; similarly with the third plane, and so on until I was as far off the smallest group as my operating room would allow, and then I was not far enough off by yards: so I

reversed the whole scene and took them from a looking-glass, thus increasing the distance.

.... I could not be perfectly sure when taking individual figures whether the backgrounds should be light or dark, which difficulty you may easily understand. I had, in printing one figure whose general background might be dark when placed in the picture, to put one side or other against a light background; for the sketch I made was not sufficiently worked out in light and shade. Circumstances, too, made me vary the sketch. The various peculiarities in the positions of some of the models are owing to their being more or less perfect in shape. Anxious to display the good lines, I had to hide what seemed less correct, not being able, like the painter, to draw upon the antique [meaning, to copy].[59]

Rejlander told the Society of his motives in undertaking *The Two Ways of Life.* He had wanted to create a picture that would be "competitive with what might be expected from abroad"—possibly meaning other combination prints.[60] He had also wanted "to show artists how useful photography might be made as an *aid* [the italics are Rejlander's] to their art . . . in preparing what might be regarded as a most perfect sketch of their composition; thereby enabling them to judge of effect, before proceeding to the elaboration of their finished work." Considering the complications involved, it is difficult to believe that Rejlander seriously thought painters would flock to this idea. Rejlander's third reason:

To show the plasticity of photography, I sought to bring in figures draped and nude, some clear and rounded in the light, others transparent in the shade; and to prove that you are not, by my way of proceeding, confined to one plane, but may place figures and objects at any distances, as clear and distinct as they relatively ought to be.

In effect, Rejlander was talking here about the problems of camera syntax: He could not have gotten both the foreground figures and the landscape in the background in focus at the same time in *The Two Ways of Life* without resorting to a special technique. And it would have been virtually impossible to photograph figures in direct light and figures in shadow on one plate and maintain control over the tones in each. In fact, apart from

its dubious moral lesson *The Two Ways of Life* was a lesson in various types of lighting effects. Some figures are flatly lighted, others are lighted from an angle to bring out their modeling. In the print, consequently, the light appears to come from several directions at once.

Rejlander printed the various figures to different depths—the figure of the murderer, just visible above the lower edge in the center foreground, he fittingly printed darkest of all. He started with the foreground figures on the left side of the picture (masking the nonprinting areas) then worked his way into the background. He printed the figures in each successive plane slightly lighter to give the illusion of aerial perspective. After printing all the negatives, Rejlander adjusted the general tonal relationships by placing a sheet of glass over the print and selectively exposing various figures directly to light without a negative, while covering the rest of the picture. If Rejlander were not sufficiently eccentric when he conceived the plan of *The Two Ways of Life* he was well down the road by the time it neared completion. He confided that as he performed this last operation—he called it "sun-painting"—he spoke with the sunlight, giving it specific instructions and thanking it when it had done its job. (On second thought, passing this off as "eccentricity" is cheap. Creative moments can bring on giddiness, and the accounts we have of Rejlander describe a perpetually giddy man.)

Rejlander never felt entirely satisfied with *The Two Ways of Life,* yet he was proud of it as a demonstration of the possibilities open to the photographer. The picture was applauded by some critics and denounced by others. There seem to have been no neutral opinions. The denouncements were strong enough to dissuade Rejlander from attempting another combination print on as grand a scale, but he did produce less ambitious works using the same methods. Of course, a good share of the criticism of *The Two Ways of Life* was directed toward the nudity, the excess of which some people feared made the ignoble way too tempting. The Photographic Society of Scotland refused to exhibit the picture for that reason, but finally agreed, with the stipula-

tion that the offending side remain covered. On the other hand, the entirely proper Queen Victoria purchased a copy for Prince Albert, who put it on display at Windsor.

In his own way Rejlander repeated Lacan's views. He felt that combination printing could be more than just a method of making up for the deficiencies in the available camera syntax. It was an artistic syntax because it allowed the photographer "the same operations of the mind" in the selection and arrangement of the elements of his composition and the "same artistic treatment and careful manipulation" as was available to artists who worked in traditional media. In 1863, Rejlander told the South London Photographic Society:

> The same way a painter goes if he wishes to paint, a photographer must go if he wishes to make a composition photograph. The two go together; part here to meet again. Fine art consists of many parts, and a photographic composition commenced in this manner must contain many parts in common with art; and even where they part company,

photographic art does not stand still, but proceeds and gathers other merits on another road, which, though a more humble one, is yet full of difficulties, requiring much thought and skill up to the last moment, when they [art and photography?] again converge in the production of the light, shade, and reflected light which have been predetermined (in the sketch) all in general keeping, and (with) aerial perspective [A.H. Wall's parentheses].[61]

Apparently Rejlander never committed himself in plain language to the idea that a finished combination print could be considered a work of art on the level of painting, but only said, as quoted above, that the *methods* were analogous. Henry Peach Robinson had already been more forceful on this point. Speaking to the Photographic Society of Scotland in March of 1860, Robinson had contended that "the means of producing pictures in our art [photography] are as good as those of producing paintings in Raphael's time; and nothing but a deep and earnest study is required to make our pictures rank with the works of the most famous men."

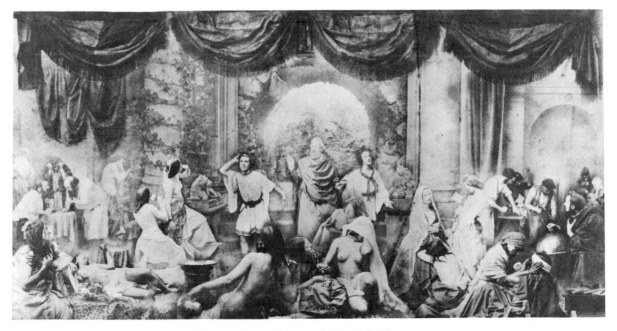

FIG. 48 OSCAR G. REJLANDER, *The Two Ways of Life,* 1857.
(Courtesy, The Royal Photographic Society of Great Britain)

In the same lecture Robinson compared the combination printer to the resourceful Greek painter Zeuxis, who for his picture of Helena chose five of the most beautiful women in the town of Crotona and painted from the best parts of each.[62] Yet Robinson insisted that the restuls of all this ingenious eclecticism be plausible and true to nature. The following is from his book *Pictorial Effect in Photography*:

> The photographer must not let his invention tempt him to represent, by any trick, any scene that does not occur in nature; if he does, he does violence to his art, because it is known that his finished result represents some object or thing that has existed for a space of time before his camera. But any "dodge," or trick, or conjuration of any kind is open to the photographer's use *so that it belongs to his art and is not false to nature* [Robinson's italics]. If the dodges, tricks, etc., lead the photographer astray, so much the worse for him; if they do not assist him to represent nature, he is not fit to use them. It is not the fault of the dodges, it is the fault of the bungler.[63]

In Robinson's mind, nature was the standard, although nature was nothing much when seen at random. Nature improved considerably if one could find the right physical point of view, and it improved even more if one could select and combine its best features. Taking nature apart, mixing it around, then putting it back together in a more pleasing package was for Robinson no violation of Naturalism. But a quick survey will tell you that in many of Robinson's combination prints the package looks as if it is coming unwrapped. Sometimes the seams between figures are ap-

FIG. 49 *Sequence of printing, as reconstructed from Rejlander's account:*

1. Old Hag
2. Bacchante
3. Murder
4. Repentance
5. Idlers
6. Sirens
7. Gamblers
8. Complicity
9. Disobedient Youth
10. Sage
11. Good Youth
12. Religion
13. Knowledge
14. Mercy
15. Mental Application
16. Industry and Handcraft
17. Married Life

The sequence for 13 through 17 is unclear. After all the figures were printed, the background was begun. The two pillars and lions were printed first, then the archway, landscape, curtains and fringe.

FIG. 50
HENRY PEACH ROBINSON, *When Day's Work is Done,* 1877.

The Robinsons shown in Figs. 50-56 are modern prints made on studio proof paper (P.O.P.) from the original negatives.

(Courtesy, John Buck, Photographic Collections Ltd./Harry Lunn, Graphics International Ltd.)

parent, and sometimes the figures pop out from the background as figures often do in the paintings of Robinson's Pre-Raphaelite contemporaries. Even in the more nearly perfect prints the objects represented appear incongruously mixed. The pictures look ready to fly apart.

For example, although not all the seam locations are obvious, the details in *When Day's Work is Done* (1877) are somehow incompatible. The reason may not be apparent at first, but after you examine the buckets in the lower right a moment it suddenly dawns on you that their perspective is not consistent with their position in the print. Given the wide field of view in the photograph, the buckets should be slightly elongated—at least they would be had the picture been taken all at once. Instead, they look as though they had been photographed at or near the center of the camera's optical axis, in the center of the field of view. The seam around the buckets is also visible, but their perspective flaw is what gives the clue to the picture's overall oddity. We can see Robinson's procedure more clearly in the sequence of negatives used in *Bringing Home the May* (1862). The picture again takes in a wide field of view, but each pair of figures was photographed head on. Consequently, the final combination does not have one

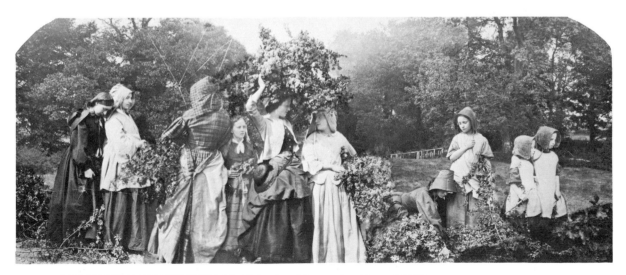

FIG. 51 HENRY PEACH ROBINSON, *Bringing Home the May,* 1862.
(Courtesy, Buck/Lunn)

head-on point of view but several: As we examine it we have the vertiginous sensation of our point of view sliding back and forth as we shift our attention among the picture's various parts. The picture moves us horizontally, the same way the perspective treatment in many Renaissance paintings lifts us as we switch our attention from foreground to landscape background. The difference is, among other things, that Renaissance perspective takes us to heaven, or at least to the mountaintop, while the best Robinson can do is knock us sideways. In terms of perspective, *Bringing Home the May* should be viewed in sections, unrolled like a scroll. The effect of sliding perspective can also be found in *The Two Ways of Life*.

This inconsistent perspective produces another result: It makes the details in the picture seem to lie on staggered planes. The picture space lacks homogeneous volume and might remind us of a series of stage flats with painted figures. A surprisingly small perspective disparity is enough to generate this illusion. The illusion persists even if the lighting in the picture is uniform and the seams concealed.

Because we often see only the defects in combination prints, we tend to forget that behind all the earnest art-making lay the syntactical problem of collodion photography's often faulty way of representing the world. Because by now we accept the look of the syntax, we are not bothered by

FIG. 52

FIG. 53

FIGS. 52-56
Prints from five of the nine negatives used in *Bringing Home the May*.
(Courtesy, Buck/Lunn)

or even particularly aware of photography's inherent distortions unless they are extreme. But the photographically naive 19th-century eye found the syntax's gaps and distortions harder to ignore, as Lady Eastlake's essay revealed. During the 1850's John Ruskin, whom Robinson lionized and frequently quoted, and who was certainly the century's most influential art critic, called for art to be minutely faithful to the ocular appearance of things and then complained about the ways photography was unfaithful, especially in recording highlight and shadow tones. Because of the prevalence of such complaints, it is not enough simply to say that Robinson's pictures ooze sentimentality and are derived from stock 19th-century notions of composition and subject. There is more to them. Robinson was trying in his combination works not only to make photography into an art but also to make it an art that "look-

FIG. 55

FIG. 56

FIG. 54

ed right" according to the tastes of his time. This meant correcting the faults of the standard syntax.[64]

One of the best examples of attempted syntactical correction is Robinson's famous combination print *Fading Away* (1858), in which all the planes in the interior portion of the picture are in focus and both the dark interior of the room and the clouds outside the window are properly exposed. To mid-19th-century photographers, *Fading Away's* syntactical characteristics of simultaneous tonal balance and deep focus must have

been as shocking as was the picture's morbid subject. They made the photograph look more like normal visual experience or, if you prefer, more like the model of normal visual experience presented in Academic painting. If *Fading Away* had been taken on one negative, the sky would have come out blank white, the focus and the modeling of the figures would have been far less under control, and the critics could have grumbled about how "unnatural" the result was.

The syntactical correction in *Fading Away* is considerably more successful than the obviously bungled job in *Bringing Home the May,* but the results can nevertheless be picked apart immediately by modern eyes: The perspective is slightly disjointed—a fact not lost on 19th-century critics—but it is above all the tonal balance of ex-

terior and interior that makes *Fading Away* seem photographically implausible today. If this is so, it is mostly because our expectations and our sense of the norm changed as we became saturated with the experience of photographs and accustomed to their often tonally imbalanced way of presenting the world. Photography has coaxed us into meeting it halfway. Above and beyond the obvious defects in many of Robinson's prints, our conditioned response actually makes it difficult for us to *see* that what Robinson was after was greater plausibility to 19th-century eyes.

Peter Henry Emerson, who became Robinson's bitter rival, also worried about the problem of making photographs "look right," but he approached it, as we will note later, in an entirely different manner.

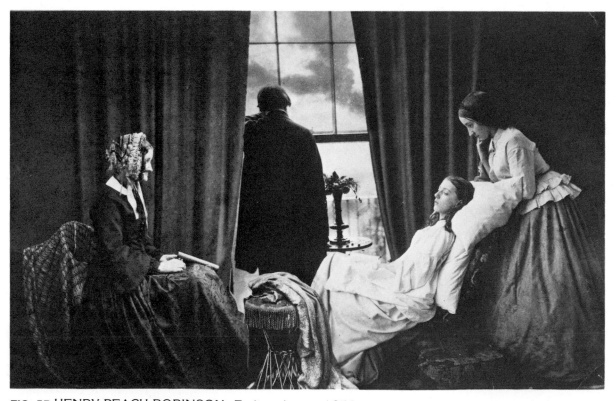

FIG. 57 HENRY PEACH ROBINSON, *Fading Away,* 1858.
(Courtesy, The Royal Photographic Society of Great Britain)

FIG. 58
HENRY PEACH ROBINSON, *Stormy Weather,*
before 1894.

*Robinson was still making combination prints in
1890's. In this case, the technique allowed him
to freeze action in both figure and background
while also maintaining depth of focus. He ap-
parently used a lens of long focal length for the
background negative and a lens of shorter focal
length for the foreground: The perspectives do
not match. The reproduction is from the 1894
album of gravures published by the Photo-Club
de Paris (see Plates 14-34).*
(Courtesy, *Ars Libri,* Boston)

Composite Montage

The combination prints of Rejlander and Robin-
son doubtless helped inspire the montages
created by commercial photographers, many of
whom had no pretensions about keeping illusion
plausible (Figure 59).

The Notman Studios were famous for their
composite montages. These began with a sketch
showing the poses of individual figures, who were
then brought into the studio and photographed in
appropriate scale. The separate prints were cut
out and mounted on a cardboard sheet. An artist
then drew in accessories and background details.
Finally the whole composition was rephoto-
graphed, and the resulting master negative was
used to make prints, which were often colored by
hand. This is how Notman memorialized the
skating carnival held in Montreal in 1870 in honor
of the visiting Prince Arthur (Plate 13). The fore-
ground and the near-middle-distance figures are
photographed, the background is painted. Com-
bining painting and photography was considered
anathema by Rejlander and Robinson.

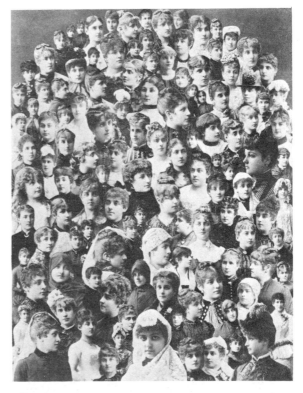

FIG. 59
ANONYMOUS. *A montage of albumen portraits,
pasted together and then rephotographed.*
(Rodger Kingston Collection)

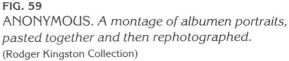

The Beginnings of Modern Printing Papers

We have been looking at the major early camera and printing processes based on the photochemistry of silver salts. Nonsilver systems were also tried during the early years, and we will deal with some of them presently. What follows is a brief summary of post-albumen silver printing papers.

The alliance between the chickens and the photographers remained in effect for some forty years, even though by today's standards albumen paper was almost as much bother to use as was the collodion wet-plate negative. The photographer or his assistant had to silver and then fume the paper, wait for it to dry, and then give it an exposure that in dull weather might take several hours or in extreme cases, with dense negatives, even days. The practice of fuming albumen paper with ammonia vapor to increase its printing speed and contrast was introduced at the end of the 1850's by Henry Anthony. Presensitized albumen papers eventually became available, but they were relatively expensive and had to be used within a week or so after purchase.

It was only with the introduction of presensitized gelatin emulsions that a real change in the way silver prints were made began to take place. The first successful gelatin dry plates for use in the camera were made by Dr. Richard L. Maddox in 1871 and were made commercially practical two years later by John Burgess.

The Liverpool Dry Plate Company offered their first gelatin-coated silver bromide *printing* paper in 1873. Unlike albumen paper, in which the excess of silver nitrate caused the image to appear during exposure, this paper had an excess of bromide and the image was brought out by development. Bromide paper was far more sensitive than albumen paper and could be exposed by artificial light. Even so, it was a number of years before bromide papers really caught on. By 1886, after the introduction of machines for coating emulsions onto paper in rolls, developing-out bromide papers began to come into general use for printing with artificial light and for making enlargements.

In the early 1890's albumen finally lost its role as a printing-out paper to the new printing-out collodion silver chloride and gelatin silver chloride presensitized papers, known in America under the general name *Aristotype*. Kodak put out a popular printing-out gelatin silver chloride paper, called *Solio*, in 1892.

Amateur photography grew at a tremendous rate during the 1880's and 1890's. The amateurs were among the first to switch to the new printing papers, but by 1900 most professionals had also given up printing on albumen (the great French documentary photographer Eugène Atget was one exception).

Several developments brought on the amateur movement. The introduction of dry plates was the first and the most important. Dry plates put an end to the inconveniences of the collodion process, and their far greater sensitivity made "snapshot" photography possible. In 1884 George Eastman introduced the first practical roll-film system, and four years later, the first Kodak camera. With the Kodak, anyone could practice photography with a minimum of preparation or trouble. The Kodak was sold containing film for 100 exposures; it was sent back to the dealer or to the Eastman factory for processing and printing and a fresh load of film.

As amateur photography began to spread, manufacturers sought easy-to-use products to

suit the new market. Among the most successful of the new products were the "gaslight" papers. One of the first to come on the market was *Velox*, in 1893. These gelatin papers, containing silver chloride, were less sensitive than bromide papers and could be handled easily in dim light. They were printed with the gaslight turned high and

At Home,

by the light of an ordinary lamp, by gaslight, or by daylight, print-making is easy

With VELOX

paper. Requires **no dark room** and renders exquisitely soft, platinum-like effects.

NEPERA CHEMICAL CO.
Division of the General Aristo Co.

For sale by all dealers

Nepera Park, N. Y.

FIG. 60

Aristotype, 1890's. Gelatin silver chloride, print-ing-out "Aristotypie" paper was first manufac-tured by Paul Eduard Liesegang, of Düsseldorf, in 1886. Others followed suit. After printing, Aristotypes were usually toned in a solution of potassium chloroplatinite. Sometimes a gold chloride toning bath was used instead, and sometimes both platinum and gold baths were used. The prints are generally warm black to blue-black in color, although brown tones were possible. Aristotypes are often hard to tell apart from platinum prints. If there is even the slightest sheen in the highlights, the print is more likely to be an Aristotype.

FIG. 61

Advertisement for Velox, 1900. The Nepera Chemical Company later became part of East-man Kodak. Velox prints are usually blue-black, but the color varies according to the developer. Sepia tones could be gained by adding potassi-um alum to the fixer or by bleaching the image and then "redeveloping" it in sodium sulfide.

developed and fixed with the light turned low. Velox was the subject of an intense advertising campaign aimed principally at amateurs, and the paper was an enormous success. One reason was that Velox (and the bromide papers) could be manufactured in various contrast grades to suit the widely varying negatives the amateurs produced.

A characteristic of the old gaslight and bromide papers, which helps in distinguishing them from the earlier albumen papers, is that over the years their shadow tones tend to become bronzed and metallic. This can also happen with albumen papers, but usually not as much.

The developing-out silver bromide, silver chloride, and combination chlorobromide papers (first described by Jospeh Eder in 1883) that appeared after the introduction of the dry plate were the direct ancestors of the modern commercial papers sold today.

For further information, see the list of recommended reading at the end of the book.

Nonsilver Processes

Cyanotype

During the 1840's a great many photographic printing processes were developed as the nature of the photochemical reaction was explored. Most were short-lived. They included, in addition to those already mentioned, the catalysotype, chromatype, chrysotype, amphitype, anthotype, energiatype, fluorotype, and cyanotype.[65] Only the cyanotype, invented by Sir John Herschel, proved to be of real value.

Herschel had discovered the use of sodium thiosulfate as a fixer. He was the first to employ the terms *positive* and *negative* to describe the steps in the photographic process. He was an early experimenter with photography on glass and he conducted a great many other photochemical investigations. Yet photography was only a minor part of this remarkable man's work. His real fame was as an astronomer. Among his many achievements, Herschel discovered 525 new stellar nebulae, made a chemical analysis of the solar spectrum, studied terrestial magnetism, investigated the effect of the Earth's orbit on climate, and even managed to survive a photographic portrait session or two with the formidable Julia Margaret Cameron.

Herschel was also the first to discover the photosensitivity of ferric (iron) salts. On June 16, 1842, Herschel read to the Royal Society a paper entitled, "On the Action of the Rays of the Solar Spectrum on Vegetable Colors, and on Some New Photographic Processes." The new processes, for which Herschel coined the names *cyanotype* and *chrysotype*, were mentioned only at the end. The first part of the paper was about flowers. Herschel had conducted a long series of experiments on the bleaching effect of light on the juices of various flowers. Later called *anthotype* (from the Greek word for flower), these processes proved to be of no practical photographic value. In most cases, it took weeks to complete a printing-out exposure on paper treated with juices from suitable plants (Herschel complained that the gloomy English weather of 1841 had delayed his

FIG. 62

SIR JOHN HERSCHEL, *cyanotype of peacock feathers, 1845.*

(Gernsheim Collection, Humanities Research Center, University of Texas at Austin)

experiments), and the resulting images were not permanent.

After describing his experiments with flowers, Herschel went on to announce one of the simplest yet most important discoveries in the history of photography: that on exposure to light ferric salts become reduced to the ferrous state, and that the ferrous salts so produced can combine with or in turn reduce other salts to create an image.

For his cyanotype (later known also as the blueprint or ferroprussiate process), Herschel coated paper with either ferric chloride or ferric ammonium citrate, and potassium ferricyanide. When exposed to light under a negative, the paper printed out a blue, positive image, which turned a deeper blue on drying after first being washed in plain water. Herschel worked out a number of variations of this basic process. In one he sensitized paper with ammonium citrate alone and exposed it to light under a positive. Development with potassium ferrocyanide produced a direct-positive image.

In his chrysotype process, Herschel sensitized a sheet of paper with ferric ammonium citrate, contact-printed it, and developed the image in a weak solution of gold chloride. The ferrous salts created by exposure to light in turn reduced the gold, which precipitated as a purple deposit over the image in proportion to the original exposure.

Two months later, in a postscript to his original paper, Herschel pointed out that ferrous salts can also reduce silver to its metallic state. This discovery became the basis of brownprint, or kallitype, processes.

Herschel used his cyanotype technique as a quick way to make copies of his notes and calculations. Anna Atkins used it for botanical studies: In 1843 she produced the first part of what eventually became the three-volume (very) limited edition, Photographs of British Algae: Cyanotype Impressions. She laid her specimens over paper sensitized for cyanotype and made contact prints.[66]

The cyanotype process soon fell into relative disuse, although Le Secq used it in the 1850's and experiments with ferric salts did continue and new formulas were published. A Parisian firm, Marion & Cie., made a cyanotype paper for producing blue images in the 1860's, and in the 1870's marketed a new paper for blueprinting, probably a modification of their earlier one, called Papier Ferro-Prussiate. Engineers and draftsmen soon took it up as a method for copying drawings and specifications, a task for which paper of its type is still used today.

The real drawback that prevented the adoption of cyanotype for regular photographic use was its bright blue color; yet the simplicity and cheapness of the process made it popular with turn-of-the-century amateur and professional photographers as a quick way to proof negatives. Many photographers, Alvin Langdon Coburn for one, got started in photography by printing their negatives on home-coated cyanotype paper.[67] Many cyanotype snapshots, postcards, amateur stereos, and even entire family albums exist, and they often have a special charm that reflects the casual and completely unpretentious way the process was used. But amateur photographers who intended to become professionals were admonished not to show up carrying cyanotypes. As for the aesthetic oppositon, Peter Henry Emerson summed it up without wasting any breath in his book Naturalistic Photography:

> . . . no one but a vandal would print a landscape in red, or in cyanotype.

The Problem of Permanence

The fading of photographic images was one of the most serious difficulties the early photographic experimenters faced. At first the problem was simply to find a way to remove or desensitize the unreduced, still-sensitive silver salts remaining after the image had been developed or printed-out. It soon became clear, however, that even though sodium thiosulfate supplied the answer, traces of thiosulfate in the image could in the long run create new difficulties. The silver image turned out to be susceptible to certain slow chemical

FIG. 63
A demonstration of photographic fading. From *Punch*, 1847.

changes that in time could destroy it. The magazine *Punch* satirized the problem in 1847:

> Behold thy portrait—day by day,
> I've seen its features die;
> First the moustachios go away,
> Then off the whiskers fly [68]

Photographers quite naturally were concerned. The general public came to expect that photographic prints would fade, and the issue even reached the attention of Prince Albert, who helped pay the expenses of a committee set up by the Photographic Society of London in 1855 to study the problem of permanence. The Fading Committee presented its findings in the November 1855 issue of *The Photographic Journal*.[69] The committee concluded that among the causes of fading were: incomplete washing of prints; the use of an exhausted fixer or one containing an excess of sulfur; hygroscopic pastes used for mounting prints; and moisture and sulfur in the atmosphere. By a vote of five to two, the committee also recommended that prints be gold-toned to increase their permanence. All agreed that no photograph had much chance for survival in London's thickly polluted air.

Yet photographers still found that after even the most thorough fixing, careful toning, and prolonged washing prints still might show signs of impermanence. Therefore, during the 1850's a search began for ways to replace silver with more stable materials. The *carbon transfer process* was the most successful of the many pigment techniques which resulted. Until the introduction of platinum papers, it was the method most widely used to make permanent photographic prints.

Dichromate Processes: Carbon Printing

In 1839, a Scottish photographic experimenter with the euphonious name of Mongo Ponton, who also happened to be the Secretary of the Bank of Scotland, had found that paper coated with potassium dichromate—then called *bi*chromate—was sensitive to light. (Whether Ponton knew it or not, the sensitivity of chromates had in fact been observed in 1832 by Gustav Suckow.[70]) Ponton had been experimenting with silver chromate when he made his discovery. Since at that early date there were no photographic journals, Ponton published his results in the July 1839 issue of *The Edinburgh New Philosophical Journal*, where it appeared immediately after a remarkably detailed article describing the course of action to take in the event of losing your rudder during a storm at sea.

A year later (1840), the French physicist Edmond Becquerel discovered that the sensitivity of the dichromate could be increased if the paper were first coated with starch paste, and from this he concluded that the sensitivity of dichromates depended on the presence of organic matter.

In 1852, William Henry Fox Talbot found that normally soluble colloids, such as gum arabic and gelatin, become insoluble when mixed with potassium dichromate and then exposed to light. *Tanning* or *hardening* are two terms often used to describe this action. Talbot used the phenomenon as the basis for an etching resist in a process he called *photoglyphy*.

Alphonse Louis Poitevin patented the first carbon process in 1855. Poitevin was a French civil engineer who had once worked for his government in the National Salt Mines.[71] His simple but important contribution was to add pigment to the colloid-and-dichromate mixture. The pigment was usually carbon black; hence the name, *carbon process*. Poitevin coated paper with a combination of gelatin (or other colloids such as albumen or gum arabic), dichromate, and pigment. When it dried, he exposed it to sunlight in

FIG. 64

MONGO PONTON, a photogravure from the *Yearbook of Photography 1881.*

(Gernsheim Collection, Humanities Research Center, University of Texas at Austin)

contact with a negative and then developed the image in warm water. The gelatin in the shadow areas was made insoluble by the chemical reduction of the dichromate during the exposure. The shadows thus resisted the water and retained their pigment. In the lighter tones, protected under the dense areas of the negative, the still-soluble gelatin could be washed away, carrying the pigment with it.

In 1856, a French nobleman and art patron, the Duc de Luynes, offered several medals and prizes for improvements in photography, among them an award of 2,000 francs for the best method of producing permanent photographic prints. In the next few years, partly as a result of this, at least eight different carbon processes were announced, all based on the principles outlined by Poitevin but differing somewhat in materials used or in the working details.[72]

In the preface to the prize offer, H.V. Regnault, a chemist and chairman of the Paris Photographic Society, wrote:

> Of all the elements with which chemistry has acquainted us, carbon is the most permanent, and the one which withstands most all chemical reagents at the temperature of our atmosphere . . . If we could therefore make it possible to reproduce photographic images in carbon we should have a basis for their permanency, as we now have in our books, and that is as much as we may hope for and wish.[73]

When they finally presented the awards, in 1859, the judges found it impossible to single out one superior technique; so they divided the honors. John Pouncy won a silver medal for his process of gum printing. Two Frenchmen, Henri Garnier and Alphonse Salmon, shared a silver medal for a process in which they sensitized paper with ferric ammonium citrate, exposed it under a transparent positive, and covered it with dry, powdered pigment, which then stuck only to the unexposed areas, creating a positive image. Poitevin won a gold medal, even though appparently he had not bothered to enter the contest. The judges felt that Poitevin deserved a reward as the original source of all the carbon techniques.

More Problems. Despite the medals and prizes, all the early carbon processes were lacking in one important respect: They could not easily produce prints showing a good continuous gradation of tones. The middle and lighter tones were usually lost. At first, the cause was thought to be the impossibility of getting as fine a particle deposit with pigments as with reduced metallic silver. But the real reason was discovered in France in 1858 by the Abbé Laborde. He noted that the sensitive coating had two distinct surfaces: an outer surface that was in contact with the negative during printing and an inner surface that was in contact with the paper. Laborde found that the insolubilization by light began on the outer surface and worked down toward the paper. In the intermediate tones it worked only part way down, leaving an insoluble layer on top and a still-soluble layer between it and the paper support. During

development, the insoluble top layer lost contact with the paper when the soluble colloid under it washed away. The result was that the lighter part of the tonal scale was lost. (See Figure 147 in the technical section.)

One way to get around this problem would have been to use a thinner coating and resort to multiple printing to build up the tonal scale, as was done in the later multiple-gum technique. But multiple printing of this sort does not seem to have occurred to anyone until Von Hübl suggested it for gum in 1898.[74] Research focused instead on finding a way to treat the dichromate-pigment-colloid coating so that the insolubilization, the so-called hardening, would proceed from the paper *up*, instead of from the surface of the coating *down*. In this way the insoluble layers of the coating, no matter how thick, would always be in contact with the paper base, and the print could be developed without losing the full range of tones.

In 1858, having come to the same conclusion as Laborde about the cause of the problem, Joseph W. Swan attempted to secure middle tones by coating a glass plate with a solution containing lampblack, gum arabic, and potassium dichromate. He exposed the plate in what must have been a kind of copy camera, with an image from a negative focused on the sensitive coating through the *uncoated* side of the glass plate. The experiment failed, probably because of either too short an exposure or a lack of adhesion between the gum and the glass; but at least Swan was on the right track.

In 1858-59, C.J. Burnett and William Blair, working independently of each other, tried experiments similar in principle to Swan's. Each coated paper with dichromate, pigment, and gelatin or gum arabic. They exposed it from the back, with the negative in contact with the un-coated side of the paper. This method did achieve middle tones; but because printing was done through the paper, the paper's texture interfered with the fine details of the image.

The next year, 1860, Adolphe Fargier revealed to the French Photographic Society a process in which he coated a sheet of glass with gelatin, dichromate, and pigment, and, after exposure

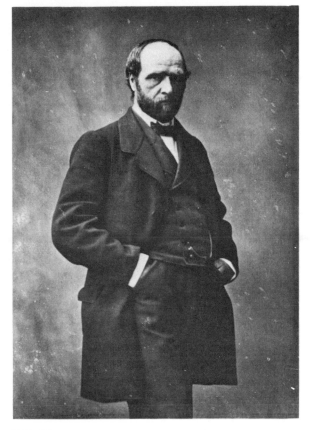

FIG. 65

ALPHONSE POITEVIN, a print from his book, *Traité de l'Impression Photographique sans sel d'Argent,* Paris, 1862.

The print was made by a "dusting-on" process Poitevin patented in 1860. He coated glass with ferric chloride and tartartic acid and exposed this in contact under a negative. The parts of the coating affected by light became sticky. Powdered pigment, brushed over the image, adhered only to the sticky parts. The image was then transferred to paper (see John Towler, *The Silver Sunbeam,* Morgan & Morgan reprint, pp. 281-86).

(Gernsheim Collection, Humanities Research Center, University of Texas at Austin)

from the front, added a thin coating of transparent collodion such as was used in the wet-plate process. He then soaked the plate in water and stripped off the collodion film, which now carried the pigmented gelatin with its soluble underside exposed for development. After development, the print was mounted—with the collodion side up—on a sheet of paper. The process worked beautifully, but it was far too difficult for general use.

Finally, in 1864, some nine years after Poitevin announced the original carbon process, Swan solved the tone-reproduction problem. In that year he patented his *carbon tissue* and his *carbon transfer process*, which he introduced commercially two years later, in 1866. Swan's process underwent several modifications during the years after its introduction. The final form was roughly as follows:

The photographer purchased from Swan's firm, or from any of the other firms that later produced materials for the process, a "carbon tissue" —a paper coated on one side with a film of pigmented gelatin. This was sensitized in a dichromate solution before use and, when dry, exposed to light with the gelatin side in contact with a negative. The entire gelatin/pigment film was then transferred to a second sheet of gelatin-coated paper (containing no pigment) and the original backing paper stripped off. It was developed in warm water, which dissolved the now-accessible soluble gelatin, leaving the image visible in insoluble gelatin.

Some Carbon Printers. In 1866, Swan began to sell the rights to the carbon process. Adolphe Braun of Dornach (Alsace) bought them for France and Belgium. Braun immediately built a plant and began to publish reproductions of paintings and Old-Master drawings. When possible, he tried to match the color of the original by using pigments of the same color in his tissues. By 1868 Braun was producing 1,500 prints a day. He had visited all the major European galleries and photographed their most important paintings and drawings.

Photographic editions of works of art had been published before Braun, but nothing had been done on quite the same scale or with such

technical success. Before the introduction of photography, paintings and sculptures had usually been reproduced as engravings or, beginning in the 19th century, as lithographs. The more precise, facsimile quality of photographs, and especially of carbon prints, gave the students and historians far more accurate and comprehensive information from which, in the absence of the original works of art, they could learn and compare. This was to have an important effect on the whole methodology of art history. It allowed interest to focus on the actual painterly aspects of a work—on qualities of handling and surface that could never be communicated by the syntactical system of an engraved or lithographed reproduction. Most older public and university libraries own art reproductions made by the carbon printing process.

FIG. 66
ADOLPHE BRAUN, carbon print of Michelangelo's *Prisoner*.
(Courtesy, Richard Benson)

FIG. 67
Developing a carbon print, line engraving from Walter E. Woodbury's *Encyclopedic Dictionary of Photography,* 1898.

Franz Hanfstaengl, a photographer and art publisher in Munich, bought the German rights to Swan's process. Hanfstaengl had switched from lithographic to photographic art reproduction in 1853. The Hanfstaengl concern is still in business in Munich and is today the only remaining manufacturer of carbon-printing supplies.

T. & R. Annan, of Lenzie, bought the rights for Scotland. Thomas Annan was a friend of David Octavius Hill and photographed Hill's commemorative painting of the founding of the Free Church of Scotland, *The Signing of the Deed of Demission*, which Hill finished in 1866, more than two decades after he started. This painting became the subject of Swan's first commercial edition of carbon prints. Using Annan's negatives, Swan made prints in three sizes, 1,000 copies of each. The largest size was 48x21¼ inches.

Soon after Annan took up the carbon process he was chosen by the Glasgow City Improvement Trust to make a photographic record of that city before certain areas were torn down for renewal. He worked on the project from 1868 to 1877,

when the Trust published for its members a limited-edition collection of forty of Annan's photographs, printed by carbon. The group of photographs documents the streets and the dreary, closed-in slums of Glasgow, and is one of the earliest attempts to use photography to show the effects of the industrial revolution on urban life (Figure 69).

In 1868, the Autotype Printing and Publishing Company was founded in London. The company began to manufacture and sell materials for carbon printing and to print editions and fill individual orders from photographers. Carbon prints are often referred to as *Autotypes.*

The Carbon Look. For reasons shown in the technical section of this book, the subtlety of the

FIG. 68
W. & D. DOWNEY, carbon print, *The Misses Dene.*

e and the whole appearance of the well-made carbon print is quite remarkable. Yet carbon prints can be difficult to identify. The print will look much like any long-scale silver photograph, but there should be no sign of the chemical deterioration that can occur in silver prints. Carbon prints can be any color; so if the color in the print you are looking at is not one of the familiar ones associated with silver, the print may be a carbon. Under a magnifier you will see no grain or mechanical halftone pattern, but the surface may appear speckled with particles of pigment or dust lying between the paper base and the thin gelatin film. If the print is held at an angle against the light the surface will show a gloss, but usually this will appear more in the shadows than in the highlights (see the chapter on Woodburytypes). Glossy albumen prints and other glossy silver prints, on the other hand, will be glossy all over, even though at first the gloss is more obvious in the shadows. On some early or flawed carbon prints there may be image areas where the gelatin film has wrinkled slightly.

A modification of the carbon technique called the *carbro* process is described in the technical section.

Gum Printing: Early Experiments

The gum dichromate and the carbon transfer processes had a common origin: the need to find a method for making permanent prints. Both processes were derived from the same series of discoveries: Mongo Ponton's detection in 1839 of the light-sensitivity of dichromates; Talbot's discovery in 1852 (or earlier) that normally soluble colloids such as gelatin and gum arabic lose their solubility when mixed in solution with a dichromate, dried, and exposed to light; and finally, in 1855, Poitevin's idea of adding to the colloid a suitable pigment. All the early techniques derived from Poitevin's work, including what we now call the *gum process*, were first given the general name *carbon processes*, since carbon black, because of its permanence, was the pigment most often used. The term *carbon print* later came to mean specifically the carbon *transfer* process introduced by Swan.

In 1858 John Pouncy, an English professional photographer, began to experiment with a process in essence the same as that outlined by Poitevin. He settled on the use of gum arabic, though, as the colloidal vehicle for the dichromate and pigment. Pouncy coated paper with a solution containing pigment, potassium dichromate, and gum arabic. When the coating was dry he exposed it in contact with a negative and then developed it in water, which washed the soluble gum away and left the insoluble gum holding the pigment, in this way forming the image.

Pouncy was keenly aware of the financial reward that could be in store for the person who first came up with a really workable method for making permanent prints in pigment—a method that could give image resolution and a tonal scale

FIG. 69
THOMAS ANNAN, *No. 118 High Street,* carbon print.

equal to that of silver prints. *The Photographic News* of March 5, 1858, went so far as to state that when such a method was perfected "the abominable process [silver] at present employed will be swept away, and superseded by another, which will satisfy both artist and chemist."

Pouncy started a publicity campaign for his process, but, since he was unwilling to give any details, rumors began that it was nothing but a hoax. He displayed some specimen prints at the Photographic Society in London in April of 1858. The prints were criticized for their inferior tonal scale, and Pouncy for his refusal to give the details of his method. Pouncy returned to the Society in December, but again failed to give a satisfactory description of how he worked what had been characterized as potentially "one of the greatest discoveries photography has ever known."[75]

Pouncy was reluctant to reveal anything about his process because he was at that time entered in the contest for the Duc de Luynes prize for the best method of making permanent photographic prints. Most likely he was also reluctant because he knew that his technique was really no different from the one Poitevin had already patented. Nevertheless, under the sponsorship of Thomas Sutton (editor of the biweekly *Photographic Notes*), Pouncy undertook to sell subscriptions to his process at a shilling each: When he had raised a specified sum he would release the details to his subscribers. Prince Albert headed the subscription list. Unfortunately, Pouncy appears to have been the sort of man destined to travel through life spreading disgruntlement, and the affair did not turn out to everyone's satisfaction. One unhappy subscriber complained of being

> rather crestfallen, when expecting to receive a "Pamphlet" with full particulars, at finding that half a sheet of indifferent (letter-size) paper was sent, with extra wide margins, sufficed to contain all the "would-be patentee" has thought fit to divulge to his subscribers. It approximates most to the directions usually to be found on packets of patent starch, baking powder, &c. I may add, the proportions and mode of applying are rather *vague* . . . whilst the "vegetable carbon and the particular kind of paper" are never alluded to; but a separate circular states they can be *purchased from the inventor*.[76]

Despite the considerable ill will Pouncy managed to generate in England, the French Photographic Society awarded him a silver medal in the Duc de Luynes competition—not for originating the process he showed, but for excellence in manipulation. Yet Pouncy persisted in claiming the honor of having invented the carbon process. In fact most historians give him credit at least for being the first in England to make prints in gum. Yet even that is contradicted by Pouncy's irate former apprentice, W. Portbury, who wrote to *The Photographic News* in 1860:

> Sir:
>
> It appears to me that those who are most tender when their own interest is affected, are most unscrupulous towards others. How very consistent of Mr. Pouncy to complain of having his "brain sucked" when he was not the originator of the Carbon Process at all; for the action of the bichromate salt, with organic matter influenced by light, was known long before he dabbled with it. But if there is any merit in applying a known principle, I can certainly claim it, having produced the first picture by the process, and also those Mr. Pouncy triumphantly exhibited to the Photographic Society, and at Paris; though being his apprentice at the time, my name was never heard in connection with the affair.
>
> I have troubled you with these few lines, thinking it may interest you slightly to know the truth.
>
> Yours, respectfully,
>
> W. Portbury.[77]

In any case, although the basic gum process was known by the end of the 1850's it did not come into wide use until many years later. The main reason was the clear superiority of Swan's carbon transfer technique of 1864 for reproducing in pigment, in a relatively foolproof operation, all the fine details and tones of a negative. Transfer was thought to be a necessary step for successful, full-tonal-scale work with a pigment process, and so gum printing—not being a transfer process—was more or less ignored until rediscovered by the Pictorialists in the 1890's.

Platinum Printing

Sir John Herschel announced at a meeting of the British Association at Oxford in 1832 his discovery that certain platinum compounds, in the presence of organic matter, could be reduced by the action of light. Twelve years later, Robert Hunt described in his book *Researches on Light* (1844) his own experiments with platinum. Hunt coated paper with ferric oxalate and platinum and observed that the combination darkened on exposure to light. He did not discover, however, that you had to develop the image for the full effect.

It was not until some thirty years after Hunt's experiments that William Willis was able to perfect and patent a platinum process. Willis was the son of a British engraver, William Willis Sr., who himself had invented a printing technique using potassium dichromate and aniline, known as the

Willis Aniline Process. Willis the younger took out his first patent on the platinum process in 1873 under the optimistic and misleading title, "Perfection in the the Photo-Mechanical Process." New patents on modifications followed in 1878 and again in 1880. Willis formed the Platinotype Company in the fall of 1879 (platinum prints are often referred to as *Platinotypes*) and began to market his papers the following year. He sold licenses at five shillings each to photographers—both professionals and amateurs—who wanted to use the process, and then sold them the materials. Twelve sheets of 10x12-inch paper cost six shilling and sixpence. By the end of the decade, licenses were no longer required.

Two Austrian army officers, Giuseppe Pizzighelli and Baron Arthur von Hübl, further refined the platinum process and worked out methods for photographers who wanted to prepare their own

FIG. 70 *Platinum print. A Bertillon Measurement photograph* (see Gernsheim, *The History of Photography, p. 516*) *made for the New York Police Department in 1908. The subject is Albert Johnson, alias Albert Jones. Crime: dishonest employee.* (Rodger Kingston Collection)

platinum papers. They published their findings in 1882 in *Die Platinotype*, much to the annoyance of the Platinotype Company, which tried to discredit their formulas. Their work was translated into English and published in *The Photographic Journal* the following year and helped popularize the process.[78] Pizzighelli later devised a printing-out platinum technique.

When exposed to light, ferric (iron) salts are reduced to the ferrous state. In a suitable developing agent, these ferrous salts can in turn reduce platinum salts to the metallic state. The platinum process is based on these facts. Paper coated with ferric oxalate and potassium chloroplatinite is contact-printed beneath a negative. The ferric salts become ferrous in proportion to the exposure. The print is developed in potassium oxalate, which dissolves the ferrous salts and causes the platinum to become reduced to the metallic state. The image appears almost immediately. The light-sensitive ferric salts remaining in the paper are removed by clearing in dilute hydrochloric acid. The image then consists of pure

FIG. 71
The Platinotype Company later became Willis & Clements. The ad is from *The Photo-Miniature,* July 1901.

platinum—a metal that is extremely stable, having the virtue of being unaffected by any but the strongest combination of acids. A normal platinum print will last as long as the paper on which it is made.

Glycerin-Developed Platinum. This modification of the platinum process allowed considerable area-by-area control over the image. After exposure, the print was covered with a layer of glycerin and the image then brought out with a brush dipped in developer. The viscosity of the glycerin acted as a restrainer on the rate of development and prevented the developer from flowing. In this way it was possible to modify tonal values. By using different developers, the printmaker could bring out different colors (Plate 39). After processing, platinum prints were often gold-toned, again using glycerin in order to control the rate of toning and confine the effect to certain areas. Glycerin modifications became especially popular toward the end of the 1890's.

The Platinum Look. Most platinum prints have matte surfaces. They have a long-scale tonality like that of albumen, but the matte surface tends to soften contrasts more. The usual colors vary from cool to neutral black to warm sandy brown. The brown tones were made by adding mercury to the sensitive coating or the developer and/or by using the developer hot. The color also has much to do with the chemistry and sizing of the paper itself. After a while you begin to pick out the special colors of platinum prints and in this way learn to tell platinum apart from other matte-surfaced images.

In platinum prints the image lies slightly in, as well as on, the paper. You can see this if you look at a print under a microscope. The physical relationship between the paper and the individual particles of metallic platinum gives the prints their characteristic "tactility"—a word most people come to use to describe them. This look can be quite lovely, but it is like certain minor keys in music: You hear them and right away they put you in a definite mood. Platinum prints often do the same. The most beautiful ones make you take in a deep breath, and then sometimes you hear yourself let out a sigh.

One of the best platinum printers was Frederick H. Evans, whose turn-of-the-century prints of British and European cathedrals are a perfect match of subject and medium. Evans gave up photography when platinum papers became unavailable during the First World War.

FIG. 72
From *The Photo-Miniature*, November 1900. The account in question appeared in *Camera Notes* for April 1900.

FIG. 73
FREDERICK H. EVANS, platinum print of Ely Cathedral, southwest transept, 1899/1900.

Evan's platinum prints have a wonderful luminosity. In his architectural work the texture of the printing material often seems to match that of the subject; the viewer can almost feel the stone walls. The strongest criticism ever made of Evans was that his work was too perfect, and thus predictable and static.

Naturalistic Photography

The introduction of platinum paper was a turning point in the art of photographic printing. Platinum paper was more sensitive than the albumen printing-out papers then in general use and it allowed greater control over the contrast of the image. Printing with platinum was easier, for the most part, than printing with albumen. The reason Willis had begun to experiment with platinum was its stability in the metallic state, and platinum prints, unlike silver ones, were permanent. Not all photographers switched to platinum—it was more expensive than silver even then—but those who did welcomed its soft tonal scale and slightly subdued detail as an alternative to the glossy albumen prints then common.

On the other hand, a questionnaire sent out to professional gallery operators by one of the photographic journals in the late 1870's revealed how important the quality of a glossy print surface had been to many photographers, at least to professionals. The questionnaire asked what the photographers thought were the most important improvements in photography since the wet-plate negative. The response showed that, in addition to retouching, the most important improvement was the introduction of burnishing techniques to give prints a still higher gloss.[79]

Among those who did not subscribe to the ideal of the glossy print were Thomas Sutton, who inveighed against them continuously in the 1850's,[80] and Edward Wilson, who in *The American Carbon Manual* (1868) called the glossy print definitely "vulgar." But by far the strongest attack against the style of printing represented by glossy papers—and for that matter against the artificiality, indifferent craftsmanship, and often gross sentimentality of pictorial photography as practiced in the last quarter of the 19th century—came from Peter Henry Emerson. Emerson was the one most responsible for the artistic popularity of the new platinum papers. He tied their use to a definite aesthetic ideal.

Emerson and the Physiological Syntax

Peter Henry Emerson was trained as a physician. He took up photography in 1882, and that same year showed a platinum print at the Photographic Society of Great Britain's annual exhibition. In 1886, after piloting a houseboat through the waterways of the Norfolk Broads with T.F. Goodall, a landscape painter, Emerson published *Life and Landscape on the Norfolk Broads*. The book contains forty mounted platinum prints and is perhaps the most beautiful photographic book ever produced using actual prints. In Emerson's later picture books his images were reproduced by photogravure, but in a style that imitated the platinum print.

Emerson began writing *Naturalistic Photography for Students of the Art* in 1888. Published the following year, it was a full-scale exposition of ideas he had already developed in his lectures and in articles in *The Amateur Photographer*. *Naturalistic Photography* was an attack on the prevailing theories of art photography, namely those contained in H.P. Robinson's *Pictorial Effect in Photography* (1869). It favored instead a theory based on science and on the philosophy of the Naturalistic school of painting. It is an unusual book, in places incoherent and frustrating, in others scathing and quite entertaining. For

Emerson, staking out an intellectual position held features in common with going to war. He roundly denounced combination printing, dressed-up models posing as the real thing, and the academic formulas of composition that Robinson had diagramed in *Pictorial Effect in Photography* and William Lake Price had promoted even earlier in his *Manual of Photographic Manipulation* (1858).

The central theme of *Naturalistic Photography* was Emerson's theory of selective "naturalistic" focusing. Where Robinson had built his argument on the accepted principles of artistic refinement and composition, Emerson built his on physiological principles. After reading Hermann von Helmholtz's *Physiological Optics* (1867), Emerson had reasoned that because the human field of vision (as Helmholtz had shown) is distinct only at the point of "fixation" (when the image falls on the relatively small central area of the retina) the completely sharp and uniform photographic image could not accurately represent the way the world appears to the eye. Even when it falls on the center of the retina, the image in the eye is not as sharp as that produced by the corrected photo-

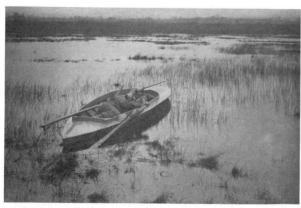

FIG. 74

PETER HENRY EMERSON, *Gunner Working Up to Fowl,* 1885. One of the platinum prints from *Life and Landscape on the Norfolk Broads.*

The exposure was long enough to allow some of the reeds surrounding the boat to blow in the wind, enhancing the "naturalistic" effect.

graphic lens. Emerson therefore encouraged photographers to focus only on the main subject of the photograph, making it *"just as sharp as the eye sees it and no sharper"* [Emerson's italics], and let the rest of the image fall slightly out of focus by not fully stopping down the lens.[81] In this way the photographic image could become more like the physiological image.

To understand why he felt the two should become alike, it helps to run down Emerson's list of *isms.* He did not believe Realism was possible. Because of the inherent defects of the human eye, one could never know, visually, what the world was really like. The best one could manage was an impression of things. It followed that art could only be truthful to the extent that it represented the *true nature of impressions.* According to Emerson, only Naturalism and Impressionism had truth as their goal. Both were concerned with representing the world *as seen,* rather than restructuring it falsely according to the canons of Neoclassical or Romantic art. Emerson preferred the term *Naturalism* because he thought it more clearly set nature, and not the subjective individual, as the standard. He also believed that physiological factors common to everyone played the major role in forming visual perceptions, and that this made purely subjective arguments invalid. Thus, everyone saw things in the same "naturalistic" way, whether they were willing to admit it or not, and general rules could be laid down. Emerson argued that the rule in art was to accept the natural characteristic of human vision and to reproduce them, defects and all. This, in Emerson's scheme of things, was what the great artists throughout history had always tried to do.

The idea that a sharp photograph was not consistent with the way the world actually appears had been proposed before. When Hugh Miller wrote about Hill and Adamson, he described how their photographic lens (an uncorrected one) was sharp at the center of the field but dim and indistinct around the circumference. This brought to mind Dr. Thomas Brown's theory of attention, a theory stating that we see clearly only what we concentrate on, the remainder of the visual field being only vaguely perceived. Miller thought that

a photographic image from an uncorrected lens was thus much like an image given by the eye. This is not exactly what Emerson was talking about, but it is not unrelated.

In 1853 Sir William Newton had suggested, while addressing the Photographic Society of London, that in a photograph used for artistic rather than scientifice purposes—that is, for providing painters with studies—"the whole subject" should be "a litte *out of focus,* thereby giving a greater bredth of effect, and consequently more *suggestive* of the true character of nature [Newton's italics]."[82] This is different from Emerson's naturalilstic focusing in that Emerson wanted the principal subject clear, though not precisely sharp, and the rest thrown slightly out of focus, while Newton seems to have been advocating that the entyire picture be out of focus. But they share the desire to bring the photographic image closer to what was considered the appearance of nature.

The defenders of the calotype had used a similar argument, although it had nothing specifically to do with modifying focus. In the introduction to the second part of *Plain Directions for Obtaining Photographic Pictures* (1853), J.H. Croucher had told how "Artists . . . very much prefer the proofs from negatives taken on paper, which present images of objects, with an exquisite blending of light and shade, and a softer outline, more in accordance with the appearances of nature." In her *London Quarterly Review* article, quoted earlier, Lady Eastlake had supported Newton's proposal and given her own reason for preferring the early calotype to the products of collodion and albumen:

> If the photograph in its early and imperfect state was more consonant to our feelings for art, it is because, as far as it went, it was more true to our experience of nature. Mere broad light and shade, with the correctness of general forms and the absence of all convention, which are the beautiful conditions of photography, will, when nothing further is attempted, give artistic pleasure of a very high kind; it is only when greater precision and details are superadded that the eye misses the further truths which should accompany the further finish.

In the same essay Lady Eastlake also complained that photography distorted its subjects by giving false tonal values. Apparently she saw no contradiction between that complaint and the assertion, quoted above, that what photography *could* show it showed too much of, at least for artistic purposes.

It is clear that Emerson was suggesting nothing really new in turning from the uniformly detailed photograph in to order to approach more closely the way the world appears to the eye. The general idea had been a concern in the 1850's and, as one can gather from passing references, remained a subject for discussion, although it always faced strong opposition. Emerson's contribution was to give it a more systematic basis and a more vociferous defense.

For his part, Robinson found the theory of naturalistic focusing absurd and thought Emerson's book "considerably out of focus, and wanting in definition and composition." Back in the 1860's Robinson had joined several other photographers in asking for "lenses giving a softer image and more diffusion of focus," but this had been far short of what Emerson was calling for in 1888. Robinson protested, "healthy human eyes never saw any part of a scene out of focus."[83] Robinson felt that all one need do to demolish

FIG. 75

PETER HENRY EMERSON, platinum print, *Pond in Winter,* 1888.

(International Museum of Photography/George Eastman House)

Emerson's theory was point out that the eyes constantly move and constantly change their focus:

> The fallacy consists in the fact that the eye is *not* a fixed instrument; and if the picture is to represent more than a very momentary first impression indeed, as pictures always do if the eye be given time to see, a great deal more will be seen than the center of vision. This keystone removed, away goes the whole structure. On the other side [Robinson's side], it is held that art must represent what the eye does or could see, and recognizes that it changes its focus so as to adapt itself to every plane so instantaneously that we practically see the whole of a scene in focus at the same time.[84]

Of course, Emerson had anticipated this:

> It will be said, but in nature the eye wanders up and down the landscape, and so gathers up the impressions, and all the landscape in turn appears sharp. But a picture is not "all the landscape," it should be seen at a certain distance—the focal length of the lens used, as a rule, and the observer, to look at it thoughtfully, *if it be a picture*, will settle on a principal object, and dwell upon it, and when he tires of this, he will want to gather up *suggestions* of the rest of the picture [Emerson's italics].[85]

This is a crucial point in Emerson's argument. In effect, he was relying on a long-standing principle of composition—one that Robinson endorsed—that a picture should have a principal subject as the center of attention, the rest of the picture playing a supporting role. Emerson in this way acknowledged that a picture represented a special case in visual experience: While it should imitate the natural impression, the impression should be hierarchical and fixed and not something that caused the eye to wander with the randomness of everyday vision. The difficulty is that Emerson used his physiological model only to a point—then, when it suited him, dropped it cold for more traditional ideas. But if one carries through with the physiology, Robinson's criticism appears inescapable. The eyes do move, and so in physiological terms a naturalistic photograph can indeed only represent a "momentary first impression."

Naturalistic focusing was only half of Emerson's thesis. The other half concerned tonality. On this subject Emerson also referred to Helmholtz, who had written that it was impossible for an artist to "imitate exactly the impression which the object produces on our eye" because it was impossible to reproduce in a work of art "brightness and darkness equal to that which nature offers." The difference between the darkest black in nature and the brightest light was many times greater than that between the artist's darkest lampblack and brightest white lead. Emerson pointed out that the photographic tonal scale was even more limited. This meant that a photograph could never have "the values correct throughout a picture." The best that could be done was the uniform translation of the brightness range of the original scene into a reduced scale of print values. But in Emerson's way of thinking this did not mean that the photographer should produce prints showing the full scale of which his paper was capable, from it deepest black to paper white. Instead, the tonal scale in the print should be reduced even more! His reasoning was that the deepest black of the paper did not represent the actual appearance of shadows in nature:

> . . . shadows [in nature] are filled with reflected light. It will be seen, therefore, that it is of paramount importance that the shadows [in the print] shall not be too black, that in them shall be light as there always is in nature—more of course in bright pictures, less in low-toned pictures—that therefore the rule of "detail in the shadows" is in a way a good rough-and-ready photographic rule. Yet photographers often stop down their lens and cut off the light, at the same time sharpening the shadows and darkening them [by underexposure], and throwing the picture out of tone. It cannot be too strongly insisted upon that "strength" in a photograph is not to be judged by its so-called "pluck" or "sparkle," but by its subtlety of tone, its truthful relative values in shadow and middle shadow, and its true colouring.[86]

Having reviewed the theory behind them, we can understand why Emerson's prints look the way they do and why he preferred the platinum process. His formula for exposure and printing was to get the shadow values in their "proper" relation and simply let the highlights take care of themselves. This meant printing the shadows light, and it also must have meant being careful not to

overdevelop the negative. Emerson's prints thus tend to be flat, the shadows showing comparatively little separation of tones. The matte surface of platinum paper automatically compresses shadow tones (unlike a glossy surface, which extends them), but the paper can give considerably more contrast and separation than Emerson advocated. He exaggerated the compression in order to produce what he took to be the equivalent of the way relative values of brightness are registered in the eye. His prints are demonstrations of Helmholtzian psycho-physiology; they are visual models of the perceptual process. If they fail as persuasive models, at least they frequently succeed as persuasively gracious works of art.

FIG. 76 PETER HENRY EMERSON, Photogravure from *Wild Life on a Tidal Water,* 1890.

Pictorialism

The Photographic Society of Great Britain's Pall Mall Exhibition in the autumn of 1890 was a watershed event in the history of photographic printmaking. Emerson described it:

> On entering the exhibition the first impression is one of joyful surprise. Purple and black gloss have given way to black and white and brown, in short the general appearance of the exhibition is more like an exhibition of etchings or engravings than any photographic exhibition we have ever seen.[87]

For the first time there were "naturalistic" photographs by a number of photographers on the Society's walls. The number of albumen prints had dropped considerably from years past, replaced by matte bromide and platinum prints. There were some carbon prints described as "showing drypoint finishing," and also prints on rough-surfaced paper, a style introduced by Colonel Noverre the year before.[88]

Expressive printmaking, matte surfaces, and the optically softened image had become the center of attention and were the chief syntactical characteristics of what came to be known as the *Pictorialist* movement.[89] One of the proponents of this syntax—and there were, and remained, many opponents—was George Davison.

Davison had been an ardent supporter of Emerson but had shifted to a more general theory of Naturalism than Emerson was able to tolerate. He agreed that artistic photographs should not be uniformly sharp, yet held that the focus could be naturalistic *or* generally diffuse, depending on what seemed most appropriate for the subject at hand. This made Emerson howl, as did the rumor that Davison had in fact originated some of the ideas in *Naturalistic Photography.* The rumor apparently started as a result of a lecture Davison delivered at the Society of Arts in December of 1890 in which he discussed naturalistic photography without mentioning Emerson. In this lecture Davison repeated Emerson's dictum that the shadows in a landscape photograph should be printed light, not dark as in the ordinary style; but then he committed what was to Emerson the heresy of endorsing rough-surfaced papers. Emerson thought such rough surfaces belonged only in "Colonel Noverre's dustheap." The following is from Davison's Society of Arts lecture.[90] It is quoted less for the discussion of rough-surfaced papers, however, than for its general ideas concerning printmaking syntax.

> A not unimportant consideration, bearing in some measure both upon the matter of values and definition, is the printing medium employed. I find, in the newest extra rough-surfaced papers, very excellent and distinctive qualities, in respect, particularly, of breadth and luminousness. Some extraordinary objections have been taken to the results of these papers as not being photography because they bear resemblance to wash-drawings; and one gentleman finds in this, and [in] the character of diffraction photographs, an opening of the door to any and every kind of brush-work upon the print. But the answer is, first, that there is no aim to get wash-drawing appearance; and secondly, all the process is pure photography. Both the photographer and the painter have the same aim, and it is not surprising if printing upon the same papers produce similar results, for photographic deposit more resembles painted surfaces than any other method. Both work in tones, or shades of monochrome, and both may be worked upon any medium which promises to give more truly and more effectively our impressions of nature. It is certainly very refreshing in its

audacity to be told that, because photographers have consented to smirch the fair name of their art by the general use of albumenised paper and small stops, therefore this is to be its character for ever. In some respects the use of these rough papers, which are only now likely to become general for artistic work, constitute [sic] one of the greatest advances yet made. It need hardly be said that rough paper will not make a bad picture good or great, but it will do this: It will make all the difference to the majority of educated spectators between interested observation and contempt. It is difficult to overestimate the importance of the printing medium, as far as the credit of artistic photography with the critical public is concerned. There is almost as great a superiority for most subjects in the new [rough-surfaced] platinotype paper over the ordinary platinum surfaces, as there is between these latter and silver printing. This quality of the printing has more effect upon the casual tasteful observer than any other quality of the production. The defective printing medium [albumen] has obscured the qualities of photography. The effect of prints upon such papers as I allude to at once shakes the superstition of honest critics, who have hated photography for its hardness, vulgarity, and untruth.[91]

FIG. 77

GEORGE DAVISON, *The Onion Field,* 1889, from a reproduction.

Davison's first exhibited pinhole photograph. It quickly gained fame as an early example of photographic Impressionism. Davison also had a practical side: He became wealthy as one of the founding directors of Kodak Ltd. in England.
(Gernsheim Collection, Humanities Research Center, University of Texas at Austin)

Soft Focus

The diffraction photographs Davison refers to were what is more commonly known as *pinhole* photographs. Davison was experimenting with the technique at this time. It involved punching a tiny hole in a thin metal sheet and using this in place of a lens. Pinhole photographs have complete depth of field, but the image is never entirely sharp; it becomes even blurrier by making the pinhole either too big or too small. Another way to soften the image, more popular than the pinhole because less exposure was required, was the use of an uncorrected lens. By 1890 some photographers were beginning to use lenses of earlier design that had either spherical or chromatic aberration, or both—there were plenty of those lenses around.

In 1896 a special soft-focus lens was introduced: the Dallmeyer-Bergheim. It was of telephoto design and consisted of two simple elements, the distance between which could be varied by the photographer to change the combined focal length. It was thus something like a modern zoom lens. Most soft-focus lenses depended on spherical aberration, and the degree of diffusion could be reduced simply by stopping down the aperture.

Impressionism

Neither Emerson's ideas nor Davison's modification of them would have found as receptive an audience as they did if it had not been for the favorable climate already created by the Impressionist movement in painting. The Impressionists took their canvases outdoors and painted directly from nature, instead of from studies carted back to the studio. As a result, the open, spontaneous technique the Academically trained painter ordinarily used only in his sketchbook was applied by the Impressionists to the painting itself.

The Impressionists examined the properties of light, but they concentrated on the *sensation* light produces in the viewer rather than on the way it defines contour. To do this, they put color ahead

of half-tone modeling. They recorded both the intimate and the public moments in the lives of the peasants and the bourgeoisie, but without degenerating into sentimentality or insisting on storytelling. The Impressionists discovered new ways to compose their pictures by using the four borders of the frame as a kind of viewfinder, even boldly cutting into figures along the edge of the field of view—an effect often seen in early instantaneous photographs from the 1850's and 1860's and in snapshots from later dates. Degas's adaptation of this is the example everyone cites.

The extent to which such syntactically derived characteristics as the cutting off of figures, blurred motion, and halation may have influenced the rise of Impressionism in the first place has been discussed by various authors.[92] Whatever their debt to photographers, the Impressionists paid it back by giving in return an artistic model that in its superficial features was much easier for photographers to emulate than the Academic one. By simply modifying his technique, any photographer with a reasonably good eye could call himself an Impressionist, and could through this try to gain the "artistic" standing that had until then been denied.

One of the most important—yet less-commented-on—links between Impressionism in painting and Pictorialism in photography has to do with the representation of surfaces. In most Impressionist paintings, surfaces are not bound by hard edges, nor are they represented by their actual texture. As Rudolf Arnheim has written, "In Impressionist paintings the world appears as inherently bright and luminous . . . Things have no specific substance, because the only texture given is essentially that of the whole picture, the pattern of strokes on the canvas."[93] The only tactility is the physical tactility of the picture itself. The same effect can be seen in varying degrees in the work of Emerson and the majority of the Pictorialists who came after him. In their photographs broad tonality has precedence over texture, so that the surface one experiences is not that of the objects represented, but rather, as the paragraph from Davison's lecture suggests, of the *print*. If the textures of objects are all the same everything

appears homogeneous: There is no counterpoint to supply a feeling of substance. The only substance left is that inherent in the printing medium. This is about as far from the daguerrean syntax of precisely delineated surfaces as one can get.

The tendency in artistic printmaking to soften detail and compress the tonal scale outlived Impressionism by a remarkably long stretch. It lasted roughly four decades and even characterized in one way or another the work of such "straight" photographers as Alfred Stieglitz and Paul Strand. The man who finally succeeded in overturning it was Edward Weston. More about this later.

Gum Printing Returns

Back in the 1850's, the main criticism of the gum process had been that it could not rival the clarity of tonal scale and image definition of the albumen print, then the dominant syntactical standard. By the 1890's this standard had broken down and photographers had finally become receptive to gum. They were reminded of the gum process through a printing paper introduced by Victor Artigue at the Paris International Exhibition in 1889. It was an improvement on a technique originally worked out by his father for copying architectural plans.

Artigue the younger coated his paper with a very thin layer of pigment-bearing colloid (the exact nature of which was kept secret), sensitized it with dichromate, and, after printing, developed it without transfer by pouring a mixture of fine sawdust and water over the image—in effect, developing it by abrasion. When put on the market in 1893, the Artigue papers, or *Charbon Velours*, helped focus interest on the older, non-transfer pigment methods.[94]

A French amateur named A. Rouillé-Ladevèze exhibited gum prints at the Photo Club of Paris in 1894. Alfred Maskell, an English amateur and one of the founding members of the famous photographic society called The Linked Ring, saw the prints by Rouillé-Ladevèze in Paris and arranged to show them later that year in the London Photographic Salon. Also in the London exhibi-

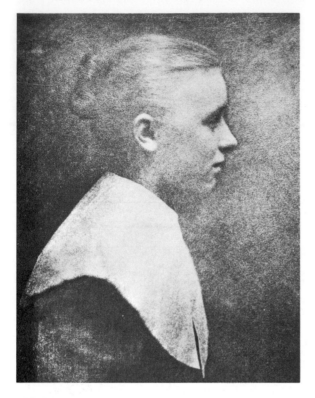

FIG. 78
ALFRED MASKELL, *Young Dutchwoman,* gum print shown at the Photo Club of Paris 1896 exhibition and reproduced in the gravure album for that year. *See Plates 14/15 and 27/28 for examples of change in printmaking style after the rediscovery of gum.*

tion were gum prints by Maskell and by Robert Demachy. Maskell and Demachy together published instructions for gum printing in *The Photo-Aquatint, or the Gum Bichromate Process* in 1897.[95]

The Gum-Print Look. To recapitulate our earlier description: Gum prints are made by coating paper with a solution of gum arabic, a dichromate salt, and pigment. When the paper is exposed to light in contact with a negative, the parts of the coating that the light reaches become insoluble. The image is developed by washing the unexposed, still-soluble gum away with water, leaving the insoluble gum and the pigment behind.

One of the important features of the process is that development can be interfered with: It can be speeded up—and density removed—by working the print over with a brush or by directing a stream of water against its surface. One often sees on a gum print signs of the brush strokes used to help develop the image.

Von Hübl, in 1898, introduced the practice of resensitizing the image and then reprinting it in registration under the same negative and developing it again. A gum print made with only one coating tends to lack contrast, but multiple-printing in this way increases the depth of the shadows and fills out the tonal scale. Gum printers sometimes recoated and reprinted half-a-dozen or more times, often using different colors. If the print was left untrimmed, brush strokes from the successive application of the sensitive coating can often be seen along the edges. In multiple-gum prints the shadows have a gloss and often also a physical relief that can easily be seen by looking at the print at an angle across its surface. Because of the unequal expansion and contraction of the paper each time it is wetted and dried, multiple prints in larger sizes are difficult to register exactly; the result is usually a blurred image, and double lines from the successive printings can often be seen. For this reason, the highlights of multiple-gum prints usually lack sharpness. Often the highlights are slightly stained with pigment because of the paper's sizing having been worn away by repeated applications of the sensitive coating and repeated development (see the technical chapter on gum printing).

Because of the problem of registration, the trade-off in gum printing is between density and sharpness. The denser the shadows, the less sharp the overall image is likely to be. If the image is sharp and dense at the same time, or dense but lacking the usual relief, either the photographer was a superb technician or the example is actually a multiple print in which the gum printing was done on top of a photographic image printed by other means, usually platinum. Alvin Langdon Coburn and Edward Steichen were famous for their gum-platinum prints, though not for any addiction to sharpness.

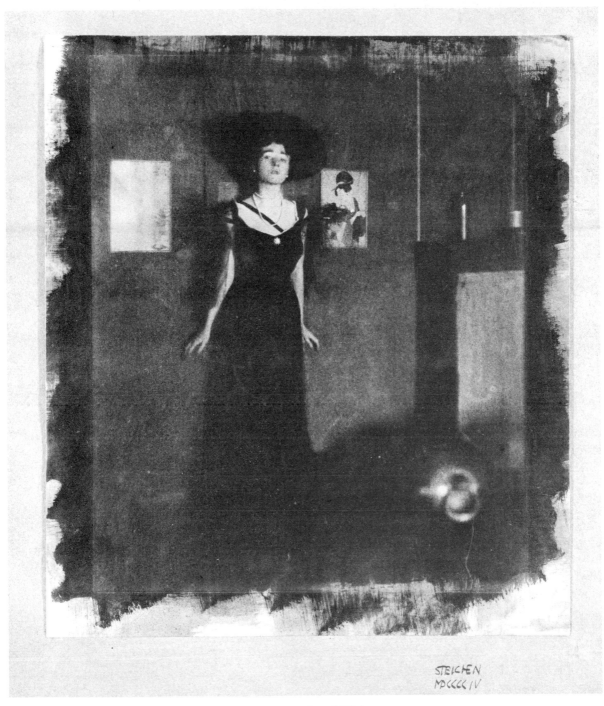

FIG. 79 EDWARD STEICHEN, untrimmed gum print, 1904.

An important study piece showing the characteristics of a multiple print.
(The Metropolitan Museum of Art, Gift of Alfred Stieglitz, 1933)

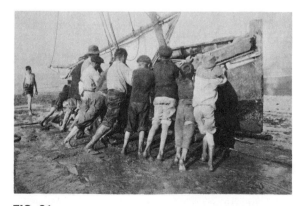

FIG. 80
Steichen's annotation, written on the mount of Fig. 79.

The photographers of the 1890's who took up gum discovered, in what had originally been intended solely as a method for making permanent prints, the potential for a new manipulative print-making syntax. As will be more fully described in the technical section, the gum process allowed selective local control over tonality and detail and permitted painterly effects of texture and color (multiple-printing using different pigments) impossible with earlier printing techniques.

A Gum Printer: Robert Demachy

Robert Demachy was the acknowledged master among the gum printers and the most respected and influential amateur photographer in France. A Parisian of independent means, he had come to photography from painting and drawing. Although his gum prints were a radical departure from anything photography had seen before, his ideas were not. He wrote that a photograph had to be a "transcription, not a copy, of nature" if it were to qualify as a work of art. Francis Wey and Ernest Lacan had said virtually the same thing in the pages of *La Lumière* some fifty years earlier.

Demachy believed that a photographer might show evidence of an artistic ability through his choice of subject and selection of a point of view, but if he made a straight print from his negative it could never be considered a work of art. What was needed was the intervening hand. According to Demachy: "The beauty of the motive [subject] in nature has nothing to do with the quality that makes a work of art. This special quality is given by the artist's way of expressing himself." Demachy was responding to the long-standing argument that photographs could not be art because the camera was merely a machine, incapable of providing the means for self-expression. He felt that the answer to this perennial criticism of photography could only be found in the use of manipulative techniques like gum or the oil process (described next). He saw the importance of pointing out that the techniques did not in themselves automatically guarantee artistic results; but at least they made it possible for photographers to overcome certain of the mechanical limitations of photography and, like painters, achieve self-expression through direct manipulation of the image. He put it this way: "Meddling with a gum print may or may not add the vital spark, though without meddling there will surely be no spark whatever."[96]

In Demachy's gum prints the destruction of object texture goes much further than in Emerson's platinums. In fact, the texture of the

FIG. 81
ROBERT DEMACHY, *L'Effort,* contact print on chloride paper, no date.
(The Metropolitan Museum of Art, The Alfred Stieglitz Collection)

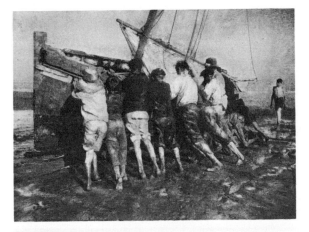

FIG. 82

ROBERT DEMACHY, *L'Effort,* gum print made from an enlarged copy negative, figures reversed, first exhibited in 1904.

Plates 15 and 16 are gravure reproductions of Demachy gum prints.

(The Metropolitan Museum of Art, The Alfred Stieglitz Collection)

printing *medium* takes over almost completely. Demachy's writing on the subject does not suggest that he was particularly concerned with the elimination of photographically precise detail as an issue in itself, though the gum process does tend to this elimination anyway. Demachy was more interested in the painterly and gestural qualities the process made possible. His prints often make a considerable show of brush strokes, and the tonal scale, instead of having the continuous, low-contrast progression of an Emerson platinum, often jumps in patches from light to dark. His prints show no desire to imitate the appearance of nature. The desire to imitate the appearance of painting is unconcealed.

Other Opinions. Not everyone agreed with Demachy. Emerson blasted the new interest in gum printing—even though his theory of naturalistic focusing, by challenging the dominant syntax, had been largely responsible for setting the stage for the gum printers in the first place. In *Naturalistic Photography* Emerson had championed photography as art. But in 1890, only a year

after the book was published, he reversed his position and announced that if photography were an art, it was at best only a very lowly and limited one.

The reasons Emerson gave for this change of heart were not particularly clear, and they were only partly set down in his famous pamphlet, *The Death of Naturalistic Photography* (1890). In it he argued that the control the photographic process allowed was too limited to let the individuality of the photographer do more than "scarcely show itself." Yet he rejected the kind of controls that Demachy insisted elevated photography to real art status. In the 1899 (the third) edition of *Naturalistic Photography*, Emerson wrote

Recently some French and English amateurs have revived the old "gum-bichromate" printing method, announcing it by the stupid and specious name "photo-aquatint," which should be applied to photo-etching [gravure] if to anything photographic. The chief claim of these amateurs has been that the process allows of the exercise of "individuality." Of course this is mere verbal juggling—for what is photography is mechanical. We have examined what are given out to be the best examples of this work and find them all most false in tone and bad in texture, in no way whatever comparable to a naturalistic platinotype, say. Every good quality of photography is lost in them except the mere outline of things . . . The process merely uses photography as a basis for after "hand-work" of a most fumbling or bungling description.

Oil and Bromoil

The years between roughly 1895 and 1910 mark the era in which Pictorial photography, in its most painterly and manipulative forms, enjoyed its greatest success. The gum process caused a sensation in the mid-1890's by releasing photographers from what many felt were the severe artistic limitations of the "straight" print. The manipulative photographers, chiefly gum printers, fell in line with Demachy in asserting that straight photographs were not "art" because straight photography did not permit the control necessary for personal expression. While almost everyone agreed that personal expression was fundamental to an

artistic photograph, many, like Emerson, felt that the manipulative photographers simply went too far. The straight photographers nicknamed the gum printers "gum splodgers" and referred to their often moody, dark, and low-toned style as the "mud-flat school." The battle between the straight and the manipulative photographers raged in the camera clubs and in the pages of the photography journals.

The manipulative photographers deserve much of the credit for gaining popular acceptance of photography as a legitimate art: By imitating painting they were able to bring photography into line with the popular notions of what an art object should be. Yet in all too much of their work their use of Impressionism and Tonalism and the pictorial structures of Whistler and of Japanese printmakers has a definitely secondhand look. Whatever genuine challenges to photography these borrowings may have offered were soon outlived, while the dangers inherent in the confusion of photography with painting lingered on. In 1905, the critic and photographer Clive Holland, writing more clearly and calmly than the often volatile Emerson, put the case against the manipulative workers:

> The most recent developments of the pictorial school of photography, whether it be those of Great Britain, France, or America, will be seen to be an adaptation or modification of the methods which created so much comment and gave rise to so much often adverse and bitter criticism on their introduction some five or six years back. Many of the most prominent and successful workers in Great Britain have recognized that at the outset the extreme pictorialists, who were many of them willing to sacrifice everything to effect and for the attainment of a resemblance to painting, were, in fact, checking the truest and sanest development of their art. That, indeed, greater success and greater honor would be achieved by a less close following of the art of painting as practiced at the present time. The limitations of photography as regards the rendering of color, and the fact that the elimination of the superfluous is not easy of accomplishment, prevent it, at all events at present, being considered on the same plane as painting, or gaining its chief success in a similar way or by identical methods. In the case of both landscape and portraiture it has been found over and over again that to succumb to the ruse of

> excessive diffusion of focus and flat low tones in the hope that the resultant photograph may be considered to have been evolved by the same methods as a modern painting by a member of the "impressionist" school is but to court ridicule by artists and invite the stigma of failure at the hands of the less educated. As in monochrome drawing, tone values and a good range of them constitutes with symmetrical form the chief charm and elements of success, so in a photograph for it to be well and suitably printed and the original negative perfectly exposed with a long range of tones will prove the best factors in obtaining a success.[97]

In 1904, the year before this was written, the oil process was introduced. The oil process and its modifications gave manipulative photographers their ultimate weapon.

Oil. G.E.H. Rawlins, inventor of the oil process, had originally used platinum papers but had switched to gum after becoming dissatisfied with the small amount of control possible in platinum printing.[98] Then he came to feel that even gum was too limited, and he began to search for a printing technique more suited to the needs of the manipulative Pictorial photographer.

Rawlins turned to the then-popular collotype process as the starting point for his experiments. The technique he evolved was a simplified form of collotype. It was identical in principle to certain earlier processes he was evidently unaware of— Asser's process patented in 1860, Mariot's *oleography* of 1866, and a process developed by Captain Sir William Abney in 1873 and called *papyrography*—which in turn were derived from Alphonse Poitevin's original patent of 1855. (See the chapter on collotype in Part II for historical details.)

FIG. 83
Inking brush for oil printing.

Rawlins announced his process in a long article in the British publication *The Amateur Photographer* for October 18, 1904. The technique was based on the natural repulsion between water and greasy or oily substances, in this case between water-swollen gelatin and printing ink.

Rawlins used potassium dichromate to sensitize paper already coated with gelatin. After it dried, he contact-printed the paper and then soaked it in water. The exposure hardened the gelatin (made it insoluble) in proportion to the amount of light passed through the negative. Afterward, in the water, the unexposed gelatin began to *swell*. The result was a gelatin *matrix* in slight relief. The matrix was taken out of the water and carefully wiped surface-dry. It now consisted of dry, hardened gelatin in the shadows and completely water-swollen gelatin in the highlights, with intermediate swelling in the tones in between. Rawlins next inked the matrix with a stiff printer's ink. Originally he used rollers to apply the ink, but then he adopted a modified form of stencil brush, and this became the special feature of the process. Charging the tips of the brush's hairs with ink, he dabbed it over the print. The ink took freely to the dry shadows, but was repelled by the water-swollen highlights and accepted more or less proportionately by the tones in between. Rawlins discovered that by different actions of the brush he could deposit ink on the surface of the print and then, if he wanted, lift it off again, and that when he thinned the ink slightly he could make details appear in the highlights in places where the stiffer ink had originally been repelled.

The new oil process promised a field day for the manipulative school of photographers. By controlling brushing action and ink consistency, it was possible to vary the tones of the original image almost at will. The process was perfect for creating the kind of atmospheric effects of light and shadow the manipulative photographers admired. The photographer could add or subtract detail and change the effect of the entire image. In the rather picturesque words of F.C. Tilney, some seven weeks after Rawlins's original article, "It is this vista of potency that has excited the hopes and curiosity of the majority of pictorial photographers; who are eager at all times to break down the barriers separating the mechanical and immutable from the artistic and volitional."[99]

As the oil process began to catch on, many of the leading gum printers switched to the new technique. Certainly the most prominent was Robert Demachy himself. Demachy took up oil printing in 1906. He believed that oil printing—even more than gum—demanded special skills and enough artistic training to counteract the tendency of many Pictorialists to "meddle with their prints in the fond belief that any alteration, however bungling, is the touchstone of art."

Demachy arranged a series of lectures on oil printing for the benefit of the Photo Club of Paris. As he reported in *Photograms of the Year 1909*, he acquired the services of a painter and etcher, a Monsieur Homere. Once a week, Homere gave his criticism of the oil prints produced by the class, demonstrated with charcoal and paper the principles of modeling, and lectured on what

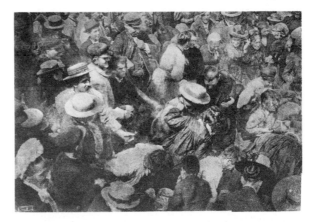

FIG. 84

ROBERT DEMACHY, *The Crowd,* oil print, 1910.

Gum printing is basically a subtractive process —the printer removes density. In oil printing density can be added or removed. In The Crowd *Demachy added density to areas that otherwise would have printed as highlights, while artificially creating highlights in the center.*

(The Metropolitan Museum of Art, The Alfred Stieglitz Collection, 1949)

Demachy termed the "primordial rules, adopted by instinct perhaps, but always noticeable in all the masterpieces of the painter's art."[100] Demachy, despite his stature in the photographic world, was content to take on the role of mere technical advisor, showing the correct brush techniques and pointing out the proper choice of inks. Calling in a painter to lecture photographers on the principles of art was a frequent occurrence at the camera clubs, both in Europe and in the United States. It is an example of how eager photographers were to bring their work into line with standards and traditions evolved for media quite different from the photographer's own.

Bromoil. In 1907, C. Welborne Piper made an important contribution to the oil process. Acting on a suggestion made by E.J. Wall, Piper discovered a technique for bleaching a standard

FIG. 86
Bromoil print of the same subject. Both figures reproduced from halftones in *The Photo-Miniature,* March 1910.

FIG. 85
F.C. TILNEY, *In Old Nuremberg,* direct bromide print.

bromide print and at the same time hardening its gelatin surface. The hardening occurred in direct proportion to the density of the original silver image. The bromide print thus became a gelatin matrix, ready for inking. Almost any brand of bromide enlarging paper then in production was suitable for the process. The new bromoil process made it possible for photographers to enjoy the convenience of using hand cameras and small negatives: They could now produce prints by direct enlargement without first having to make enlarged duplicate negatives.

Transfer. The last development in the oil process was the transfer technique introduced by Robert Demachy in 1911. It consisted of placing a freshly inked oil or bromoil print in face-to-face

contact with a sheet of plain paper and then passing the combination through a press, so that the ink transferred to the second sheet. The transfer process allowed the use of a variety of textures and colors for the final paper support and eliminated the sheen characteristic of prints made on gelatin paper. The original matrix could be re-inked and the image transferred again, aligned with the first transfer, onto the final support to build up density or add a new color.

Oil and bromoil prints and transfers can often be identified by their manipulated look and especially by the physical texture of the ink itself. Usually the image is grainy and the highlight detail lacks smoothness and resolution. The graininess comes from the way the ink was dabbed on with just the tips of the brush's hairs.

FIG. 87
From *The Photo-Miniature,* March 1910.

Stieglitz and the Photo-Secession

Alfred Stieglitz is such a fixed monument in the history of photography that discussing him only in terms of the development of printmaking syntax is a bit like honking your horn at Mt. Everest and then expecting it to move. The same goes—although in ranks of descending importance—for the other members of the Photo-Secession and—ascending again—for later photographers of the likes of Strand and Weston. Their lives were sometimes complicated and uneasy, and the motivations behind their photographs were complicated, too. Yet as printmakers they all participated, at one stage or another, in a movement that attempted to redefine the nature of the photographic print along more painterly lines. Ultimately the attempt failed, and most of those who participated came to reject what they had done. The failure of the Pictorialist experiment and the rejection by photographers of its syntactical tools in favor of those of "straight" photography were the events most responsible for forming the attitudes toward photography we hold today.

Stieglitz has to be examined both as an individual artist and as the driving force behind the Photo-Secession. The photographers Stieglitz brought together under that banner were the leading lights of the Pictorialist movement in America. They became identified as a group as a result of an exhibition arranged by Stieglitz at the National Arts Club in New York in 1902. Charles de Kay, founder and director of the National Arts Club, who was also an art editor of *The New York Times*, asked Stieglitz to prepare a show. When De Kay and Stieglitz tried to decide on a title, Stieglitz came up with *An Exhibition of American Photography Arranged by the Photo-Secession*. De Kay asked Stieglitz what the name *Photo-Secession* meant and who its members were. Stieglitz, who said he had only just then dreamed it up, answered:

> Yours truly, for the present, and there'll be others when the show opens. The idea of Secession is hateful to the American—they'll be thinking of the Civil War. I'm not. *Photo-Secession* actually means a seceding from the accepted idea of what constitutes a photograph; besides which, in Europe, in Germany and in Austria, there've been splits in the art circles and the moderns call themselves Secessionists, so *Photo-Secession* really hitches up with the art world. There is a sense of humor in the word Photo-Secession.[101]

Stieglitz's allusion to the European Secessionists hints at the kind of relationship he hoped to establish between photography and contemporary art. He wanted to put photography on an equal footing. He believed that standards of criticism used in evaluating painting and serious prints had to be applied to photography with equal vigor, independently, by photographers themselves.

Stieglitz was calling for a level of quality that most photographers had not felt obliged to attain, and for a self-reliance in critical matters that most photographers had never dared. His position was certainly a secession from the status quo, and it went against the grain of many of those camera club members who had allowed their salons to be juried by benign but condescending painters and whose activities were more social and recreational in character than seriously artistic. This was true of many of the members of Stieglitz's own club, The Camera Club of New York, and it contributed to Stieglitz's decision to resign as vice-president of the Club in 1900, and, two years later, withdraw as the editor of the club's publication, *Camera*

Notes. In fact, so great was the hostility certain members of the club felt toward Stieglitz that they managed to have him expelled from membership in 1908. Three dozen pro-Stieglitz members then resigned in protest. Eventually Stieglitz was reinstated. He accepted the news by resigning on his own.

The Photo-Secession did not "hitch up" with the work of Cézanne, Picasso, or Matisse, who were unknown in the United States at the time, but with far less revolutionary models. The Munich Secession, to which Stieglitz had alluded in his conversation with De Kay, had been founded by Franz von Stuck. Edward Steichen recalled visiting Stieglitz's home about this time and seeing on the walls two large reproductions of Von Stuck's work. One, entitled *Sin*, was of a standing nude surrounded by a coiled snake with a nasty look in its eye; the other was the nude torso of a woman terminating in the body of a sphinx. Stieglitz also had hanging a reproduction of the widely popular *Island of the Dead*, by the Swiss painter Arnold Boecklin.[102] The mixture of brooding sensuality and Symbolist contrivance in paintings of this sort is echoed in many of the Photo-Secession prints. Stieglitz's photographs, however, along with many of those of Henry C. Rubincam, Paul B. Haviland, and, on occasion, other Photo-Secessionists, can be connected more closely with the paintings of the group of American realists called the Eight. Stieglitz's prints, in particular, often resemble in subject matter and treatment the paintings of George Luks and John Sloan. But, in turn, these were men whose stylistic contact with European art was with developments that had taken place some forty or so years earlier.

Most of the seceding that the Photo-Secessionists were to accomplish was in fact already completed by the time of the National Arts Club exhibition. What made the Photo-Secession important was not that it initiated an American movement, but that it consolidated one already going on. It brought together individuals who had been working independently, yet toward roughly the same goals. Their collective strength and the conviction and encouragement of Stieglitz allowed them to pursue their goals with an intensity and self-assurance that would otherwise have been hard to sustain.

Secessionist Printmakers

The photographers who participated in the Photo-Secession by appearing in the shows at the Photo-Secession Galleries in New York at 291 Fifth Avenue, or in the pages of *Camera Work*, the magazine Stieglitz began in 1903, were exceptionally inventive printmakers. As Peter Bunnell, the photo-historian, has put it, they had a tendency to equate "variety in prints with greater individualism of statement," and this led to an enormous amount of experimentation.[103] Joseph Keiley experimented with platinum prints developed by the glycerin technique, which allowed

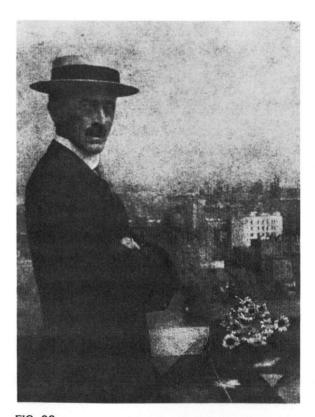

FIG. 88

GERTRUDE KÄSEBIER, *Man in Straw Hat*, gum print in black.

(All Käsebier prints courtesy Wellesley College Museum)

area-by-area control over the tone and color of the image (Plate 39).[104] Gertrude Käsebier made gum prints and platinum prints, sometimes experimenting by printing the same negative in a variety of ways. Frank Eugene scratched lines in the emulsion of his negatives, giving his prints something of the appearance of engravings, but doing it in such a broad and unlikely manner that the result resembles less a polite nod to the earlier medium than a parody of it. His imposition of alien elements over and around the photographic image suggests the mixed-media work done decades later by the American painter Robert Rauschenberg.

Heinrich Kühn, Hugo Henneberg, and Hans Watzek, who collectively were known as the *Viennese Trifolium*, and the brothers Theodor and Oskar Hofmeister, from Hamburg, Germany,

FIG. 89
GERTRUDE KÄSEBIER, *A Chateau,* gum print in brown.

FIG. 90
GERTRUDE KASEBIER, *Girl in Berét,* glossy silver print, background lightened with white pigment.

FIG. 91
Gum print in black, possibly printed from a copy negative of Fig. 90.

FIG. 92
Sepia platinum print from original negative.

worked mostly in gum and mostly with landscape and outdoor subjects (Figures 93-95). They made very large prints, some roughly 20 by 30 inches; their work always stood out in exhibition, partly because it dwarfed everything else. Their prints have the physical scale and impact of paintings.

FIG. 93
HEINRICH KÜHN, *Venetian Bridge,* 1898. Gum print in brown, 20¹/₈ x 29¼ inches.
(The Metropolitan Museum of Art, The Alfred Stieglitz Collection)

FIG. 94
HEINRICH KÜHN, *Scirócco,* 1896. Gum print in green, 22¹/₈ x 29¼ inches.
(The Metropolitan Museum of Art, The Alfred Stieglitz Collection)

FIG. 95
THEODOR & OSKAR HOFMEISTER, *Solitary Horseman,* 1903. Gum print in blue, 27 x 38⁵/₈ inches.
(The Metropolitan Museum of Art, The Alfred Stieglitz Collection)

Edward Steichen

Edward Steichen (who at this time spelled his name Eduard) carried printmaking experimentation even further than Demachy. He made multiple-gum prints using different pigment colors for each printing. He experimented with nearly all the possible combinations of gum, platinum, and cyanotype (which he called *ferroprussiate*) together, and he often applied a color stain to areas of his prints. Steichen even hand-colored the gravure reproductions of his prints in *Camera Work*. His *Moonlight* and *Moonrise* scenes, his series on New York's Flatiron Building (Plate 38), and his *Steeplechase Day*, are some of the best examples of his printmaking.

Steichen was an active painter as well as a photographer, and his prints are among the most painterly of all the Photo-Secessionist works. Sometimes the painterliness is *gestural*—brush strokes, for example. But Steichen also used his painterly printing techniques to produce tonal and color illusions that seem to emanate from the subject itself: Steichen wanted you to believe you were having a vision in the twilight. You generally

look *at* a Demachy—the effects lie on the surface—but you can often peer *into* a Steichen. Part of the reason for this, however, is that you actually have to peer, since Steichen frequently printed very dark. George Bernard Shaw, who was not exactly a fan of this style, remarked that some of them looked as if they had been taken in a coal cellar.[105] The false, overweight tonalism is often

Fig. 96 EDWARD STEICHEN, *Steeplechase Day, Paris—After the Races,* gum or possibly Artigue print in black, negative made in 1907.

Steichen applied by hand a yellow tone—now badly faded—to the highlights in the center of the image. Walker Evans, who was fond of this print, called it "a blend of the Elysian and the moribund" (in Louis Kronenberger, *Quality,* New York, 1969, p. 182).

(The Metropolitan Museum of Art, The Alfred Stieglitz Collection, 1933)

too much for modern eyes. Even so, the surprise on encountering an early Steichen—and discovering that a photographic print can look as convincingly romantic as that—is an experience not soon forgotten. Nymphs and satyrs could picnic in some of Steichen's works.

Weston Naef, curator at the Metropolitan Museum of Art in New York, believes that certain Steichen prints now in the Stieglitz Collection at the museum are not originals, as has always been assumed, but copies of originals. Large multiple prints are not easy to produce, and Steichen was known to make copy negatives of his work in order to supply prints for sale. Apparently, the copy prints were sometimes worked up by hand, using a local application of color or an overprinting of gum to reproduce the effect of the original. The puzzle is that under close inspection some of the Steichen prints in the collection lack the physical qualities one would expect from their descriptive labels, and this leads to the conclusion that they are facsimiles made by Steichen.[106]

Final Glory

The Photo-Secession reached its peak with an exhibition held in 1910 at the Albright Gallery in Buffalo, New York. The show beat all previous attendance records at the gallery: Between fifteen and sixteen thousand people saw the six hundred or so photographs on display. It was planned as a Secessionist retrospective, but there was also an open section for photographers not affiliated with the Secession. Stieglitz and the other organizers gave it historical depth by including examples of the work of Hill and Adamson in the form of forty prints made by Alvin Langdon Coburn from the original calotype negatives. Hill and Adamson supplied all the historical justification the Secessionists could desire. Had you been there to make the comparison, you would have noticed how frequently the Secessionists, for the sake of dramatic effect, voluntarily eliminated detail from the shadows of their prints—something that had virtually been forced on Hill by the calotype syntax.

Joseph Keiley, whose own photographs were represented, recorded his feelings as he sat looking at the show. He described the role Stieglitz had been playing:

> Visible to me were the creative forces behind all of these pictures—the lives that had gone into their making. Many of these forces were warring with themselves, warring with each other, seeking violently to rend the whole asunder. Many of them, apparently, if left to themselves, would have destroyed their own work. Clouds of jealousies from time to time obscured the whole. But all the while some central force held the mass together, drawing out and sometimes shaping the best work, helping those who stumbled and uniting all the complex, imaginative energy into one purposeful whole towards a definite end. This central observing, guiding mind appeared to see and understand the evolving minds about him, and to be endeavoring to evoke for each that which was finest and best, to be endeavoring to make each bigger and finer and immortal.[107]

Keiley and Stieglitz were close friends. There were other Secessionists who would not have spoken as kindly. For Stieglitz, playing the "central force" was not always easy. Like Emerson, he was naturally contentious and had little patience for those with whom he disagreed. Yet during the years of the Photo-Secession he was willing to encourage and to show photographers whose work was quite unlike his own. This was a kind of leadership Emerson was too inflexible to have managed. Stieglitz managed it by being in other matters a towering autocrat. After the Albright show, when the group broke up, the partings were often bitter, and Stieglitz became the focus of considerable hostility.

Printmaking and Post-Impressionism

In January 1907, Alfred Stieglitz showed nonphotographic work at the Photo-Secession Galleries for the first time: drawings by Pamela Coleman Smith. The following year the name *Photo-Secession* was dropped, and the gallery became known simply as *291*, its number on Fifth Avenue in New York City. That year, Stieglitz showed drawings by Auguste Rodin and also gave the first American exhibition of work by Henri Matisse. He gave the first American exhibition of Henri de Toulouse-Lautrec (1909), of Henri

Rousseau (1910), of Pablo Picasso (1911), and of Francis Picabia (1913). From 1909 on, gradually fewer and fewer photographs were shown, and increasingly more paintings and drawings, and, on occasion, sculpture. Starting in 1910, Stieglitz began to print reproductions of nonphotographic work in *Camera Work*, begining with caricatures by Marius de Zayas and then drawings by Matisse. Two years later he ran an essay on Picasso by Gertrude Stein, her first published piece and one that must have seemed to many *Camera Work* subscribers the closest thing they would ever experience to a message from Mars. But by that time not quite as many subscribers were left.

The photographers associated with Stieglitz were thus in contact with some of the most important developments in Post-Impressionist art. Those photographers who had used manipulative processes, particularly gum and oil, might have found in them a way to emulate the modernist painters, as they had emulated the Impressionists before. But the connection was not made: The timing was off. Painterly printmaking methods were already in disrepute among the most advanced photographers when the abstractionism of Post-Impressionist art finally began to have an influence. Instead of updating their painterly processes, photographers abandoned them. In America, photographers responded to modern painting by borrowing its abstract forms and incorporating them into straight photography. Alvin Langdon Coburn made photographs inspired by Cubism, and then "vortographs" after the Vorticist painters; but these were camera experiments, not printmaking ones. In Europe, Man Ray, Christian Schad, László Moholy-Nagy, and others, experimented with the cameraless technique of photograms, but they used commercial papers. Man Ray experimented with reversal effects in negatives and prints but, again, on commercial papers. There seems to have been no attempt to make the older manipulative processes serve the new abstract vision. Only recently, with the revival of the old processes, have photographers begun to try.

The manipulative processes continued to be used, however, by Pictorialist holdouts well into the 1930's and even later. I have met one or two venerable holdouts who never stopped. One man I wish I had met was William Mortensen, who hit his peak stride during the 1930's and 1940's. Mortensen was the author of a number of books on photography and had an elegant way of expressing what were sometimes only half-baked ideas. He liked scenes of violence, torture, and especially nudes. His work was Pictorialism gone Hollywood: escapist, garish, commercial, and thus innately surrealistic in the American vein.

Mortensen was the inventor of the Abrasion-Tone Process, which basically involved lightly covering a processed print with a mixture of ivory black and burnt sienna powder, then working over the print with eraser, brush, razor blade, and carbon pencil to modify tones and details. He used—and may even have invented—the electric bromoil brush.

FIG. 97
WILLIAM MORTENSEN, *Preparation for the Sabbot*, Abrasion-Tone Process, 1927. Figs. 97 and 98 are reproduced from the photogravures in Mortensen's *Monsters and Madonnas*.
(Camera Craft Publishing Co., 1936, second printing, 1943)

FIG. 98 WILLIAM MORTENSEN, *The Pit and the Pendulum,* bromoil transfer, 1934.

Three Printmakers

Stieglitz's Prints

It is a shame that comprehensive exhibitions of Stieglitz's work have been so infrequent, because reproductions of his prints never tell you enough. Stieglitz knew how inadequate reproductions could be, and late in his career refused to allow them to be made. To one request, Stieglitz answered

> My photographs do not lend themselves to reproduction. The very qualities that give them their life would be completely lost in reproduction. The quality of *touch* in its deepest living sense is inherent in my photographs. When that sense of touch is lost, the heartbeat of the photograph is extinct—dead. My interest is in the living. That is why I cannot give permission to reproduce my photographs.[108]

True to form, Stieglitz managed to put this in fairly haughty terms. Yet behind his answer there lay a real feeling of intense frustration. You can sense this as soon as you compare his prints with even the most respectful attempts to reproduce them. The difference between the originals and their reproductions is to us a nuisance, but to him it must have seemed a disaster.

From the start Stieglitz was an excellent technician. As a student in Germany in the early 1880's, he studied photochemistry under Hermann Wilhelm Vogel, one of the leading photographic scientists at the time. Vogel was the inventor of the orthochromatic plate and Stieglitz was among the first to use it. During the 1880's and 1890's Stieglitz experimented constantly, trying to push photography beyond its assumed technical limits. He tried night photography out-of-doors by the light of street lamps. He used a hand camera when

most considered it an amateur's toy—the kind of toy that could only work on bright, sunny days. Stieglitz made it work in a snowstorm, and with characteristic genius made a technical experiment serve an artistic purpose. (Plate 19.)

In the 1890's he showed that the mobility of the hand camera gave the photographer the chance for compositional control over transient, real-life scenes, control impossible with a camera fixed on a tripod. This amounted to the discovery that if one could respond quickly enough—having first had the patience to wait for the right moment—life could be made to look like art. It was a visual revelation that took most people by surprise and was one of Stieglitz's most important achievements as an artist, his later work notwithstanding. The hand camera, and the example Stieglitz set with it, proved as much a stimulus to Pictorialism as did the development of painterly printing techniques, and the hand camera survived Pictorialism as one of the key syntactical tools of modern photography.

Early in his career as a printmaker Stieglitz made carbon prints and lantern slides, and he continued to make at least an occasional carbon print until 1899. In 1889, he was printing on Pizzitype paper, a printing-out platinum paper. He used various platinum processes during the 1890's, and his pictures were often reproduced by photogravure. Between roughly 1898 and 1900, he became an avid experimenter in gum, having admired Robert Demachy's work. He also experimented with glycerin-developed platinum prints at that time. From the founding of the Photo-Secession until about 1920, he printed mostly on platinum and palladium papers. (Palladium, sometimes called *palladio*, is a pro-

cess very similar to platinum. See the technical section on ferric salts processes in Part II.) From about 1920 on, he printed mostly on silver chloride developing-out papers. Stieglitz worked when chloride papers were at their best—almost the equivalent of platinum in their tonal qualities. They have deteriorated since his day.

Because the hand camera produced a small negative, Stieglitz made enlarged negatives for contact-printing or enlarged positive transparencies from which photogravure plates were produced. He rarely composed his hand-camera pictures using the entire negative; the final image was almost always cropped. The enlarging procedure caused a certain loss of sharpness and of tonal separation. In later years, as he became more concerned with retaining the subtleties in his negatives, whether made by the view or by the hand camera, Stieglitz printed only by contact from original negatives.

The Stieglitz prints actually dating from the Photo-Secession period and earlier exist in two forms: photographic prints and gravures. The gravures were made for the most part under Stieglitz's supervision and were considered by him as equivalent to original prints; so we can take their quality as intentional. Up to 1898, Stieglitz's printing style, in both actual prints and gravures, was derived from Emerson's, although Stieglitz depended less than Emerson did on compressed tonality and his negatives were more in focus. When Stieglitz lowered the contrast of a print— graying it out—it was usually to suggest the atmospheric quality of a gray or inclement day. Stieglitz's interest in gum was short-lived (and later repudiated by him; only reproductions of his gum prints survive), but it appears to have had a lingering effect on his later work. I say this because the Photo-Secession prints, in general, are less straightforward than the pre-1898 work. Their tonal scale is more compressed and the details less defined. The printing mannerisms are such that many of the Photo-Secession gravures, even the ones printed low-key, have a decidedly anemic look in spite of the undeniable strength of their formal composition. Recent offset reproductions of these gravures, in books on Stieglitz, have

FIG. 99

ALFRED STIEGLITZ, *Spring Showers,* New York, 1900 (?). Photogravure from *Camera Work,* October 1911.

This reproduction cannot do justice to the soft scale of grays in the original. Stieglitz did a lot of foul-weather photography early on. Meterologically, this is one of the best prints.

tended to make them look more contrasty (longer in density range) than they in fact are. No gravures were produced after the Photo-Secession.

Stieglitz's post-Photo-Secession platinum and palladium prints tended to be low-key and in deeply printed tones. But this gradually gave way, in fits and starts, to a more normal balance of tones and clearer detail. The chloride prints made from the mid-1920's on, with the exception of the cloud series, tend to be bright and sharp compared with the work of the previous decade.

During the 1920's he reprinted many of his old (1890 through 1910) hand-camera negatives by contact on chloride papers. Because he printed them in his 1920's style, one should not take them as examples of his attitude toward printmaking at the time the negatives were made.

Stieglitz preferred matte papers of fine, unobtrusive texture. He often waxed (or varnished?) his prints—just enough to deepen the shadows without introducing an overall gloss.

Stieglitz's ability to extract nuances of tone and color from platinum and palladium prints was astonishing. There are platinum prints in the Stieglitz Archive at Yale University, and in other collections, that go from a cool, blueish color in the shadows to a warm, brownish color in the highlights. The shift is subtle but effective and shows how color-change can be used in printing to supplement the gray scale and enhance separation of tones. In a palladium print of Georgia O'Keeffe's hands, the shadows around the fingers are solarized (reversed). This gives them a glistening metallic luster that in turn makes the shadows seem to lie on another plane. The result is striking, and in practical terms impossible to reproduce photomechanically.

Historians and critics habitually characterize Stieglitz as a *straight* photographer. While otherwise accurate, the term can be misleading if applied too literally to his printmaking, as the paragraphs above should suggest. Compared with the work of Demachy or with Steichen in his early period, Stieglitz was a relatively straight printer. Compared with Edward Weston, though, he never quite went straight. Instead, he stood a kind of middle ground; and because he stood it so

well he was arguably the best printmaker photography has known. This is a laurel wreath contemporary opinion likes to hang upon Weston; but Stieglitz deserves it more because his prints tell us more about *printmaking*.

Any curator, anticipating the day his museum might go up in flames, should resolve to run for the Stieglitz prints first. Posterity needs them because they help us see the balance that printmaking teeters on: On one end is the print that presents its image directly, without intrusion; on the other, the print that covers its image with tonal or color manipulations or with its own physical texture. Weston's prints, made from 1930 on, tilt the balance toward direct presentation. Demachy's and Steichen's prints at their most painterly tilt it the other way. In individual Stieglitz prints the balance sometimes goes one way, sometimes the other; but in his most impressive work it rests even.

By finding the even balance, Stieglitz makes us *see* the relationship that exists in photography between the image and the surface that carries it—a relationship in which each contends with, yet depends on, the other. His images are tactile objects, full of their own physical substance, yet do not seem anything other than photographs. No other photographer did this with as much variety and inventiveness as Stieglitz, or with as profound a sense of the qualities necessary to carry it off. This careful balance between image and object is the source of the irreproducible "heartbeat" of which he spoke.

Paul Strand

Along with Stieglitz, the work of two other famous photographers, Paul Strand and Edward Weston, best respresents the major direction taken by artistic printmaking after the Pictorialist heyday.

Paul Strand's photographs appeared for the first time in *Camera Work* and at *291* in 1916. Born in 1890, Strand had been a student of Lewis W. Hine, the social reformer and documentary photographer, who taught science at the Ethical Culture School in New York. Hine also taught an extracurricular course in photography. Strand

signed up, learned the fundamentals of camera and darkroom and, with the other students, was taken by Hine to see the work at *291*. The visits to *291* made Strand certain he wanted to become a photographer, and over the years, as he continued to photograph, he took his prints to Stieglitz for criticism. He worked his way through Pictorialism—experimenting with gum prints and soft-focus effects—but under Stieglitz's influence became convinced of the arguments for straight photography.

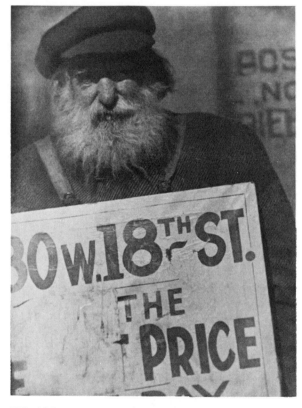

FIG. 100

PAUL STRAND, *The Sandwich Man.* Photogravure from *Camera Work,* June 1917.

The final two issues of Camera Work *contain gravures of Strand's work. The printing varies—some plates are fairly bright and contrasty, others, like this one, are comparatively flat. There seems to be no reason for the difference. The printing does not bear a consistent relationship to the images.*

Strand saw the work of the modernist European and American painters on the walls at *291* and he began to experiment with the same ideas by photographing abstract forms. From this work with pure abstraction he learned the vocabulary of picture structure that was to be fundamental to much of his later photography.

In 1917, in the last issue of *Camera Work*, Stieglitz described Strand's work as "brutally direct." It was, he wrote, "Devoid of all flim-flam; devoid of trickery and of any 'ism'; devoid of any attempt to mystify an ignorant public, including the photographers themselves. These photographs are the direct expression of today." Comparing Strand's work with the bulk of the "serious" photography then being produced, one can understand Stieglitz's enthusiasm; yet his often-quoted tribute does not ring entirely true. Strand had indeed found his way clear of the more overt mannerisms of Pictorialism: His subject matter— the famous *Blind Woman*, for example, or any number of candid portraits—was a considerably more "direct expression of today" than was the standard Pictorialist fluff. Nevertheless, his print-making retained much of the Pictorialist temperament. Many of the prints from this period have broad, flat tones, empty shadows, and soft detail. They are not bright and sharp like the prints made by his first mentor, Hine. Instead, they have a quality akin to the haziness of the work shown in the Photo-Secession Galleries a decade before. Even the early abstractions are printed in a Pictorialist style. Over the years, Strand gradually lifted the veil. His prints became far more direct in the way they presented their subjects. The impression one gets is that Strand's printing style only slowly caught up with the implications of his vision. (See Plate 44.)

Strand preferred platinum paper and used it until it went off the market in 1937. He experimented by applying an additional coating of sensitizer over the surface of commercial platinum paper to deepen the tone, and then gold-toned the print to make the shadows even richer. Strand's interest in gravure printing (see the chapter on photogravure) was another aspect of his concern for print quality. Also notice the

Strand quotation at the beginning of Part Two, the technical section.

In "The Art Motive in Photography," an essay written in 1923, Strand defined his position regarding certain still-popular photographic methods:

> Gums, oils, soft-focus lenses, these are the worst enemies, not of photography, which can vindicate itself easily and naturally, but of photographers. The whole photographic past and present, with few exceptions, has been weakened and sterilized by the use of these things. Between the past and the present, however, remember that there is this distinction—that in the past these extrinsic methods were perhaps necessary as a part of photographic experimentation and clarification. But there is no such excuse for their continued use today. Men like Kühn and Steichen, who were masters of manipulation and diffusion, have themselves abandoned this interference because they found the result was a meaningless mixture, not painting, and certainly not photography. And yet photographers go right on today gumming and oiling and soft-focussing without a trace of that skill and conviction which these two men possessed, who have abandoned it. Of course, there is nothing immoral in it. And there is no reason why they should not amuse themselves. It merely has nothing to do with photography, nothing to do with painting, and is a product of a misconception of both. For this is what these processes and materials do—your oil and your gum introduce a paint feeling, a thing even more alien to photography than colour is in an etching, and Lord knows a coloured etching is enough of an abomination.[109]

Edward Weston

About the time Strand's essay was written, Edward Weston, who was once among the fuzziest of Pictorialists, was reassessing his own photography in similar terms. In the early 1920's Weston began to move away from the sentimental, soft-focus style that had characterized his early work—and had already won him a certain fame. Weston's renunciation of Pictorialism was more dramatic and complete than that of Kühn or Steichen, who embraced the idea of straight photography while managing to produce work that suggests they did not always feel at home in it.[110] Weston, as is well known, was another case entirely.

Weston continued to use platinum and palladium papers—at least, when he could afford them—or matte chloride papers, long after his turnaround from Pictorialism had taken place. But in 1930 he finally abandoned matte papers in favor of a way of printing that was free of any secondary qualities imposed by the print surface. A comment in his *Daybook* (for March 15, 1930) neatly sums this up.

> Long ago I thought of printing my own work—work not done for the public—on high-gloss paper. This was some years back in Mexico, but habit is so strong that not until this last month did I actually start mounting glossy prints for my collection.
>
> It was but a logical step, this printing on glossy paper, in my desire for photographic beauty. Such prints retain most of the original negative quality. Subterfuge becomes impossible. Every defect is exposed, all weaknesses equally with strength. I want the stark beauty that a lens can so exactly render, presented without interference of "artistic effect."

FIG. 101
EDWARD WESTON, *Jean Charlot,* 1933.

Now all reactions on every plane must come directly from the original seeing of the thing, no second-hand emotion from exquisite paper surfaces or color. Honesty unembellished—first conceptions coming straight through unadulterated—no suggestion, no allegiance to any other medium. One is faced with the real issue, significant presentation of the Thing Itself with photographic quality.

This statement is a complete rejection of the idea of the artistic print as it had been defined since the late 1880's. Of course, commercial and documentary photographers had made glossy prints all along; but photographers who thought of themselves as artists in the usual sense had not. Although Stieglitz and Strand also began from roughly 1920 on to depend less on altering tonal relationships or covering the image with effects derived from the printing surface, Weston was the first to tip the printmaking balance all the way toward pure presentation. He redefined the artistic print by paring its syntax down to the bare essentials, leaving only the tonal controls made possible by varying the exposure and the development given to the negative and the print (including burning and dodging). He used the controls only to present the tonal values of the original scene, not to impose values for the sake of "artistic effect"—two words Weston put in quotation marks to banish them from photography. Weston knew what his print would be like even before he released the camera's shutter; printmaking was simply the closest possible duplication on paper of what had been seen on the ground glass.

What Weston did, in effect, was complete the circle that brought serious photographic printing back in spirit to where printing had been in the straightforward days of glossy albumen, before William Willis's beautiful platinum papers, Peter Henry Emerson's peculiar theories, and all the Pictorialist paraphernalia had arrived on the scene.

Final Words

The Weston printmaking standard (glossy paper, careful translation of the scale of values in the subject into a scale of tones in the print) has had a monoply over serious photographic printing since the 1930's, especially as passed down by Ansel Adams in the Zone System of exposure and print control. But since the 1960's a number of photographers have begun to re-examine the options in printmaking. Today, all sorts of experiments are going on using revived historical methods, or using the new electrostatic, photolithographic, and photo-etching techniques, some of which are described in this book's companion volume, *Alternative Photographic Processes*, by Kent E. Wade.

These experiments have resulted in some startlingly new forms of nonobjective imagery, but they are worth the attention of even the most objective of straight photographers. They are worth it because of the regrettable state of commercially made printing papers, now undeniably inferior to the papers of a few decades ago. Whatever the reasons, manufacturers have lost track of the tonal, color, and surface characteristics the best paper once had. The conveniences

gained from such things as resin-coated papers have been at the expense of the qualities that give prints their physical beauty—that pull us across the room and make us take notice. Turning to historical or alternative materials may not be an ideal solution to the problems the manufacturers have created, but for photographers who care about printmaking it is the only solution at hand.

☆ ☆ ☆ ☆

In talking about printmaking I have wandered considerably from the point where I started; the link between syntax and communication. Yet the idea that photography has in its technology syntactical rules of structure that affect what photographs can tell us about the world seems to me so fundamental that it bears repeating. An understanding of the syntactical rules through which camera-made pictures operate is vital in an age when photography and its descendants, film and television, play the central role in channeling our visual perceptions of the life around us. The account above tells just part of the story.

Part II

The light is pretty good at this time, and we count only as far as thirty, when we cover the lens again with the cap. Then we replace the slide in the shield, draw this out of the camera, and carry it back into the shadowy realm where Cocytus flows in black nitrate of silver and Acheron stagnates in the pool of hyposulphite, and invisible ghosts, trooping down from the world of day, cross a Styx of dissolved sulphate of iron, and appear before the Rhadamanthus of that lurid Hades.

OLIVER WENDELL HOLMES, "Doings of the Sunbeam," *The Atlantic Monthly,* July, 1863

Films are quite good these days . . . but the papers are still made only for the amateur and for the average professional who doesn't care too much about quality and longevity. These papers lack variety and, in themselves, any kind of real beauty. The photographer has never had the best materials that could be made. Photography is still a new art, and in some people's minds it doesn't compete, doesn't qualify. They think of it as an inferior, mechanical medium, because it isn't done by the human hand. But, of course, the photographer deserves the best materials that could be made, because what he is doing is something added, something new through which the human spirit and mind can express themselves.

PAUL STRAND, quoted in "Talk of the Town," *The New Yorker,* March 17, 1973

Technical Introduction

The processes and formulas chosen for this book represent only a small portion of the technical lore of photography. There is a surprising number of ways to produce images using photosensitive materials. If you look through some of the books recommended in this volume you will find that the list of processes is just about endless. Yet the standard references often fail to make clear whether or not a process can produce a controllable tonal scale with a full range of values between black and white. Many processes cannot, and so their usefulness is limited. All of the processes described here can produce excellent tonal scales. The technical explanations are intended to show you how.

Most photographers will find that only one or two of the processes will fit their needs. My advice is to experiment tentatively with several that seem promising, but then choose one and settle down to master it. Skillful printmaking is an uphill fight. It takes concentrated practice, but it is worth the trouble. In themselves, the methods described in this book are not very important. Their only value comes from the way they require you to exercise your vision. The craft of printmaking is the art of seeing.

Negatives and Printing Papers

Here is some basic background on the characteristics, or sensitometry, of photographic films and papers. It is intended to help you review some of the things you should already know—or be trying to learn—about controlling films and papers and also to introduce you to some of the problems in making negatives suitable for printing with the historical processes. For a more extensive account of sensitometry and exposure and development controls, see *Photographic Tone Control*, by Norman Sanders, published by Morgan & Morgan, Inc.

The Characteristic Curve

The density of the silver deposit in any part of a processed photographic negative of a given sensitivity depends, first of all, on the amount of exposure. The relationship between density and exposure is usually represented by a graph known as a *characteristic curve,* as in Figure 102. Density

is plotted along the vertical axis of the graph, exposure along the horizontal axis.

Both density and exposure are expressed in logarithmic form and abbreviated D for density and $Log\ E$ for exposure. Density is found by reading the negative with a device known as a densitometer, which measures the amount of light transmitted through any given area.

The formula for calculating density is
$$D = Log\frac{1}{T},$$
where D equals density and T equals transmittance. Transmittance is given as a percentage, written in decimal form. For example, if the negative transmits 25% of the light falling on it, its density is the log of $\frac{1}{.25}$. Since $\frac{1}{.25} = 4$, and the log of 4 is 0.60, the density of the negative is 0.60.

Figure 103 shows the relationship between transmittance and density. You can see that each time the transmittance is cut in half, the density increases by 0.30. Conversely, each time the transmittance doubles, the density decreases by 0.30.

A similar relationship holds for exposure. Each increase in $Log\ E$ of 0.30 means that the film

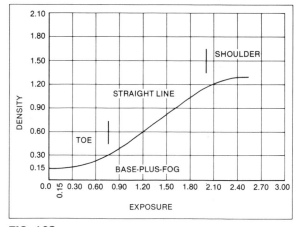

FIG. 102
Characteristic curve.

TRANSMITTANCE (percentage)	DENSITY (logarithm)
1.00	0.00
0.50	0.30
0.25	0.60
0.125	0.90
0.063	1.20
0.031	1.50
0.015	1.80

FIG. 103
Abbreviated table of transmittance and density.

received double the exposure (in other words one f-stop more exposure). Each decrease in log exposure of 0.30 means that the exposure was cut in half (one f-stop less exposure).

You should not worry if you do not quite understand what logarithms mean. All you really need to remember to use them in photography is *that each additional 0.30 means a doubling* of density or of exposure—whichever is applicable

The shape of the characteristic curve varies from film to film. The curves shown here are symbolic and not intended to represent a specific film. We think of the curve as being divided into three parts: the *toe*, the *straight-line* section, and the *shoulder.* In Figure 104 you can see that on the straight-line section of the curve, equal differences in exposure will result in proportionately equal differences in density. This constant ratio does not hold, however, for either the toe or the shoulder sections. In these areas, equal differences in exposure do not result in equal density differences. Compared with the straight-line section, the density differences resulting from equal exposure differences tend to become less toward the extremes of under- and overexposure, as represented by the toe and the shoulder sections of the curve. Because of this, differences in brightness in the original scene are reduced when they are recorded on the toe or the shoulder sections, and contrast and separation are partly lost.

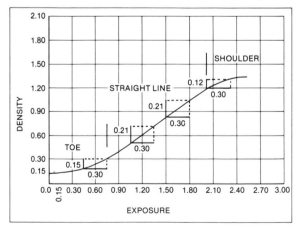

FIG. 104
Tone separation on toe, straight-line, and shoulder.

As a result, a print made from the negative will show a more accurate and distinct separation of tones in the areas printed from the straight-line section than in the areas printed from the toe or the shoulder sections.

You will see that the toe of the characteristic curve does not begin at a density of 0.0, but slightly higher. This initial density—called *base-plus-fog* or *gross fog*—is the sum of the density of the film base itself plus the additional density, or *fog,* produced by the action of the developer on the unexposed portions of the emulsion.

Exposure. When we use 35mm or other cameras that make small negatives, we usually try to expose so that the shadow details lie mostly on the toe region of the characteristic curve. Using the toe allows us to take full advantage of the film's speed and produce negatives that have maximum definition and minimum grain—factors with special importance for small negatives.

With medium and large-format negatives, however, where problems of definition and grain are less critical (either because less magnification is used in enlarging or the negative is printed by contact), exposure is usually increased so that the shadows lie less on the toe and more on the straight-line section of the curve. This results in a more accurate recording of shadow detail.

With either large or small negatives the rest of the tonal scale, from the deep middle tones to the highlights, should lie on the straight-line section. Normally we do not want the highlights to fall on the shoulder of the curve. This is what happens when the negative is overexposed or made to record a contrasty scene—a scene with an extreme range of brightnesses. You can see from the curve that when the lighter tones do fall on the shoulder, their separation becomes less: They become "blocked."

Effect of Development on the Characteristic Curve. An old adage in photography goes, "expose for the shadows and develop for the highlights." A slightly more exact, if less economical, way of putting it would be, "expose for the toe of the characteristic curve and develop for the slope." The reason behind this can be seen in the characterisitic curves in Figure 105. The curves

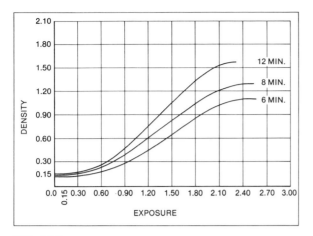

FIG. 105
Density and development time.

show that when development time is increased, the density of the negative for any given exposure is also increased. The density increase, however, is small in the toe of the curve and becomes greater as the curve ascends. Notice how the steepness of the slope of the curve increases with increased development. The result is an increase in tonal separation between any given range of exposure units. Again, the increase is greatest in the upper part of the curve.

Density Range

The *density range* of a photographic negative is the difference between the most and the least dense areas on the negative from which you will want to see detail in the print.

To find the density range with a densitometer, first measure the densest part of the negative that should retain detail. In the print this will correspond to the first highlight tone just perceptibly darker than the white of the paper. (When making this measurement, ignore anything in the negative that you wish to print as pure white.) Next, measure the thinnest, most transparent part of the negative from which detail is required in the print. Normally this will correspond to the deepest shadow value just preceptibly lighter than the maximum density (the blackest black) of which

the paper is capable. Subtract the shadow density from the highlight density. The result is the density range of the negative. For example, highlight density 1.60 minus shadow density 0.30 equals a density range of 1.30.

If you refer to Figures 106-107 you can see that the time of development (and also, but not shown, the choice of developer and dilution) provides a way of controlling the density range of a negative. *Increasing development time increases density range; decreasing development time decreases density range.*

FIG. 106
Increase development to increase density range.

FIG. 107
Decrease development to decrease density range.

This has great practical use. If the scene you are photographing has low contrast—for instance an outdoor scene under a gray, overcast sky—after normal development your negative will have a fairly short density range. Negatives of this sort can be difficult to print. By increasing the development time beyond normal, you can bring the density range of the negative up to a level more appropriate for printing. On the other hand, if you photograph a scene on a clear sunny day, and your scene has an extreme range of brightnesses from dark shadows to bright highlights, after normal development your negative may have a density range too long to print easily. In this case you would want to decrease development time in order to bring the density range down to a more manageable level.

Matching Negatives and Papers. The alternative to changing the development times of your negatives is to print on papers of different contrast grades. You can find the right paper by trial and error, but knowing the density range of your negative allows you to pick immediately the contrast grade of paper that will give the best result. "Best result" is normally taken to mean a print showing a full range of tones, from maximum black to paper white, with good detail in both the light tones and the deep shadows. The chart shows Eastman Kodak's guide for matching density ranges of negatives to Kodak's numbered paper grades.

The Step Tablet. The easiest and most accurate way to measure the densities of a negative is with a transmission densitometer, but you do not need a densitometer to make practical use of

the concept of density range. All you need is an extremely useful device called the *Photographic Step Tablet No. 2* made by Kodak.

The No. 2 tablet is simply a strip of film exposed to give a series of increasing densities in 21 steps running from a base-plus-fog density of about 0.05 to a greatest density of about 3.05. Each step represents an increase in density of about 0.15. You buy the tablets either calibrated or uncalibrated. The calibrated tablets are more expensive, but give an exact density number for each of the 21 steps. Actually, the tablets are made close enough to an average density difference of 0.15 between steps that you can go ahead and assume that an uncalibrated tablet will follow the progression given in Figure 108. The *exact* densities of the steps are not really important for our purposes, anyway.

The No. 2 Step Tablet is useful in a number of ways. As explained below, you can use it to determine the density range to aim for in your negatives in order to get the best results from your chosen printing technique. Once you determine the target density range, you can use the tablet as a visual comparison guide for checking negative densities by laying the tablet down next to the negative on a light table. As described in later chapters, the tablet is also handy as an exposure guide for use with printing-out techniques such as salted paper and cyanotype.

It is a good idea to number the steps on the tablet with acetate ink (acetate ink will stick to the film base). This way, when you print the tablet the numbers will show in white, making it much easier to count steps and compare results.

Paper Contrast Grade Number		Density Range of Suitable Negative	Log Exposure Range of Paper
Lowest	0	1.40 and higher	1.40 to 1.70
Contrast	1	1.20 to 1.40	1.15 to 1.40
	2	1.00 to 1.20	0.95 to 1.15
	3	0.80 to 1.00	0.80 to 0.95
Highest	4	0.60 to 0.80	0.65 to 0.80
Contrast	5	0.60 and lower	0.50 to 0.65

The meaning of the right column, Log Exposure Range of Paper, is explained in the text.

NO. 2 STEP TABLET	
Step Number	Density
1	0.05
2	0.20
3	0.35
4	0.50
5	0.65
6	0.80
7	0.95
8	1.10
9	1.25
10	1.40
11	1.55
12	1.70
13	1.85
14	2.00
15	2.15
16	2.30
17	2.45
18	2.60
19	2.75
20	2.90
21	3.05

FIG. 108
Density steps on Kodak No. 2 Tablet.

Characteristics of Printing Papers

Photographic papers also have characteristic curves. In a paper's curve, the toe represents the *lightest* tones and the shoulder the *darkest*. Usually the curves for modern photographic papers are steeper than those for films, more abrupt in their transition from straight-line section to shoulder, and have a longer toe. Figure 109 shows curves plotted for different contrast grades of paper. With papers, density is measured with a *reflection densitometer*, which measures the amount of light reflected from the surface of the paper.

Exposure Range. The curves in Figure 109 show the increase in slope that accompanies increased contrast grade. They also illustrate the concept of *exposure range*. The exposure range (or *latitude*) of the paper is the difference between the minimum exposure necessary to produce the first perceptible tone and the exposure necessary to produce the deepest possible tone. Looking at the horizontal axis of the graph, you can see that high-contrast papers (high numbers) have short exposure ranges and that low-contrast papers (low numbers) have long exposure ranges. The *best-results* print happens when the exposure range of the paper (expressed logarithmically) equals approximately the density range of the negative. Flat negatives (those with a low density range) print "best" on contrasty (short exposure range) papers. Contrasty negatives (those with a high density range) print "best" on low contrast (long exposure range) papers. Refer back to the table of Kodak paper contrast grades to see how exposure range and density range should compare.

Keep in mind those quotation marks around the word *best*. All that an equivalence between density range and exposure range actually ensures is that the negative will allow you to print the full scale of the paper while retaining detail in both shadow and high values. It does not tell you how the tonal values will be modulated as they go up the scale: That depends on the shape of the characteristic curve.

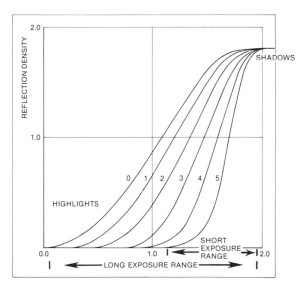

FIG. 109
Characteristic curves of Kodak papers (glossy) of different contrast grades.

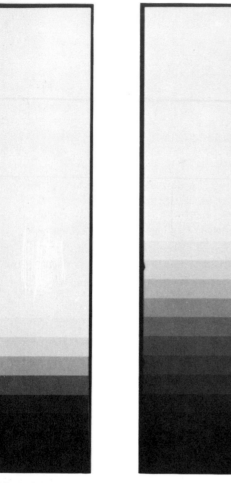

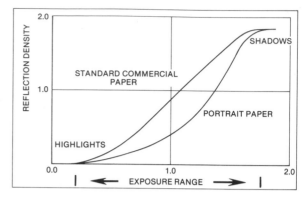

FIG. 112
Curve shapes of paper for different purposes.

FIG. 110
No. 2 Step Tablet
printed on a short
exposure range paper.

FIG. 111
No. 2 Step Tablet
printed on a long
exposure range paper.

For example, Figure 112 shows the curves for two types of printing paper that have the same exposure range. The first is a "commercial" paper, the second is a "portrait" paper. You can see that the toe section of the portrait paper is longer and less abrupt than that of the commercial paper. Compared with the commercial paper, the portrait paper will give a more gradual, less contrasty gradation of tones in the lighter values of the print.

Modern Versus Historical Film and Papers. The steep curve and the sharp shoulder of modern printing papers are designed to compensate for the long toe and gradually ascending curve of most modern films. This combination is supposed to produce prints in which the tonal relationships correspond closely to those in the original scene.

Most of the historical materials covered in this book have characteristic curves unlike those of modern papers. The curves for the historical materials have long straight-line sections, often with a negligible toe or shoulder. A curve of this sort is "ideal" in the sense that it maintains highlight and shadow separation equal to the separation of the intermediate tones. When the historical printing materials were originally in use, films and plates also tended to be more straight-line in character. Basically, this meant that their toe region was shorter and straighter than that of today's films (a film like Kodak Royal Pan comes close to this earlier configuration). Working together, the straight line of the paper and the straight line of the negative could produce prints showing a remarkably faithful gradation of tones with regard to the original scene. The older combination of materials was often superior to the modern.

Modern films are not as suited to the historical printing process as their predecessors were. Instead of compensating for the compression of

tonal values due to the long toe of modern negatives, the historical processes actually reproduce this compression on the print. The only way to adjust for this is to overexpose the modern negative slightly in order to place the shadow values more on the straight-line section of the curve.

Exposure Ranges of Historical Papers. There is another important difference between modern and historical printing papers. *The historical papers tend to have longer exposure ranges, and consequently print best with negatives developed to a greater density range than would be appropriate for modern papers* (the exceptions to this are gum, carbro, and bromoil). Although some contrast control is possible with the historical papers, for successful prints you *have to start* with the right kind of negative. In general, this means developing your negatives 20% to 30% longer than normal. (**NOTE:** If you intend to make an enlarged duplicate negative [see next page] develop the original negative as you normally would; you can raise the density range in the duplicate.)

The best way to find the right density range for your negatives is to contact-print a No. 2 Step Tablet over your historical paper. Expose the paper beneath the tablet so that the first step prints the maximum black the paper is capable of and the second step has a tone discernibly lighter. Note the number of the last step on the tablet that prints a tone just perceptibly darker than paper white. Use that step as the highlight density to aim for when you develop your negatives.

The Effect of Surface Texture. Note in Figure 113 that the maximum reflection density (or shadow depth) is higher for glossy-surface than for matte-surface papers. This is because the surfaces reflect light differently. Figure 114 compares surface types. The rough matte surface tends to scatter light in all directions, while the glossy surface reflects most of the light at an angle opposite to the angle of incidence. If you view a glossy print from this *angle of reflectance* you see a glare. Since there is less scattered reflectance from a glossy print, under normal conditions of viewing less light is reflected back to the viewer.

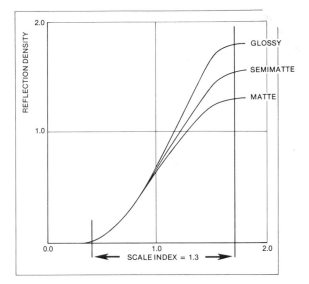

FIG. 113
Maximum reflection density possible from different surface types.

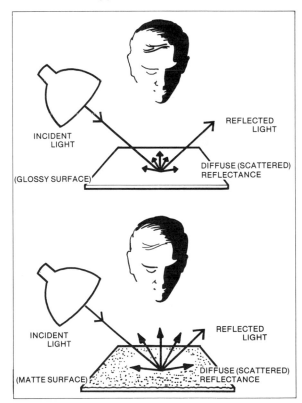

FIG. 114
Reflectance from glossy and matte surfaces.

tonal values due to the long toe of modern negatives, the historical processes actually reproduce this compression on the print. The only way to adjust for this is to overexpose the modern negative slightly in order to place the shadow values more on the straight-line section of the curve.

Exposure Ranges of Historical Papers. There is another important difference between modern and historical printing papers. *The historical papers tend to have longer exposure ranges, and consequently print best with negatives developed to a greater density range than would be appropriate for modern papers* (the exceptions to this are gum, carbro, and bromoil). Although some contrast control is possible with the historical papers, for successful prints you *have to start* with the right kind of negative. In general, this means developing your negatives 20% to 30% longer than normal. (**NOTE:** If you intend to make an enlarged duplicate negative [see next page] develop the original negative as you normally would; you can raise the density range in the duplicate.)

The best way to find the right density range for your negatives is to contact-print a No. 2 Step Tablet over your historical paper. Expose the paper beneath the tablet so that the first step prints the maximum black the paper is capable of and the second step has a tone discernibly lighter. Note the number of the last step on the tablet that prints a tone just perceptibly darker than paper white. Use that step as the highlight density to aim for when you develop your negatives.

The Effect of Surface Texture. Note in Figure 113 that the maximum reflection density (or shadow depth) is higher for glossy-surface than for matte-surface papers. This is because the surfaces reflect light differently. Figure 114 compares surface types. The rough matte surface tends to scatter light in all directions, while the glossy surface reflects most of the light at an angle opposite to the angle of incidence. If you view a glossy print from this *angle of reflectance* you see a glare. Since there is less scattered reflectance from a glossy print, under normal conditions of viewing less light is reflected back to the viewer.

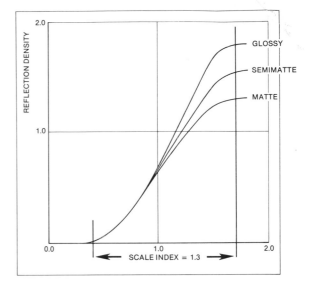

FIG. 113
Maximum reflection density possible from different surface types.

FIG. 114
Reflectance from glossy and matte surfaces.

The result is that the shadows in a glossy print will appear darker than the shadows in a matte print. You see this difference each time you process a print. The layer of water on a wet print gives it a very efficient glossy surface. As the print dries, the gloss disappears and the shadows become lighter and less contrasty.

Making Enlarged Duplicate Negatives

Except for carbro and bromoil, all the processes described in this book are contact processes and require negatives (or sometimes positives) *the same size as the final print*. Technically, the best negative for this purpose is an original large-format negative developed to the right density range for the chosen printing process. If you use a camera with a negative size smaller than your intended print size, such as a 35mm camera, you will have to make an enlarged duplicate negative using one of the following methods:

(1) Enlarge the negative directly onto Kodak Professional Direct Duplicating Film SO-015.

(2) Make an intermediate film positive and from that an enlarged duplicate negative.

(3) Use a large-format camera to make a new negative the size you want by copying a print made from the original negative.

(4) Reversal-process your film and enlarge the resulting positive onto film to make a negative.

Method One: Kodak Professional Direct Duplicating Film SO-015. This film allows you to make one-step duplicate negatives from your original continuous-tone negatives by standard processing techniques.

The "SO" in SO-015 means *special order*, but many professional camera stores now carry the film in stock. This film is in the developmental stage, though, and still being tested and changed. Kodak may drop the "SO" designation in the future but probably will not change the name. The film currently is available in 10x13cm (4x5-in.),

13x18cm (5x7-in.), and 20x25cm (8x10-in.) sizes. Use a No. 1A (light red) or a No. 1 (red) Kodak safelight filter.

It is important to store the film at 13 °C (55 ° F) or cooler. The base-plus-fog density of the film is high to begin with, and heat will increase it.

SO-015 has a transparent base. This makes it almost impossible to tell the base and the emulsion side apart under safelight illumination. If you hold the film vertically, with the code notch at the very top right or very bottom left, the emulsion will be facing towards you (the same is true of any other code-notched sheet film), as in Figure 115. It does not seem to matter whether you expose this film emulsion side up or through the base, though correct procedure would normally be emulsion side up in the enlarging easel, with the original negative in the enlarger emulsion side down. Place a sheet of matte black paper underneath the SO-015 when making the duplicate negative to reduce the halation that would otherwise be caused by light reflected from the easel.

CODE NOTCH

FIG. 115
Code notch lets you identify emulsion side in the dark.

SO-015 has already been exposed in manufacture, and additional exposure by you will actually *decrease* the film's density after development. In practice, this means that when you enlarge your original negative onto SO-015 you must *decrease* exposure if the shadow areas of the duplicate have *too little density* and *increase* exposure if the shadow areas have *too much density*.

The first time you use SO-015, cut a strip and expose it to the room light for a minute. Develop it for 4 minutes, as directed below, and then fix. This will show you the minimum base-plus-fog density possible with this film. In making an enlarged negative, try to aim for the exposure that gives the lowest base-plus-fog density consistent with good shadow tone separation as compared with the original negative.

Develop SO-015 in a tray with continuous agitation using Kodak Dektol (1:1 dilution) at 21°C (70° F). Despite the reversed exposure procedure, development is the same as with any standard film: Increasing the development time will increase the density range of the SO-015 duplicate. Kodak suggests a developing time of 2 minutes, but this time is usually far too short to gain a sufficient density range for most of the historical printing techniques. You will probably find you need a time between 4 and 8 minutes, depending on your original negative. Bear in mind that increased development also increases base-fog.

The disadvantage of using SO-015 lies in its high base-plus-fog density, which makes longer exposure times necessary when you start making prints. This density can be reduced by treating the negative for 1 minute in Farmer's Reducer, as explained at the end of this section. Otherwise, using SO-015 is the easiest way to make enlarged duplicate negatives.

A Note on Tray-Developing of Films: Always tray-develop film using a tray at least one size larger than the film size. This will allow the film to move freely and develop evenly. Agitate gently by alternately lifting and lowering each side of the tray. Keep doing this the whole time. If the tray is too small, the effect of agitation tends to be greater along the the edges of the film than at the center. This can result in excessive edge density and uneven density overall. If you must use a small tray, agitate the film by continually lifting it and turning it over in the developing solution.

Method Two: Intermediate Film Positive. With this method you first make a film positive and from this, an enlarged negative. The best film to use is Kodak Commercial Film 6127 (or 4127 Estar Thick Base). Use a Kodak No. 1 (red) safelight filter. The film is available in 10x13cm (4x5-in.), 13x18cm (5x7-in.), 20x25cm (8x10-in.), and 28x36cm (11x14-in.) sizes.

In terms of the amount of film needed, the most economical procedure is first to make a continuous-tone film positive by contact-printing your original negative onto Commercial Film, and then to enlarge the positive again onto Commercial Film to make the new negative. In making the positive, try to use only the straight-line section of the characteristic curve. This means exposing the positive for full, actually rather heavy detail in the highlights, and developing for adequate separation in the shadows, but *not developing to the film's maximum density*.

Start by making test strips. If you use your enlarger light for contact-printing, set the lens at $f/5.6$ and place the white side of a Kodak gray card or a white sheet of paper on the easel. With only the enlarger light and safelight on, raise or lower the enlarger head until a reflected-light meter reading of the card gives an exposure setting of $f/8$ at 1/15 second or its equivalent with the meter set for ASA 400. Stop the lens down to $f/16$. The exposure for contact-printing the positive will now be about 1½ seconds, depending on the highlight density of your original negative.

Develop the test strip for 2¼ minutes with constant agitation in Kodak DK-50 or Kodak HC-110 (Dilution A) at 21° C (70° F). After fixing and rinsing, squeegee the surface water off and examine the strip over a light table. It should not have clear film in the highlights (except for spectral reflections or blank whites), and should have fairly soft shadows. Adjust the exposure and development times as necessary. With a contrasty original negative, you might have to switch to softer-working HC-110 (Dilution B). With a very flat original negative, a more active developer like

Kodak D-11 (used 1:1, or more concentrated if necessary) may be required to produce an adequate density range.

When you have made the film positive on the basis of your test strip, enlarge it onto Commercial Film to make the duplicate negative. Expose for proper shadow separation and develop for the time necessary to achieve the appropriate density range for the printing process you have in mind. Compare the duplicate with the original negative. You will not be able to get an absolute match in the shadow tones, but try to come as close as you can. Despite your adjustments in exposure time, the shadow values of the duplicate negative may not show enough tonal separation. If this happens, the only thing to do is remake the positive, giving it a longer developing time to increase its shadow separation. Unfortunately, the only way to learn whether your positive has been made correctly is to go ahead and try to use it to make the enlarged duplicate negative.

This two-step process is not as easy as using Direct Duplicating Film, but it is good practice in learning to control density ranges through exposure and development.

Method Three: Copying. Sometimes the original negative will need so much careful burning and dodging during printing that it may turn out to be easier to make the enlarged duplicate negative by copying a print instead of by either of the methods described above.

One advantage of copying is the possibility it presents for handwork on the copy print or for techniques like collage or the use of existing artwork. The main thing to remember about copying is that the brightness range of a glossy print is only about 1:50, and it is even less for a matte-surfaced print. This means that they are both low-contrast subjects, and so the copy negative will need a long development time to produce a density range suitable for printing with historical—and for that matter, modern—papers. For details on copying see Kodak Publication No. M-1, *Copying* (Eastman Kodak Company, Rochester, New York 14650).

Method Four: Reversal Processing. A black-and-white transparent positive results when the original film is processed by bleach-and-redevelop reversal processing. The positive image can then be enlarged directly onto Kodak Commercial Film 6127 to make a negative.

The drawback of this technique is that most reversal chemistry is designed to produce positive transparencies of a high density range suitable for projection but not for use in making enlarged negatives.

For information on reversal processing, see Arnold Gassan, *Handbook for Contemporary Photography*, distributed by Light Impressions (Box 3012, Rochester, New York 14614) and Kodak Pamphlet No. J-6, *Small-Batch Reversal Processing of Kodak B/W Films*.

Density Control With Farmer's Reducer

Farmer's Reducer is a "cutting" reducer, meaning that it tends to remove the same amount of silver from all areas of the negatives. Because the subtraction is more obvious in the shadow areas, the reducer appears to increase the density range of the negative; but this is not the case. Farmer's Reducer can be used for correcting overexposed negatives, for treatment of Kodak Professional Direct Duplicating Film SO-015, as mentioned above, and for local reduction as described below.

STOCK SOLUTION A

Potassium ferricyanide *37.5 grams*
Water to make total volume *500 ml*

STOCK SOLUTION B

Sodium thiosulfate (hypo) *120 grams*
Water to make total volume *500 ml*

To use, mix 1 part Stock Solution A, 4 parts Stock Solution B, and 32 parts water, and use immediately—the combined solution will keep only for about 10 minutes. If the weather is warm, treat the negative first in Kodak Hardener SH-1 (the formula is given in the chapter on Conservation and Restoration). Immerse the fixed and washed negative (a dry negative should be soaked in water for several minutes before treatment) quickly in the reducer and agitate constantly. Periodically take the negative out, rinse it in running water to stop

reduction, then examine its density and return it to the bath if necessary. Afterwards, wash it for at least 10 minutes before drying.

To apply the reducer locally, first place the negative on a light table with the emulsion side up. The negative should be wet. Wipe the excess water from the surface of the emulsion with a dampened and wrung-out cotton ball or a film sponge. Using a brush or a cotton ball, apply the reducer to the areas of the emulsion to be treated. Move the brush or cotton constantly to blend the edges of the reduced area. Flood the emulsion with water from time to time to stop the action, and study your progress. Wash the negative after treatment at least 10 minutes and hang to dry.

To accelerate the action of the reducer, increase the proportion of Stock Solution A used in making the combined solution.

Chemicals

Buying Chemicals

When you begin work with historical processes the first, and often most frustrating, step is to find a source for chemicals. If you live near a college or university there will usually be a laboratory supply department in the chemistry building where you can pick up supplies, or you can look in the back of this book for the address of a chemical supply house near you (for certain hard-to-find or especially expensive items you will probably need to use this list).

Many chemical suppliers prefer not to sell to individuals. There are several reasons. Although suppliers are not legally liable for injuries that result from the use of their products—as long as the product was labeled with appropriate warnings and otherwise properly represented—they are concerned about chemicals getting into the hands of children or being used for illicit purposes. Also, and perhaps more to the point, suppliers do not care for the clerical nuisance of processing small orders. If you find that a supplier is unwilling to sell to you as an individual, use the name of your educational or business affiliation.

When buying an expensive chemical, check prices from a number of suppliers. Quotations can vary considerably and it pays to shop around.

Scales

It will be necessary to have a small and accurate scale for weighing out chemicals. One of the best scales for photographic use is the Ohaus Series 700 metric triple-beam balance shown in Figure 116. It has a single pan to hold the chemical and a capacity range from 0.1 gram to 610 grams. You can extend the capacity by adding attachment weights. The scale is sensitive to 0.1 gram. It is available from chemical supply houses that deal in apparatus, or from the Edmund Scientific Company, 617 Edscorp Building, Barrington, New Jersey 08007.

A smaller scale, about half as expensive as the Ohaus Series 700, is the Pelouze R-47, made by the Pelouze Manufacturing Company of

FIG. 116
Ohaus triple-beam balance.

FIG. 117
Pelouze R-47.

Evanston, Illinois. It has two pans (one for the chemical being weighed, the other for the balance weights) and a beam that can be set for up to 3.2 grams, and currently comes equipped with either metric or avoirdupois (U.S. customary) weights. Choose the metric weights. Many professional camera stores carry this scale in stock or can order it from the manufacturer.

Weighing Chemicals. Before weighing out a chemical, place a clean sheet of paper on the balance pan. If you are using a single-pan balance such as the Ohaus Series 700, start by setting the poise on each beam at 0, then slide the 0–10 gram poise to the right until the scale balances. This gives you the weight of the paper. Next, set the poises for the required weight of the chemical *plus* the weight of the paper. Adjusting or compensating for the weight of the paper like this is only important when weighing small quantities. The paper is there simply to give you a means of conveying the chemical from the scale to the mixing container (Ohaus scales are available with accessory plastic or stainless steel scoops for this purpose). Use a fresh sheet of paper for each new chemical if there is any danger of contamination. Always place the chemical (and the paper) in the middle of the pan to avoid errors introduced by leverage.

When using a double-pan balance, such as the Pelouze R-47, first position the removable pans as shown in the photograph. The handles should be parallel to one another and perpendicular to the beam—otherwise the weight of the handles will put the scale out of balance. Slide the 0–3.2-grams poise all the way to the left and then use the adjustment screw as necessary to bring the scale into balance. If you decide to use paper, place a sheet in *each* pan — if they are the same size their weights should cancel out. Place the appropriate balance weights in the *middle* of the right-hand pan and adjust for additional weight by sliding the poise to the right as necessary. Add the chemical to the *middle* of the left-hand pan until the scale balances.

With any balance scale the most accurate way to judge the balance is by watching the oscillations of the pointer. Sometimes, especially on cheaper scales, friction at the fulcrum causes the pointer to come to rest at the center even though the scale is not in exact balance. The scale is properly balanced if the pointer, on being given a gentle nudge, oscillates in equal arcs to both sides of center.

Preparing Solutions

General Rules. Treat all chemicals as if they were poisonous—in sufficient quantities, most are. . . . Always read the warnings and directions given on the label Store chemicals beyond the reach of children Wash your hands after handling chemicals Clean spilled chemicals immediately from the worktable.

Keep the caps on chemical bottles screwed down tight. Some chemicals are *deliquescent*—they absorb water from the air (sodium hydroxide and ferric ammonium citrate are examples). If left in half-closed bottles, deliquescent chemicals can pick up weight in the form of additional water molecules, and this makes accurate weighing impossible. Deliquescent chemicals may also form a hard crust if left exposed. Other chemicals are *efflorescent*—they lose their normal water content when exposed to the air. Still other chemicals fume or evaporate. Loose caps on acid bottles can allow the escape of unsafe, corrosive fumes.

When mixing solutions, follow the temperature instructions given with the formula. Most, but not all, chemicals show increased solubility with increased water temperature. In many cases a chemical will dissolve only gradually when mixed at the solution's working temperature but will dissolve quickly when the water is warmer. Some chemicals liberate heat when dissolved, showing what is known as an *exothermic* reaction (ferric chloride and sodium hydroxide are examples). Such chemicals should be dissolved in cool water. Other chemicals are *endothermic*, absorbing heat when dissolved, which cools the solution (crystalline sodium thiosulfate—"hypo"—is an example of the latter).

Always dissolve chemicals in the order listed in the formula. The best policy is to wait until each chemical has dissolved before adding the next.

Formulas Given in Parts. In older photographic texts, formulas are sometimes given in *parts*. Simply convert the formula into equivalent units of grams and milliliters, or ounces and fluid ounces. A formula that calls for "7 *parts* silver nitrate and 60 *parts* water" could be rewritten as "7 *grams* silver nitrate and 60 *ml* water," or as "7 *ounces* silver nitrate and 60 *fluid ounces* water."

Percentage Solutions. Sometimes the amount of a chemical called for in a particular formula is too small to be weighed accurately. In such cases a percentage stock solution is made, from which a few milliliters (ml) or a few drops are used at a time. Percentage solutions are always prepared using compatible units: either grams dissolved in milliliters or in cubic centimeters (1 ml = 1.000027 cc; 1 cc of pure water at maximum density weighs about 1 gram), or ounces dissolved in fluid ounces.

The rule when making percentage solutions is to dissolve the chemical in less than the total volume of water, then add water to bring the total volume to 100 units or whatever multiple of 100 you may need. To make a 2% solution, for example, dissolve 2 grams (or, if liquid, 2 ml) of the chemical in about 90 ml of water, then add water as necessary to bring the total volume to 100 ml. The following are both 10% solutions: 5 grams dissolved in water to make 50 ml; 20 grams dissolved in water to make 200 ml.

Percentage by Weight. Sometimes chemicals are sold in solution and the percentage is given by weight. For example, a 25%-by-weight solution weighing, say, 8 grams would contain 2 grams of the actual chemical. Two grams is 25% of 8 grams. To weigh out a chemical from a percentage solution given by weight, take the number of grams you need and multiply this by the product of the percent (written as a whole number) divided into 100.

Example: If 5 grams of a chemical from a 37% solution is required, the formula would be $5 \times \frac{100}{37} = 13.5$. This means that 13.5 grams of the 37%-by-weight solution will contain 5 grams of the actual chemical.

To weigh out the amount of solution, place an empty beaker on a scale and find its weight. Then set the scale for the weight of the beaker plus the weight of the solution you need, as found by the formula. Pour the solution into the beaker until the scale balances.

Saturated Solutions. A saturated solution contains all of a particular chemical that the solvent can hold in solution at a given temperature. You can prepare saturated solutions by simply dissolving the chemical in the solvent until a small amount remains that cannot be dissolved. In most cases the temperature of the solvent can be raised to help the chemical dissolve faster. Then, when the solution cools to room temperature, the presence of undissolved particles confirms that it is saturated.

The amount of chemical actually in a saturated solution depends on the storage temperature. Generally, if the solution is allowed to cool some of the chemical will precipitate out. If the temperature is raised, the precipitate will redissolve until the saturation point for the higher temperature is reached, although it sometimes takes a considerable increase in temperature to begin to redissolve a precipitate formed in a solution stored below the recommended temperature.

Filtering Solutions. Figure 118 shows how to fold filter paper for use in a funnel. Before insert-

FIG. 118
How to fold filter paper.

ing the paper into the funnel, wet the inside of the funnel with tap water or distilled water—which-ever was used to make the solution being filtered. Then place the paper in the funnel. A "fast" filter paper like Whatman No. 4 is appropriate for most photographic filtering. A filter pump (see Figure 228) makes the job of filtering solutions faster and easier.

Some Chemical Terms Mentioned in the Text

Acids. By tradition, an acid is described as a substance that dissociates in water to produce hydrogen ions (H^+). Acid solutions have a characteristically sour taste, turn blue litmus paper red, and react with certain metals to release hydrogen. *When using acids, always add acid to water, never water to acids.* Water poured into an acid causes possibly dangerous heat and spattering.

Bases. A base is defined as a substance that dissociates in water to produce hydroxyl ions (OH^-). Bases, also called *alkalies*, have a characteristically bitter taste and turn red litmus paper blue. Basic solutions feel slippery and have a strong detergent-like action.

Salts. Acids and bases react together to form salts. The reaction also produces water. For example, when sulfuric acid, H_2SO_4, and the base sodium hydroxide, $NaOH$, react the result is sodium sulfate, Na_2SO_4, plus water, H_2O.

$$2NaOH + H_2SO_4 \;\blacktriangleright\; Na_2SO_4 + 2H_2O$$

In the above case the acid is completely neutralized by the base. Such a salt is called a *normal salt*. If a strong acid reacts with a weak base the result is an *acid salt*, a salt with acid characteristics. An example is ammonium chloride, NH_4Cl, the salt of a strong acid (hydrochloric) and a weak base (ammonium hydroxide). If a weak acid reacts with a strong base the result is a *basic salt*. An example is sodium carbonate, Na_2CO_3, the salt of a weak acid (carbonic) and a strong base (sodium hydroxide).

pH. The pH (potential of hydrogen) of a solution is a measurement of its acidity or alkalinity. The pH scale runs from 1 to 14; 7 being the neutral midpoint. In general, solutions in which ionization takes place contain both hydrogen (H^+) and hydroxyl (OH^-) ions. In an acid solution, the hydrogen ions predominate. Acid solutions have a pH value below 7. Each successive whole number from 7 down indicates a tenfold increase in the concentration of hydrogen ions. In an alkaline solution, the hydroxyl ions predominate. Alkaline solutions have pH values above 7. Each successive whole number from 7 up indicates a tenfold increase in the concentration of hydroxyl ions. A solution with a pH of 7 contains equal concentrations of hydrogen and hydroxyl ions.

Pure, distilled water has a pH of 7. Since distilled water takes in carbon dioxide from the air and forms carbonic acid, its pH usually drops to about 5. This does not, however, affect the pH of substances dissolved in the water later on.

A solution's pH can affect both the nature and the rate of its chemical reactions. For example, developing agents become active only in an alkaline environment, and developer activity increases with increasing pH value. Kodak Developer D-76, for instance, contains a weak alkali—borax—and works more slowly than Kodak Developer D-11, which contains a stronger alkali—sodium carbonate (both borax and sodium carbonate are actually basic salts).

The pH of a solution can also affect its keeping qualities, and the pH of a sensitive coating can affect its printing speed.

The pH measurement of paper stock is important because it gives an indication of the paper's probable archival characteristics.

It is possible to measure pH electronically, or by colorimetric indicator solutions, or by test papers dyed with indicator solutions. A glass-electrode pH meter is the most accurate pH measuring device, and also the most expensive (upwards of $100). Indicator solutions are slightly less accurate, and somewhat complicated to use. Test papers are the least accurate of all (about ± 0.25 pH, depending on the brand) but are convenient and inexpensive. Several brands are on the market and are available from most chemical supply houses.

pH Scale

Intensity | **pH degrees**
0.1 normal solutions

10,000,000	14
1,000,000	13 SODIUM HYDROXIDE
100,000	12 TRI-SOD. PHOSPHATE
	SODIUM CARBONATE
10,000	11 AMMONIA
1,000	10
100	9 SODIUM BORATE
10	8 SODIUM BICARBONATE
NEUTRAL	7 DIST. WATER
10	6
100	5 BORIC
1,000	4
10,000	3 ACETIC
100,000	2 CITRIC
	OXALIC
1,000,000	1 SULFURIC / HYDROCHLORIC
10,000,000	0

ALKALINE

ACID

A change of one degree pH amounts to a ten-fold change of intensity of the acid or alkaline reaction.

FIG. 119 pH values.

To use pH test paper, place a few drops of the solution on the paper and then match the color change against the pH color chart provided with the package. The test paper works best on buffered solutions. A *buffered solution* is one that contains reserve acidity or alkalinity, thus tending to maintain a constant pH. An alkaline buffered solution, for example, will maintain its pH even when acid is added, at least until the reserve alkalinity is used up.

Litmus paper, the most widely known pH indicator, only shows whether a solution is acid or base. In neutral solutions (pH7) the paper does not change color.

Oxidation and Reduction

Two interdependent chemical reactions, oxidation and reduction, are mentioned in this book. *Oxidation* is the *removal* of an electron or electrons from an atom or molecule. *Reduction* is the *addition* of an electron or electrons to an atom or molecule. Oxidation and reduction always occur simultaneously. One substance cannot be reduced (gain electrons) unless another substance is there to give up electrons and become oxidized.

An oxidizing agent is a substance that *takes up* electrons (consequently becoming reduced).

A reducing agent is a substance that *gives up* electrons (consequently itself becoming oxidized).

An oxidation-reduction (or *redox*) reaction takes place during the development of the exposed silver halide of photographic films and papers. Development in an organic reducing agent such as hydroquinone (a component in most developers) reduces the exposed silver halide to its metallic state. A platinum print is another redox example. Platinum paper is coated with ferric oxalate and potassium chloroplatinite. When exposed to light, the ferric ion is reduced to the ferrous state. In a suitable developer the ferrous ion in turn reduces the chloroplatinite to metallic platinum. In the process, the ferrous ion is oxidized back to the ferric state.

For more information on chemicals, see the *Photo-Lab-Index* or *The Compact Photo-Lab-Index*, both published by Morgan & Morgan, Inc.

Both contain excellent glossaries on photographic chemicals, including formulas, synonyms, and notes on their characteristics and uses. For further information on handling and storage of chemicals, see *Alternative Photographic Processes,* by Kent E. Wade (Morgan & Morgan).

At the end of this book you will find information on weights and measures and tables for converting units of one system into those of another.

Papers

The appearance and the permanence of your prints will depend largely on the paper stock on which they are made. With the historical processes you will generally not be using conventional photographic papers but high-quality artist's papers that you select and sensitize yourself. Because of this, it is helpful to know something about the characterisitics of paper. Following is an introduction to the ingredients and methods used in paper manufacture, together with information on applying sizing to paper (sizing, in effect, "waterproofs" paper) and recommendations on papers to use.

There is a lot of information here. The best plan, especially for the beginning printer, is to skim through the material now, then come back to it as necessary later on.

The Manufacture of Paper

Raw Materials. The basic ingredient of paper is cellulose fiber, and until the last half of the 19th century most of the fiber for papermaking came from the recycling of linen and cotton rags. Today, most papers produced for commercial printing, for specialized uses such as packaging, and for general use are made with cellulose fibers from wood, though many art papers and finer stationery papers are still manufactured from rag or raw cotton stock.

The first stage in paper manufacture is the reduction of the raw material to a pulp. The best and most durable paper has traditionally been made from the rags.

Rag Pulps. When the rags arrive at the papermaking plant they are sorted, cut into small pieces, inspected to remove buttons, elastic, and other foreign materials, and then passed under magnets to remove metal particles. They are next placed in a large, horizontal, cylindrical boiler, which rotates slowly while cooking the rags under pressure in a caustic (alkaline) solution. This treatment softens the cellulose fibers and removes any remaining noncellulose matter such as starch, dyes, or grease. A rinse follows, and then the rags are placed in a machine called a *breaker*. The

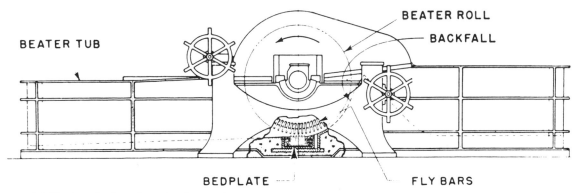

FIG. 120 Beater design (see next page).

breaker's mechanical action unravels the rags into a pulp of individual fibers, while constantly washing the pulp with a continuous flow of clean water. Calcium hypochlorite or chlorine gas is

FIG. 121
Unbeaten cotton fibers.

FIG. 122
Cotton fibers after beating.

then introduced to bleach the pulp. When the bleaching operation is over, the pulp enters a machine similar in design to the breaker, called a *beater*. The treatment the pulp receives in the beater determines in large part the eventual characteristics of the paper, as explained in part under the heading, *Dimensional Stability,* below. The beater shreds and mashes the fibers, creating tiny, hairlike *fibrils* that act to interlock the fibers when the paper is formed. During the beating operation, the fibers react with water in a process of hydration, resulting in the creation of a gelatinous material known as *hydrocellulose.* The longer the pulp is beaten, the more hydrocellulose is produced.

Other materials are often added during beating, including sizing, dyes, and clay or chalk fillers. These fillers, also called *loading*, increase the opacity of the paper and improve its receptivity to printing ink. Wood pulp will be added to the beater if the paper is to be a combination of wood and rag. The mixture that finally results is called *stuff*. The next stage is to form the stuff into paper.

Wood Pulps. Cellulose fibers other than those taken from rags or from raw cotton, such as esparto grass and straw fibers, can also be used for papermaking. The familiar Japanese rice paper is not made from rice but from mulberry bark. Most paper manufactured today is made from wood pulp, refined according to processes introduced in the mid-19th century to supply an increased demand for paper in the face of a relative scarcity of rags. Wood consists on the average of about 50% cellulose and 30% lignin, with the remainder made up of carbohydrates, proteins, resins, and fat. Lignin is a substance related to cellulose and is the binding material in the cell walls of plants. For high-grade papers, the lignin and other noncellulose matter must be removed.

There are two types of wood pulp: *mechanical* and *chemical*. Mechanical (*groundwood*) pulp is cheaper. It is prepared by first removing the bark from a log and then grinding the log into a pulp against a special grindstone. Newsprint is about 85% groundwood and 15% sulfite pulp (see below). Paper made with groundwood pulp is fragile because the fibers are short, and it turns

yellow and disintegrates with age as the lignin breaks down into acid by-products.

Two processes are used for production of chemical wood pulps. The *sulfate* pulping technique is an alkaline process that is mainly used with coniferous wood because it can dissolve out thick coniferous resins. In this process, wood chips are dumped into a vertical boiler and cooked under pressure in a solution containing sodium sulfate and other chemicals. This produces a pulp used to make sturdy papers of the kraft type. Because the process does not completely dissolve out the lignin, it is not possible to bleach the pulp. The brown paper that eventually results is used for wrapping and containers, and for paper bags.

In the second method, the acid *sulfite* process, the wood chips are boiled in a solution containing calcium or magnesium bisulfite and sulfur dioxide. At the end of this chemical treatment the pulp is passed through a screening device that removes any large fibers or incompletely processed bundles of fibers. Unlike sulfate pulps, sulfite pulps can be bleached, and this is usually the next step. Bleaching whitens the pulp and further refines it by removing residues of noncellulose matter, some of which can be harmful to the paper if allowed to remain. After bleaching, the pulp undergoes the beating process described above for rag pulps. Sulfite pulp is used in most book papers. Stationery and ledger papers and the less expensive art papers are often a combination of sulfite and rag pulps. Commercial photographic papers are made from highly refined sulfite pulps.

Handmade Paper. Paper is formed by spreading the cellulose pulp mixture over a finely woven wire screen. For handmade papers, this is done with a hand mold consisting of a wire screen attached to a wooden frame, surrounded by a wooden rim called a *deckle*. The screen gives a texture to one side of the paper: *Wove* paper has a fine texture resulting from a tightly woven screen; *laid* paper has a pattern of linked parallel lines. Sometimes an identifying watermark is woven into the screen and leaves its impression in the wet pulp.

The screen is submerged in the pulp solution and then lifted out horizontally, so that the water drains through, leaving the cellulose fibers behind. As the water drains, the frame is shaken to interlock the fibers. It takes considerable skill to do this by hand and produce paper of consistent quality. The deckle is then removed and the frame turned over onto a felt pad, depositing the newly formed sheet. Another felt pad is laid over the sheet; a pile of wet sheets alternating with felt pads is gradually built up. The pile is eventually placed in a press where as much of the remaining water as possible is forced out under pressure. Finally, the individual sheets are removed and arranged on racks to dry.

Machine-made Paper. Most papers today are not made by hand but by a machine that performs essentially the same function as the traditional hand mold. The chief difference is that in the machine the wire screen, known as a *Fourdrinier screen*, is a continuous belt. The pulp (which is mostly water and contains only 0.2% to 1.5% fibers) flows out over the screen as it moves forward. Along with its forward motion, the screen vibrates from side to side, causing the pulp fibers to interlock as the water drains through the wire. The continuous sheet (or *web*) of paper thus formed passes under a cylinder called a *dandyroll*. The dandyroll levels the surface of the paper and can press into it a texture pattern or a watermark. The web is now consolidated to the point where it can carry its own weight. It passes across

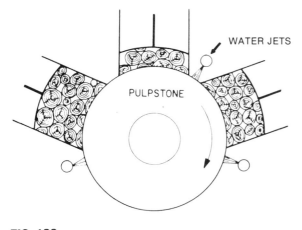

WATER JETS

PULPSTONE

FIG. 123
Design of a mechanical pulper.

a gap onto a continuous felt, which in turn carries it through rollers that force out more water. Sometimes these felts are specially woven to press a pattern into the paper's surface. The web next passes over a series of heated drying cylinders and then through calendering rollers, which level and smooth its surface. Super-calendered (or *hot pressed*) paper has a very smooth surface—the result of passing through heated rollers under great pressure. *Cold-pressed* paper is calendered under cold rollers and has a slightly textured surface. Finally, the web is wound onto a roll or cut into individual sheets.

Mold-made Paper. Another type of paper-making machine is called the *mold* machine. Mold-made papers are similar in appearance and characteristics to handmade papers and generally are made from the same high-quality pulps. The mold machine consists of a cylindrical frame that supports a wire screen divided into sections by strips of waxed cloth. Since the wet pulp will not stick to the waxed cloth, the positioning of the cloth strips regulates the size of the sheets. The cylinder rotates through a vat containing the pulp mixture and picks up the pulp on the outer surface of the wire. The sheets thus formed are transferred to felt pads and are stacked for pressing, after which they are laid on racks to dry. Rives BFK and Arches Cover are examples of mold-made paper.

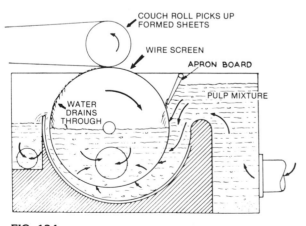

FIG. 124
Mold papermaking machine.

Coating. The surface of paper manufactured for printing with letterpress or offset lithography is often coated to give it a smoother texture and improve its printing characteristics. Coatings usually consist of a pigment and an adhesive (or *binder*). The most frequently used coating pigment is clay, though talc, calcium carbonate, titanium dioxide, calcium sulfate, and barium sulfate are also used. Barium sulfate, also known as *baryta*, is used on commercial photographic papers. On photographic papers the baryta coating lies between the paper stock and the sensitive gelatin emulsion. Starch is the most common adhesive (the binder for the baryta coating on photographic papers is usually gelatin); next in popularity is casein, and then synthetic adhesives.

The coating can be applied to the paper at some point during the drying operation, or in an additional operation after the paper is dry. In the *cast* coating process the coating dries on the paper while in contact with polished, hot, rotating cylinders. This treatment gives a high gloss and a very smooth surface.

Except with the collotype process, the only reason the photographer who uses historical processes needs to know about glossy coated papers is so that he or she can avoid them, at least to start with. The glossy surface is difficult to use in sensitizing by hand because the sensitizer will not take to it evenly: It tends to slide across and puddle up instead. The chemicals in the coating may also interfere with the reactions of the sensitizer. Glossy photographic papers (or matte photographic papers), however, can be used for hand-sensitizing if first fixed in a nonhardening, plain sodium thiosulfate fixing bath. The gelatin will take the sensitizer by absorption.

Technical Characteristics of Paper

Felt Side and Wire Side. The side of the paper that rests in contact with the wire screen of the Fourdrinier papermaking machine or the mold cylinder during manufacture is known as the *wire side*. The opposite side is the *felt side*. The wire side of the paper is usually covered with a geometical pattern of lines formed on the paper

by its contact with the screen. Sometimes this pattern shows itself only on close examination, and sometimes it is quite distinct. The felt side of the paper has a less mechanical, more random texture. On watermarked paper, the side on which the watermark reads correctly is the felt side. Watermarks are often a nuisance in photographic work because they can show up in the final print.

On some papers the wire side appears smoother than the felt side; on other papers just the opposite. If the paper has been calendered to a smooth surface it will often be difficult to tell the two sides apart, but as soon as the paper is put in water and the cellulose fibers begin to swell the difference may become obvious. This is the case with hot-pressed Strathmore Artist Drawing paper. Strathmore papers are not watermarked, but the large single sheets carry a corner-stamp that reads correctly on the felt side. Paper bound in pads has the felt side on top.

When a sheet of paper dries after soaking in water it will usually show a rougher texture than when new. This is important to remember when you buy paper, because it means that the texture of the paper you examine in the store will be smoother than the texture of the final print. If you print on the wire side of the paper, it is possible that after the print dries its surface will have a decided mechanical texture. This is often a subtle point, and you will have to decide for yourself whether the texture detracts from the quality of the print.

Machine and Cross Direction. The *machine direction*, or *grain direction*, of paper is the direction in which the paper moved through the Fourdrinier papermaking machine in manufacture. Because of the tension of the web, the cellulose fibers tend to line up in that direction. As a result, the paper has different characteristics in the machine direction than in the direction at right-angles, the *cross direction*. Paper generally has higher folding endurance when folded parallel to the machine direction, and also tears more easily and uniformly parallel to the machine direction. Books are manufactured (or should be manufactured) so that the machine direction of the paper is parallel to the spine of the book.

With handmade and mold-made papers, the distribution of the fibers is more random; they interlock in all directions. This makes these papers stronger than Fourdrinier-machine papers and also makes their characteristics more uniform in all directions across their surface.

You can determine the machine direction of a sheet of paper by cutting out a small circle and floating it on a pool of water: The paper will curl—the axis around which it curls is the machine direction.

Dimensional Stability. When a sheet of paper is dampened or placed in a moist atmosphere, its fibers swell. As the paper dries, its fibers contract. This leads to the expansion and contraction of the sheet as a whole. Paper tends to expand and contract more in the cross direction than in the machine direction. One reason is that as a newly formed sheet of paper dries on the papermaking machine the tension that pulls it along keeps it from shrinking in the machine direction, while in the cross direction it can shrink freely. This treatment in effect conditions the paper so that in the future it will expand and contract more in the cross direction than in the machine direction. Another reason is that individual cellulose fibers can swell laterally (in diameter) as much as 20% from the dry state (equilibrium with the moisure in the atmosphere) to the saturated state. The swelling along the length of the fiber, however, is no more than 5% of the lateral swelling. Since the fibers tend to line up parallel to the machine direction, the least swelling and contraction occurs in this direction. Handmade and mold-made papers will expand and contract about equally in all directions because their fiber direction is random.

Papers made from highly beaten, hydrated pulp usually have greater strength than papers made from less hydrated pulps. The high degree of interfiber bonding and the density of the former make them strong—but also less dimensionally stable, because changes in the fiber size due to changes in water content have a greater combined effect on the expansion and contraction of the entire sheet. Papers made from less hydrated pulp tend to be less strong because fewer bonds are formed between the fibers, but since these

papers are less dense in structure, each fiber has more freedom to move. Thus the dimensional stability of the paper is greater because the swelling or contraction of the fibers has less effect on the dimensions of the entire sheet.

You will discover the importance of all this when you work with multiple-printing techniques involving repeated registration of the negative. In such cases the negative should be printed with its long side parallel to the machine direction of the paper to minimize the effects of expansion and contraction.

Sizing. This is the term for the noncellulose material that is added to paper to increase its strength and its resistance to penetration by liquids or inks. Size is added either to the pulp in the beater, when it is known as *body sizing* or *engine sizing*, or is coated on the surface of the formed paper. The latter is known as *surface sizing* or *tub sizing.*

In the production of handmade and mold-made papers, individual sheets are commonly immersed in a tub of hot gelatin (also called *glue*) or starch and afterward hung up to dry. This coats the fibers and seals the spaces in between. When papermaking machines came into use at the beginning of the 19th century, papermakers looked for a way to avoid this step by adding the sizing material directly to the pulp in the beater. The method they adopted starts with the partial or complete saponification ("making into soap") of rosin in an alkali. The resulting emulsion is added directly to the pulp in the beater. Alum is added to lower the pH to between 4 and 6, which causes a fine precipitate of rosin, alumina, and basic aluminum sulfate to attach itself to the paper fibers. This technique is called *alum-rosin sizing.*

Problems of Permanance

The presence of acid is the main factor leading to the deterioration of paper. Acid can come from several sources. Sulfur dioxide from a polluted atmosphere can be absorbed by the paper and converted into sulfuric acid. The noncellulose materials found in poorly refined chemical wood pulp and in groundwood pulp can decompose to form acid by-products, as can the chemical residues left after pulping and bleaching. The strong chemical treatment necessary with wood pulps can also make cellulose deteriorate. Pulps made of cotton or linen fibers require less severe processing than those made of wood, and consequently fewer long-term problems are likely to result.

The alum-rosin method is a cheap and effective way to size paper, and its use is widespread throughout the papermaking industry. Yet alum-rosin size is probably the most important source of acidity in paper. The hydrolysis of the alum forms sulfuric acid, which leads to the physical breakdown and the discoloration of cellulose fibers.

The best paper for permanence and strength is an acid-free cotton or linen paper made without alum. With careful processing, however, papers with excellent *archival* characteristics can be made from sulfite wood pulps—for example, commercial photographic papers. In archivally safe sulfite papers a nonacid size, such as Aquapel, is used, and the paper often contains calcium, magnesium, or barium carbonate to act as an alkaline buffer to neutralize acid. *Permalife* is one such alkaline-buffered paper.

The important thing, whatever the pulp, is the absence of acid and the absence of substances that in time will produce acid. Despite what the clerk in an art store may say, the fact that a paper is made entirely from cotton does not necessarily mean that it is acid-free.

Tests for Acidity. A pH test can determine whether a paper is acidic. It is impossible to point to an exact threshold pH value above which a paper is archivally acceptable, but a pH of 5 or lower is generally considered to be of less than archival standard. A pH between 6 and 8 is best for long-term stability.

The *cold extraction* test is probably the most accurate way of measuring the pH of a paper sample. This method calls for an electric pH meter. Weigh out one gram of paper, tear it up and place it in a beaker. Then mash it with a stirring rod in 20 ml of distilled or de-ionized water. Add 50 ml more water and cover the beaker. After one hour,

stir the contents and measure the pH with the meter.

Another—but less accurate—method is to dampen the paper with distilled or de-ionized water and wrap it around a sheet of color-indicator pH paper, such as Hydrion Short Range Paper. Press the combination together between two sheets of glass, or other chemically inert surfaces, and after one hour compare the color of the pH paper with the color chart that came with it.

Archivist's Pen kits for pH testing are also available. These are felt-tipped pens that contain an indicator solution and can be applied directly to paper moistened first with distilled or de-ionized water. Archivist's Pens are available from the Talas Division of Technical Library Services, 104 Fifth Avenue, New York, New York 10011.

The pH figures given below are mostly the results of cold extraction tests made on paper samples by the Conservation Department of the Fogg Museum at Harvard University. Other samples of the same papers might produce different readings.

Rives BFK pH 6.1-6.2
(The pH of BFK, according to the distributor, averages about 5.5).

Fabriano Text	pH 6.5
Rives (white)	pH 6.2
Arches Cover	pH 4.6
Glassine	pH 4.6
Fabriano (hot pressed)	pH 6.3
Fabriano Italia	pH 5.9
Mohawk Superfine Cover	pH 8.8
Olde White Permalife Bristol	pH 7.6
Permalife Cover	pH 8.1
Strathmore Artist Drawing	pH 5.1
Strathmore Museum Mounting Board .	pH 6.3

Crane's Kid Finish AS 8111 *(according to the manufacturer)* pH 5.0-5.2

Strathmore Artist Watercolor *(according to the manufacturer)* . . . "acid-free"

Strathmore Artist Print *(according to the manufacturer)* "acid-free"

An alkaline-buffered paper like Mohawk or Permalife gradually loses its high pH as it is exposed to carbon dioxide in the atmosphere. It becomes nearly neutral, but it continues to buffer against acid until finally exhausted.

Other factors concerning the archival permanence of paper, and of photographs in particular, are described in the section on Conservation and Restoration.

Sizing Paper For Yourself

As a rule, paper for coating and printing with any of the historical processes should be well sized. The sizing helps keep the sensitive coating on the surface of the paper. Otherwise, the image can literally be sunken-in, which results in poor tone separation in the shadows and possible difficulty in clearing the paper of that portion of the sensitive coating not affected by exposure to the printing light. The sizing material often enters into the chemical reactions that take place in the sensitive coating and through this affects the tonal scale and color of the image.

You can usually find papers for sensitizing that do not require any extra sizing. Two such papers are Strathmore Artist Drawing and Crane's Kid Finish AS 8111. These are given enough sizing in manufacture so that no additional sizing is necessary for most sensitizing procedures. Strathmore Artist Drawing paper is sold in most art stores in pads and in large sheets. The sheets are available in one-ply and also laminated together in multiple plies, forming what is generally referred to as *bristol board.* In bristol board the sheets are glued together with a starch-based adhesive that tends to soften when the paper is immersed in water, causing the plies to separate and often resulting in what appear to be bubbles or blisters. This starch layer also may tend to absorb chemicals that instead should be washed out of the paper after processing. For these reasons it is best to avoid multiply papers. Any minor creases or dents found in single-ply paper as it comes from the store will flatten out when the paper is placed in water during processing.

Crane's AS 8111 is not available in art stores but can be ordered through the stationery depart-

ments of most department stores. The largest size the paper comes in is 21.6x28cm (8½x11 in.). Crane's AS 8111 has relatively poor wet-strength and can easily be torn when wet. This makes it unsuitable for gum printing. Although this paper is body sized with alum-rosin and has a low pH, it is recommended anyway because it is relatively inexpensive, has an attractive but not excessively textured surface, and prints well with every process with the exception given above. Crane's AS 8111 is also surface sized with starch by the manufacturer.

Rives BFK is another paper that has become popular for work with the historical processes. BFK is manufactured unsized and lightly sized ("quarter-sized"). Because of its limited sizing, BFK tends to be absorbent, and it is generally best, though not essential, to size it before use in order to keep the sensitive coating from sinking too far into the paper's surface. BFK, as well as any other paper you may decide to use, can be sized with gelatin, starch, or synthetic size as described below.

Preshrinking. When a sheet of paper becomes wet it expands; as it dries, it contracts. The first time the sheet gets wet it will usually contract to less than its size when new. It is important to take this into account when making multiple prints with gum or with other processes where re-registration is necessary. Unless the paper has been preshrunk it will usually be impossible to register the negative again over the image for the second and subsequent printings.

If you plan to use paper for multiple printing where proper registration is important, shrink the paper first: Immerse it in water at about 39°C (100°F) for about 10 minutes, then let it dry before sizing it as described here. Even though the paper will be immersed in the sizing bath anyway, and usually more than once, it generally should be soaked and dried first *before* sizing.

Gelatin Sizing. Dissolve 28 grams of gelatin (4 envelopes of Knox gelatin) in 1 liter (1000 ml) of cold water. Allow the gelatin to swell for 10 minutes and then heat the solution to 43°C (110°F). Pour this into a tray and then place each sheet of paper in the solution. Turn the paper over

at least once to be sure that both sides are covered.

At the end of 1 minute, lift the paper and allow the excess solution to drain back into the tray. It may be necessary to draw the surface of the paper over a glass rod, a towel rod, or the round edge of a darkroom tray in order to wipe off the excess gelatin and any bubbles that may have formed. This step usually is not necessary when the gelatin solution is hot, but as it cools in the tray the gelatin tends to leave a thicker coating, which may require smoothing.

Hang the paper with spring clothespins on a line to dry. Do not stretch it tight when hanging it up; instead, bow it slightly so that it can shrink freely as it dries.

The sizing can also be applied to the paper on one side only. Use a wide brush or a sponge— wring it out in hot water before dipping it in the gelatin.

Give the paper a second coat of sizing after the first has dried. This time, reheat the solution and add 25 ml of formalin (37% formaldehyde) to each liter of gelatin solution. The formalin will harden the gelatin as it dries. The fumes from the formalin are very irritating; so use it only in a *well ventilated* area. After coating the paper this second time, hang it *by the opposite end* to equalize the coating. Throw out the gelatin after use, once formalin has been added.

Between coatings, store the gelatin (without formalin) in the refrigerator. Properly covered, it will keep there for at least several days, and can be reheated as necessary. Repeated reheating or prolonged heating of the gelatin, however, will eventually destroy its ability to set. About one drop of a saturated solution of thymol crystals dissolved in methyl or denatured alcohol added to each 30 ml or so of gelatin solution will help preserve it between use. Thymol, in the same proportions, can also be used to preserve the starch size given below. Store the thymol solution in a brown bottle in a cool place.

CAUTION: Thymol is poisonous.

If you prefer, you can size the paper the second time in the gelatin without adding formalin. Afterwards, let the paper dry and then soak it in a liter of

water containing 25 ml of formalin. Use this at about 18°C (65°F) and soak the paper for 1 minute. Hang it in a well-ventilated area to dry. Because the formalin evaporates, it is not believed that treating paper in it produces any long-term harmful effects (as could treatment in potassium alum, the hardener recommended in many sizing formulas).

Starch Sizing. Dissolve Argo starch (or other corn starch), available in grocery and super-markets, in

Water, about 21°C (70°F) *80 ml*
Starch *5 grams*

Place 200 ml of water in a saucepan and bring to a full boil. Add the starch solution and boil for about 3 minutes. Remove the starch from the heat, but use the solution while still warm. Coat the paper as described above for gelatin sizing. The starch solution can be kept for a time in the refrigerator (covered) and rewarmed for use.

Unlike gelatin, starch cannot be hardened effectively and is therefore a less durable sizing material, not recommended for multiple-printing techniques.

Many printers starch-size paper with aerosol spray starch, as sold for use in the laundry.

A commercial nonacid size such as Aquapel 380 (available from Talas at 104 Fifth Avenue, New York, New York 1011) can also be used to size papers for historical photographic processes.

Sensitizing and Printing

Sensitizing Paper

It is not difficult to apply a sensitive coating to a sheet of paper, but it does take some practice. Often, the first attempt results in disaster, but the knack comes quickly on the second or third try. Paper is sensitized by brushing on the sensitizing solution or by floating the paper on the solution in a tray. Of the two methods, brushing is usually the most efficient and economical.

Brush Coating. In addition to a wide, flat artist's brush, or a Japanese brush (Figure 126), you will need a wooden board or a sheet of stiff cardboard somewhat larger than the paper to be sensitized.

Trim the paper, if possible, to a size about five centimeters (two inches) or more larger on all sides than the actual area to be sensitized. Use pushpins to fasten the paper by its corners to the board. If the sensitizing solution is expensive— platinum, for example—first outline the area for sensitizing with guide marks as shown in Figure 125. With an inexpensive sensitizer, or when you want to include the brush strokes themselves as part of the image, you can judge the area by eye, coating a space larger than the negative and then trimming the paper as required.

When brushing on the solution, use only as much as necessary to cover the surface of the paper. Do not flood it. If you start with too much solution, puddles can form that may then be impossible to smooth out for a uniform coating. How much sensitizer you need will depend on the process and on the area to be covered, and also on the amount of sizing the paper contains. Poorly sized papers require greater amounts of sensitizer because they tend to absorb it before it can be spread across the surface. As a rule, a 20x25 cm

FIG. 125
Guide marks for sensitizing. Make them outside the image area.

(8x10 in.) print on a reasonably well sized paper requires 2¼ to 3 ml of sensitizer, taking into account a little extra solution to produce a margin around the image area for test strips.

With inexpensive sensitive coatings, such as cyanotype, the easiest way to proceed is to first dip the sensitizing brush into the solution, squeeze out the excess against the side of the container, and then spread it across the paper with *long, parallel strokes*, first from side to side and then up and down. Continue brushing *only* until the coating is smooth. Too much brushing can abrade the paper.

Dry the paper with a hot plate or a blower hair dryer, or simply hang it to dry in the dark. An initial heat drying is usually a good idea because heat helps to dry the solution before it has a chance to

sink too far into the surface of the paper. Remember to wash out the brush after use.

When coating with expensive solutions (platinum or silver), first rinse the brush out in tap water and then squeeze it almost dry. This helps prevent the brush from absorbing the sensitizer. Then pour a measured amount of the solution in a line down the center of the paper, as shown in Figure 126. Spread it across the paper with the brush, keeping the solution within the guide marks described above. Wash the brush out after use.

Tray Sensitizing. For certain reasons you may decide that you prefer to sensitize paper by floating it on the solution in a tray. Obviously, this method is only practical with sensitizing solutions that can be prepared economically in quantity.

Use a flat-bottomed tray, filled with at least 6mm (¼ in.) of solution. Make sure that the surface of the solution is free of bubbles, and then, as shown in Figure 129, carefully lower the paper onto it—middle first, to avoid trapping air bubbles underneath. As the underside becomes saturated the paper will begin to curl away from the solution. Place your hands over the paper and gently hold it down. It should gradually become limp. (Some papers tend to curl uncontrollably. Before floating, these should be steamed on both sides over hot water to equalize the expansion of the fibers on both sides of the sheet.) After the paper becomes limp, remove it by drawing it across the edge of the trays as in Figure 129. This will wipe off the excess sensitizer and should even out the coating. Dry the paper as directed above.

If you want your print to have a glossy or semi-matte surface, you can use regular photographic paper for sensitizing. First fix it in a plain thiosulfate or other nonhardening fixer, then wash it thoroughly. The sensitizer can be applied with a brush or by floating the paper in a tray. Streaks occur more frequently with glossy paper, but with a little practice in sensitizing they can be avoided.

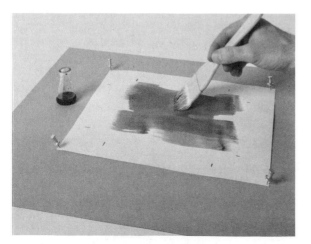

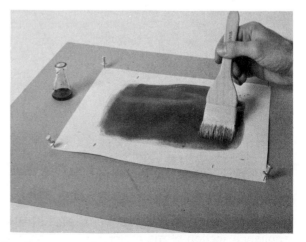

FIG. 127, 128 Brush from side to side, then up and down.

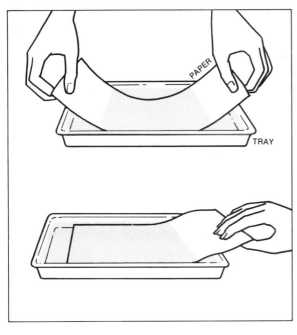

FIG. 129
Tray sensitizing.

Equipment for Printing

Printing Lights. The printing processes described in this book have their maximum sensitivity in the ultraviolet end of the spectrum—generally in the far ultraviolet, to wavelengths shorter than those actually transmitted by the glass in the printing frame. Since glass will not transmit wavelengths shorter than about 300 nanometers, the most effective wavelengths are absorbed before they even reach the paper. Of the longer wavelengths that do reach the paper, most of the processes have peaks of sensitivity in the 350-360 nanometer region. To be effective, this is where the printing light should emit the substantial portion of its radiation. (Figures 130-132.)

One relatively inexpensive source of ultraviolet light is the RS Sun Lamp manufactured by GTE Sylvania. It is a 275-watt self-ballasted mercury lamp with a built-in reflector and is available in the appliance section of many department stores. It requires a warm-up time of approximately two

minutes to reach its full ultraviolet output. Once the lamp has been turned off, a three-minute delay is usually necessary before it will restart. More powerful lamps of the mercury variety may also be used for printing. They should be of the clear-glass type—not phosphor-coated.

Black-light fluorescent tubes are another source of ultraviolet light. These radiate most of their energy at about 350 nanometers. The BL bulb is preferred to the more expensive BLB, which differs from the BL in being made with a

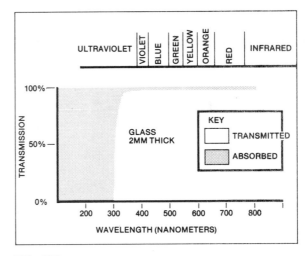

FIG. 130
Transmission characteristics of glass.

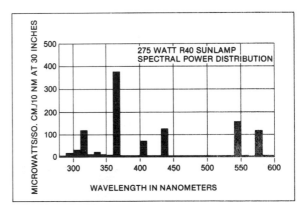

FIG. 131
Spectral radiation of a Sylvania 275-watt sun lamp.

FIG. 132

Spectral radiation of a Sylvania BL black light fluorescent tube.

special filter glass that absorbs most of the visible light. You can construct a bank of BL tubes in fluorescent-lamp fixtures to use as a printing light.

Other types of printing lights are those commonly used in the graphic arts industry, including carbon-arc lights and the more recent and more powerful pulsed-xenon lights. These are the quickest printing artificial sources, and also the most expensive. The smallest carbon arc that I am aware of is the NuArc N20S, which costs about $400 new. Used carbon arcs can often be bought for considerably less at auction.

The sun is an excellent printing light, the quickest of all, and the most economical, too.

Ultraviolet light in the wavelengths between 260 and 288 nanometers is harmful to the eyes, causing a corneal inflammation (keratitis) that only becomes apparent, in symptoms of pain and intolerance to light, some six to twelve hours *after* exposure. If this should occur—and there is no reason it should except for carelessness—*do not use eye drops*. See an ophthalmologist *immediately*. Ordinary window glass or crown glass (spectacle glass) absorbs light at these wavelengths and provides adequate protection. The most dangerous light sources are those not enclosed in glass, such as carbon arcs and quartz-enclosed mercury and pulsed-zenon lamps, and

to a lesser extent the Vycor glass of an RS Sun Lamp. *Avoid looking directly into these light sources.*

If you find that it is necessary to "burn in" an area of your print for additional density, you can adopt a trick of Paul Strand's and use a magnifying glass to focus more light on the area during the general exposure. Be careful not to burn the negative!

Safelights. Unless noted, the techniques in this book that call for hand sensitizing can all be done under an ordinary 60-watt tungsten incandescent bulb about four feet (1.2 meters) from the sensitive coating. Actually, considerably brighter tungsten light can be tolerated for brief periods, but always store sensitized paper in the dark. Since all fluorescent lamps emit some ultraviolet radiation, ideally they should not be used in the area where sensitive paper is handled. In work areas in most schools fluorescent lights seem inevitable, but the brief periods of time that sensitive materials are exposed to them during coating and during loading into printing frames in most cases will do no harm. Use fluorescent tubes of the "warm white" type if possible. *Direct daylight should be excluded* from the work area.

Printing Frames. The old-fashioned hinge-back wooden contact printing frame is designed

FIG. 133

Contact printing frame. A No. 2 Step Tablet is next to the negative.

so that one side can be folded back for examination of the image during printing without disturbing the registration of the negative. This is one piece of equipment you cannot do without.

Buy a printing frame at *least* one size larger than the image size you intend to print. This way you can avoid the nuisance of having to trim off the borders of the paper around the sensitized area before loading the paper into the frame. You may have to put a rubber pad inside the frame to ensure firm and complete contact between the negative and the printing paper.

Exposure Computations Using Density Readings

Printing with the historical processes can be time-consuming because long exposures are often required. If a number of test exposures have to be made, and if developing the image takes a while, considerable time can be spent just tracking down the correct exposure for the particular negative and printing process in use. There is a way to compute exposures using density readings and a little simple mathematics. It can save time and it can save on the use of sometimes costly materials. The only necessary tool is a No. 2 Step Tablet, although having a densitometer along makes things a bit more certain.

It should be understood that different batches of sensitizer can have different printing speeds. This can be due to a difference in the quantity of a contrast agent, or to a difference in the age of the sensitizer or the sensitive coating, or to the use of a different paper stock. Sometimes apparently identical formulas produce sensitizers having speeds that differ considerably, and the reasons why this happens may not always be easy to track down. Because of these variations, it is best if the exposure time can be computed on the basis of the speed of the sensitized material actually in use. A computation based on a standard print made using a sensitizer mixed at another time is often inaccurate because of the printing-speed variation possible from batch to batch. The procedure given below takes this into account. It will work only if printing is done with a light source of constant intensity placed at a fixed distance from the printing frame.

Place a No. 2 Step Tablet next to your negative during printing. After the initial trial exposure and development, find the tone printed under the tablet that is *just perceptibly darker than the paper* itself. You will use this highlight tone as your exposure guide. Write down on a slip of paper the density of the step on the No. 2 Step Tablet from which this tone was printed.

Use the table in Figure 108 to find the density of the step, if your own tablet has not been calibrated.

Next, examine the negative on a light table. Find the area in the negative that in the final print should show the same tone as the highlight tone from the step tablet. Measure the density of this area of the negative with a densitometer, or visually by comparing it with the known densities of the tablet when negative and tablet are placed side by side on a light table. Write this density down on your slip of paper.

Subtract the lower number from the higher.

Take the resulting number and refer to the table in Figure 134. This will give you a correction factor (the table is actually a transmittance/opacity table in disguise). Find the number in the density column and read across. Find the correction factor in either the *Increase Exposure* column or the *Decrease Exposure* column, depending on whether you need to increase or decrease the exposure for the final print as compared with the initial test print.

Multiply the appropriate correction factor by the exposure time given the initial print. The result is the new exposure time.

An example: If the density of the highlight step in the tablet was 1.05, and the same highlight tone in the final print is desired from an area of the negative having a density of 1.25, the difference between the two is $1.25 - 1.05 = 0.20$. In this case an increase in exposure is necessary to make the final print. The number in the *Increase Exposure* column opposite 0.20 density is 1.58. If the original exposure time was 6 minutes, the new exposure time will be $6 \times 1.58 = 9.48$ minutes (9 minutes and 28.8 seconds).

EXPOSURE CALCULATION TABLE

Highlight Density Difference	Increase Exposure (multiply original exposure by)	Decrease Exposure (multiply original exposure by)	Highlight Density Difference	Increase Exposure (multiply original exposure by)	Decrease Exposure (multiply original exposure by)
0.05	1.12	0.89	0.33	2.14	0.47
0.06	1.15	0.87	0.34	2.19	0.46
0.07	1.17	0.85	0.35	2.24	0.45
0.08	1.20	0.83	0.36	2.29	0.44
0.09	1.23	0.81	0.37	2.34	0.43
0.10	1.26	0.79	0.38	2.40	0.42
0.11	1.29	0.78	0.39	2.45	0.41
0.12	1.32	0.76	0.40	2.51	0.40
0.13	1.35	0.74	0.41	2.57	0.39
0.14	1.38	0.72	0.42	2.63	0.38
0.15	1.41	0.71	0.43	2.69	0.37
0.16	1.44	0.69	0.44	2.75	0.36
0.17	1.48	0.68	0.45	2.82	0.35
0.18	1.51	0.66	0.46	2.88	0.35
0.19	1.55	0.64	0.47	2.95	0.34
0.20	1.58	0.63	0.48	3.02	0.33
0.21	1.62	0.61	0.49	3.09	0.32
0.22	1.66	0.60	0.50	3.16	0.32
0.23	1.70	0.58	0.51	3.24	0.31
0.24	1.74	0.57	0.52	3.31	0.30
0.25	1.78	0.56	0.53	3.39	0.29
0.26	1.82	0.55	0.54	3.47	0.29
0.27	1.86	0.54	0.55	3.55	0.28
0.28	1.90	0.52	0.56	3.63	0.27
0.29	1.95	0.51	0.57	3.71	0.27
0.30	2.00	0.50	0.58	3.80	0.26
0.31	2.04	0.49	0.59	3.89	0.26
0.32	2.09	0.48	0.60	4.00	0.25

(exposure factors are rounded to the nearest hundredth)

FIG. 134

At some point, give this exposure calculation technique a try. You can apply it to all the historical (and for that matter modern) printing methods, but it is especially helpful when working with techniques like platinum and carbon and when exposing a gelatin resist for gravure—processes in which accurate judging of the exposure from the faint printing-out image is impossible.

Salted Paper

Our subject here is Talbot's original printing technique, along with certain of its later modifications. It is best to use the term *salted paper* when referring to the process. This is not a particularly inspiring title, but using it will avoid at least one third of the usual confusion between the terms *calotype*, which really applied to Talbot's process for making negatives, *kallitype*, the name of ferric (iron) printing process, and *collotype,* a photomechanical technique.

In the salted paper process, paper is first treated in a chloride solution. After drying, it is coated with a solution of silver nitrate and dried again. It is printed-out under a negative, rinsed in water, toned if desired, fixed, and given a final wash.

Paper. Crane's Kid Finish AS 8111 gives excellent results with salted paper, as does Strathmore Artist Drawing. Rives and Rives BFK can also be used, but for best results should be given a coat of gelatin or starch size beforehand.

Negatives. Negatives for salted paper must have a long density range, and they should have good separation of tone in the shadows (that is, not be underexposed). The paper requires negatives with a density range of about 1.70 in order to print the full scale of tones from "paper white" to the maximum "black". You would have trouble printing contrasty negatives of this sort on even a soft, Contrast Grade 0 Kodak paper.

Salted paper has a self-masking printing-out image. In other words, while the image is printing out, the top layers of darkened silver act as a filter restricting penetration of light to the still-unchanged silver underneath. The filter effect is greatest in the shadows because there the printing-out image reaches its greatest density. As the darkest shadows increase in density, they let pro-

gressively less light pass through, and thus the printing rate in the darkest areas of the print slows down. The next lighter shadow tones continue to print-out until they, too, slow down as their density builds. Consequently, the shadows of a salted-paper print lose separation, or contrast, the longer they are exposed. The masking effect is negligible in the lighter tones because they darken relatively little. The result is that salted paper prints have a beautiful delicacy in the lighter tones, while the deeper shadow tones may seem flat.

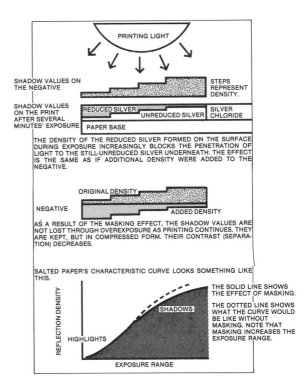

FIG. 135
Self-masking in salted paper.

Salting the Paper

The formula below is one of the simplest of the many salting formulas devised in the 19th century, and seems to be as good as any.

GELATIN SALTING FORMULA

Water . 280 ml
Gelatin 2 grams
Sodium citrate 6 grams
Ammonium chloride 6 grams

Prepare the gelatin by soaking it in 100 ml of the water at room temperature for about 10 minutes. Then add the remaining 180 ml of water at about 43° C (100° F) and dissolve the rest of the chemicals. The solution will keep for several weeks before the gelatin begins to decompose.

The gelatin acts as a sizing agent to prevent the silver solution from sinking too far into the fibers of the paper. You can increase the amount of gelatin, or omit it altogether, as you think necessary. Gelatin sizing produces cooler image tones.

Salt the paper by brushing on the salting solution or by totally immersing the paper in the salting solution in a tray. Even though it means using more solution, the latter method is suggested for your first attempts. This is because the solution is clear and it is easy to miss spots while brushing it on, which will result in unevenness in the final print. Immerse the paper in the solution for about 30 seconds.

Salting can be done under normal daylight illumination and the paper dried quickly with heat, if desired. The salted paper is not sensitive to light until brushed over with a solution of silver nitrate, and until then it will keep indefinitely.

STARCH SALTING FORMULA

Water . 280 ml
Starch . 5 grams
Sodium citrate 6 grams
Ammonium chloride 6 grams

(These quantities work with Argo cornstarch. Other brands may need adjustment.)

Dissolve the starch in 80 ml of the water at room temperature and add this to 200 ml of water at a full boil.

Allow the starch to boil for 3 minutes and then remove from heat. Add the sodium citrate and the ammonium chloride while stirring.

Coat the paper as described above. Use the solution either warm or cold. As it cools, it thickens slightly and gives a thicker protective sizing. Starch sizing produces warmer image tones than does gelatin sizing.

Sensitizing

Sensitize the paper by brushing on one or two even coats of silver nitrate (refer to Figure 126). Carry out sensitizing under tungsten light and heat-dry the paper, or just let it dry in the dark.

SILVER NITRATE SOLUTION

Distilled water, at about
 38°C (100°F) 30 ml
Silver nitrate 4 grams

Silver nitrate alone or in solution is not sensitive to light, but it becomes sensitive in contact with organic matter or dust or with chemicals such as the chlorides usually found in tap water. This sensitivity will result in a black precipitate on exposure to light. If you do use tap water, it is a good idea to expose the resulting solution to sunlight and then filter out any precipitate, to prevent spotting the prints.

Silver nitrate will stain skin and clothing. *Wear rubber gloves;* otherwise, no matter how careful you try to be, stains are almost certain to result. The stains will not wear off skin for several days. Consider them a badge of honor, or remove them in Kodak Tray Cleaner TC-3 or in the following solution:

STAIN REMOVER

Water . 120 ml
Chlorinated lime (calcium
 hypochlorite) 30 grams
Sodium sulfate 50 grams

Storing Sensitized Paper. Store the paper in the dark. If kept in a humid place, the paper may begin to darken after a few hours. In a dry atmosphere, the paper may stay good for a week.

There are several ways to preserve sensitized paper for longer periods of time. One is to add citric acid to the silver nitrate solution—but this makes the paper more difficult to tone. Another is to store the paper in a dry place between sheets of blotting paper treated with sodium carbonate. Soak each sheet of blotting paper in a 10% solution of sodium carbonate (sodium carbonate 50 grams; water to make 500 ml). Dry them thoroughly. Store each sheet of dry sensitized paper between two sheets of blotting paper. You can use the blotting paper repeatedly without retreatment. A third way is to wash the paper in water for several minutes after sensitizing. This removes the free silver nitrate and makes the paper less prone to spoiling—but also less sensitive. This can be corrected somewhat by fuming the paper before use, as described below.

Fuming. The paper is ready for printing as soon as it is dry after sensitizing. Most of the old textbooks on printing suggest that, before printing, the paper should be fumed with ammonia to increase its printing speed and contrast. I have found that fuming actually makes little difference with salted paper (except in the case of washed paper, described in the paragraph above). Apparently its effect on albumen paper was greater. The shadows of a finished salt print, sensitized in the normal way and subjected to fuming, are only slightly darker than the shadows of an unfumed print. The difference is not significant. The highlights print the same whether fumed or not.

If you wish to try fuming, use a box made of cardboard. It should be about 20 cm (8 in.) deep, with a lid larger than the sensitized paper. Pour a few milliliters of any type of ammonia into a small dish and place it in the middle of the box. Replace the lid and allow the ammonia vapor to fill the box. After a minute, take the lid off and turn it over on top of the box to keep the vapor from escaping. Pin the sensitized paper to the inside of the lid, turn it over, and close the box. Expose the paper to the ammonia fumes for about 10 minutes. Longer times do not seem to increase the effect. For your own comfort, do the fuming in a ventilated area.

Printing

Print out the paper in a contact-printing frame in sunlight or under any artificial ultraviolet source. The paper will begin to darken very quickly, then seem to slow down.

If the sensitized paper is not dry, it can cause stains on negatives. With proper care this will not happen, but if you are worried about an irreplaceable negative, sandwich a sheet of clear acetate between it and the paper during the exposure.

The nature of the printing light and the overall exposure time affect print contrast to some degree. Artificial light sources with high ultraviolet output will print rapidly, but with lower effective contrast than sources less rich in ultraviolet. About the quickest-printing, lowest-contrast source is summer sunlight. When printing on sunny days, unless the negative is especially contrasty (has a long density range) you may find it best to turn the printing frame away from the sun and face it toward the north sky for a slower but more contrasty printing. Negatives low in contrast should generally be printed this way.

To check the progress of printing, take the printing frame into the shade, or away from the artificial light. Unhinge one side of the back. Peel the edge of the print away from the negative, taking care not to fog the paper by exposure to bright light or disturb its registration with the negative. The printing-out image should be allowed to go rather deep. The highlights should be a good deal darker than the tone desired in the final print. The shadows may even start to acquire a bronzed, metallic sheen.

The best way to learn to judge the exposure is by placing a Kodak No. 2 Step Tablet along the edge of the negative during printing. *Right after* the exposure, make a mark on the lightest step printed out under the tablet that shows the first tone just preceptibly darker than the white of the paper. This lightest tone will be lost when the print is washed, toned, and fixed. In the processed print, the lightest tone may have dropped five steps down the tablet from the lightest tone before

processing. See Figure 137. Once you know by experiment how many steps of the tablet are lost when the image is processed, you can use the step tablet as a guide in exposing the image. Place your negative next to the step tablet on a light table or use a densitometer and find the step on the tablet that corresponds to the highlight density of your negative. When printing, lay the tablet alongside the negative, and then print out the tablet to the necessary *extra* number of steps (usually five) above the corresponding highlight step to compensate for the lightening of the image when put through the various baths.

Washing. After printing, if you intend to tone using gold, trim off any excess paper surrounding the image. This is done to save gold in the toning bath. In any case, wash the print in several changes of tap water. Washing is important for successful toning because the free silver nitrate not removed from the print will precipitate gold from the toning bath. It also makes fixing more efficient. Wash until all milkiness in the water has been carried away—but not longer, or the image may weaken. The paper is much less sensitive after the free silver has been washed out, but is still sensitive until fixed. When the print is first placed

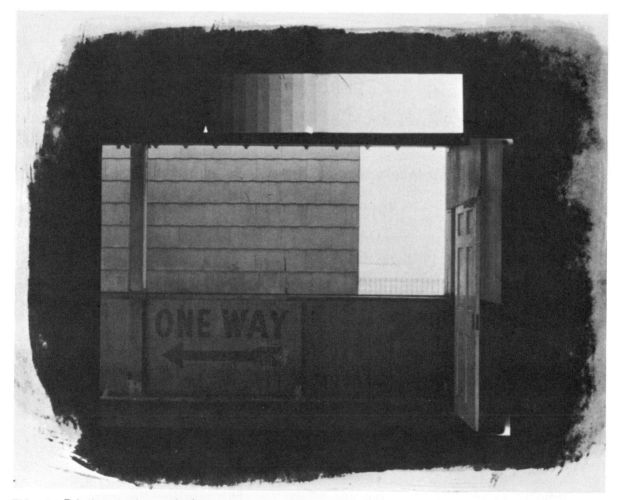

FIG. 136 Printing-out image before processing. Print it fairly deep.

in the water its tone will lighten and shift toward red.

Toning

If the print is put directly into the fixer after washing, its color when finished will be a reddish brown. This is not unattractive, but toning with gold makes possible a variety of colors, from reddish brown to purple-brown or blue-brown. Gold toning is thought to increase the permanence of the image by attaching gold molecules to the less stable silver molecules.

The color the print takes on as the result of toning depends on the size of the gold particles deposited over its surface, and this, in turn, depends on the pH of the toner and the rate at which toning takes place. An alkaline toner acts quickly and gives a coarse deposit, resulting in a tone shifted toward blue. An acid toner acts slowly and leaves a finer deposit and a tone more toward red (which usually will not shift much toward blue no matter how long the print remains in the bath).

Many toning formulas were used in the 19th century. The two given below are selected because between them they give quite different

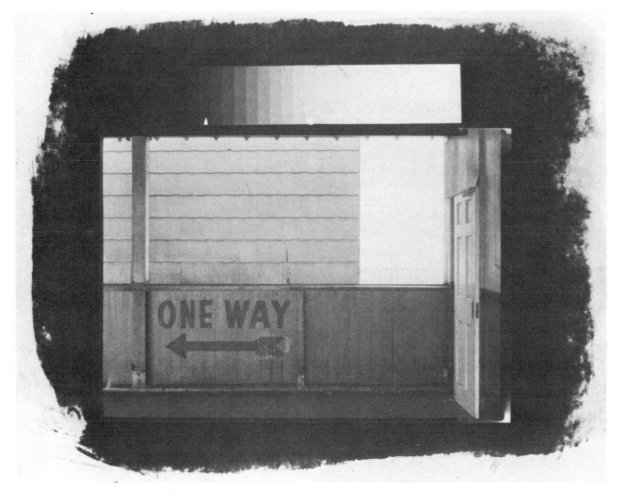

FIG. 137 Same print after fixing and washing.

results. Use the borax toner for warm (redder) image tones, and the thiocyanate toner for colder (bluer) tones. To save gold, always remember to trim off the darkened edges of paper around the margins of the print before toning.

BORAX TONING BATH

Water (38° C or 100° F) 400 ml
Borax 3 grams
Gold chloride (1% solution) 6 ml

Dissolve the borax in hot water first, then add the gold.

Allow the bath to cool to approximately 21 °C (70 °F) for use. Prepare it about an hour before use and store in a brown bottle. The borax makes the toner mildly alkaline and stabilizes it to prevent spontaneous precipitation of the gold in contact with the organic matter in the paper. The borax bath will keep but with use will require the addition of gold. Wait an hour before use after adding more gold.

Toning time varies from about 6 to 12 minutes, depending on the tone desired. The tone of the print becomes colder as toning proceeds. It is difficult to judge the final tone until the print is actually fixed and dried. When salted prints dry, their color becomes colder. In order to see how the time in the toning bath affects print color, print out a scale of tones under a step tablet and then slice it up into four narrow strips. Place them in the toning bath together, then take one out every three or four minutes. Mark each one carefully and, after fixing and washing, mount them for reference.

The following is an acid bath, but with a silver solvent—ammonium thiocyanate—which accelerates its action. For the same toning time, it gives considerably colder tones than the borax toning bath. Six minutes in the thiocyanate bath is enough to give the print almost blue-gray tones.

THIOCYANATE TONING BATH

Water 400 ml
Ammonium thiocyanate 12.5 grams
Tartaric acid 1 gram
Sodium chloride 2.5 grams
Gold chloride (1% solution) 10 ml
Water to make total volume 500 ml

The thiocyanate toning bath will not keep. Mix it only on the day of use.

Fixing

Fix untoned prints or prints toned in the borax bath in a plain "hypo" (sodium thiosulfate) solution for 10 minutes with frequent agitation.

FIXING BATH

Water (about 32° C; 90°F) 500 ml
Sodium thiosulfate 50 grams

Cool this to about 20°C (68°F) for use.

Prints will become lighter in the fixer. If you prefer, you can use a regular acid fixing bath such as Kodak Rapid Fixer (diluted for prints) or Kodak General Purpose Fixing Bath, in which case reduce fixing time to 5 minutes.

The plain thiosulfate fixing bath should not be used after the thiocyanate toner, because the acid carried over from the toner can cause the plain bath to precipitate sulfur. Instead, use a regular acid fixing bath or add 5 grams of sodium sulfite (desiccated) to the plain thiosulfate bath given above. The bath given above should be replaced after four 20x25cm (8x10 in.) prints have been fixed in each 500 ml of solution.

Prints may go directly from the toning bath into the fixer, but be careful not to contaminate the toning bath with fixer. If the bath does become contaminated, its toning power will be destroyed and the prints may show yellow stains.

Final Wash. After fixing, wash prints for one hour; less, if a hypo clearing agent is used. Since the image surface is delicate, and the wet-strength of the paper may be poor, be careful not to allow prints to rub together during the wash.

If you decide to tone prints after fixing, be sure they are washed thoroughly first. Wash again for 10 minutes after toning.

Contrast Control

There is really no way to get around the need for a long-density-range, fully developed negative for salted paper printing, but a certain amount of con-

trast control during printing is possible. The effect of exposure time on the contrast of the print has already been noted. In addition, potassium dichromate added to the salting solution will increase contrast. Make up a solution of

Potassium dichromate 2 grams
Water . 28 ml

The effect of the dichromate will be noticeable after 3 drops of this solution have been added to each 28 ml of the salting solution. Use more as necessary.

Paper salted with a solution containing potassium dichromate should be kept out of the light and sensitized and used as soon as possible.

P.O.P.

The term P.O.P. (for printing-out paper) came into use in the early 1890's to distinguish the gelatin chloride printing-out papers then being introduced from the developing-out papers (D.O.P.) introduced the decade before. There is only one gelatin chloride printing-out paper now on the market, Kodak Studio Proof. It is sold sensitized and can be printed-out, washed, toned, fixed, and given a final wash in the same way as described above for salted paper.

If left untoned, the prints usually take on an unattractive orangeish-brown color when placed in the fixer. Because of the glossy surface, prints on this paper are more brilliant than prints on matte salted paper and show better separation of tones in the shadows. Like salted paper, P.O.P. requires negatives of long density range, and it should be printed deeply because it lightens in processing. Older textbooks contain many toning formulas for P.O.P.

Ambrotype

The ambrotype is a wet collodion process that forms a direct-positive image on a glass plate. The glass is first coated with a collodion solution containing iodide and bromide. Before the collodion dries, it is sensitized in a bath of silver nitrate. It is exposed in the camera while still wet and then immediately developed in a solution of ferrous sulfate. Afterwards, the plate is fixed in sodium thiosulfate and washed. The white, developed image can then be printed as a negative, or else viewed as a positive after being backed on one side with black material or lacquer.

Preparing the Chemicals

Collodion U.S.P., also called *cellulose nitrate*, is available from the J.T. Baker Chemical Company and from Amed Drug and Chemical Co., Inc. This solution must be thinned with ether and alcohol.

CAUTION: *All these liquids are flammable.* Work in a well-ventilated area, away from open flames, and store the collodion in a cool place.

COLLODION SOLUTION

Add *100 ml ether* to *120 ml collodion*. Stir these together. Then add *1.5 grams cadmium bromide*, continuing to stir until the latter has dissolved.

In a second beaker, dissolve *2 grams of potassium iodide* in only as much distilled water as necessary to bring the iodide into solution. Into this second beaker, *add 50 ml reagent-grade ethyl alcohol* and stir.

Finally, pour the iodide-and-alcohol solution into the collodion while stirring. Place in a brown bottle for storage.

If the solution becomes cloudy or forms a precipitate, add distilled water, drop by drop, and stir until the solution clears, adding water as necessary. At most, this should require about 10 ml of water.

Sensitizing Bath. The sensitizing solution will stain hands and clothing; so it is a good idea to wear rubber gloves. Store it in a brown bottle.

THE SILVER BATH

Distilled water	*375 ml*
Silver nitrate	*26 grams*

The best way to sensitize the collodion plate is by lowering it vertically into the solution. Construct a narrow box as shown in Figure 138. The sides and bottom are made from glass seamed with G.E. Silicone Rubber or equivalent. A bent plastic or glass rod is used to hold the plate immersed in the silver. The formula given here will make enough silver solution to fill a sensitizing container the size of the one in the illustration.

The collodion plate can also be sensitized flat in a tray, but streaking will likely result.

Developer. This developer gives the white image tones necessary for viewing the image as a positive.

DEVELOPER

Distilled water	*300 ml*
Ferrous sulfate (hydrous)	*14 grams*
or	
Ferrous sulfate (anhydrous)	*10 grams*
Add to the above	
Glacial acetic acid	*20 drops*
Nitric acid	*10 drops*

The solution will be milky at first but will clear on settling; it can be used until it becomes discolored.

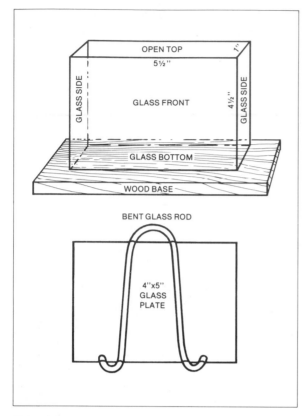

FIG. 138
Sensitizing box and plate holder.

Preparing the Glass Plate

You will need a film holder designed to carry glass plates. These can be purchased new or often found in junk and antique shops. Or you can alter a sheet-film holder to take glass.

Cut the glass to size as required. Take coarse emery paper and sand around the edge of the glass on the side on which the collodion will be applied. This will help keep the collodion film from fraying. Clean the glass with household ammonia, rinse in hot water, and then flood with Photo-Flo or alcohol to prevent drying spots. Dry the glass thoroughly before applying the collodion.

Coating With Collodion. Pour a fair quantity of collodion into the center of the plate. Tilt the plate

as necessary to make the collodion flow over the surface. Do this as quickly as possible (it is an ancient art and takes some practice). When the plate has been coated, tilt it to drain the excess collodion back into the bottle. If cracks (*crazing*) appear on the emulsion surface, add more ether to the collodion next time around.

The collodion should set properly for sensitizing in 10 to 15 seconds, becoming slightly dull and tacky.

Sensitizing. Sensitize the plate immediately after coating it with the collodion: Under OC safelight illumination, submerge the plate with a rapid, even motion into the silver bath. Allow the plate to remain in the bath until its surface becomes yellow and all streaks and oiliness have disappeared.

The plate must be exposed and developed *before the collodion dries.*

Exposing and Processing

The ASA of the plate is roughly 1.6 to 8; so long exposures are necessary.

If you pour the developer directly on the plate, the area first contacted may lose density. To avoid this (working under safelight illumination, of course) place the plate in one end of a large dry tray. Pour sufficient developer in the *opposite* end of the tray and then tilt the tray so that the developer covers the plate in one continuous flow, without leaving "stop marks." Lift the plate from the tray, hold it in your hand and rock it from side to side, developing it by inspection. It is important not to wash the excess silver nitrate from the plate during processing. Its presence is necessary for proper development. When development is complete, drain the developer into a second bottle and then flush both sides of the plate with water.

Fix the plate in regular film fixer or rapid fixer for twice the time necessary for the unexposed areas of the image to clear. Follow by a 15-minute wash in slowly running water. Rinse with Photo-Flo and dry in a dust-free place.

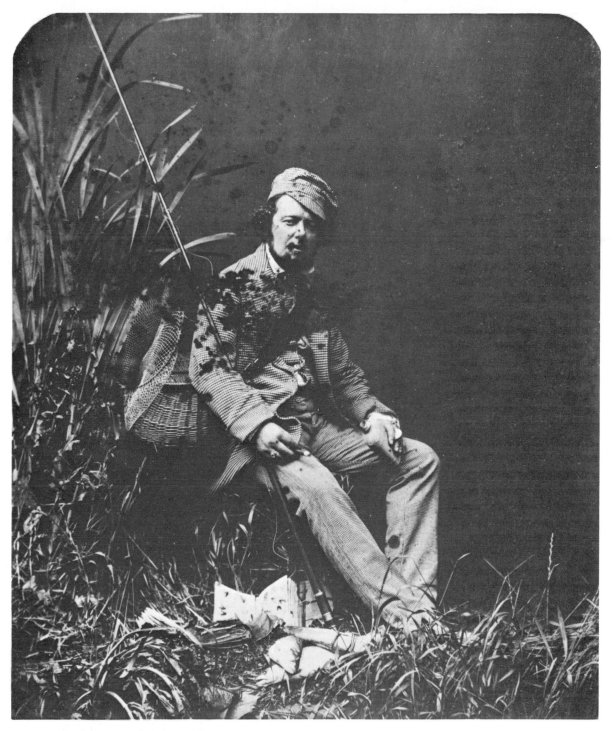

FIG. 139 Ambrotype, *Sir John Herd, Derby Hall, Liverpool,* 1850's. 10¼ × 12¼ inches.
(Rodger Kingston Collection)

Converting the Image Into a Positive

To view the image as a positive, cover one side of the plate with black paper or coat it with a black lacquer (such as Krylon spray) or asphaltum.

If the collodion side of the plate is covered, the image will appear with the correct left-to-right orientation. If the glass side is covered, the image will be reversed, but it will be somewhat brighter. When you leave the collodion side exposed, varnish it or cover it with another sheet of glass for protection.

The research on ambrotype was done entirely by Dennis Bookstaber, who mentions that ambrotypes can also be made on plastic.

Cyanotype

In the cyanotype process, paper is sensitized with ferric ammonium citrate and potassium ferricyanide. Exposure to light reduces a portion of the ferric salt to the ferrous state, and a portion of the ferrricyanide to ferrocyanide, resulting in the formation of a pale, blue-white image consisting of ferrous ferrocyanide. After exposure, the cyanotype is washed in water. Washing removes the soluble, unreduced salts, leaving insoluble ferrous ferrocyanide behind. On drying, the ferrous ferrocyanide slowly oxidizes to a deep blue tone consisting of a mixture of compounds, probably ferric ferrocyanide and ferric ferricyanide. The print can be changed to this deep tone immediately by treating it in a hydrogen peroxide or potassium dichromate oxiding bath.

Except for a tendency toward slight fading, and a vulnerability to alkalinity, cyanotype images are permanent.

Negatives. Cyanotype paper has a long exposure scale and will give flat prints unless used with negatives of correspondingly long density range. For a full range of tones from paper white to the deepest practical blue, negtives for cyanotype should be developed to a density range of about 1.60 or more—the kind of negative normally requiring printing on a Kodak Contrast Grade 0 paper. Increased printing contrast is possible by adding potassium dichromate to the sensitizer (details will be given later).

Paper. Virtually any paper (except for alkaline-buffered papers) can be used for cyanotype printing. Crane's Kid Finish AS 8111 and Strathmore Artist Drawing both work well. As a general rule, the paper should be well sized, although excellent prints have been made on unsized Rives BFK.

Sensitizing

Instructions usually call for preparing the sensitizer from two stock solutions, on the assumption that separate solutions keep better. For one-time use, however, the two chemicals can be dissolved in water together.

SOLUTION A

Water, at about 21°C (70°F) *100 ml*
Ferric ammonium citrate (green) . . . *20 grams*

SOLUTION B

Water at about 21°C (70°F) *100 ml*
Potassium ferricyanide *8 grams*
For use, add 1 part A *to 1 part* B. *Store the separate or combined solutions in brown bottles for protection from light.*

Ferric ammonium citrate comes in green and in brown varieties. The green is the more sensitive. *Keep the cap of the ferric ammonium citrate bottle tightly closed.* Otherwise, it will form a hard crust.

The ferric ammonium citrate is the primary light-sensitive component in the formula. The potassium ferricyanide forms the color. Additional quantities of ferricyanide beyond what is strictly necessary tend to lower printing speed, probably because the orange color of the ferricyanide filters out light of the wavelengths to which the citrate is most sensitive. If there is too little ferricyanide, the blue color can bleed from the dark areas of the print into the light areas.

Working under normal tungsten light, coat the paper either by brushing or by floating the paper on the sensitizer in a tray. If you use a brush, you can simply dip it in the sensitizer and then spread the coating across the paper.

Dry the paper in the dark. Considerable heat may be used in drying without harming the sensitive coating. The sensitized paper should remain good for more than a week if stored in the dark in a cool, dry place. Protect the paper from daylight and from ultraviolet sources.

Paper sensitized with the above formula should look greenish-yellow. A blue tone indicates the presence of reduced salts from contaminated or spoiled chemicals.

Printing

Cyanotype is fairly slow. With a fully developed negative, an exposure of as much as 30 minutes may be necessary under a Sylvania 275-watt sunlamp placed 38cm (15 in.) from the printing frame. The sunlight exposure might be 15 minutes.

The cyanotype image prints-out during exposure. Print until the high values have considerably more tone than you desire in the final print. When this point is reached the shadows will probably have begun to reverse, becoming temporarily lighter in tone. Overprinting is necessary because the high values will lighten when the print is washed.

To check the exposure, take the printing frame out of the light, open the one side of the back, and, without disturbing the registration, gently peel the

FIG. 140 Printing-out cyanotype image before washing.

paper away from the negative. Then examine the image.

As in the salted paper process, it is a good practice to place a Kodak No. 2 Step Tablet next to the edge of the negative during printing. After the exposure, but *before* washing the print, look at the steps printed-out under the tablet: Make a mark on the first step that shows a tone darker than the sensitized paper itself. After washing, the lightest tone in the final print will be about five or so steps down the tablet from this original lightest printing-out tone. Do some tests to find out exactly how many steps of the tablet are normally lost after washing. Remember this number. Then use the tablet as a guide for exposing the image. Place your negative on a light table or use a densitometer and find the step on the No. 2 Tablet that corresponds best to the highlight density in the negative. When printing, lay the step tablet beside the negative in the printing frame. Then print the tablet out the extra number of steps above the corresponding highlight step as needed to compensate for the lightening of the image. See Figures 140, 141.

Washing. Wash the print for about 5 minutes in running water at approximately 20°C (68°F). This will clear the highlights. Too little washing will leave soluble ferric salts in the image, which in turn will cause fading on exposure to light. (Even properly washed cyanotypes can fade slightly, but

FIG. 141 Same image after washing and oxidation bath.

they will return to their original color if left to oxidize in the dark or if treated in an oxidation bath—see below.) Prolonged washing in alkaline water will lighten the image. If the pH of the water is sufficiently increased, for example by the addition of ammonia, the blue image will bleach to a light brown ferric hydroxide.

Many instructions for making cyanotypes call for the addition of a small amount of hydrochloric or acetic acid in the final wash water to deepen the tone. Adding acid to the first wash will actually fog the whites. Adding acid to the final wash will deepen the tone initially but will not affect the final tone of the dry print. Presumably, the only time the acid might really be useful is when the wash water comes from an alkaline source.

Oxidation Bath. After washing, place the print for a few seconds in the following bath. This oxidation bath is not absolutely necessary, since the print will gradually oxidize in the air as it dries, but the bath lets you see the final tone right away.

<div align="center">OXIDATION BATH</div>

Water, at about 20°C (68°F)　　200 ml
Hydrogen peroxide (standard 3%
solution)　　20 ml

Afterward rinse, then hang the print to dry, or dry it with heat.

Contrast Control

As mentioned earlier, you can add potassium dichromate to the sensitizer to increase printing contrast. Six drops of a 1% potassium dichromate solution added to each 2 ml of sensitizer will cause an increase in contrast equivalent to the loss of about two steps on a Kodak No. 2 Step Tablet.

Toning

Most serious writers on cyanotype have discouraged toning on the grounds that the colors are unpredictable and unstable. Formulas calling for the direct toning of the image in ammonia or ferrous sulfate, for example, give fugitive tones. On preliminary observation, the two formulas below seem to produce stable tones.

Deep Purple Tones: Bleach the print in a 5% solution of ammonia, wash, and then tone in a saturated solution of tannic or gallic acid (about 1 gram of gallic acid in each 100 ml of water). Wash afterward.

Deep Blue—"Ultramarine": Tone the print in a 5% solution of lead acetate at 30°C (85°F) or higher. Wash afterward.

Red-Brown Tones: The following formula produces a very attractive red tone, but, unfortunately, in about a week the highlights of the print will begin to turn yellow.

Treat the print for 5 minutes in
Water . 180 ml
Tannic acid 6 grams

Then transfer to a solution of
Water . 180 ml
Sodium carbonate 6 grams

Wash afterward.

You can reduce the blue image to white by brushing it with a 20% solution of neutral potassium oxalate or a 5% solution of oxalic acid. Wash the print again afterward.

Platinum and Palladium

In the platinum process, paper is sensitized with ferric oxalate and potassium chloroplatinite. On exposure to light the ferric salts are reduced to the ferrous state. When the paper is placed in a potassium oxalate developer, the new ferrous salts are dissolved and in turn reduce the platinum in contact with them to the metallic state. The print is then cleared in hydrochloric acid to eliminate the ferric salts remaining in the paper. The image that is left consists of metallic platinum in a finely divided state.

Platinum's straight-line characterisitic curve enables the process to register the tones of a negative with a remarkable delicacy. Tonal separation is reduced in the shadows by the matte surface of the paper, and if really deep blacks are printed some of the shadow detail may be lost; but this is true of any matte-surfaced paper.

The color of platinum images can range from a cool, slightly purple black to split tones of brown and warm black to a very warm brown. By toning with uranium, the image can even be changed to red, green, or blue.

Chemicals. The only chemical used in platinum printing that is hard to find is ferric oxalate, for which there is apparently no longer a commercial demand. It is now being manufactured in small lots by Brand-Nu Laboratories, 30 Maynard Street, Meriden, Connecticut 06450, and is also listed in the Alfa-Ventron catalog as Iron (III) oxalate—$Fe_2(C_2O_4)_3$ $6H_2O$. Kits for platinum and palladium printing are sold by Elegant Images, 2637 Majestic Drive, Wilmington, Delaware 19810. This concern supplies chemicals separately.

Keep the ferric oxalate container tightly closed and store it in the dark. If the prints seem fogged, test the ferric oxalate by dissolving a little in water and add to it a weak solution of potassium ferricyanide. If the mixture turns blue, the ferric oxalate has become partly ferrous and cannot be used. Demand your money back.

You will need it for the platinum. Unfortunately, platinum is expensive. Potassium chloroplatinite (K_2PtCl_4), also called *potassium tetrachloroplatinate,* was about $11.00 per gram in 1975, depending on the source and the quantity purchased. (In 1905, pure platinum sold at $18.50 an *ounce*—65¢ a gram.) When buying platinum, call a number of suppliers and ask for their prices. There can be a considerable difference.

As a precious metal, platinum tends to vary in price with the value of the dollar and the state of the stock market. When either of the latter go down, platinum tends to go up. It also depends on the success of the Russian wheat crop. Russia is one of the principal suppliers of platinum (South Africa is the other). When the Russian wheat crop is small, the authorities sell platinum to gain the foreign exchange necessary to buy grain from the United States. This increase in supply brings the price of platinum down. These changes eventually show up in the price of potassium chloroplatinite. Platinum printers should pray for a strong dollar and a long Russian winter.

The high cost of platinum is offset by the fact that, used intelligently, the platinum process gives a greater proportion of successful prints than almost any other technique described in this book. The cost is offset, as well, by the very special quality possible in a platinum print.

Negatives. The best negatives for platinum printing have good separation of detail in the shadows and a fairly long density range: Because platinum paper is a low-contrast material, nega-

tives for it must be developed to a great enough density range so that the shadows can be printed down without overprinting the highlights. This means a negative with a density range of about 1.35 for the "normal" platinum sensitizer, the kind of negative that prints best on a Kodak Contrast Grade 1 paper. Fortunately, since the contrast (exposure range) of the paper can be controlled, most negatives of fair density range can produce a good print.

Paper. Paper for platinum printing should have enough sizing to prevent the sensitizer from soaking into the paper. When that happens, prints develop slowly, are difficult to clear, and have poor separation of shadow tones. Smooth, well-sized papers are the easiest to sensitize and require the least amount of sensitizer.

Crane's Kid Finish AS 8111 is excellent for platinum printing; so is Bienfang Designer's Series 100% Rag Layout Pad. Strathmore Artist Drawing can be used successfully with mercury development but tends to give grainy prints with a plain oxalate developer. None of these three requires sizing. Rives BFK works best if sized first; otherwise it needs an excessive amount of sensitizer because the paper will absorb the sensitizer before it can be spread across the surface (starch size tends to produce warm tones; gelatin size, cool tones). Good results have been reported on Fabriano hot-pressed, Arches 88, Opaline Parchment, and Esleeck Collatoral Bond (Esleeck Paper Company, Turner's Falls, Massachusetts).

The chemistry of the paper stock can have a considerable effect on the color and tonal scale of the final image. Many of the problems faced in printing can be traced to the paper, rather than to impurities in the sensitizer.

Sensitizing

The best sensitizing brush is about 5cm (2 in.) wide. It has been said that the brush must not contain metal, but it is all right if it does as long as the sensitizer does not come into contact with the metal parts. It is more important that the brush does not itself absorb, and thus waste, the sensitizer. Its only role is to push the sensitizer over the paper. You can limit its absorption by first trimming off several rows of hairs from both of the flat sides of the brush, leaving it with a fairly thin profile.

Prepare the sensitizer in three stock solutions, using glass or plastic containers. *Avoid contact with metal.* Keep each stock solution separately in small brown bottles, tightly sealed and carefully labeled, with a medicine dropper in each. Store the bottles in the dark. Take care not to interchange the droppers. If only one dropper is available, rinse it in distilled water between use in each solution, and afterwards.

THE SENSITIZER

(Mix the chemicals in the order listed.)

Solution 1
Distilled water,
 at about 49°C (120°F) 55 ml
Oxalic acid 1 gram
Ferric oxalate 15 grams

Solution 2
Distilled water,
 at about 49°C (120°F) 55 ml
Oxalic acid 1 gram
Ferric oxalate 15 grams
Potassium chlorate 0.3 gram

Solution 3
Distilled water,
 at about 38°C (100°F) 50 ml
Potassium chloroplatinite
 (K_2PtCl_4) 10 grams

The 50 ml Solution 3 should be enough for about forty 20x25-cm (8x10-in.) prints, calculated on the basis of 20 drops = 1 ml.

At room temperature, some of the platinum may precipitate out of the solution. Simply warm the solution in a water bath to redissolve the platinum before use.

The platinum solution should keep indefinitely. The oxalate solutions have a shelf-life that varies from several weeks to roughly six months. As the oxalate solutions go bad, the print highlights become fogged and uneven.

Before combining the three solutions, cut the paper for sensitizing about 5cm (2 in.) wider on all

sides than the negative. Pin it down by the corners onto a clean, paper-covered surface and indicate the area of the negative by guide marks. Place them as shown in Figure 125, so that they will not be in the way if the negative has to be positioned a bit to one side to avoid any uneven areas in the sensitive coating.

The sensitizer is measured by drops. The quantity given below is for a 20x25-cm (8x10-in.) print, plus test strips. Contrast is controlled by varying the proportion of Solution 1 to Solution 2. Absorbent papers will need a greater total volume of the combined sensitizer; so it is obviously cheaper to give such papers a coating of size first. Using extra sensitizer on most papers will deepen the blacks to a certain degree, but with proper printing technique this should not be necessary.

SENSITIZER MIXTURES FOR CONTRAST CONTROL

For soft prints
Solution 1 *22 drops*
Solution 2 *0 drops*
Solution 3 *24 drops*

For moderately soft prints
Solution 1 *18 drops*
Solution 2 *4 drops*
Solution 3 *24 drops*

For average prints
Solution 1 *14 drops*
Solution 2 *8 drops*
Solution 3 *24 drops*

For moderate-contrast prints
Solution 1 *10 drops*
Solution 2 *12 drops*
Solution 3 *24 drops*

For contrasty prints
Solution 1 *0 drops*
Solution 2 *22 drops*
Solution 3 *24 drops*

Combine the sensitizer solutions in a small glass and mix by shaking. Next, dampen the brush with tap water and then squeeze it out. This helps keep the brush from absorbing the sensitizer.

The paper can be coated under tungsten room light. Pour the sensitizer in a line down the center of the printing area. Start spreading it by brushing at right angles to this line. Use long, parallel, rapid strokes, first from side to side and then up and down. Coat an area slightly larger than the negative. This way you will have room to maneuver the negative to avoid printing on uneven areas around the edge of the coating, and you will have enough to trim off for test strips.

An absolutely uniform coating is not necessary, but spread the sensitizer as evenly as possible. The image will print properly in any area as long as there is enough sensitizer to respond to the corresponding amount of light passed through the negative. Brush the paper quickly enough to prevent any puddles of sensitizer from remaining too long in any one place: Puddles can soak in and cause areas of uneven density in the print.

Continue brushing only until the coating looks even and the paper starts to become surface-dry. Too much brushing can cause streaks, especially with a high-contrast sensitizer, and can even abrade the paper. Wash the brush after each use. Otherwise, on exposure to light ferrous salts can form, and these could contaminate the next print.

If you have not applied a sensitizer with a brush before, practice first by coating several sheets of paper with a quantity of the sensitizing solution—minus the platinum—or with water to which a drop of food coloring has been added to make it easier to see.

FIG. 142
Figures 142 through 144 are platinum prints by the author.

Dry the sensitized paper by hanging it in the dark, or dry it with *moderate* heat as described below.

Platinum paper is hygroscopic (it absorbs moisture from the atmosphere), and if it takes in too much moisture the highlights may become grainy and degraded. Be careful to keep both the sensitized paper and the felt backing of the printing frame dry when printing on humid days or in a humid environment (the usual case in darkrooms). *Do not touch the sensitized surface* of the paper with your fingers, either before or after the exposure.

Drying with heat helps control the moisture problem, with the added benefit that it dries the sensitive coating before it has time to sink too deeply into the paper. Heat-dry right after sensitizing, using a hot plate or a blower hair dryer. Do this in subdued tungsten light and do not allow the temperature on the surface of the paper to go much above 49 °C (120 °F). Higher temperatures for any length of time might reduce the ferric salts, causing dark spots in the final print.

Sensitize paper only as you need it for printing, and use it as soon as possible. If for some reason you must prepare paper to store for future use, heat-dry the paper stock first, coat it under conditions of low humidity, heat-dry the coating, and store the paper in an airtight container with a fresh silica gel desiccant.

Printing

Use an ultraviolet source or the sun. The average exposure with a Sylvania 275-watt sunlamp 38cm (15 in.) from the printing frame is about 25 minutes. The average exposure using a single-carbon-arc lamp with a "white flame" carbon is about 8 minutes. In direct summer sun the exposure can be about 1 minute.

First expose a test strip cut from the edge of the sensitized paper. Place it under both a highlight and a shadow area of the negative where detail is required in the print. Try to restrain the impulse to make full-sized prints without making test strips first. In the long run, using test strips will save money and result in better prints, and it will give you more data from which to learn to control the process.

The image will print-out to some degree in the shadows, appearing either pale brown or lavender against a yellowish ground, but this is too faint to serve as more than a general exposure guide. After developing the test strip, clear it for a minute in the acid bath and blot it surface-dry before studying it to decide on the correct exposure for the full negative. For a method of calculating exposure time from density measurements see page 149.

The printing speed of any sensitizer combination depends on the amount of chlorate it contains. Potassium chlorate is a strong oxidizer. An increase in the chlorate (Solution 2) results in a decrease in printing speed, as well as an increase in contrast. A sensitizer with no Solution 2 may require 25 % less exposure than normal; one with a maximum amount of Solution 2 may need 75 % more exposure than normal.

Developing. Before developing the print, trim it close to the edge of the image. This reduces the amount of developer carried off by each print and makes subsequent clearing and washing more efficient. Because the sensitive coating stays hygroscopic, develop the print right after making the exposure.

The developer is a saturated solution of potassium oxalate.

Water (warm) 1363 ml (48 oz)
Potassium oxalate 454 grams (1 lb)

The developer should be neutral or just slightly acid. Test with litmus paper and add a small amount of oxalic acid if necessary. Too much acid can cause incomplete reduction of the platinum.

The action of the developer is almost instantaneous. Either immerse the print quickly and smoothly beneath the surface of the developer or place the print in the bottom of a dry empty tray and pour the developer *quickly* on top. A delay in covering the entire print can result in marks along the edges where the developer stopped. This is especially true when using hot developer (see below). If developing marks occur, sometimes they can be removed by rubbing the print immediately while it is still in the developer.

Develop for at least 1 minute at room temperature. Longer development will not increase the density of the print. Both developing and clearing operations can be done under tungsten light.

The developer lasts indefinitely; in some cases it appears to improve over time. After a number of prints have passed through it a precipitate will form, consisting of platinum and iron salts. This may interfere physically with development. If it does, decant the clear solution.

Repeated contact with the developer can cause skin problems. Minimal contact, or the use of tongs or gloves, is suggested.

Clearing. The clearing bath is dilute hydrochloric acid, which removes the remaining ferric salts by transforming them into soluble ferric chloride.

Water *420 ml (60 parts)*
Hydrochloric acid (37%) . . 7 ml (1 part)

NOTE: *Always add acid to water, not water to acid.*

Clear the prints for 5 minutes in each of three successive acid baths, with agitation at least once every minute. After one or two prints have been through all three baths, dump the first, fill it with fresh acid, and use it as the new third bath. Then move the second bath up to number one position and the third bath to number two. This ensures a fresh final bath for each print. The final bath should remain clear after the print has passed through it. If not, place the print in an additional acid bath.

After clearing, drain the print and wash for at least 20 minutes to remove the acid. Use a Kodak tray siphon or an archival washer and a good flow of water. Since the wet paper surface may be delicate, it is usually best not to wash more than two prints (back to back) in one tray at a time. Air-dry the print afterward or dry it with heat.

Depending on the choice of paper and sizing, the basic procedure described above usually gives prints with neutral or warm-black tones.

Graininess

Sometimes the potassium chlorate in Solution 2 reacts with the sizing of the paper and produces grainy prints. The more chlorate, the more noticeable the grain. This can often be corrected by substituting hydrogen peroxide for the chlorate.

For a trial, mix one drop of 3% hydrogen peroxide with 22 drops of Solution 1 and 24 drops of Solution 3.

Color

Warm tones are possible by heating the developer, by adding mercuric chloride, or both.

HOT DEVELOPER: Heat the developer in an unchipped enamelware saucepan or a Pyrex double-boiler (which is then permanently retired from kitchen use). The developer can be heated all the way up to the boiling point; the color of the prints becomes increasingly warmer as the developer temperature rises.

High developing temperatures also increase printing speed. When using a hot developer, give the print less than normal exposure and be sure to develop both the test strip and the final print *at the same temperature.* Hot developer also tends to reduce image contrast, and you may find it necessary to use more Solution 2 for a negative of

FIG. 143

a given contrast range than necessary when developing at room temperature.

MERCURY DEVELOPER: Mercuric chloride (mercury bichloride) added to the developer also gives brown tones. Use the mercury developer at about 21 °C (70 °F) or heat it to increase the effect. Increased amounts of mercury carry the print color from warm black through brown to sepia. The exact color depends in part on the choice of paper stock. Strathmore Artist Drawing produces an almost pink brown. At a concentration of about 8 grams of mercury to 680 ml (24 oz) of developer, Strathmore has a split tone—warm black shadows, and brown highlight tones with a reddish cast. In the same developer, Crane's AS 8111 shows less of a tonal split, a more neutral brown, and better highlight contrast.

To prepare the developer, dissolve the mercuric chloride in a few milliliters of very hot water, adding this solution to the normal developer only when the mercury has completely dissolved. An alternative is to dissolve the mercury in alcohol. (It will dissolve in alcohol more easily than in water.) Prepare a 10% solution by placing 10 grams of mercuric chloride in a graduate and filling up to the 100-ml level with alcohol. Keep this stock solution tightly capped and add it to the developer as desired.

CAUTION: Mercuric chloride is a *poison and must be handled with care.* Wash your hands throughly after weighing out the mercury and try to keep your fingers out of the developer.

It is important to keep records of developer temperature and mercury content, since you may discover effects that you particularly like and will want to be able to reproduce when you have to heat the developer again or mix a fresh supply. Mercury also increases printing speed.

With certain papers, such as Strathmore, the use of mercury may slightly stain the highlights. This can usually be corrected by diluting the developer with an equal volume of glycerin. Glycerin (glycerol) is a clear, viscous liquid that will physically slow the action of the developer. With glycerin, it is possible to remove the print from the developer before the highlights become stained.

Normally, most of the brown in the highlights of a print developed with mercury will lighten in the acid bath. You may find that the tone lightens more than you wish. If this occurs, clear your next prints in acid baths prepared at half the normal strength.

Baron von Hübl, one of the early authorities on platinum printing, believed that the brown tone achieved by adding mercury to the developer, or directly to the sensitive coating (as was done with almost all commercial "sepia" platinum papers), was due to a resulting increase in the grain size of the platinum deposit, rather than to the addition to the image of a possibly unstable compound (mercury). Work by others showed that mercury in the metallic state was in fact present in the brown-tone image and that the image, though light-fast, was likely to fade through oxidation of the mercury. Fading might occur in several years, or not for many decades, if at all. I have examined a number of prints from around the turn of the century that were almost certainly made with mercury and that have grown darker, if anything. The choice of paper might influence the stability of the brown image.

Cold tones, in the area of blue-black, are possible by adding potassium phosphate to the oxalate developer.

DEVELOPER FOR COLD TONES

Water (warm)	1000 ml
Potassium oxalate	180 grams
Potassium phosphate (monobasic)	60 grams

Since heat shifts the color toward brown, use this developer at no higher than 21°C (70°F).

Reportedly, diluting the sensitizing solution with an equal volume of distilled water and sensitizing the paper twice, drying it for 10 minutes in between and using half the solution each time, results in cooler image color.

Contrast Controls

A platinum sensitizer prepared with no chlorate gives very low contrast. Even less contrast is

possible by heating the developer as described above. Adding a few drops of hydrochloric acid to the developer will also reduce contrast.

Potassium dichromate acts as a restrainer and increases contrast when added to the developer. A gram of dichromate in 1.36 liter (1½ quarts) of developer should produce a noticeable effect. Print slightly deeper than normal. The dichromate gradually becomes exhausted through use.

Glycerin Development

Local modifications of tone and color are possible, with some degree of control, through brush development with glycerin.

First, coat a sheet of glass with glycerin and lay the exposed print on top. Cover the print with an even coating of glycerin and develop it locally by using a brush charged with the developer. The glycerin slows the action of the developer and keeps it from spreading. You can slow the developer even more by first diluting it with an equal volume of glycerin, or accelerate development in chosen areas by blotting up the glycerin from the face of the print before applying the brush.

Control over image color is possible by using two developers, one with and one without mercury. Use two brushes or, if only one is available, rinse it each time you switch developers. Stop development by placing the print under a fairly vigorous stream of water, and then transfer it to the clearing baths. Do not use a developer containing glycerin at a temperature much above 60 °C (140 °F).

Joseph T. Keiley and Alfred Stieglitz together worked out improvements on the glycerin process. Keiley used the technique quite successfully in a series of portraits of American Indians. Some of these portraits are now in the Stieglitz Collection of the Metropolitan Museum in New York. But Paul L. Anderson, who for many years was a leading teacher of photographic techniques (see the list of recommended readings), wrote that whenever he used glycerin the final step was "generally to place the print face down in the ash can." The moral is that the results of glycerin work will vary, depending on your skill with the brush and on the appropriateness of the technique to the image at hand.

Uranium Toning

A platinum print can be toned to a variety of colors by the use of a single uranium toning formula. The color depends on how long the print has been cleared before toning and on the number of prints already passed through the toning bath. The bath is in two parts.

URANIUM TONING BATH

Solution A

Water	284	ml
Uranium (uranyl) nitrate	1.3	grams
Glacial acetic acid	7	ml

or

Hydrochloric acid	3.6	ml

Solution B

Water	284	ml
Potassium ferricyanide	1.3	grams
Glacial acetic acid	7	ml

or

Hydrochloric acid	3.6	ml

Mix the two solutions together in equal parts right before use. Add and thoroughly dissolve a piece of sodium sulfite about the size of a pea.

FIG. 144

Prints to be toned with uranium (except for blue colors) should be lighter than normal. Mercury in the developer will improve the action of the toner, and especially the intensity of the red tones.

Blue tones. Develop a normally exposed print and clear it for no more than 10 seconds. Place it in the toning bath. After toning clear and wash as usual.

Olive tones. An olive-green tone is possible by clearing the print for slightly longer, perhaps 35 seconds, before toning. You can tone a blue-toned print olive by returning it to the toning bath after clearing. Prolonged immersion in the toning bath will turn the print a dark brown, perhaps with slightly blue highlights. After toning, rinse the print in hot water and wash for 10 minutes.

Red tones. Print the image lighter than normal, clear it fully, and then wash. Use a fresh toning bath for red tones. As the bath is used, it becomes darker and gives reddish chocolate tones. Afterwards, rinse the print in hot water and wash for 10 minutes.

The tones obtained with uranium are not stable and in time may change. The colors fade in alkaline solutions. You can use this to advantage to remove the color, if necessary, leaving the platinum image behind, by soaking the print in a 10% solution of sodium carbonate. Use the same or a more concentrated hot solution to clean uranium-stained trays.

Intensification

Here is an intensification procedure to increase image contrast. It works best with prints with full highlight detail but weak shadows. Prepare the solution immediately before use.

INTENSIFIER

Distilled water	200	ml
Gallic acid	1	gram
Silver nitrate (dissolve the silver		
first in a few ml of water)	0.35	gram
Glacial acetic acid	20	drops

Place a wet print in this bath and agitate until the tones reach the required depth. Rinse in several changes of water made slightly acid with acetic acid. When viewed by transmitted light, the print will now show a red color from the silver deposit. Tone this with metallic platinum in

Distilled water	237.0 ml
Sensitizing Solution 3	32 drops
	(1.6 ml)
Phosphoric acid	4.7 ml

Finish with a 30-minute wash.

Gold toning. Platinum prints can be toned with gold. This intensifies the image and gives it a black or blue-black color. Soak the print for a few minutes in warm water and then place it on a sheet of warmed glass. Blot it to remove the surface water and then cover the print with a thin film of glycerin. Brush a solution of gold chloride, made as follows, uniformly over the print.

GOLD TONER

Distilled water	26 ml
Gold chloride	1 gram

When the desired tone is reached, rinse the print in flowing water to remove the glycerin and the gold.

Any gold remaining on the print can be precipitated by the organic matter of the paper itself, staining the highlights. To prevent this, treat the print for a minute or so in any standard alkaline paper developer used for modern developing-out silver papers. Wash it thoroughly afterward.

Palladium Printing

The sensitizing and printing procedures for palladium are virtually identical to those for platinum. Palladium is a slightly less expensive metal and gives permanent brown-tone prints in a plain oxalate developer, used cold. Solution 1 is the same as for platinum. Solution 2 might best be prepared with double the amount of potassium chlorate, because for contrast control palladium

does not respond as readily to the chlorate as platinum does. Solution 3 is as follows:

PALLADIUM SOLUTION 3 (A)

Distilled water, at about 38°C
(100°F) *60 ml*
Sodium chloropalladite
(Na₂PdCl₄: also called
sodium tetrachloropalladate) *9 grams*

If the above is not available, use palladium chloride (*PdCl₂*, also called *palladous chloride*), adding sodium chloride to it.

PALLADIUM SOLUTION 3 (B)

Distilled water at 38°C (100°F) . . . *40 ml*
Palladium chloride *5 grams*
Sodium chloride *3.5 grams*

Potassium dichromate should not be used with palladium for increased contrast. It will bleach the image. Palladium does not respond to hydrogen peroxide as a contrast agent.

Platinum and palladium solutions can be mixed together. In this way the platinum supply can be stretched by the addition of the less expensive metal. Prepare the stock solutions separately and combine them drop by drop when mixing the actual sensitizer, varying the proportion as you see fit but keeping the total number of drops constant as called for in Solution 3. Increased palladium will warm the image color and reduce contrast, re-quiring the use of more chlorate. If you use hydrogen peroxide in place of the chlorate for contrast control, it will affect only the platinum present. This tends to produce warm highlights and cool shadows.

Combination Printing

The least expensive and probably the most effective after-treatment for a platinum or palladium print is to sensitize it for gum and print the same negative again in register (see the chapter on Gum Printing). This can enrich the shadows tremendously, and it opens the possibility of adding another color to the image.

If you experiment with combining cyanotype and platinum or palladium, print the cyanotype image last. The potassium oxalate developer will bleach a cyanotype.

Reclaiming Platinum and Palladium Wastes

Unfortunately, this is beyond the means of anyone lacking a considerable practical background in chemistry. While there are commercial refiners who might be willing to process the precious metals from developer residues or from paper clippings, they would only be interested if the quantity of metal likely to result were in the hundreds of grams.

Kallitype

Kallitype was anticipated in the early 1840's by the chrysotype and related silver processes of Sir John Herschel, but the name dates back only to 1889 and the work of Dr. W.W.J. Nichol, a lecturer on chemistry at Mason College in Birmingham, England. The chemistry of kallitype and of platinum printing are similar, with the important difference that the kallitype image consists of metallic silver. Kallitype paper is coated with silver nitrate and ferric salts. Exposure to light reduces some of the ferric salt to ferrous state. During development, the silver lying in contact with these new ferrous salts is in turn reduced to the metallic state. The result is a final image of metallic silver.

In the past, kallitype never quite caught on. Commercial modifications of the technique came on the market under such names as *Polychrome, Sensitol,* and even *Platinograph,* and there is evidence of enthusiasm for kallitype among American amateurs, especially for preparing homemade papers. But the process had the misfortune of arriving just as the gaslight papers were becoming popular and about a decade after the commercial introduction of the very successful platinum papers. Kallitype was neither as convenient to use as gaslight paper nor as permanent as platinum. The competition simply left kallitype behind.

Probably the most important argument against kallitype was its alleged impermanence. This reputation was enough to scare away photographers who at least knew that they could depend on platinum for a permanent image. When Nichol first announced his process, and put prepared papers on the market, his instructions called for ammonia as the fixer, apparently because ammonia had less effect on image than thiosulfate

did. But it became clear that the use of ammonia did not result in permanent prints. Sodium thiosulfate eventually replaced ammonia; but for years the literature on the process still contained references to impermanence—usually followed by assurances that kallitype prints were in fact as permanent as any other silver image.

The problem is that the finely divided metallic silver in a kallitype image is much less stable than metallic platinum, especially if the silver has carried down ferric salts, as is probably inevitable to some extent. Permanent prints with kallitype would depend on adequate removal of the ferric salts in their appropriate solvent, adequate removal of nonimage silver in sodium thiosulfate afterwards, and the creation of no unstable silver compounds.

Kallitype may not be as versatile as platinum, but it is definitely an economical way of achieving platinumlike print quality. Like platinum prints, kallitypes have a long straight-line characteristic curve. Unlike salted-paper prints, they do not suffer loss of contrast in the deep shadows because of a self-masking image.

Many experimenters brought out kallitype formulas of their own in the years following Nichol's introduction of the process. The methods that eventually gained popularity were quite different from Nichol's original formulations. The two given below are the most practical, in my opinion. See the recommended readings for the location of other kallitype formulas.

Method One

Commonly known as the *vandyke* or *brownprint,* this is the simplest kallitype technique. It has the

advantage of not requiring either ferric oxalate or a special developer.

Negatives. In order to print the full scale of tones of which the process is capable, negatives should be developed to a density range of approximately 1.85. This is quite a range. It is not absolutely necessary to use negatives of this great range—shorter-range negatives will simply give less-deep shadow values in the print. The printing contrast of the paper can be increased by adding potassium dichromate to the developing water.

Paper. Crane's Kid Finish AS 8111 works well, as does Rives BFK, although generally the latter should be sized first. Strathmore Artist Drawing often gives the shadow tones an uneven, bronzed-out appearance.

Sensitizing and Printing.

THE SENSITIZER

Solution A
Distilled water *33 ml*
Ferric ammonium citrate *9 grams*

Solution B
Distilled water *33 ml*
Tartaric acid *1.5 grams*

Solution C
Distilled water *33 ml*
Silver nitrate *3.8 grams*

After all three solutions have dissolved, combine the ferric ammonium citrate and the tartaric acid solutions (Solutions A and B) and then slowly add the silver nitrate (Solution C) while stirring.

FIG. 145 Printing-out kallitype image (Method One).

NOTE: *The sensitizer will stain hands and clothing.*

The combined solution should remain good for several months if stored in a brown glass bottle protected from bright light.

Coat the paper by brushing on the sensitizer as described in previous chapters. You can do this in normal tungsten room light. Dry the paper with moderate heat, if available. Store it in the dark.

Print in sunlight or with an ultraviolet artificial source until the shadows and middle tones of the printed-out image begin to show detail.

Developing and Fixing. Develop the print by washing in running water at about 20 °C (68 °F) for 1 minute. The image will become darker in the water and take on a yellowish tone.

The fixer comes next. Use a 5% plain thiosulfate fixing bath for 5 minutes at about 20 °C (68 °F):

FIXER

Water (warm) *500 ml*
Sodium thiosulfate *25 grams*

As soon as the print enters the fixer the image will darken and become brown. If fixed for longer than the five minutes, the image may then begin to lighten. Do *not* use a strong fixing bath. Since the above is a diluted fixer, replace it often.

Washing. After fixing, wash prints for about 40 minutes in running water. A hypo-clearing agent can be used to shorten washing time.

After washing, the image can be toned in the gold baths given in the chapter on Salted Paper.

FIG. 146 Same image after fixing and washing.

Contrast Control. Add potassium dichromate to the developing water as necessary to increase the printing contrast of the paper. Ten drops of a 10% potassium dichromate solution in 560 ml of water will give an increase in contrast equal to the loss of about one step from the tonal scale printed under a Kodak No. 2 Step Tablet.

Method Two

The following is probably the most common kallitype formula. It requires ferric oxalate for the sensitizer (for sources of this chemical, see the chapter on platinum), plus a developer and clearing bath, in addition to the fixer.

Sensitizing and Printing. Prepare the sensitizer as follows and allow it to ripen for several days before use.

THE SENSITIZER

Distilled water, at 38°C (100°F) . . 47 ml
Oxalic acid 0.5 gram
Ferric oxalate 7.8 grams
Silver nitrate 3.1 grams

Dissolve the oxalic acid and the ferric oxalate first, then add the silver.

NOTE: The solution will stain hands and clothing.

Store the solution in a brown bottle. The solution will throw down a precipitate of silver oxalate, which does no harm.

Sensitize, dry, and print as described for Method One.

Developing. For black tones on most papers, develop the print for 5 minutes in

Water, at 38°C (100°F) 500 ml
Borax 48 grams
Sodium potassium tartrate
 (Rochelle Salts) 36 grams

Dissolve the borax before adding the sodium potassium tartrate.

The developer works best if used warm.

The tones of the print can be made warmer by using less borax and more sodium potassium tartrate in the developer, as follows:

FOR BROWN TONES

Water, at 38°C (100°F) 500 ml
Borax 24 grams
Sodium potassium tartrate 48 grams

FOR SEPIA TONES

Water, 38°C (100°F) 500 ml
Sodium potassium tartrate 24 grams

NOTE: This last bath can be used at room temperature, but then develop the print for 10 minutes instead of 5.

Add from 5 to 20 drops of a 10% potassium dichromate solution to the developer as necessary for contrast control. Increasing the dichromate increases contrast.

Clearing and Fixing. Clear the print in the following bath at about 20°C (68°F) for 5 minutes.

CLEARING BATH

Water 500 ml
Potassium oxalate 60 grams

Fix at about 20°C (68°F) for no longer than 5 minutes in sodium thiosulfate, diluted as below.

Water (warm) 500 ml
Sodium thiosulfate 25 grams
Ammonia 6 ml

Replace this fixer often.

Washing. Wash prints in water for about 40 minutes after fixing. A hypo-clearing bath can be used, as can the gold-toning baths.

Dichromated Colloids

The following processes depend on the ability of colloids to become insoluble when mixed with potassium dichromate or ammonium dichromate and exposed to light. This effect is also referred to as *hardening* or, especially in early books, as *tanning*. The colloids most frequently used in photography are gelatin, gum arabic, and albumen.

The chemical reaction raises the melting point of the colloid and reduces its tendency to absorb water. If the water is hot enough, though, the colloid will eventually dissolve.

Carbon, Carbro, and Three-Color Carbro

Carbon

The carbon process employs a special *carbon tissue* (also called *pigment tissue*)—a sheet of paper coated on one side with a layer of pigmented gelatin. This "tissue"—which is actually thicker than the word implies—is sensitized with potassium dichromate or ammonium dichromate. When dry, it is exposed, gelatin side up, in contact with a negative. The exposure causes the gelatin to become insoluble in proportion to the light passed through the negative. The carbon tissue is then placed gelatin side down on a sheet of *transfer paper*—a paper coated on one side with plain, insoluble gelatin. The two are squeezed together and kept in contact for about twenty minutes. Then they go into a tray filled with warm water. In a few minutes the water penetrates through the paper backing of the carbon tissue and softens the gelatin in contact with it. The backing can then be pulled away, leaving the pigmented gelatin attached to the transfer paper. The image develops in the warm water as the soluble, unexposed gelatin melts and washes away.

At one time several companies manufactured carbon tissue. For decades the principal supplier in the world was the Autotype Company in England. Autotype made more than fifty different tissues in thirty colors, plus a variety of transfer papers. Carbon tissue became unavailable in the United States in the early 1960's but was reintroduced in 1971 by Dr. Robert F. Green of Fort Wayne, Indiana. Dr. Green now markets German-made tissues in several different colors, including those for three-color printing. He also supplies all the materials for the carbon and carbro processes,

a paper for oil printing, and a nonsupercoated bromide paper (see note on *Bromide Paper for Carbro* later in this chapter). Send for a list of materials and prices by writing to Gallery 614, 614 West Berry Street, Fort Wayne, Indiana 46802. The Gallery also offers seminars in carbon and carbro printings.

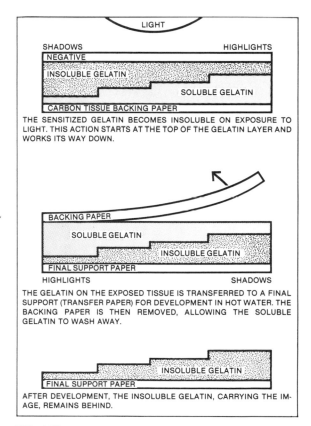

FIG. 147
Cross sections showing how carbon printing works.

Store carbon tissue at a temperature of 20 °C (68 °F) or lower, at a relative humidity of about 50%. The gelatin may lose some solubility after an extended time. To test it, cut off a strip and put it in water at 38 °C (100 °F). In cool water gelatin will swell up, but at this temperature it should dissolve.

Negatives. All the dichromated colloid processes have excellent straight-line characteristic curves, but for mechanical reasons the carbon process (and the related Woodburytype process) are the only colloid techniques that can really take advantage of this. Because of its long tonal scale, carbon works best with negatives of long density range; that is, negatives that have good separation of detail in the shadows (correct exposure) and strong density in the highlights (extended development). This is the kind of negative that prints easily on a contrast Grade 0 or Grade 1 commercial paper. Carbon will give excellent separation of detail in the shadow areas of the print, much better than is possible with the strictly matte-surface techniques described in other chapters. It is helped in this by the presence on the print of a gelatin layer that becomes thicker toward the shadow values. This gelatin layer gives the shadow a slight gloss, which increases the separation of shadow tones.

Before contact printing, mask the negative by taping a strip of paper or red lithographic tape along all four sides. Make this *safe edge* 13mm (½ in.) wide, if possible. It will protect the tissue from light and thus provide a soluble margin around the print. This will in turn keep the edge of the image from frilling and losing contact with the paper during development. The mask does not have to be entirely opaque. In fact, it will serve its purpose better if it does allow the margin to become slightly insoluble, otherwise the shadow areas right at the edge of the image may frill in spite of the masked border. Another way to achieve this slight insolubility is to separate the mask from the negative by the thickness of the glass in the printing frame: Placing the paper mask on the *outside* of the printing frame will give a diffuse edge to the border, reducing the chances of its frilling up.

Sensitizing

The sensitizer is potassium dichromate or ammonium dichromate. Using the latter, the standard concentration for average negatives intended for carbon printing is about 3%. For example:

Ammonium dichromate 6 grams
Water to make 200 ml

The concentration of the sensitizing solution controls printing contrast. Lower concentrations of dichromate, down to about 1%, increase contrast but decrease sensitivity. Higher concentrations, up to about 6%, decrease contrast but increase sensitivity. A 6% solution is 3-to-4 times more sensitive than a 1% solution.

Identical concentrations of the two dichromates do not produce identical printing characteristics: A 3.5% potassium dichromate sensitizer actually has the same sensitivity, contrast, and keeping qualities as a 2.5% ammonium dichromate sensitizer.

Before sensitizing, cut the tissue to a size at least equal to that of the negative plus the mask. Flatten the tissue by holding it under water at a temperature of 20 °C (68 °F). As soon as the tissue becomes limp, drain it and then immerse it, pigment side up, in a tray filled with sensitizer, also at 20 °C (68 °F). Agitate as necessary to keep the tissue covered by the solution and brush away any bubbles that form on the surface. After 2 minutes, hang the tissue in the dark to dry or—better—place it pigment side down on a sheet of glass, squeegee the excess sensitizer from the back, and then hang it to dry. As the tissue dries it will begin to curl inward. When this happens, take the tissue down and pin it by the corners to a stiff sheet of cardboard, pigment side up, so that it will dry flat for use. It is safe to handle the tissue under tungsten light when dry, but *protect it from daylight and ultraviolet sources.*

Tissue sensitized in this way will dry slowly. It will take several hours to dry if placed in front of a fan, longer if merely hung in the dark in a reasonably airy or ventilated space. Too much heat during the drying can melt the coating or cause reticu-

lation. If heat is used, it should be occasional and moderate and removed as soon as the tissue is dry. Do not dry the tissue in an area exposed to the fumes of turpentine or other paint solvents. Reportedly, this can reduce the dichromate, causing the gelatin to become insoluble. Lightning storms are said to insolubilize the tissue; but personally the opportunity to test this has yet to occur.

The sensitizer will keep if filtered after each use and stored in a brown bottle. Its printing characteristics may change, however, especially if not filtered, because the dichromate slowly becomes reduced by contact with the organic matter from the tissue: 3.8 liters (one gallon) of sensitizer is good for *not more than* six 40x50-cm (16x 20-in.) prints. Dr. Green suggests storing it in the refrigerator.

Spirit Sensitizers. Alcohol or acetone can be used to prepare fast-drying *spirit sensitizers.* Use either isopropyl alcohol or acetone with ammonium dichromate, but with potassium dichromate use only acetone (alcohol will reduce the potassium dichromate). Make up a stock solution of dichromate with water at twice the concentration you intend to use for sensitizing—that is, a 6% stock for a 3% working sensitizer. Pin the tissue down by its corners. Dilute a few ounces of the stock solution with an *equal volume* of acetone or alcohol. Prepare the tissue by brushing the sensitizer over the gelatin surface. Use a wide brush (a foam-plastic brush is ideal), dip it in the sensitizer, and go over the tissue with parallel, long strokes. Work for a uniform coating. Apply a second coating after the first is surface-dry. Throw the sensitizer out after use. Tissue coated with a spirit sensitizer is not as sensitive as tissue coated by immersion, but it will be dry and ready for use in 15-to-30 minutes.

If kept in a cool, dry place, and of course in the dark, the tissue will remain in usable condition for several days. Dichromated colloids gradually become insoluble during storage, even when not exposed to light. This *dark reaction* speeds up when the temperature or the relative humidity increases. The effect of the dark reaction is a gain in printing speed and a loss in contrast. Raising the pH of the sensitizer (by adding ammonia or potassium or sodium citrate) is sometimes recommended as a preservative—but raising pH lowers sensitivity. Instead, the best plan is to seal the tissue in a plastic bag after drying and then place it in a box in the refrigerator. Under these conditions the tissue should keep in good condition for months. To prevent condensation, allow the tissue to come to room temperature before removing it from the bag.

Printing

Preparing Transfer Paper. Trim the transfer paper slightly larger than the tissue and soak it face down in water at 20°C (68°F) for about 15 minutes. Avoiding bubbles, immerse it so that the gelatin side remains under water. *Begin soaking the transfer paper before making the exposure,* so that it will be ready when the exposure is completed.

Exposure. Expose the tissue in contact with the negative to any ultraviolet light source. The exposure with a single carbon arc placed 38cm (15 in.) from the printing frame is generally less than 2 minutes for a normal carbon negative and a 3% sensitizer. Use test strips, masked to prevent frills. (Figure 148.)

In *single-transfer* printing the image will be reversed from left to right when transferred to the final support. To make sure the final print has the correct orientation, expose the tissue in contact with the *base* side of the negative. Make sure the contact frame is tight, or is made to press tight with a little extra padding. When glass-plate negatives were in use, a *double-transfer* technique was necessary because the image would be unsharp if printed from a reversed negative with the

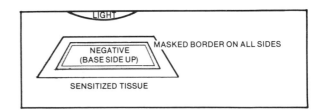

FIG. 148
Negative, mask, and tissue.

thickness of the glass separating emulsion from tissue. The double-transfer method is still useful, though, and is described in the section on three-color carbro.

Dichromated gelatin will continue to harden after being exposed, even if placed in the dark. There is no convenient way to gauge how fast this *continuing action* works, although it is rapid at first and slows down greatly by the end of an hour. You do not have to rush, but it is best to transfer and develop the print right away.

After exposure, rinse the tissue in several changes of water at 20 °C (68 °F) for about 45 seconds to remove the excess dichromate. This rinse reduces the chance that the final print will have a yellowish stain. The tissue loses its sensitivity once it is immersed in water and the dichromate washes out.

Transfer. Turn the soaking transfer paper coated side up, making sure its surface is clear of bubbles.

Place the carbon tissue in the same tray, gelatin side up. Brush the bubbles from the carbon tissue. Turn it over so that the gelatin sides of both papers are in contact. Do this carefully to avoid catching bubbles between the surfaces.

Holding the sheets together at one end, bring them in contact under water, then lift them together from the tray. (Figure 149.) Drain for a few seconds and then place the combination on a sheet of plate glass, with the transfer paper on the bottom.

Hold them against the glass at one end and use a squeegee to squeeze them together, lightly at first, and then with repeated strokes and increased pressure. (Figure 150.) They may slip a bit at first, but this does no harm. Start the squeegee first in the middle of the print and work once toward all four sides, then squeegee across with considerable pressure. The specific technique is not important as long as a firm contact is made and any air bubbles are expelled.

After squeegeeing, place the tissue/transfer-paper combination between two sheets of newsprint and lay them on the glass again. Put another sheet of plate glass on top. (Figure 151.) The newsprint will help the tissue dry out and secure a better transfer with less danger of frilling. It is a good idea to weigh the glass down, for instance with a gallon bottle filled with water or stock chemicals.

Separation. At the end of 20 minutes, immerse the transfer paper and the tissue, still in contact, in a tray of water between 37.5 °C and 40.5 °C (100 °–105 °F). The tissue should be on top, and thoroughly covered with water. In about a minute the pigment will begin to ooze out from beneath the edges of the tissue. After another

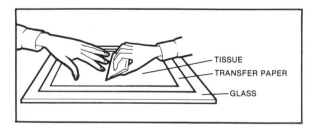

FIG. 150
Squeegee tissue and transfer paper into firm contact.

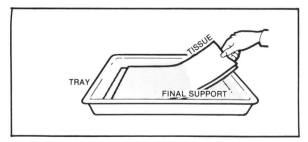

FIG. 149
Bring tissue and transfer paper together under water. Remove them together.

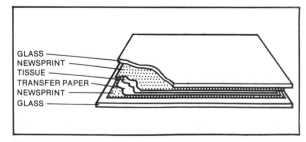

FIG. 151
Place tissue and transfer paper between newsprint and glass plates.

minute, gently begin to peel back one corner of the tissue. (Figure 152.) The backing paper should come away easily, leaving the pigmented gelatin in contact with its new support. *Do not force them apart:* If the tissue sticks, gradually increase the temperature of the water until the backing paper loosens.

Development. At this stage there will be no image, only an unpromising-looking mass of pigment. Turn the paper pigment-side down and, holding it by one corner, agitate it gently. You can turn it over a few times, or just let the print float face down in the tray. The warm water will dissolve the gelatin and the image will slowly appear. *The gelatin film is very delicate.* Do not touch it with your fingers or allow it to come in contact with the sides or bottom of the tray. Add warm water as necessary to maintain the temperature.

The print has been *overexposed* if development seems to stop before the image reaches the correct density. Sometimes heating the water to about 43 °C (110 °F) will save an overexposed print, but this is risky: At this high temperature the gelatin may begin to blister and frill. If raising the temperature does not work, lower it again to about 40 °C (104 °F) and add a little ammonia to the water. Add just a milliliter at a time and then watch for a result before adding more. The ammonia will soften the gelatin; so use it with care.

Local development is sometimes possible by lightly touching the print with a brush or a stream of water. Do this with great care because it can tear the thin gelatin film.

Not much can be done with an *underexposed* print. Remove it from the tray as soon as you suspect underexposure. If necessary, continue development in water at about 27 °C (80 °F).

Cooling Down. After development, place the print directly in a tray of water at a temperature no higher than 18 °C (65 °F). Five minutes in this will cool and harden the gelatin.

Drying. Drain the print and dry it without heat. When dry, the print can be mounted in a dry-mounting press at a temperature up to 104 °C (220 °F).

Clearing. The print may have a slight yellowish stain from the dichromate sensitizer. An alum bath is usually recommended to remove this, on the grounds that alum not only clears the stain but also hardens the gelatin. But alum can introduce an acid condition that is bad for the archival keeping quality of paper. Instead, use a 5% sodium bisulfite or potassium metabisulfite bath, at about 18 °C (65 °F), to clear the stain. The only problem with these sulphite alternatives is that they can soften the gelatin as they work; so it is best to allow the print to dry overnight before clearing. Clear prints one at a time and be careful not to touch the gelatin surface. When the stain is gone, wash the print again in cold water for several minutes.

The gelatin should dry to a sufficient hardness without special treatment, but if a hardening bath is thought necessary use a 2.5% solution of formalin. Soak the print in this for 5 minutes and then wash briefly in cold water.

Making Final Support Paper

To make your own transfer paper, give the paper several coatings of gelatin size as described on pages 141-143. This should be hardened as directed. Nearly any paper with good wet-strength is suitable.

Carbro

First, here is some history.

In 1873, A. Marion discovered that when paper sensitized with a dichromate (but without pigment) was exposed to light under a negative and then placed in contact with carbon tissue for

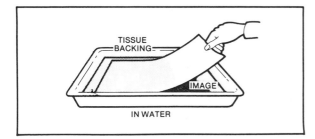

FIG. 152
Remove tissue backing and develop the image.

several hours, the pigment on the tissue would become insoluble.

Thomas Manly in 1899 introduced a process based on this phenomenon. He called his technique *ozotype* on the mistaken assumption that the creation of ozone caused the gelatin to become insoluble. Manly sensitized paper with a solution of gelatin, dichromate, and a manganous salt. The paper gave a printing-out image and could be kept indefinitely after the exposure if washed first to remove the soluble salts. To make a final print, Manly treated carbon tissue in a solution of acetic acid, copper sulfate, and hydroquinone, then laid the tissue in contact with the exposed paper and pressed them together with a squeegee. The gelatin on the tissue became insoluble in proportion to the printing-out image. The picture was developed by separating the two sheets and dissolving the pigmented gelatin, which was now transferred from the tissue onto the surface of the original printing-out image.

This system had several advantages over the standard method of carbon printing: The correct exposure was easier to figure because it depended on a printing-out image; the actual treatment of the carbon tissue did not require a printing

FIG. 153
An ad from *The Photo-Miniature*, May 1901.

light; and double transfer was not necessary when printing from glass negatives.

Thomas Manly's brother, Robert, worked out a modification of the process and called it *gum ozotype.* In this method the printed-out manganous paper was brushed over with a pigmented gum arabic solution. As in the other process, the gum became insoluble in proportion to the printing-out image. The picture was developed in the same way as a standard gum print.

Both the ozotype and the gum-ozotype processes created a stir when they were first introduced and had some popularity among Pictorialists.

In 1905, Thomas Manly introduced a variation on ozotype using bromide prints. His new *ozobrome* process was based on the discovery—made in 1889 by E. Howard Farmer—that dichromates are reduced by contact with finely divided metallic silver in the presence of gelatin, and that this in turn causes the gelatin to become insoluble. Manly treated a sheet of carbon tissue with potassium dichromate, potassium ferricyanide, and potassium bromide. He then pressed the tissue face-to-face with a bromide print. While the two were in contact, the silver image of the bromide bleached out, and the gelatin on the carbon tissue became insoluble in proportion to the tones of the original bromide print.

This method had all the benefits of the ozotype process plus one important and timely addition: Because the negatives could be printed first by enlargement on bromide paper, the technique was convenient for use with the small negatives from the hand cameras that had become increasingly popular. Enlarged duplicate negatives were not necessary.

In 1919, H.F. Farmer (no relation to E. Howard Farmer) improved the process, which was then marketed by the Autotype Company as the *carbro* (carbon + bromide) technique. The carbro process, however, and also the updated carbro technique worked out by Dr. Robert Green of Gallery 614, are essentially the ozobrome method described above.

Carbro has an advantage over *carbon* in not requiring large negatives or negatives developed to

so high a density range that they are difficult to print on regular silver papers. Control of print contrast also is easier with carbro, as are local modifications, which can be done by burning and dodging on the original bromide image. If the bromide is correctly printed, and if each step is properly carried out, there is none of the risk faced in carbon printing of wasting tissue through mistakes in exposure.

Bromide Paper for Carbro. At one time almost any bromide paper could be used for carbro printing, but the practice of "supercoating" emulsions with a superficial nonsensitive layer of hardened (insoluble) gelatin (which in effect acts as a barrier between the silver image and the carbon tissue) has made most papers on the market today unsuitable for the process. Kentmere's matte-surfaced non-supercoated bromide enlarging paper, available by order from Gallery 614, can be used for carbro, as can Luminos RD-Matte Bromide (white) and Kodak Polycontrast Rapid RC (matte surface). The Kentmere paper is available in contrast grades 1,2,3, and 4, comparable in contrast to Agfa papers with the same number grades. The paper also responds well to contrast control by means of changes in exposure and/or developing time or developer dilution.

Making the Bromide Print

Certain metol-hydroquinone developers, such as Kodak's Dektol, tend to harden the emulsion slightly during processing. This can interfere with proper insolubilization of the carbon tissue. It is best to develop the bromide print in a nonhardening developer, such as Ethol LPD, or in any of the Amidol developer formulas given in most older textbooks.

For a full-range carbro print, expose the bromide for good highlight detail and develop for full shadows. If you intend it for use with the #1 Warm Black tissue, make the bromide print slightly lighter than would be correct for normal viewing.

Adjust the enlarging easel so that a white border about 13mm (½ in.) wide will surround the image. This will prevent frilling along the edges of the gelatin film when the image is developed after transfer.

After development, rinse prints in a plain water stop bath, and then fix for 5 minutes in plain hypo, *without* hardener, at 20 °C (68 °F).

FIXER FOR BROMIDE PRINTS

Water, at 38 °C (100 °F) *500 ml*
Sodium thiosulfate *100 grams*

Wash prints for 30 minutes—less if resin-coated.

Prints may be used at once or dried and used at a later date. If the print has dried, soak it in water at 20 °C (68 °F) for 15 minutes before use. This softens the gelatin and (in the case of non-resin-coated papers) allows the paper fibers to expand uniformly, preventing distortion of the image.

Sensitizing and Contact

SENSITIZER FOR CARBRO

Water (1,000 ml) *1 liter**
Potassium ferricyanide *16 grams*
Potassium dichromate *16 grams*
Potassium bromide *8 grams*
Succinic acid *2.4 grams*
Potassium alum *1 gram*

*The dilution of the sensitizing formula controls contrast. 1 liter is average. *For more contrast use 1.25 liter (1,250 ml) of water. For less contrast use .75 liter (750 ml) of water.*

The sensitizing solution must be used within a temperature range of 7.2°–12.5°C (45°–55°F), 12.5 °C being preferred. You can make up three sensitizer stocks—one in each of the above dilutions—and store them in the refrigerator for temperature convenience until needed. The sensitizer may be used again. (More on this below.)

Trim the carbon tissue to the same size as the physical edge of the bromide print. Then trim the transfer paper slightly larger than the carbon tissue.

If the bromide print is dry, soak it in water at 20 °C (68 °F) for 15 minutes, then place it face up on a sheet of glass. Use a squeegee to press the

print down so that it adheres firmly to the glass and will not slip when the sensitized tissue is later squeegeed on top. Splash water over the bromide print until its entire face is covered. Do not leave bubbles.

Sensitizing the Carbon Tissue. Place the carbon tissue in a tray of water at 20 °C (68 °F) for about 2 minutes. Then lay it, gelatin side *down*, on a second sheet of glass and squeegee off the excess water. Quickly place the tissue, gelatin side *up*, in the sensitizing bath at 12.5 °C (55 °F). Agitate the tissue constantly, keeping it under the surface of the solution. Leave it in the sensitizer for no less than 2 and no more than 3 minutes. Contrast increases with increased time in the sensitizing bath, between these limits.

Squeegeeing. Remove the tissue from the sensitizing bath and drain the excess sensitizer from its surface. Check that the bromide print is covered with water and that both the print and the tissue are free of bubbles. Lower the tissue's gelatin side into contact with the print: Place *one end* of the tissue along the edge of the print. Hold this firmly in place and lower the rest of the tissue down the remaining length of the print. Do this carefully, because as soon as the tissue and the print make contact the insolubilization of the gelatin begins. A double image will result if the tissue is then moved. Starting from the end held down, carefully squeegee the tissue to the print.

Place a sheet of newsprint, cut larger than the tissue, over the combination and then lay a second sheet of glass on top. Since no transfer of the pigmented gelatin takes place at this stage it is not necessary to weigh the glass down, but make sure contact is complete. Leave the two in contact 15 minutes.

Preparing the Transfer Paper. *Right after* placing tissue and bromide together, put the transfer paper in water at 20 °C (68 °F) to soak for 15 minutes. Keep the gelatin side under water.

Stripping. After tissue and bromide have been in contact for 15 minutes, remove the glass and the newsprint and place the tissue/bromide sandwich, bromide uppermost, in a tray of water at 20 °C (68 °F). Strip the bromide from the tissue and set the bromide aside in a tray of water.

From here on the process is identical to regular carbon printing: Rinse the tissue in several changes of water at 20 °C (68 °F) for no longer than 45 seconds to remove the excess dichromate. Turn the transfer paper gelatin side up and brush off any bubbles. Again avoiding bubbles, lower the tissue face to face with the transfer paper and bring them into contact *under water*. Holding them together at one end, lift them from the tray. Drain, then lay the combination on the glass with the tissue on top. Squeegee the tissue firmly into contact with the transfer paper and then sandwich the combination between two sheets of newsprint. Put the new combination back on the glass. Put a second sheet of glass on top, with a full gallon bottle as a weight.

After 20 minutes, remove the combination and immerse it, with the tissue on top, in a tray of water at 37.5°–40.5 °C (100°–105 °F). In about a minute the pigment should begin to ooze out from along the edge of the tissue. Then strip off the tissue backing and develop the print in the warm water as directed in the section on carbon printing. Follow with a soak for 5 minutes in water not warmer than 18 °C (65 °F) to harden the gelatin.

Redeveloping the Bromide Print. The bromide print can be redeveloped and reused up to five times. Rinse off the bleach and redevelop the bromide in the original developer for the original time. Afterwards, wash it for 30 minutes—refixing is not necessary. The print will increase in contrast after each use and eventually will require sensitizing in the 750 ml, low-contrast sensitizing solution described earlier.

Nontransfer Method

It is possible to develop the carbon image right on the bromide print without transfer. This works well and is worth a try. If you use this method, be sure to fix the bromide first in fresh nonhardening fixer and then wash it thoroughly to make sure all fixer is removed.

Soak the bromide in water at about 24 °C (75 °F) and then squeegee the sensitized tissue

onto it in the regular way. A transfer is desired; so sandwich the tissue/bromide combination between newsprint and put the second sheet of glass and a weight on top. Let them remain in contact for 30 minutes. Then place the sandwich in a tray of water at 40°C (104°F). In a few minutes the tissue will loosen. Peel off the backing and develop as usual.

After the bromide print with the new carbon image on top has dried, either remove the silver image entirely by refixing or else redevelop the silver image in the original developer. Redeveloping the underlying bromide will strengthen the image and can be used to create two-toned effects—one color coming from the redeveloped image and the other from the pigment. Either method will also remove any color stain from the bleached print. In the case of a redeveloped image, wash the print afterwards for at least 30 minutes in water at 18°C (65°F). If you refix the print, wash it for about an hour or use a hypo-clearing agent to shorten the time. Even with the silver image gone, traces of fixer can still have harmful effects on the paper itself.

Materials for Carbon Printing

1. Carbon tissue
2. Transfer paper
3. Potassium *or* ammonium dichromate
4. Two sheets of plate glass
5. Newsprint
6. Sodium bisulfite *or* potassium metabisulfite
7. Rubber squeegee

Additional Materials for Carbro

8. Ethol LPD developer
9. Bromide enlarging paper
10. Potassium ferricyanide
11. Potassium dichromate
12. Potassium bromide
13. Succinic acid
14. Potassium alum
15. Waxed paper

Outline of Carbon Process

1. Mask the negative.
2. Sensitize the carbon tissue and let it dry.
3. Soak the transfer paper in water at 20°C (68°F) for 15 minutes.
4. Contact-print the tissue and negative.
5. Rinse the exposed tissue, place in the water with the transfer paper; squeegee them together face to face, leave in contact between glass for 20 minutes.
6. Place the combination in water 37.5°–40.5°C (100°–105°F); separate, then develop the image.
7. Place the print in cold water—no warmer than 18°C (65°F)—for 5 minutes.
8. Drain and dry.

Outline of Carbro

1. Prepare the bromide print.
2. Place the bromide print on plate glass, face up; cover it with water.
3. Sensitize the carbon tissue 2-to-3 minutes at 12.5°C (55°F); squeegee it into face-to-face contact with the bromide; leave in contact for 15 minutes.
4. Soak transfer paper in water at 20°C (68°F) for 15 minutes.
5. Place the bromide-and-tissue combination in water at 20°C (68°F); peel off the tissue backing.
6. Squeegee the tissue in contact with the transfer paper; leave them in contact for 20 minutes.
7. Place the combination in water 37.5°–40.5° (100°–105°F); separate; develop the image.
8. Place in cold water—no warmer than 18°C (65°F)—for 5 minutes.
9. Drain and dry.

Possible Faults

The most frequent problem is frilling of the edge of the image during development on the transfer paper. This can happen if the water used for

placing the tissue in contact with the support paper is too warm or too alkaline, or if the temperature and humidity of the work area are too high. Work-area temperature should be 20 °C (68 °F) or lower, and the relative humidity 50 % or lower.

Sometimes the entire surface of the print appears wrinkled or *bubbled.* This can be caused by dissolved gases in the water used for the transfer step. The cure is to boil the water first to drive out the gases, then cool it for use.

See also the notes on faults at the end of this chapter.

Three-Color Carbro

In the three-color carbro process, three bromide prints are made (from three different color-separation negatives) and transferred onto yellow, magenta, and cyan carbon tissues. The three tissues are in turn transferred in registration onto a single support to produce a full-color print.

Three-color carbro and the earlier three-color carbon methods were the first commercially practical techniques for making permanent color prints. A primitive form of three-color carbon was patented in 1868 by one of the pioneers of color photography, Louis Ducos du Hauron; but the technique did not become widespread until carbro was introduced at the end of the First World War. It was taken up chiefly by professional photographers and photofinishers. Three-color carbro fell completely into disuse when carbon tissues became unavailable in the 1960's. The rebirth of the process is due to Dr. Robert F. Green of Gallery 614.

Color Separation. The Three-Color Printing chapter describes the theory and technique of making color-separation negatives directly in the camera or from color transparencies. The instructions below cover the printing of the bromides from the separation negatives and the production of the three-color carbro print. If you are not familiar with color-separation negatives, have a look now at the chapter on Three-Color Printing.

Separation Negatives and Prints

Negatives. In your first attempts at three-color carbro, you should definitely include a gray scale in each separation negative. Either include a reflection gray scale at the edge of the actual scene when you take the color transparency or make in-camera separation negatives, or else place a transparency gray scale (step tablet) next to the color transparency when you make separation negatives in the darkroom. Either way will allow you to balance the negatives by adjusting the exposure and development until the gray scales match, or are at least not more than one step apart. Your exposure and development times will then be the same for all three bromide prints. For three-color carbro, the separation negatives should have a shadow density of about 0.35 in those areas where you want to show detail. The total density range should be approximately 1.10.

If the gray scales on the negatives match, the negatives will all have the same density in the areas representing pure white highlights in the original scene (Zone IX in Zone System terminology). *This highlight must print pure white on each of the bromides;* otherwise, there will be a slight veil of color in the highlights of the final print.

The Bromide Prints. After you have made your set of color-separation negatives, prepare a set of matched bromide prints by contact or enlargement.

Place the separation negatives on a light table and select the one in which you can most clearly see the difference in density between the areas that should print pure white and the first highlight step that should actually show a definite tone. In Zone System terminology this is analogous to finding the densities on the negative that correspond to Zone IX and Zone VIII. It is easy to do if you included a reflection gray scale in the original scene.

Take this negative and make a bromide print, following the processing directions given below (the same as for monochrome carbro). Make test strips, adjusting exposure until the pure white shows white and the first step below it just barely

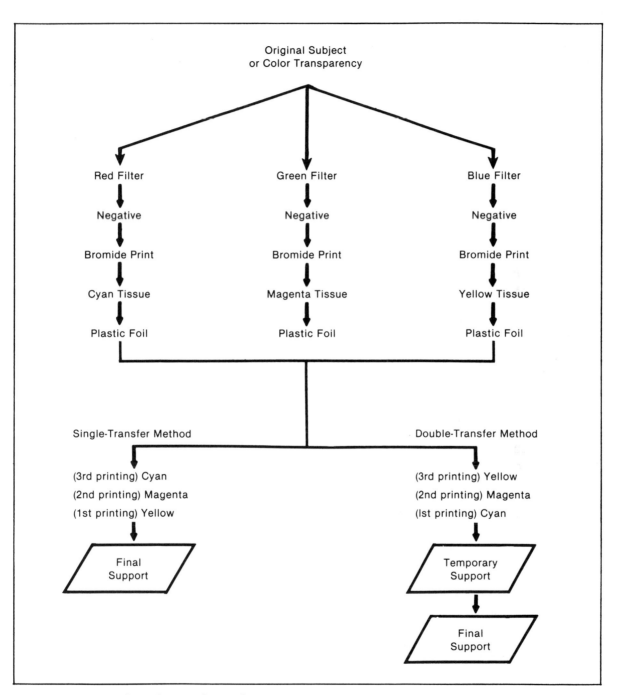

FIG. 154 Image path in three-color carbro.

shows tone. Fix and surface-dry the test strips, then inspect them under white light. When you finally have a test strip with the correct exposure, make a full bromide print and use its gray-scale image as a guide for making the bromides from the other two separation negatives.

If the gray scales on the separation negatives all match, the same exposure time will be correct for all three bromides, and the corresponding gray scales on each of the *prints* will automatically match. If the original gray scales on the separation negatives do not match, adjust the exposure and, if necessary, the developing time of the bromides until the prints made from the two remaining separation negatives have gray scales matching that of the first bromide print.

The bromides will not look like regular black-and-white prints. For instance, a blue sky will be light in the print made from the blue-filter negative, darker in the print made from the green-filter negative, and darkest in the print made from the red-filter negative. The *blue-filter negative is printed in yellow,* the *green-filter negative is printed in magenta,* and the *red-filter negative is printed in cyan.* A Caucasian face will be light in the print made from the red-filter negative and darker in the prints made from the green-filter and blue-filter negatives. This can all be very confusing if you have not worked with color separations. As I just discovered, it remains confusing even if you have. The standard reference provided by the gray scales helps keep the confusion to a minimum.

Remember to mark the back of each bromide with the initial of the filter that was used to make that particular separation negative. For the double-transfer technique (see below), print the negative so that the bromide print has the normal left-to-right orientation. This will guarantee correct left-to-right orientation of the final color print. For the single-transfer technique, print so that the bromide is reversed from left to right. As with monochrome carbro, *make sure that a border 13mm (½ in.) wide surrounds each bromide print to prevent frilling.*

Processing the bromide prints. Develop the bromides for 2 minutes in Ethol LPD, using con-

stant agitation. Rinse in plain water for 1 minute. Fix in plain fixer *without hardener* for 5 minutes with frequent agitation. Follow this by a 30-minute wash, taking care that prints do not rub against each other: Rubbing can cause abrasion marks that can show up as defects in the final image.

After washing, you can either dry the bromides and use them later or go right to the next operation of squeezing them into contact with the sensitized carbon tissues.

If you dry the bromides, first gently sponge them off or hang them up to keep water from pooling on the emulsion, which can cause spots on the final print. Do not use heat for drying. When you are ready to use them, be sure to soak all the dried prints in water for the *same length of time,* about 15 minutes at 20 °C (68 °F). This allows the paper fibers to swell equally and the prints to expand to the same size. If this is not done, accurate registration may not be possible. This is not critical with resin-coated papers because of their dimensional stability.

Sensitizing and Contact

Place the already-soaked bromide print made from the red-separation negative in a tray of water at 20 °C (68 °F) and then trim a piece of cyan tissue (No. 122) to the same size as the physical edge of the bromide print. Place this tissue pigment side up in the same water as the print for about 30 seconds, or just until the tissue starts to flatten and becomes limp. Then place it pigment side up in the carbro sensitizing bath for 2 minutes. The temperature of the bath should be 12.5 °C (55 °F). Agitate as often as necessary to keep the tissue completely covered with the solution.

While the tissue is in the bath, take the bromide print and squeegee it, image side up, onto a sheet of plate glass, then splash its face with water, avoiding bubbles.

After the 2 minutes, remove the pigment tissue from the sensitizing bath and squeegee it face to face with the bromide print, exactly as in monochrome work. Remember, the tissue must not be allowed to slip across the bromide print or a double image will result. Place a sheet of newsprint over

the combination and then another sheet of plate glass on top. You can weigh it down if you prefer. The bromide and the tissue should remain in contact for 15 minutes.

Transfer and Development

The Plastic Support. In the three-color carbro process, the tissues are transferred onto separate transparent plastic supports for development. The supports make registration of the three images possible.

While the tissue is in contact with the bromide print, take a piece of the 107S Plastic Foil (supplied by Gallery 614) and place it on a flat surface. Scrub one side of the foil with detergent (Ivory Liquid works best) for 5 minutes, using a sponge. This combination of scrubbing time and detergent abrades the foil just enough to give it the texture to accept and hold the pigment transferred from the tissue. Rinse the foil thoroughly and place it in a tray of clean water at 20 °C (68 °C) with the scrubbed side *down.*

Transfer to the support. At the end of the 15 minutes of contact between the bromide print and the tissue, remove the plate glass and newsprint and place the print-and-tissue combination in a tray of water at 20 °C (68 °F). Strip the bromide print from the tissue and set it aside for redevelopment. Rinse the carbon tissue in several changes of water to remove the excess dichromate to help prevent a yellow stain from appearing in the final print.

Slip the tissue face up into the tray containing the plastic foil. Slide it *under* the foil so that the pigment is in contact with the foil's scrubbed side. This will allow you to inspect the combination to be sure that there are no bubbles between the two surfaces. Remove the tissue and foil from the water together, holding them in contact along one side. Drain for 15 seconds (this also helps reduce the dichromate stain) and place the combination on the plate glass with the tissue side up. Press them together firmly with a rubber squeegee, using several strokes to ensure complete contact. Cover the tissue with newsprint, then with a se-

cond sheet of plate glass, and weigh them down with a full gallon bottle.

Development. Leave the tissue and the plastic foil in contact for 30 minutes. Then immerse them in a tray of water between 37.5 °C and 40.5 °C (100 °–105 °F), tissue side up. After a minute or so, pigment will begin to ooze from the edges. Slowly strip them apart. Develop the image (now transferred to the foil), using gentle agitation for several minutes until the gray scale shows the proper tones.

Place the plastic foil in water at 15.5 °C (60 °F) for 5 minutes to cool and harden the gelatin, then drain it and hang to dry in a dust-free place. Wipe the plastic dry around the edges of the image. Do not use heat in drying.

Follow the same procedure with the bromide print made from the blue-separation negative, using the yellow tissue (No. 120), and with the bromide print made from the green-separation negative, using the magenta tissue (No. 121). When all three foils are dry, they are ready to be transferred in registration by one of the methods described below.

Time Chart

The following time chart gives a schedule that will allow you to process all three tissues—from sensitizing through development—in a little more than an hour. It assumes that the bromide prints are coming straight from the wash after fixing.

If you are using dry prints, do this first: Place the red-filter bromide in the soaking-water and start your clock. At 6 minutes, place the green-filter bromide in the water. At 12 minutes, place the blue-filter bromide in the water. Wait 3 minutes, then set the clock back to 0 and begin the chart sequence.

(see next page)

TIME CHART FOR THREE-COLOR CARBRO

Cut tissues and foils to size, scrub foils, set up trays, cool sensitizer to 12.5 °C (55 °F).

Time	Red-Filter Bromide Cyan Tissue	Green-Filter Bromide Magenta Tissue	Blue-Filter Bromide Yellow Tissue
	Flatten tissue in water.		
Start clock:	*Place tissue in sensitizer.*		
2 min.	*Squeegee bromide and tissue in contact.*		
5 min.	*Flatten tissue in water.*	
5½ min.	*Place tissue in sensitizer.*	
7½ min.	*Squeegee bromide and tissue in contact.*	
11 min.	*Flatten tissue in water.*
11½ min.	*Place tissue in sensitizer.*
13½ min.	*Squeegee bromide and tissue in contact.*
19 min.	*Strip, rinse tissue, and transfer to foil.*		
25 min.	*Strip, rinse tissue, and transfer to foil.*	
31 min.	*Strip, rinse tissue, and transfer to foil.*
53 min.	*Develop foil.*		
59 min.	*Develop foil.*	
65 min.	*Develop foil.*

The times given are for the start *of each step and allow enough time before the start of the next step. Developing times, however, may overlap.*

Registration and Final Transfer

In most three-color printing the yellow image is usually printed first because it is the most opaque, the magenta image next, and finally the cyan image on top. This is the procedure followed in *single-transfer* three-color carbro. The only problem with single transfer is that sometimes it is difficult to register the red and the cyan images over the yellow image—unless the subject contains definite edges or lines that are repeated in each of the separations.

In the *double-transfer* method the cyan image is printed first, then the magenta, and the yellow last. This sequence is the easier to register. The three images are first transferred in registration from the foils onto a single sheet of soluble temporary support paper (available from Gallery 614), which is manufactured with a coating of soluble gelatin. The complete color image is then transferred onto a final support. This final step puts the yellow image on the bottom, where it belongs for the proper color rendition of the print.

Double Transfer. Cut the soluble temporary support to the same size as the plastic foil and then submerge it face *up* in water at about 55°C (60°F) for 2 minutes.

Next, slip the plastic foil with the cyan image under the water pigment side *down*—face to face with the temporary support— taking care to avoid bubbles. Remove the two from the water together and place them on a sheet of plate glass, the temporary support on top.

Squeegee them together firmly, then place newsprint on top and add a second sheet of plate glass. Weight this down with a full gallon bottle and let it sit for about 10 minutes.

At the end of that time, remove the glass and newsprint and hang the foil/temporary-support combination up to dry, using four spring-clothespins: two along the top and two for weight along the bottom.

When dry (about four hours under normal conditions), the plastic foil will strip from the temporary support when the clothespins are removed, leaving the pigment image behind. Sometimes a slight pull may be necessary to help it along. Save the plastic foil—you can use it again.

Follow the same procedure with the magenta image, registering it over the cyan image after removing them together from the water. Dry and strip as directed above, and then repeat with the yellow image.

Transfer to the final support. Place a sheet of single-transfer paper in water at about 20°C (68°F), gelatin side down so that the gelatin remains immersed. After 12 minutes, turn this over and place the temporary support carrying the three pigment images in the same water, face down, and allow it to soak for 3 or 4 minutes. Then draw the two sheets out together in face-to-face contact. Place them on a sheet of glass. Squeegee together firmly and sandwich between two sheets of newsprint. Then place a second sheet of glass and a filled-gallon-bottle weight on top.

After 20 minutes, immerse the combination in a tray of water at 43°–46°C (110°–115°F). In a short time the temporary support will begin to loosen, leaving the pigment image in contact with the final support paper. Once this starts, gently peel the temporary and final supports apart.

Gently and briefly wash the image to remove the soluble gelatin. Place it for a few minutes in cold water. Finally, drain the finished three-color print and dry it in a dust-free place.

Single Transfer. Double transfer is a nuisance and by no means always necessary. If the separation images you are working with are not difficult to register, or contain registration guide marks, you can transfer directly to the final support and skip the intermediate step called for in double transfer. Print the separation negatives for single transfer so that the *bromide image is reversed.* This will bring the *final* image the right way around. The order of transfer is yellow, magenta, cyan.

Soak single-transfer paper in water at 20°C (68°F) for 15 minutes before transferring the image from the yellow foil. As it dries the foil will separate from the paper, leaving the image behind ready for the next transfer.

Gelatin solution. Using a gelatin solution between the foils and the transfer paper will make it easier to slide the magenta and cyan images into registration over the yellow image. The gelatin solution also gives the final image a greater physical relief.

<div align="center">3% GELATIN SOLUTION</div>

Water (cold) 300 ml
Gelatin 15 grams

Allow the gelatin to swell for about 10 minutes, then add

Water to make total volume 500 ml

Heat the solution to dissolve the gelatin, then cool to 21°–27°C (70°–80°F) for use.

Soak the transfer paper carrying the transferred yellow image in water at 15.5°C (60°F) for 15 minutes, then place it face up on a sheet of glass and squeegee it into contact with the glass. Coat it with a uniform layer of the gelatin solution; break any bubbles on the surface. Take the foil with the magenta image and lower it over the yellow image, one end first. Slide the foil until the images are in register. Squeegee them together. Turn the combination over. Place newsprint over the

paper, then glass, and a weight on top. Follow with the drying and stripping procedure given earlier. Repeat with the cyan image.

Color Reduction. The cyan image can be reduced by soaking in a 1% potassium ferrocyanide solution for 5 minutes. The magenta image can be reduced in methyl alcohol, followed by a rinse in cold water. The yellow image cannot be reduced.

Possible Faults

Dr. Green describes common faults and their probable causes.

Air bells or irregular spots. Uneven contact between tissue and plastic foil, or incomplete removal of fixer from the bromide print. Dissolved gases in the water used in transfer steps.

Frills or loosening of the pigmented gelatin on the plastic foil. Sensitizing solution, soaking bath, or plate glass was too warm during transfer.

Time of contact between bromide and tissue was too brief. Margin around the bromide was too small. A relative humidity above 50% can also be the cause.

Highlight tones mottled. Bromides not sufficiently washed, and so not free of fixer. Uneven squeegeeing or a lack of pressure on the squeegee.

Tissue sticks to plastic foil. Sensitizing bath or plate glass was too warm.

Transferred image develops incompletely. Image was left too long on the plastic foil before transfer. Water in which tissue and foil were brought together was too warm.

Bromide sticks to tissue. Temperature of baths was too high.

Image does not transfer from tissue to plastic foil. Solutions were too warm or there was not enough texture on the plastic foil.

Gum Printing

Gum dichromate is probably the technique most responsible for the current revival of the historical processes. Gum prints can be made in any color, and color and contrast are easily modified. The possibilities go from prints with normal photographic tonality and deep, lustrous shadows to prints with graphic color effects similar to those seen in silkscreen work. The cost is low, yet with the right papers and pigments gum prints are permanent. The main drawback is that gum cannot register fine details. Also, because it is as much a physical as a chemical process, gum takes a certain amount of finesse to control: Success at gum printing takes practice.

Paper for gum printing is coated with a solution of gum arabic, ammonium dichromate or potassium dichromate, and a watercolor pigment. It is dried and contact-printed. During the exposure the gum becomes insoluble in proportion to the light passed through the negative. The image is developed by floating the print face down in a tray of water. The gum gradually dissolves off the face of the print from those areas that did not receive exposure, carrying the pigment with it. The exposed areas, having lost their solubility, retain the image, which consists of pigment held in the now-insoluble layers of gum left sticking to the paper's surface.

Figure 155 shows how the insolubilization takes place in the gum coating. The coating has a certain thickness. On exposure to light, the part or layer first made insoluble is that nearest to the negative, farthest from the paper itself. In the shadow areas of the image, where the exposure is greatest, the insolubilization goes all the way down through the coating to the paper base. But in the highlights and middle tones, where the gum receives less exposure, only the top layer of the coating becomes insoluble. A still-soluble layer lies underneath, between the insoluble gum and the paper base. The lighter tones would flake off during development, pushed by the dissolving soluble gum beneath, if the top layer of insoluble gum were not held in place by the high points of the paper's fibrous surface. Because of the fibers, the soluble gum can ooze out slowly without taking the lighter tones with it.

The process works best when certain conditions are met.

1. The surface of the paper must have enough texture, or *tooth*, so that the top layer of insoluble gum in the lighter tones is always at least partly touching the paper. This does not mean that the paper must be noticeably rough in texture, but it does mean that very smooth papers will not work well with the gum process if a continuous tonal scale is desired. With smooth papers, only the shadows will stick.

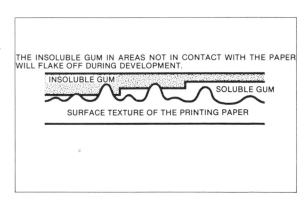

FIG. 155
The surface of a gum print before development.

2. The print will not develop properly unless the coating is thin and fairly even. If the coating is too thick, the insolubilization of the gum will not work down far enough into it—in which case the lighter tones, and often the shadows, will contain layers of insoluble gum "floating" entirely out of touch with the paper. These superficial layers will flake off during development when the soluble gum under them dissolves, leaving white spots in the print.

3. If the coating mixture contains too much pigment, the pigment will stain the paper. The gum itself acts as a sizing agent and keeps the pigment from catching in the paper fibers; but beyond a certain pigment-to-gum concentration the paper will stain, and it will be nearly impossible to remove the color without harming the paper's surface. The point where staining begins depends mainly on how much surface sizing the paper received before printing.

One more point: As a result of the necessary conditions described above, only a limited amount of image density can be created on the print at one time. Therefore, gum prints that have been coated and printed only once usually have low contrast. In practical terms, this means that if you want to print a rich tonal scale, with deep shadows, you will have to recoat and reprint the image at least two or more times. With each printing the shadows will deepen and the overall contrast will increase. Multiple printing like this takes time, and care in re-registering the image for each exposure, but it can result in a shadow depth unmatched by any other printing technique. Multiple printing also opens up the possibility of multiple-image graphic effects, as well as the option of printing the image in more than one color.

Materials

Negatives. Unlike most of the printing processes described in the previous chapters, gum does not require negatives of long density range. A negative with a normal range suitable for printing on a Kodak Contrast Grade 2 paper will print well in gum.

Paper. Paper for gum should be slightly textured and able to stand up to repeated soakings. The following are suggested: Strathmore Artist Drawing (medium surface), Hot Pressed Strathmore Artist Watercolor, Strathmore Artist Print, Rives BFK. Absorbent papers, such as Rives, should be sized first, and even the harder-surfaced papers will print better and have less tendency to stain in the highlights if given a coating of size before printing.

As explained in the chapter on Papers, paper is not dimensionally stable. When wet, it expands as its fibers swell; it contracts again as they dry. The first time a sheet of paper dries after soaking it usually contracts to *less* than its previous dimensions. Thereafter, it will expand again each time it becomes wet and on drying will return to about the same dimensions it reached when dried *after the first soaking*. For this reason, if you plan to make accurately registered multiple gum prints in image sizes larger than about 13x18cm (4x5 in.) you should presoak the paper before sizing to take care of that initial shrinkage. If you skip this step you may not be able to register the second printing.

See the end of the Papers chapter for instructions on presoaking and sizing of paper.

For accurate registration of prints larger than 20x25cm (8x10 in.) you may have to stretch the paper on a sheet of glass before printing. This technique will be described in the section on multiple printing later in this chapter.

Brushes. You will need at least two flat brushes for applying and blending the sensitive coating, plus a variety of smaller, pointed brushes for spotting and working on wet prints.

The *coating brush* should be at least two inches wide and flexible, but without a tendency for the hairs to spread apart (and thus leave streaks in the coating). The wide Japanese brushes available in many art stores are excellent and relatively cheap, as are the new polyfoam plastic brushes sold in most hardware or paint stores.

The *blending brush* is used dry to smooth out the coating. Here again a wide brush is best; it could well be three inches wide or even more. For the blender, use a thick brush, somewhat stiffer

than the coating brush. For very large prints you will want correspondingly wider brushes.

Every brush that comes into contact with the combined gum and dichromate solutions should be washed thoroughly after use to keep it from becoming clotted with insoluble gum.

Pigments. Three types of pigment can be used for gum printing: transparent watercolors, gouache, and tempera "poster colors." Transparent watercolors are traditionally the favored medium. Gouache is really only transparent color to which a white pigment has been added. This is usually chinese white (zinc white), which increases the covering power of the pigment by reducing its transparency. Gouache is useful because it provides good pigment density from one printing. This gets around some of the problems inherent in multiple printing, but the print will not have the same sort of continuous tonal scale you can get with transparent colors.

The finest readily available pigments are made by Winsor & Newton and by Grumbacher. Stay away from the cheap "student grades" or colors that come in cakes. It will be easier to start with

FIG. 156 STEPHEN LIVICK, multiple gum print, 1974.

tube colors, but you can also use powder colors. Choose pigments that resist changes caused by exposure to light, moisture, or chemicals in the atmosphere, and ones that will not react when mixed with the sensitizer or with other pigments. The colors listed here make up a good basic palette. Except when noted, you can depend on them to be permanent.

Lampblack. Almost pure carbon powder. It sometimes has a slightly blue cast, that shifts to green when mixed with dichromate.

Alizarin Crimson. A red pigment, very close to magenta.

Monastral Blue. This is a phthalocyanine dye, close to prussian blue but about twice as intense. (It is the modern substitute for prussian blue, which may fade in bright light but recovers in the dark). Prussian blue is chemically incompatible with cadmiums or vermilions. Monastral blue is available under the name *Thalo Blue.* Phthalocyanine colors made by Winsor & Newton are prefaced with the word "Winsor"—as in *Winsor Blue.*

Cadmium Yellow. This is available in *pale* or *deep*, the latter being somewhat toward orange. Cadmium yellow is more opaque than most other watercolors.

Alizarin crimson, monastral blue, and cadmium yellow are about as close as it is possible to come in straight watercolors to the subtractive primary pigments from which all other pigment colors can be mixed. They are the pigments used in three-color printing.

Burnt Sienna. Siennas and umbers are earth colors. Burnt sienna is brick red going toward brown.

Raw Sienna. More yellow and less red than burnt sienna.

Raw Umber. Yellowish brown.

Burnt Umber. A redder, darker brown than raw umber.

Other colors more or less suited to conventional photographic tonality, are: sepia, ivory black, Indian red, Thalo green, and hansa yellow.

The permanence and durability of the following colors are suspect, especially the first six:
Carmine
Chrome Lemon
Vandyke Brown
Chrome Yellow
Rose Carthame
Mauve
Prussian Blue
Crimson Lake
Purple Lake
Gamboge
Hooker's Green, Light
Violet Carmine
Rose Dore

Chrome colors may be chemically incompatible with certain organic pigments or with the sensitizer.

Emerald Green: For chemical reasons, do not mix it with other colors. Also **CAUTION:** Emerald green is poisonous.

Powdered colors are less expensive than those in tubes and are easier to weigh out for consistent results. To prepare them, first grind the powder into a paste with a small amount of gum (see below), then add the rest of the gum and mix thoroughly. Use a mortar and pestle or a palette knife and a sheet of glass. Occasionally, powdered pigments will clump together and refuse to go into uniform suspension in the gum solution, This results in spots of color stain on the print. It is sometimes caused by mineral salts in the water and can be remedied by using distilled water or by preparing the pigment with the formula below. Use just enough to grind the pigment, then add the bulk of the regular gum solution to make up the desired volume.

White (table) sugar *20 grams*
Water (hot) *10 ml*
Standard gum solution *80 ml*
Kodak Photo-Flo *8 drops*

Gum Solution

The gum solution is made from *gum arabic,* also called *gum acacia* because it is harvested from the

exudations of the bark of the acacia tree. (In Africa, elephants scratch their backs on acacia trees. This reduces the number of acacia trees.) Dissolved in water at a high enough concentration, the gum forms a viscous colloidal fluid. You can buy gum arabic from chemical supply houses and from most art stores. One manufacturer is Permanent Pigments, 2700 Highland Avenue, Cincinnati, Ohio 45212. Gum arabic comes in granular or, more commonly, in powdered form. Both are suitable for gum printing.

No matter how it is treated, gum arabic dissolves slowly. The standard method is to weigh out the gum (see formula below) and place it on several folds of cheesecloth. Wrap the corners of the cheesecloth around the gum and tie it up with a piece of string to form a bag. Set the bag in a wide-mouthed jar filled with water at room temperature and leave it until the gum dissolves. Under normal conditions this will take about a day. Keep the jar capped. When removing the bag, allow the remaining fluid to drip back into the solution and then gently squeeze the bag to force out the rest. If you squeeze too hard some of the dirt and insoluble matter caught in the cheesecloth may be forced out, as well. Afterwards, throw the bag away.

If you are in a hurry you can grind the gum into solution, a bit at a time, using a mortar and pestle or a similar arrangement. This may take half an hour, but then you can use the gum right away. If you use this method, you will notice that after a while dirt and insoluble material will sink to the bottom of the storage container. Filter it out with cheesecloth.

Do not use hot water to force the gum to dissolve more rapidly. A gum solution prepared with hot water has less viscosity (for any given concentration) than a solution prepared with cold water. The loss of viscosity allows the pigment to penetrate the paper and stain. According to the Permanent Pigments Company, gum dissolved in hot water also produces a less soluble coating.

The gum solution will sour unless it contains a preservative, becoming thin, more acidic, and less soluble. Gum that has soured has an obvious odor. The gum solution will keep for a short time if refrigerated. For longer periods add a preservative to the gum after it has dissolved. Use mercuric chloride (a *poison*—use it with care and wash your hands afterwards) or formalin. Formalin is less expensive and more convenient, especially if you have it on hand anyway for use as a hardener when sizing paper. Only a few drops are necessary, since the level of formalin required for preservative use is minute.

GUM SOLUTION

Water *200 ml*
Gum arabic *70 grams*

Add several drops of formalin or 0.5 gram mercuric chloride dissolved first in 5 ml of hot water.

The Sensitizer

The sensitizer is a saturated solution of either potassium dichromate or ammonium dichromate. (Sodium dichromate can also be used, but it has generally been ignored because its deliquescence makes it difficult to weigh accurately.) Ammonium dichromate gives greater sensitivity for the same concentration than potassium dichromate does. The speed depends on the solubility of the dichromate (in other words, on the number of dichromate ions that can be put into solution) and

FIG. 157
STEPHEN LIVICK, multiple gum print, 1974.

on the pH of the resulting solution. (Printing speed decreases as the pH goes up—increased alkalinity changes the dichromate into the much less sensitive monochromate.)

Each of the following solutions is saturated at 20°C (68°F); if the storage temperature drops below that, a precipitate may form. Simply warm the solution to dissolve the precipitate befor use.

SENSITIZER

Water (warm) 88.3 ml
Potassium dichromate 11.7 grams

OR

Water (warm) 64.3 ml
Ammonium dichromate 35.7 grams

OR

Water (warm) 26.7 ml
Sodium dichromate (2:H₂0) 73.2 grams

Whichever dichromate solution you use, store it in a brown bottle. It should keep indefinitely.

CAUTION: *Dichromates can cause skin irritations.* Sensitivity seems to vary among individuals, but evidently can be acquired after repeated contact with dichromate solutions. The dichromate ions are absorbed by the skin and can produce dermatitis and ulceration. In normal use there is no reason for fingers to come into contact with the dichromate except when developing prints, but then the concentration of the dichromate is quite low anyway. Wear rubber gloves if you find that you have problems with dichromates, or, after contact, wash your hands with carbolic soap and then rinse in hydrogen peroxide.

Sensitive Coating. The proportions of the ingredients used in the sensitive coating will depend on the effect you want and on your choice of pigment and paper. Start with the formula given below.

SENSITIVE COATING

Gum arabic solution 20 ml
Pigment (see below)
Dichromate sensitizer 20 ml

For the volume of gum arabic solution given above use

Lampblack—tube: 1 gram; powder: 0.2 gram
Alizarin Crimson—tube: 1.4 grams; powder: 0.5 gram
Monastral (Thalo) Blue—tube: 1 gram; powder: 0.3 gram
Cadium Yellow (Pale)—tube: 1.6 grams; powder: 1.2 grams
Hansa Yellow—powder: 0.3 gram
Burnt Sienna—tube: 1.6 grams; powder: 0.8 gram
Burnt Umber—tube: 1.6 grams; powder: 0.8 gram

You can mix stock solutions of pigment and gum in the proportions given above, and then store them until needed. For use, mix 1 part stock gum-pigment solution with 1 part dichromate sensitizer.

Mix the pigment and the gum together first, then add the dichromate. The mixture has some sensitivity, so protect it from daylight and ultraviolet light. Once mixed with the dichromate, the gum solution has a tendency to harden, even without exposure to light. This *dark reaction* depends on the pH of the solution and can be slowed down by adding ammonia to raise the pH. (Raising the pH also lowers sensitivity.) A combined solution will keep for about a day at a pH of 7 and for a month at a pH of 9. Ammonia is used because it evaporates as the sensitive coating dries, leaving it with a lower pH than when in solution and thus resulting in minimum loss of sensitivity. Since the ammonia is volatile, keep the solution capped, and of course protect it from light.

Sensitizing. Cut the paper to be sensitized at least a few inches larger all around than the negative. Pin it down at each corner. Start by dipping the brush in the sensitizing solution, then squeeze out the excess and take a couple of test strokes on a sheet of scrap paper to make sure that the brush is evenly charged. Coat the paper by brushing in *long* parallel strokes in both directions, using enough solution to cover *but not flood* the paper. Brush until the coating is fairly even. It will be impossible to eliminate all the streaked and uneven areas with the wet brush. Next, take the *dry* blending brush, hold it perpendicular to the

paper, and with gentle, *long* strokes, using just the tips of the hairs, smooth out the coating.

Work quickly so that the gum does not begin to set before the coating is even. A slight unevenness is inevitable, but the coating will blend together further as it dries and any minor irregularities will wash away during development.

Keep in mind that the coating must not be too thick and that it should be as even as possible. Also, never brush the paper for longer than it takes for the coating to become reasonably smooth and surface-dry. The entire coating operation should not take more than about 45 seconds for a 20x25 cm (8x10 in.) print. Brushing longer than this can abrade the paper's surface and break down the sizing, possibly resulting in pigment-stained highlights.

You can sensitize paper under tungsten light, but protect it from daylight and other ultraviolet sources. Hang it to dry in the dark in front of a fan, or dry it more quickly with a hot plate or hair dryer. Be careful—too much heat can partly insolubilize the coating. In my experience temperatures around 38 °C (100 °F) or even higher for several minutes have no ill effect and shorten drying time considerably.

Because of the *dark reaction* the coating will slowly become insoluble, even if not exposed to light. For this reason it is generally best to use paper soon after it is dry. Heat and humidity increase the rate at which the dark reaction takes place. Paper stored in normal temperature and humidity will not remain in good condition for more than a day or so, but when sealed in a plastic bag after drying and refrigerated and protected from light, it should keep for several weeks.

Printing

Expose the paper to ultraviolet light in contact with the negative. Gum requires less exposure than do the ferric (except for kallitype) or silver printing-out techniques described in previous chapters. With potassium dichromate as the sensitizer, a 275-watt sunlamp 38cm (15 in.) from the printing frame will give an exposure time of about 6 minutes for normal negatives. Ammonium dichromate is faster.

Development. After a dichromated colloid has been exposed to light it will continue to lose solubility, even if returned to the dark. This *continuing action* is slow but is accelerated by increased temperature and humidity. For this reason, develop gum prints as soon after exposure as possible. The paper quickly loses its sensitivity as the dichromate washes out.

Slide the print, face up, into a tray filled with water at room temperature. After the surface is covered, turn the print face down, carefully, so that no bubbles are caught underneath. Then let it float quietly without agitation. In a few minutes, the water will become clouded with pigment and stained orange by the sensitizer. After about 5 minutes, transfer the print to a tray filled with fresh water, or hold it clear while you change the water in the original tray.

There are several ways to develop a gum print. The easiest is simply to float it face down on the water with only occasional, gentle agitation, and let the soluble gum and pigment soak out and settle to the bottom of the tray. With correct exposure this "automatic" development should be complete in about 30 minutes. You can follow its progress by periodically lifting the print out of the tray and letting it drain. The print will accept further development if the drippings contain pigment or if the color is still visibly coming off the surface of the image.

An underexposed print will be obvious, but a useful image will not necessrily take a full 30 minutes to develop. In fact, it may take considerably less; so remove and dry the print whenever the image looks right. An exposure time that allows about a 30-minute development usually has the advantage of giving the best reproduction of tones.

If development is not coming along properly, either because of overexposure or because too much pigment was used, raise the temperature of the water or add a few milliliters of ammonia. The ammonia alkali tends to soften the hardened gum. However, it may also shrink the paper slightly by dissolving out the sizing. (Ammonia should

not be used when doing multiple printings over cyanotypes.)

Manipulations. Automatic development often may not produce the kind of image you want, especially in the case of overexposure or when spot modifications of contrast or pigment density are necessary. One of the attractions of gum printing (its chief attraction to the Pictorialists at the turn of the century) is the ease with which these spot modifications are made.

You can develop the print locally with a brush or by directing a stream of water against its surface. The brush is best on highlights and other areas where precise work is necessary. Use a small, soft brush cut to a point. Often only a slight touch of the brush to the print is necessary. The shadows and middle tones can also be lightened by brush-work or by directing a stream of water at the print, using a hose or a plastic squeeze-bottle.

It is best to try both treatments while the print

FIG. 158 Gum print showing the effect of forced development with brush and water jet.

lies face up in just enough water to cover its surface. The layer of water helps blend the edges along the treated areas and softens the physical effect, especially of the water jet. When you have determined the resistance of the print's surface, you may decide to work on it directly, without the superficial cushion of water. Whether you use a brush or a stream of water or both, first give the print a chance to develop automatically. Forced development cannot give as delicate a rendition of tones as is possible when the print is left to develop by itself.

Manipulations of this sort will allow you to use a greater-than-normal proportion of pigment to gum in the coating, and thus increase the density and contrast possible from each printing. This is because the shadows can receive more pigment than usual since the highlights will be forced clean with the brush or the water jet. Remember that the extra pigment may make necessary fairly harsh use of the brush in order to clear the highlights, and that this can destroy detail or harm the paper's protective surface sizing.

After development, hang the print to dry or dry it with heat. The latter method is faster, but if done unevenly or too rapidly the paper may shrink too much or not uniformly and then be impossible to register for multiple printing. Gentle heat will do the job.

Clearing. The print may have a yellow or orange sensitizer stain. The stain often makes it difficult to judge the true color of the print. You can clear the print in a 5% solution of potassium metabisulfite or sodium bisulfite. Alum is often mistakenly recommended but should not be used because it threatens print permanence.

The clearing treatment weakens the surface of the wet print. For this reason it is best to dry the print first *before* clearing. Clear prints one at a time. For a multiple print, postpone clearing until after the last printing and development.

Follow the clearing bath with a short wash in cold water.

Additional spot reduction can sometimes be done with a brush by working on the surface of the print as it lies softened in the clearing bath. As the print dries, the coating will sink into the surface of the paper. The final, dry image will be quite tough.

Multiple Printing

The image from a single gum printing is often disappointingly weak. There may be cases, especially when using gouache or with brush development, when the graphic or color effects desired require only one printing. But multiple printing is necessary in order to gain the full photographic tonal scale of which the process is capable.

Multiple printing consists of recoating a dried print and then exposing it again in register beneath the negative. The process can be repeated any number of times.

You can get an idea of the effect of multiple printing by placing a Kodak No. 2 Step Tablet along the edge of a negative during the exposure. After development the tablet will show a certain number of steps, depending on exposure time and manner of development. Examination of the scale will probably show that the steps corresponding to the shadow tones in the negative lack contrast and that only a few steps of the scale are well separated. Next time you coat and print the image, lay the tablet back in place, but partly cover it lengthwise with an opaque sheet of paper, covering a strip about 6mm (¼ in.) wide. This will let you compare the effect of the second printing to that of the first. Most likely you will see that after the second printing the overall density has increased, the separation of tones in the shadows has begun to improve, and that the steps are more distinct. Each time you recoat and expose the image, cover a bit more of the step tablet. This is an excellent way to learn exactly what happens to the tonal scale when you make a multiple print.

Contrast Control. It is possible to control the effect of each subsequent printing on the tonal scale.

For instance, you can increase the shadow density—without changing the highlights—simply by decreasing the exposure time so that only the shadows have a chance to become insoluble. This is the standard practice in multiple printing if your highlights show correct tone after the first exposure.

If you want to increase the density in the highlights without affecting the shadows, decrease the amount of pigment in the coating solution and increase the exposure. Since the shadows already have density, adding a little more pigment to them will not make much of a visible difference, but even a small amount of pigment, heavily printed, will make a difference in the light areas where almost no pigment was present before.

The chart shows what happens when you change the proportions of the ingredients in the sensitive coating. Much variation is possible. The chart indicates the limiting conditions.

FIG. 159 Density build up during multiple printing.

INGREDIENTS IN SENSITIVE COATING

INCREASE	DECREASE
Pigment:	
Shadow values deepen. Highlights may stain and require forced development. Coating mixture sets quickly.	*Highlights develop easily but contrast is poor. Little shadow density.*
Sensitizer:	
Thins coating mixture and results in less pigment deposited on the print. Contrast is poor. Does not affect pigment's tendency to stain.	*Inadequate sensitivity. Prints only in the shadows. Coating mixture too thick, causing flaking. Does not affect pigment's tendency to stain.*
Gum:	
Holds more pigment without staining. Coating may be too thick to spread easily and may flake off during development.	*Thinner coating with more tendency to stain. Sets slowly.*

Registration

Many registration systems have been proposed for gum printing. One is to tape a paper mask around the negative and then punch holes in the mask so that dots are printed along the side of the image. On subsequent printings you line up the holes in the mask with the dots on the paper. This makes the negative line up (register) with the image from the previous printing.

Another system is to place the negative on the sensitized paper and then stick four pushpins, two on a side, along two adjoining edges of the negative. Without disturbing the negative, remove the pins before printing. When you next print the image, first set the pins back in the holes, then slide the negative in position against them. Tape the negative down by the edges and remove the pins.

The problem with punch-and-register or pin systems is that they do not allow for slight changes in the dimensions of the paper; and the farther the registration points are from the image, or the larger the image is, the more likely it is that problems will result.

An alternative system is to outline the four corners of the image after the first printing, along the lines printed by the edge of the negative. Use a ball-point pen and, if possible, an ink color that contrasts with the image. If you reinforce the pen lines each time before sensitizing for additional printings, you will have no trouble finding them and setting the negative back in registration. Any dimensional changes in the paper can be averaged out between the corner marks or, depending on the thickness of the paper, you can look through the negative and paper held in contact over a light table and register the most important details.

One additional nuisance: Paper that has been coated on one side with gum usually will not lie flat after drying unless it is first pressed under weight for a considerable time. Because of this, it is often necessary to register the negative and then tape it down at both ends before sealing the combination in contact in the printing frame. If you use an old-fashioned hinged-back printing frame, start by taking the back off and place it felt-side-up on a table. Place the print on top, then tape the negative down in registration, and finally lower the glass and the outside frame on top. Without letting anything slip, turn the entire printing frame over and lock it.

Large Prints. On large multiple prints—about 28x36cm (11X14 in.) or more—it is almost impossible to register the image precisely on each printing unless the paper is physically held tight. Most of the gum prints being made in these sizes in recent years have depended on montage tech-

niques using a number of negatives, each contributing only a portion of the entire image. In this situation registration is not the problem it is when only one large negative is used.

The procedure outlined below permits accurate registration of large negatives and is based on the technique watercolorists often use to prepare their papers.

You will need a sheet of glass, which does not have to be more than 3mm (l/8 in.) thick. Cover sharp edges with masking tape or smooth them with emery paper. The printing paper will be stretched on the glass and will undergo less strain if first preshrunk as discussed earlier. Usually, it should also be coated with sizing after preshrinking.

Cut the paper a few inches larger on all sides than the glass plate and soak it in water at room temperature for about 5 minutes to allow it to expand. While the paper is soaking, place the glass over a larger sheet of blotting paper or over a few sheets of newsprint (plain, without the news). Drain the printing paper and lay it down on the glass, leaving an overlap on all sides. Smooth the paper into contact with the glass and then turn the glass over and place it paper-side down. Fold the edges of the wet printing paper onto the back of the glass and glue them in place with strips of brown paper tape, down the entire length on all four sides. Use wide tape for a good hold. Turn the glass face up so that the paper can dry. (For small prints you can tape the paper directly to the face of the glass if your glass is too large.)

During drying, the paper may rip if it is too thin or if it has poor wet-strength. It may also rip or may shrink unevenly if dried at an uneven rate that causes one area to contract and pull on another area that is still wet. If you lean the glass up to dry, turn it occasionally so that the water does not sink down to the low side and swamp it while the high side dries. When using heat take special care to dry the paper at an even rate across the entire surface.

The paper will shrink to a drum-tight surface as it dries. When re-wetted it will buckle somewhat, but after each reprinting and redevelopment will again dry flat and back to its original dimensions.

Waterproof the tape by giving it a coating of shellac or Liquitex Polymer Medium; otherwise the glue will dissolve during development and the paper will come undone.

Rig up some kind of a rack or a set of supports on which to rest the glass so that the print can develop upside down in a tray in the normal fashion. An artfully twisted wire hanger is all that is necessary.

Pigment Concentration

The maximum density possible from each printing is limited mainly by the amount of pigment that you can add to the gum solution without causing stained highlights. The pigment in an unexposed area of the print should float away with the soluble gum during development. If the coating solution contains too much pigment in proportion to the gum, some pigment will inevitably fall out of suspension and get caught in the paper fibers.

Three factors have to be considered in dealing with pigment concentration: (1) the dilution of gum solution; (2) the choice of pigment; (3) the sizing on the paper surface.

1. The more concentrated the gum solution is, the greater the amount of pigment it will hold. The problem is that thicker, more concentrated solutions are difficult to spread on the paper and tend to flake off during development.

2. Pigments with low tinting strength tend to strain paper when used in concentrations high enough to provide good shadow density with only one or two printings.

3. The paper itself may encourage staining, according to the extent to which its fibers trap pigment. The tendency to stain can be reduced by proper sizing of the paper surface.

Dot Test. You can find the right pigment-to-gum ratios for various colors and paper surfaces by a simple dot test. This test is one of the most important steps to take in learning how to control gum prints. After you have made several prints, as directed above, you will see why the test is important and why you should give it a try.

The test consists of making a series of dots on a sample of the paper used for printing. Each dot will contain a different proportion of pigment to gum.

Get a small, lightweight dish or cup, weigh it, and then squeeze into it about 3.8cm (1½ in.) of tube watercolor pigment. Weigh it again and record the difference as the weight of the pigment. If you do not have a scale, just make a notation of the length of the pigment deposit. This is less accurate because it is hard to squeeze the pigment out with the same diameter each time, but it is adequate if you are careful.

If you use dry colors for the test, weigh out 0.1 gram of pigment.

Because of its viscosity the gum solution is difficult to measure precisely. If you pour some of the stock gum solution into a measuring graduate and then back into the stock bottle, you will find that one milliliter or so will remain in the graduate, clinging to the bottom and sides. Although a milliliter does not represent much of an error when the total volume is large, it does for this test. The best way to handle gum for the test is with a measuring pipette. This is simply a narrow glass tube, graded in milliliters (or their near equivalent, cubic centi-

FIG. 160 Dots of pigment and gum ready for development tests.

meters), with a hole at the top and a smaller hole at the bottom. Use it by sucking the solution up into the tube, and then cover the hole on top with your finger. Each time you lift your finger some solution will flow out of the tube.

Using the pipette, add 8 ml of gum solution to the pigment in the dish and mix them together thoroughly. With a small brush, make a dot of the solution on a sample of the paper you plan to use. Below the dot write in pencil or waterproof ink the amount of pigment and the total volume of gum. Then add 2 ml more gum to the dish, mix, and make another dot and another notation. Keep adding 2 ml at a time, making new dots containing increased proportions of gum to pigment and labeling them, until you are up to 26 ml. Try to use an equal amount of solution on the brush for each dot and spread it over an equal area.

When the dots are dry, float the paper pigment-side down in a tray of water at room temperature for about 30 minutes. Periodically, take it out and examine the dots. You should see a series of tones, graduated from dark to light in the order in which you applied the dots. The last dot that has completely washed away at the end of about 30 minutes shows you the maximum proportion of pigment to gum that can be used on that particular pigment and paper for automatic, unmanipulated tray development. Put this down in your records.

Next, let the paper float in the water with the pigment side upwards but slightly submerged. Starting from the lightest remaining dot, pour a stream of water over the dots one by one until you come to the last dot that can be cleared with this form of forced development. Make a note of the results.

Take a pointed brush and, beginning again with the lightest remaining dot, brush away the pigment. The dot with the greatest density that can still be brushed away shows the maximum pigment-to-gum proportion that it is possible to use with brush development. Record the results. You now know the pigment-to-gum ratios you can use

with this particular pigment and paper under various forms of development.

It will save you time if you do this test on several papers at once, using different brands and both sized and unsized surfaces. In most cases the sized version of the same paper will tolerate more pigment with less staining. However, each subsequent printing and development of a gum print can carry away some of the size; unless the paper is resized its resistance to staining is apt to be reduced after a few printings.

A test using a variety of pigments will show that they must often be mixed in different proportions with the gum for the best results in printing. If you want to combine two or more pigments together to make a new color, you can find the total gum solution necessary simply by adding up the corresponding amounts of gum. For example, if 0.1 gram of one pigment needs 15 ml of gum, and 0.2 gram of another pigment needs only 10 ml of gum, the two mixed together will need 25 ml of gum (15 + 10 = 25).

Because the dots represent the areas in the print that *do not* receive exposure, no sensitizer is used in the test. The dilution of the pigment/gum mixture by the sensitizer actually has no effect on staining. What is important is the relationship between a specific amount of pigment and a specific amount of stock gum solution. Once these two are combined, further dilution by the sensitizer dilutes both, while the tendency to stain remains constant.

Three-Color Gum

For three-color gum, follow the directions for making color-separation negatives outlined in the chapter on three-color printing. Use cadium yellow for the yellow printing, alizarin crimson for the magenta printing, and monastral (Thalo) or prussian blue for the cyan printing.

Oil and Bromoil

In the oil process, a sheet of paper covered with a thick coating of gelatin is sensitized with dichromate and then printed in contact with a negative. The gelatin becomes hardened in proportion to the amount of light passed through the negative. The paper is then washed in cool water, where the gelatin begins to swell. The swelling is greatest in the lighter areas, which are the least hardened because they received the least exposure. The gelatin "matrix" is then wiped surface-dry and inked with a stiff oil-based lithographic ink. Because oil and water do not mix, the ink takes to the dry, hardened shadow areas of the image matrix but not to the water-swollen highlights.

The bromoil process is a modification of the oil technique. A contact print or an enlargement made on a suitable bromide paper is treated in a special bath that bleaches the image and hardens the gelatin. This treatment allows the bromoil print to be inked in the same fashion as an oil print.

Oil Printing

Paper. In their book *The Oil and Bromoil Process,* published in 1909, F.J. Mortimer and S.L. Coulthurst listed eighteen commercially prepared gelatin-coated papers suitable for the oil process. Today, to the best of my knowledge, there is only one. It is a German-made paper, available in the United States through Gallery 614, 614 West Berry Street, Fort Wayne, Indiana 46802. It is called Gelatin Paper #75A. (Gallery 614, which also supplies carbon and carbro printing materials, will send a price list on request.) Dye-transfer paper, a gelatin-coated paper one might think suitable for oil, has not proven to be so.

It is possible to coat your own paper for oil printing. Directions for this are given at the end of the chapter. When starting out, though, it makes good sense to use the commercial paper.

Negatives. The best negatives for oil are somewhat contrasty—more so than the optimum negatives for gum, but not as contrasty as negatives for salted paper or cyanotype. Negatives that print well on a Contrast Grade 1 Kodak paper (density range around 1.30) will be fine for oil.

Sensitizing the Paper. The sensitizer is either potassium dichromate or ammonium dichromate. The choice is not critical. The paper prints quickly in either case, and the exposure can be judged by the printing-out image.

The standard strength of the sensitizing solution is about 3% (3 grams in 100 ml water), using either form of dichromate. An increase to about 6% will give a faster-printing but lower-contrast image. Decreasing the concentration to about 1% will give a slower-printing image with higher contrast. Always use the sensitizer at about 20 °C (68 °F) or lower to avoid softening of the gelatin.

For your later convenience in inking, cut the gelatin paper so that a border at least 2.5 cm (1 in.) wide will surround the image. Sensitize the paper by brushing the dichromate solution over the gelatin surface. This can be done under tungsten room lights (but away from daylight).

First, pin the gelatin paper down by its corners with pushpins, taking care to press the pins down firmly to hold against the curl of the paper. Then dip a wide brush in the sensitizer and apply in an even coating. The yellow color of the sensitizer makes it easy to judge the uniformity of the coating. As you brush, you will begin to feel the gelatin become slippery as it absorbs the solution.

Stop brushing when the entire surface has this slippery feel.

Dry the paper in the dark. Brief and moderate heat will speed drying and does no apparent harm.

Spirit sensitizer. The quickest-drying sensitizer is a *spirit sensitizer,* with the dichromate in solution with alcohol or acetone. To make a 3% spirit sensitizing solution, mix one part of 6% ammonium dichromate stock solution with an equal part of isopropyl alcohol or acetone. Apply by brushing.

Potassium dichromate cannot be used with alcohol because it will precipitate in an alcohol solution—use acetone only. Follow the proportions given above.

Stock solutions of dichromate and water will keep if stored in a brown bottle. If the portion used for sensitizing is returned to the bottle, the contrast given by the sensitizer will very gradually increase. When using the spirit sensitizers, mix the stock solution and the volatile solvents together only as needed and discard the mixture after use.

Because of the *dark reaction* of dichromated gelatin, the coating will slowly begin to harden spontaneously even when not exposed to light. You can retard this by refrigerating the paper in a sealed plastic bag. Otherwise, use it within 24 hours after sensitizing. (See page 256) for recommendations concerning refrigerated storage of sensitized gelatin materials.

Some people are prone to skin irritations caused by dichromates (see page 204). Try to avoid direct contact with the dichromate stock solutions, or wear rubber gloves.

Printing. Expose the paper until the highlight details in the image just become visible.

Wash it immediately afterwards in running water or in several changes of water at about 21°C (70°F). This will remove most of the dichromate stain, leaving only a faint image in the shadows. The paper loses its sensitivity as the dichromate washes out. A wash time of 10-to-15 minutes should be enough to clear the stain and swell the gelatin properly. If a heavy dichromate stain persists, soak the paper in a 5% solution of sodium bisulfite. This may soften the gelatin slightly.

The paper can be inked at this time, or dried and then soaked for inking later. A preliminary drying actually improves the paper's inking characteristics.

Directions for inking are given after the following section on preparing bromide prints for bromoil.

Bromoil

At one time almost all the standard matte-surfaced bromide enlarging papers were suitable for bromoil work. Kodak and Ilford each put out special papers with optimum swelling and inking characteristics. But paper manufacturers gradually changed their coating procedures, and by the 1930's most papers were "supercoated" with a nonsensitive layer of gelatin over the actual emulsion surface to protect the image and eliminate stress marks. Papers treated this way are difficult or impossible to use for bromoil. Manufacturers also began to harden emulsions to make them stand up better to drying by heat. Kodak and Ilford stopped production of their special bromoil papers at the beginning of the Second World War. They reintroduced the papers after the war, then took them off the market again. Until a few years ago, Agfa Portriga-Rapid was a suitable paper for bromoil, even though supercoated. Apparently the manufacturers have changed their procedures and the paper can no longer be recommended.

In the past several years a number of resin-coated papers have come on the market. They are supercoated but, surprisingly, at least two of these papers are (at present) quite good for bromoil: Luminos RD-Matte Bromide (White) and Kodak Polycontrast Rapid RC, matte surface (not to be confused with the new Rapid II RC).

Another suitable paper, neither resin-coated nor supercoated, is made by Kentmere in England. It is a matte bromide enlarging paper and is available in the United States only through Gallery 614. It is my understanding, though, that it may soon be discontinued.

Developers. No developer that has a hardening effect on the gelatin emulsion should be used for bromoil work. It would reduce the swelling of the gelatin and cause the ink to take too readily to the highlights of the image. Most metol-hydroquinone developers, such as Kodak's Dektol, harden the emulsion to some degree.

One developer that does not harden is Ethol's LPD. LPD is inexpensive, has excellent keeping qualities, and can be replenished using a concentrate. Follow the directions supplied by the manufacturer.

Printing. The best print for bromoil is slightly flat and rather heavy in the highlights compared with a normal bromide print.

Expose the bromide for full highlight detail and select paper grade and developing time so that the shadows of the print retain detail and good separation of tones. *Do not try to print the shadows for maximum black.* Loss of shadow detail is inevitable in the final, inked print, but the loss can be minimized by keeping the shadows of the bromide comparatively light.

Too bright a safelight can cause a general fogging of the print. You may not be able to see it in the developed bromide, but fogging can create a slight, general insolubilization that causes problems in the highlights during inking.

After development, rinse the print in fresh, plain water for 1 minute. Fix in a *nonhardening* fixer, such as the one given below.

KODAK NONHARDENING FIXING BATH F-24

Water, at about 52°C (125°F) . . .	500 ml
Sodium thiosulfate	240 grams
Sodium sulfite (desiccated)	10 grams
Sodium bisulfite	25 grams
Cold water to make	1,000 ml

Cool down to 20°C (68°F) for use.

Fix prints for no longer than 5 minutes.

Wash resin-coated papers for at least 5 minutes after fixing, regular bromide paper for at least 30 minutes. Use an efficient washing tray with a good flow of water. Prints may be bleached immediately after washing, or dried and bleached later.

Bleaching the Print. The bleaching bath is actually a bleaching-plus-hardening bath. It bleaches the silver image to silver bromide, in turn starting a chemical reaction that hardens the gelatin in proportion to the amount of silver in the image. After bleaching, the gelatin will swell in water, forming a matrix that will accept ink in the shadows but reject it in the highlights.

Over the years bromoil printers have devised a great many bleaching formulas, each printer asserting that theirs was the best. The one given below works well with resin-coated papers and with Kentmere.

BROMOIL BLEACH STOCK SOLUTION

Water	750 ml
28% Acetic acid	10 ml
Copper (cupric) sulfate	30 grams
Potassium bromide	30 grams
Potassium dichromate	2 grams
Water to make	1,000 ml

For use, add 1 part stock solution to 3 parts water. Make up a fresh working solution for each print and use it at about 20°C (68°F).

The stock solution will keep in a brown bottle.

If the print is dry, soak it first in water for 2 minutes, then drain and slide it quickly into the bleach. The image will slowly lighten. After about 6 minutes, the deepest shadows should show only a light green tone. To be sure the gelatin is properly hardened, leave the print in the bleach for about half again the time required for the image to fade to a faint tone. The total time depends on the paper. For example, Luminos bleaches more slowly than Kodak Polycontrast RC. If the shadow tones fail to bleach, or if they show a red tone, the print probably was fixed improperly or not washed adequately before bleaching.

After bleaching, wash resin-coated paper for 5 minutes, regular bromide paper for 10 minutes— or until the yellow dichromate stain washes out. Incomplete washing can lead to a slight hardening action when the print goes into the final fixing bath.

The final fixing bath dissolves out the silver bromide formed during bleaching. If not fixed, the

image would slowly darken on exposure to light. Fix for 5 minutes in a fixing bath *made fresh for each batch* of prints.

FINAL FIXING BATH

Water 32°C (90°F) *500 ml*
Sodium thiosulfate *50 grams*
Cool to 20°C (68°F) before use.

Follow the fixing bath with a 10-minute wash at 21°C (70°F) for resin-coated papers, 30 minutes for regular papers. After the wash the gelatin matrix will be ready for inking. As with oil paper, however, it will ink more easily if it is dried completely first and then resoaked.

Oil vs. Bromoil

The advantage of bromoil is that the paper is readily available and can be printed by enlarging —an enlarged duplicate negative is not necessary. Oil paper requires a large negative, but oil paper inks up far more easily than a bleached bromide print does. It also works somewhat better for transfer. Since inking is the most difficult part of the process to learn, oil printing is the best way for the beginner to start.

Inking Equipment

Brushes. For many decades the Sinclair Company in Great Britain supplied a line of brushes for inking prints. The Sinclair brushes have been discontinued, but inking brushes based on the original design are now manufactured in the United States. They are available from Robert Gumpper, Christian Street, Bridgewater, Connecticut 06752. Write for details. Other brush suppliers are: L. Reusch & Co., 2 Lister Avenue, Newark, New Jersey 07105; and Stoddard Manufacturing, Icknield Way, Letchworth Garden City, Hertfordshire, England SG6 4AH.

Figures 161-162 show the original brush designs. The large brush, called a *Mortimer* in honor of its inventor and traditionally made from hog hair, is used for the first inking of the print. It is actually a modified form of stencil brush and can be made without too much trouble by cutting a

stencil brush, illustrated in Figure 163, down to size using a good pair of scissors and a sharp razor blade for the final trimming. Most art stores do not carry stencil brushes, at least not in the larger sizes, but most paint stores do. Buy one with a base diameter of about 3.2 cm (1¼ in.) for your largest inking brush and also get a couple of smaller ones in descending sizes.

The original type of *finishing brush* is shown in Figure 162. These were originally made from polecat (European skunk) hair and later from bear hair. This brush produces a finer pigment deposit than the larger brush and is used near the conclusion of inking to smooth out the grain and fill in details. These brushes are difficult to imitate. About the best you can do is cut down a small stencil brush or a nylon brush like those used for acrylic painting.

FIG. 161
Mortimer brush for initial inking

FIG. 162
Bear hair finishing brush.

Clean the brushes after use by wiping with a rag moistened with benzine (naphtha) or nonleaded gasoline. If necessary, the brush may be wiped clean with a rag moistened with turpentine, but it will dry faster if the more volatile benzine or gasoline is used. The brushes may periodically become dirty enough to need cleansing with mild soap and warm water. Be sure to rinse the soap out thoroughly afterward. Brushes should be hung up to dry, with the bristles down. Wrapping the bristles in a paper cone will help the brush keep its proper shape.

Never clean the brush by *soaking* it in turpentine. The turpentine will be drawn up into the brush, making it useless for several days until the turpentine evaporates. When turpentine evaporates, it leaves behind a nonvolatile resinous deposit. This deposit has a greater affinity for ink than do the hairs of the brush alone. This may not be of any real importance, but it might affect the working characteristics of the brush and cause it to become easily clogged with ink.

CAUTION: Gasoline and benzine are both highly volatile and have correspondingly low flash points (15.5°C and 12°C—59.9°F and 53.6°F—respectively). *Do not use them near open flames.* Also, do not use any solvents near sensitized oil paper: Exposure to the fumes can reportedly make the gelatin coating become partly insoluble.

Brayers. In addition to the brushes, the image can also be inked with rollers, or *brayers*, as shown in Figure 164. A brayer is simply a roller with a handle. Hard-rubber brayers are available in sizes from 2.5cm (1 in.) to 20cm (8 in.) and larger. Most books on oil and bromoil neglect to mention the use of brayers for inking prints, even though it is actually easier than inking with a brush. A good outfit would consist of one 2.5-cm

FIG. 163
Ordinary stencil brush can be cut to shape for inking.

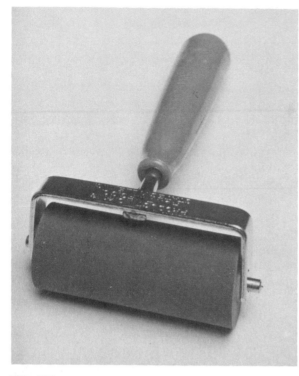

FIG. 164
A brayer for quick inking.

(1-in.) brayer for area work and a couple of 10-cm (4-in.) or larger brayers for general inking. Clean the brayers with benzine or gasoline.

Inks. The stiffer the ink, the less readily it takes to the water-swollen gelatin. Prints are usually inked first with a stiff ink for contrast and shadow detail and then, if necessary, with a softer ink for highlight detail.

The pigments used for oil painting and for etching are too soft for oil or bromoil work, but stiff lithographic inks (made for hand lithography) are suitable and generally available. These inks are usually too stiff to be worked from tubes and so are supplied in cans. Flax Black Litho Ink M 1796 works well (Sam Flax, Inc., 111 Eighth Avenue, New York, N.Y. 10011), as do the lithographic inks supplied by Graphic Chemical and Ink, P.O. Box 27, Villa Park, Illinois 60181.

You can prepare your own inks by mixing powdered pigments with a #5 or #6 linseed-oil lithographic varnish (also called *middle varnish*). To start, place about a milliliter of varnish on a glass plate and then mix in the powdered pigment with a palette knife. The more pigment you add, the stiffer the ink becomes. You can also add magnesium carbonate to stiffen the ink. The magnesium carbonate should not exceed about one-third the total volume of the ink or the ink may become too abrasive for the gelatin matrix. Magnesium carbonate can also be added to regular lithographic inks to increase their stiffness.

Inking the Print

Soaking. Soaking the print in water produces the swelling necessary for inking. With the oil paper supplied by Gallery 614, the relief caused by the swelling of the gelatin is easy to see. You can also feel it when you run your fingers gently across the surface of the gelatin. The swelling of resin-coated papers and Kentmere paper is not quite as apparent, but you can judge it by the difference between the slippery feeling in the highlights compared to the roughness in the shadows.

Water temperature and soaking time control the swelling of the gelatin. An increase in either, especially in the temperature, produces greater swelling and therefore greater resistance to the ink. If the soaking time at a given temperature is too short, or if the print dries out during inking, the highlights will accept even a hard ink much too readily and the shadow tones will lose their separation. Minimum soaking time with the Gallery 614 oil paper is about 5 minutes at 21 °C (70 °F). Minimum time with the resin-coated papers and Kentmere is about 10 minutes at the same temperature. Short soaking times at high temperatures tend to produce more contrast than do longer times at lower temperatures. High temperatures can also soften the gelatin to the point where it can be torn easily by too-vigorous action of the pigmenting brush.

Be sure the entire gelatin side of the paper remains under water during the soaking. The simplest way is to turn the paper face down in the tray, taking care not to trap bubbles underneath.

Inking With Brushes. While the matrix is soaking, prepare the ink.

Using a palette knife, take a quantity of ink about the size of a pea and spread on a sheet of glass. Form a circle of ink about two inches in diameter. Level it down as smooth as possible with the edge of the palette knife.

If the ink is so stiff that it is difficult to spread, it is probably too stiff for inking a print. Soften it by adding *one or two* drops of linseed oil or a *small* quantity of another, softer ink. Mix these into the ink by pressing down with the palette knife and repeatedly scraping the ink together and pressing it down again. Finally, spread the ink in a thin layer as described above. It is important not to thin the ink too much. At the start of inking, always use as stiff an ink as possible.

Take the swollen gelatin matrix from the tray, drain it, lay it face up on a paper towel for several seconds to blot the excess water from the back, then place it face up on a sheet of glass.

Carefully wipe the water from the matrix surface with a wet but thoroughly-wrung-out soft viscose sponge or a wet but wrung-out chamois, or pat it dry with a paper towel. Remove all the droplets from the matrix and from the glass around the edges of the paper. Any droplets accidentally picked up by the brush can interfer with pigmenting and cause white spots on the print. Check the matrix for surface water by looking across it at an angle against the light.

Take the large brush and holding it vertically, dab it repeatedly into the circle of ink. The object is to charge just the tips of the hairs with ink. After about ten dabs in the ink, dab the brush on a clean portion of the glass. This should leave a thin stipple of pigment. Go back to the ink circle and charge the brush again, then dab it again on the second (stippled) patch. Repeat this once or twice or until the brush is evenly charged with ink. When inking the print always recharge the brush from this second patch of ink, or recharge it from the original ink supply and then tap it out on the second patch. It is not a good idea to go from the original ink directly to the print without first dabbing the brush on the second patch to even out the ink load and remove any clumps.

Learning to ink an oil or bromoil print takes practice. No two people ever seem to do it in quite the same way, and there is a disconcerting lack of agreement in most of the published instructions. Here are some general things to remember: The ink deposit will build up slowly. At first, the stipple left by the brush will be grainy and uneven and will take to both the highlights and the shadows with only a grudging resemblance to the original image. The tones of the image will not automatically appear in their proper relationships; you must help them along by controlling the action of the brush. The results are not immediate—a particular action of the brush often must be repeated several times before a real change on the print can be seen.

Brush actions. There are three basic actions of the brush:

1. A slow dabbing action that deposits ink all over.

2. A fast dabbing action that deposits ink in the shadows.

3. A "hopping" action that removes ink from the print.

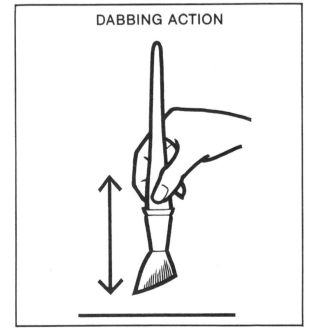

DABBING ACTION

FIG. 165
Basic dabbing action for inking up.

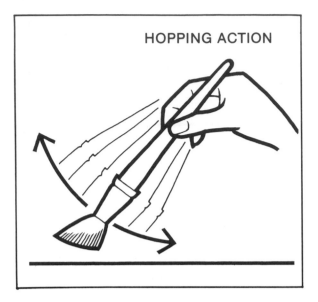

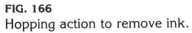

FIG. 166
Hopping action to remove ink.

The other brush actions you will devise as you go along will simply be variations on these three.

Always hold the brush with the toe pointing away from you, toward the top of the print. Grasp the brush about half way up the handle, holding it vertically or at just a slight angle above the print.

1. The *slow dabbing* action of the brush is used first (with the large brush) to cover the matrix quickly and then again as necessary to build up the ink deposit. Hold the brush vertically about 6mm (¼ in.) above the matrix, then press it down firmly on the matrix as shown in Figure 165. This will spread the hairs and leave a deposit of ink in the shadows and, to a lesser extent, also in the highlights. Lift the brush *slowly* from the print and repeat the stroke at a rate of about one every second. Using this basic stroke, cover the print with a grainy and light deposit of ink until it looks something like the example shown in Figure 169. Start with one corner of the print and work systematically to cover the entire surface, recharging and tapping out the brush as necessary. Only a vague outline of the image will result. If the ink does not take all, even with

a firm brush action, it is too stiff. If the ink takes too readily it is too soft, or the gelatin is not adequately swollen.

2. The *fast dabbing* action removes ink from the highlights while depositing it in the shadows. Dab the brush rapidly over the matrix at a rate of about eight strokes a second. This will lift the ink from the highlights and, when you

Inking a Print

FIG. 167
Bromide print before bleaching (print and inking sequence by Robert Gumpper).

FIG. 168
Bleached bromide.

move the brush to another spot, deposit it in the shadows. As a result, the contrast of the image will increase and the shadows deepen in tone. This stroke may be used with the brush freshly charged or almost depleted of ink. With a charged brush the shadows will build up quickly. Most of the brush work done on the print consists of the slow and fast dabbing actions. Figure 170 shows the effect of the fast action.

3. The third action of the brush is called the *hopping* stroke. It is easiest to accomplish by holding the brush high on the handle and at an angle of about 70 degrees to the matrix. Rapidly tap the brush, using the motion indicated in Figure 166. You will notice that this becomes more of a sweeping action when you hold the brush more nearly upright. The hopping stroke will remove ink from the highlights and to a certain extent also from the shadows. Figure 172 shows the effect of hopping.

FIG. 169
Initial inking using slow dabbing action. Ink deposited in both shadows and highlights.

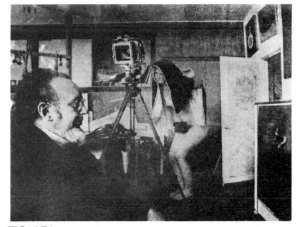

FIG. 171
Slow dabbing action puts ink back in the highlights.

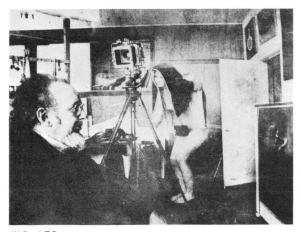

FIG. 170
Fast dabbing action removes ink from highlights, deposits it in shadows.

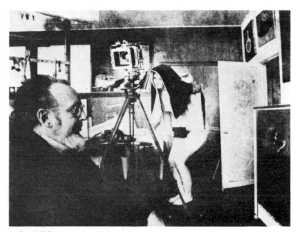

FIG. 172
Hopping stroke used to lighten the model and highlights.

FIG. 173
Final print is a result of all three brush actions.

If neither the fast dapping nor the hopping stroke is successful in removing ink from the print, the matrix has probably dried out. Resoak it for about a minute in a tray or swab it with wet cotton. Then surface-dry it with a sponge, chamois, or paper towel, as described above. You can do this without disturbing the ink already present.

Use the large brush until the print has fairly good contrast and depth. Then charge a small brush with ink and use it to even out the texture of the print and fill in details.

A soft ink will be needed if the highlights appear too light. To soften ink, thin with a drop or two of linseed oil as necesary.

Always save the soft ink until last. A hard ink cannot be used immediately over a soft ink because it will pull the soft ink from the matrix. If you let the print dry for a day or two, you can then resoak it and make additional applications of stiff ink.

White spots on the print can be caused by tears in the gelatin, but more often they are the result of drops of water picked up by the brush from the border of the image or from the edge of the paper (where water is sometimes forced out by the pressure applied during inking). Often you need only dab the spots with a sponge to remove the water. If the spots are numerous or large the best plan is to resoak the entire print briefly.

Vigorous wiping of a wet print with a wet sponge or cotton swab will remove a good part of the image, especially in the lighter tones. You can clean the borders of the print and clear the highlights this way.

If necessary, *all* the ink can be removed by soaking the print in water for a few seconds, or spraying it with water, and then wiping the surface with a paper towel soaked in benzine or gasoline. Allow the print to dry for at least 10 minutes afterwards before resoaking it for re-inking.

Inking With a Brayer. Roll the brayer across your ink patch until the surface of the brayer is evenly charged. Slowly roll it across the gelatin matrix. The ink should take to the shadows first and then to the middle tones as shown in Figure 174. Figure 175 shows the effect of continued rolling with greater pressure. In Figure 176 the print was gone over with the same brayer but with a light-and-fast motion that cleared the excess ink from the highlights.

The rule is that *slow rolling with pressure deposits ink; fast rolling with less pressure removes ink.*

Inking with a Brayer

FIG. 174
Initial inking with slow rolling, light pressure.

FIG. 175
Increasing the pressure adds more ink.

FIG. 176
Light-and-fast rolling clears the highlights. The rest of the image filled in.

One quick and practical way to ink up a print is to start with the brayer and then switch to brushes as necessary. A print inked with brayers alone tends to have greater contrast than a print inked with brushes, and also tends to look somewhat sharper.

Finishing

The print should be dry enough to stand nearly any amount of handling in about two days, but wait three or four days before dry-mounting. When the print is dry it can be touched up with a moderately hard eraser—erasing on a wet print is apt to produce smudges.

The dry ink will have a slight gloss. This can be removed by soaking the print in benzine or gasoline for several minutes.

Transfer

In the transfer process the inked matrix is run through a press in contact with a second sheet of paper. This transfers the ink to the second sheet.

Transfer has several advantages over straight oil or bromoil. Almost any paper can be used for the final support and, if the paper is acid-free and the inks permanent, an entirely permanent print will result. It is possible to re-ink the matrix and repeat the transfer (multiple transfer) to increase the depth of the image, add supplementary colors, create multiple images, or run off a small edition of prints from a single matrix. Because the final image consists of nothing more than ink on paper, the result has qualities in common with gravures or lithographs. Photographers who used the process in the past often exploited this resemblance—but for the most part only to imitate the other techniques. Yet there is potential here for a hybrid form of printmaking allowing far more than imitation of other media. Photographers who find their work moving toward a "printmaking" style should give the process serious consideration, as should printmakers trained in traditional intaglio and planographic methods who want to incorporate photographic images in their work.

The Press. The transfer of the ink must happen under pressure. It is possible to make a transfer by placing the inked matrix face down on a sheet of paper and then rubbing the back of the matrix with the bowl of a spoon, but it takes a lot of enthusiasm and a lot of rubbing. At one time Sinclair sold a special press for transfer. This passed the inked matrix and the transfer paper under pressure between two rollers. You may not have much luck in finding an old Sinclair press, but a regular etching press will do the job just as well, as will a lithographic press (although reportedly the scraper on a lithographic press tends to break down the matrix). If properly converted, a mangle can be used for transferring.

Preparing the Matrix. The transfer will be reversed in terms of the original scene unless the negative is printed with its *base* side down. This applies to both oil and bromoil matrices.

The brush actions used in inking the matrix are the same as for nontransfer, but a matrix for transfer should be inked for more contrast. This is because ink will transfer far more readily from the highlights than from the shadows, with the result that the transfer will be surprisingly flat when compared with the original inked matrix. The remedy for this is to hold ink back from the highlights slightly, while making the shadows somewhat heavy. As you gain more control over the process you can also try to over-swell the matrix in order to use a softer ink for easier transfer.

Using the Press. Figure 177 shows the best way to rig up an etching press for transfer work. Bolt or rivet two plates of zinc or aluminum together at one end and place them in the press as shown. To load the press, spread the plates apart and insert a sheet of blotting paper. Over the blotting paper place the transfer paper, then the inked matrix face down, and then another sheet of blotting paper on top. Lower the second plate and the blanket, and the entire "sandwich" is ready to go back and forth through the press. Two sheets of heavy, smooth-surfaced mat board can be substituted for the metal plates, if necessary.

Use only as much pressure as necessary to transfer the ink. Control the pressure by means of the adjustment screws on the press or by placing

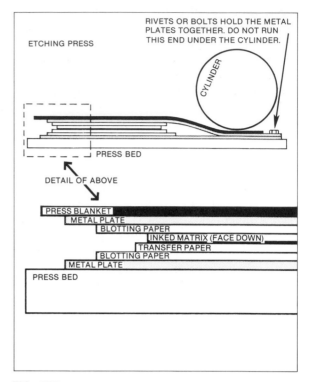

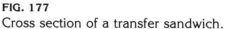

FIG. 177

Cross section of a transfer sandwich.

additional sheets of paper in or under the sandwich. If the pressure is too great it can crush the matrix or cause the soft gelatin in the highlights to stick to the transfer paper. With a single transfer it is usually better to use successive passes through the press—first at moderate, then at increased pressure—rather than one pass at high pressure. Sometimes alternately lifting the ends of the matrix from the transfer paper—without disturbing the registration—and exposing the ink to the air for a few seconds before the next pass will produce a stronger transfer. With multiple transfer, it is best to save wear on the matrix by passing it only once back and forth through the press and rely on the successive printings for increased density.

Pass the sandwich through the press at a uniform rate—about two inches per second. Do not stop in midcourse or the matrix may be ruined.

Stretching Pull and Multiple Transfer. A "stretching pull" with a partly inked matrix is often necessary when printing multiple transfers. It

compensates for the stretching of the matrix that results from the paper's first pass through the press. Without a preliminary stretching pull it may be impossible to register the image on each subsequent printing. A bromoil matrix made on resin-coated paper will not need a stretching pull.

Only a light coating of ink is necessary for the stretching pull. The same sheet of transfer paper will serve for the stretching pulls of a good many matrices. Throw it away only when too dirty for further use.

After the stretching pull, put the matrix back in the soaking water for a minute or so and then re-ink for transfer. Remember that the highlights will transfer proportionately more of their ink than the shadows; so adjust the inking accordingly.

With multiple-transfer work, after you have run the matrix through the press and before you strip it from the transfer paper, take a pencil and make registration lines across the back of the matrix and onto the transfer paper as shown in Figure 178. For a convenient way to reposition the matrix for subsequent printings, first place the inked matrix

FIG. 178
Registration system for multiple transfer.

face up on a larger, slightly dampened sheet of clear acetate. The water on the acetate will make the matrix cling. Turn the acetate over and, looking through it, line up the registration marks on the matrix and the transfer. This method will allow you to hold the matrix flat while setting it in position, and also to avoid smudging the ink with your fingers if your matrix lacks an ink-free safe edge. Remember to strip off the acetate before running the sandwich through the press.

Smooth papers will accept the transfer better, and with less chance of the paper's sticking to the matrix, if dampened before printing. Place the paper in water for several minutes, drain, run it through the press several times between two sheets of blotting paper, and use it while still damp.

Clean the matrix with benzine or gasoline after use and store it for future printings.

Registration for Three-Color Transfer

After producing color-separation negatives (see the next chapter) make a bromide print from each negative on resin-coated paper, balancing them as explained on page 192. The advantage of resin-coated paper is that its dimensional stability makes registration easy.

Make the first bromide print, dry it, and put it back *in the original position* in your enlarging easel. Insert the second separation negative in the enlarger, focus, and move the easel or the negative as necessary until the printed image and the projected image are in register. Leaving the easel in place, carefully remove the print, put in a fresh sheet of bromide paper *in the same position* as the first, and make the second bromide separation. Repeat the procedure for the third separation print. The three separation images will now have the same position with respect to the edge of the bromide paper.

Ink up the bromide for yellow and print it first. Before removing the matrix from the transfer paper, take a pencil and outline the edge of the bromide. Print the inked magenta bromide next, lining it up with the registration outline. Print the inked cyan bromide last.

An alternative method to three-color separation is to mask the image and print different areas in different colors. One way to do this is to make a bromide print for each color and mask out the nonprinting areas with Maskoid (liquid frisket) just before the bleaching bath. Remove the Maskoid in the wash directly after bleaching and before refixing the print.

Coating Paper for Oil Printing

Prepare a 7% gelatin solution using Knox 275 Bloom Gelatin (find it in the *Yellow Pages* under *Gelatin*). Soak the gelatin in cool water, then warm to 38°C (100°F). This gelatin is harder than the edible gelatin sold in supermarkets, but edible gelatin can be used if necessary. Take a portion of the 7% solution and dilute it, 1 part gel to 3 parts water (about 38°C (100°F)). Soak the paper in this solution for 1 minute, then hang it up to dry. This is the base coat. Next, give the paper two coats of the full 7% solution, rewarming it if necessary to make it liquid and workable. To coat,

place the paper on a waterproof surface and sponge the gelatin over one side. Work it evenly into the paper using a fine-grained sponge. Put a second sponge in hot water, wring it out, and use it to smooth out the coating. When the first coat is dry, repeat the operation in the same way. Two coatings should be enough. Rives BFK is a good paper for oil work.

If softer, edible gelatin is used, it may prove necessary to harden it slightly. This is done *after* the exposure has been made. Soak the coated paper for about 2 minutes in the following solution, which will also clear the dichromate stain.

Water . *500 ml*
Sodium bisulfite *5 grams*
Potassium alum *5 grams*

If you find more hardening necessary, double the alum. You can also use this formula to help condition any oil or bromoil paper that the gelatin tends to tear away from during inking. Use it before or instead of a plain water soaking bath.

Three-Color Printing

History and Theory of
Color Separation

White light contains the whole visible spectrum. When white light passes through a prism it breaks up, according to wavelength, into colors. The color spectrum comprises the limits of what the human eye is able to see as visible radiation, from the longest visible wavelengths (about 700 millimicrons) at the red end of the spectrum to the shortest wavelengths (about 350 millimicrons) at the violet end. The spectrum is continuous, but for practical purposes is considered to be divided into bands of red, orange, yellow, green, blue, indigo, and violet. If you have trouble remembering the order, just remember the name formed by the first letters of each color: Roy G. Biv.

In 1807, Thomas Young discovered that our perception of color is based on the sensation of only three basic colors: red, green, and blue. These colors are called *additive primaries* because they can be added together in different proportions to produce all the other colors normally found in nature. White light is an additive mixture of red, green, and blue in equal parts. See Plate 51.

The filters used in photography transmit only those wavelengths of the spectrum corresponding to their own color and absorb the rest. It is only the transmitted light not absorbed by the filter that reaches our eyes. When a red filter intercepts a beam of white light, it transmits only the wavelengths corresponding to red. The red filter absorbs both the green and the blue components of the light. A green filter, in turn, transmits green and absorbs red and blue. A blue filter transmits blue and absorbs both red and green. If the light passing through each of the three filters is collected and focused on one spot, the result is a patch of white.

Each of the three primary-color filters blocks transmission of the colors of the other two. For this reason, a sheet of film exposed in a camera with a red filter will record only those parts of the scene that contain in some proportion the color red; and the purer, or more saturated, the red, the greater the density produced on the negative. The same principle holds for negatives made with green or blue filters. In each case the film records only the presence of green or blue. Together the three resulting *color-separation* negatives will make up a record of all the colors of the original scene. The original colors can then be reproduced by either the additive or the subtractive color process.

Additive Color. The additive process was first demonstrated photographically in 1861. James Clerk-Maxwell had commissioned Thomas Sutton to prepare color-separation negatives of a tartan ribbon. Sutton exposed three negatives, one each through glass cells filled with either red, green, or blue liquid, and made *positive* lantern slides from the negatives. Clerk-Maxwell took the positives to a meeting of the Royal Institution in May of 1861. He set up three projectors in a darkened room and placed one colored cell in front of each. He then loaded each projector with the corresponding positive and superimposed the images on a screen. The result was a primitive, but basically correct, color reproduction in which red, green, and blue light "added up" to make the colors of the original scene.

One of the interesting things about this experiment was that it was done long before a way had been found to make emulsions sensitive to red

40. BOBBI CARREY. Cyanotype (in two printings for greater density), 1975.

41. *Stelès Turques,* from Pierre Tremaux's *Exploration Archéologique en Asie Mineure,* circa 1860. Printed by Lemercier in Poitevin's photolithographic process. National Gallery of Canada, Ottawa. *(See page 269.)*

42. STEPHEN LIVICK. Multiple-gum print, 1974.

43. WILLIAM CRAWFORD. *Dishwasher—Court Restaurant,* platinum print developed with mercury, 1973.

44. PAUL STRAND. *Rebecca,* sepia platinum, October 1920. Museum of Fine Arts, Boston.

Strand's printmaking, with its low tones and slightly solarized shadows, was inspired by Stieglitz's post-Photo-Secession portraits. Its style is transitional: partly Pictorialist, partly modern. *(See pages 107-109.)*

45. ANONYMOUS. Hand-colored photo buttons, circa 1900. International Museum of Photography/George Eastman House.

Conservation and Restoration

46, 47 Daguerreotype, before and after restoration.

48, 49 Mold-stained albumen print, 1860's, before and after ultraviolet treatment.

50. Mold-infected gelatin silver print, acidic cellophane tape.

Plates 46-50, courtesy of David Kolody. *(See pages 293-301.)*

Bobbi Carrey, cyanotype, 1975.

Anonymous, Poitevin's photolithographic process, circa 1860.

42

Stephen Livick, multiple gum, 1974.

William Crawford, platinum, 1973.

44

Paul Strand, sepia platinum, 1920.

45

Hand-colored photo buttons, circa 1900.

46

47

48

49

50

(See page 228)

51. The additive primary colors, projected on a dark screen. All three together produce white.

52. The subtractive primary colors together produce black. White light comes from the paper or, in a transparency, from a light source placed behind.

53. The subtractive pigments absorb their additive complements and reflect the others. The dotted lines show how they would work if they were perfect reflectors. Instead, they also absorb some of the other primaries.

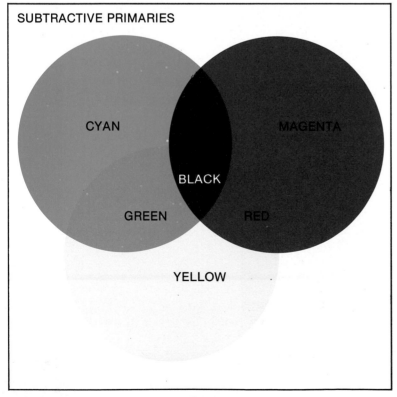

SUBTRACTIVE PRIMARIES

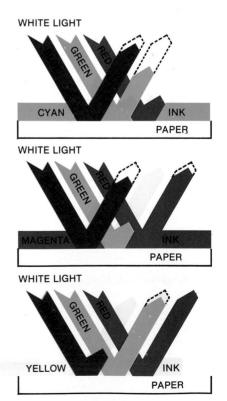

light: The negative made with the red liquid in front of the lens ought to have been completely clear. Apparently, the image the red negative did record came from the fluorescence of the red dye used to color the tartan ribbon.

Subtractive Color. Another look at the illustration for the additive primaries will show how the *subtractive primaries* are formed. Mixed in three equal parts, the additive primaries produce white. Red and green together produce yellow (this is a surprise to most people); red and blue together produce magenta; and green and blue together produce cyan. Each of these three new colors is a subtractive primary, and each is the *complementary* color of the additive primary directly opposite it in the illustration (for example, magenta and green are complementary).

Each of the subtractive primaries represents the presence of the two additive primaries of which it is composed—and the absence of the third. Magenta, for instance, contains both red and blue, but no green. A more correct way of expressing this is to say that magenta transmits (or reflects) both red and blue light but absorbs green light.

Plate 52 shows what happens when the subtractive primaries are viewed by *transmitted* light. Since each subtractive primary can absorb its complementary additive primary, all the subtractive primaries together will absorb all the additive primaries. The result of this total absorption, as shown by the illustration, is black.

You can see from the illustration that yellow and magenta together produce red; magenta and cyan produce blue; and cyan and yellow produce green.

In the subtractive process, the original separation negatives made through red, green, and blue filters are each printed in their *complementary subtractive* color. For example, the dense areas on the green-filtered negative represent the green light in the original scene, and the *clear areas* represent the absence of green—that is, *the presence of red and blue*. Since magenta contains both red and blue, the green-filtered negative is therefore printed in magenta. Following the same principle, the blue-filter negative is printed in its comple-

ment, yellow; and the red-filter negative is printed in its complement, cyan.

In subtractive color, white is supplied, not by the additive mixture of color, but by the white of the paper base on which the colors are printed, or, in a color transparency, by white light from a source placed behind the film. In the case of a print, the viewing light, containing all visible wavelengths, penetrates the pigment and reflects back again from the white paper. The colors are produced by the subtraction of certain wavelengths from the white light. Hence the term *subtractive* process. (See Plate 53.)

The processes described in this book most easily adapted to three-color printing are carbro, gum, oil, and collotype. Three-color gravure is difficult because of the problem in registering a dampened sheet of paper for each printing—the paper may not expand equally each time. Printing is done by the subtractive process.

Making Color-Separation Negatives

Method One: Directly in the Camera. The best film for direct color separation work is Kodak Super-XX Pan Film. It has an ASA rating of 200 and is available only in sheets. Other panchromatic films will work, but Super-XX has the most accurate color response and it has adequate speed.

Direct color separation requires a view camera and a tripod sturdy enough to hold the camera in the same position while three separate exposures are made. Expose one negative each through a No. 25 (red), a No. 58 (green), and a No. 47 (blue) filter, following the exposure recommendations supplied with the film. Be careful not to jar the camera while changing filters or film holders. Make each exposure at the same aperture setting, varying only the exposure times as recommended. Obviously, unless you have an old "one-shot" camera designed to make the three exposures simultaneously, this procedure can only be used for stationary objects.

It is a good idea to place a paper gray scale on the edge of the scene before making the ex-

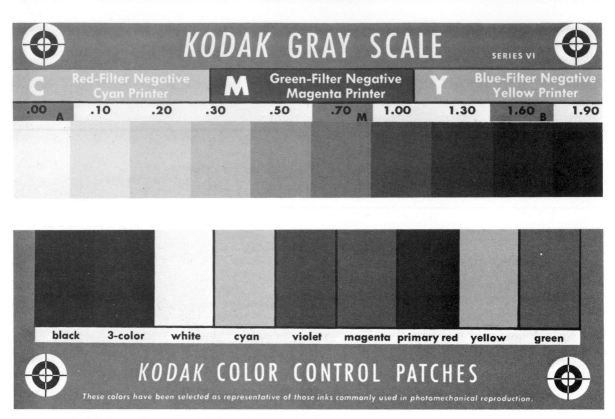

FIG. 179 Kodak Gray Scale and Color Control Patches.

posures. Place the gray scale so that its image will fall along the edge of the negative, where it can easily be masked out during printing. The scale gives you a way to check later on the balance of the three separation negatives. The negatives are in balance—that is, they correctly represent the proportions of red, green, and blue light in the original scene—when their gray scales match.

To achieve this balance, follow the standard practice of exposing for the shadows and developing for the highlights. In other words, adjust *exposure* until the shadow steps on the gray scales match, and adjust *development* until the highlight steps match. The match does not have to be exact but should not be more than one step off.

The exposures should be adequate to give those shadow values that are expected to hold detail on the print a density of at least 0.35 (about equal to the third step, counting from the base, on

a Kodak No. 2 Step Tablet). This places the shadow values on the straight-line section of the curve and helps maintain acceptable color reproduction in the shadow areas of the print. Develop the negatives to a density range appropriate for the printing process you will use.

Method Two: From Transparencies. The most accurate way to make color separations is directly in the camera, as described above. But often direct color separation is impractical. In the long run, the most versatile way to produce color-separation negatives is by photographing the original scene on color transparency film and then making separation negatives in the darkroom by contact or by enlargement. The best transparency for this purpose is one made from an original scene of limited contrast, slightly underexposed to give good color saturation and good highlight detail.

In order to balance the separation negatives more easily, put a paper gray scale along the edge of the scene, as described above. An equally good alternative is to put a transmission gray scale (step tablet) beside the transparency when making the separations. You can make a transmission scale small enough for this purpose by photographing a paper Kodak Gray Scale on 35mm black-and-white film. Photograph the scale so that its image fills the length of the 35mm frame. Process the film in your regular developer, giving it 30% more development than normal to increase the density range of the resulting transmission gray scale. Cut this out and place it next to the transparency. When making the separations by contact (*i.e.,* for three-color carbro or three-color bromoil, where a large printing negative is not necessary) simply lay the scale beside the unmounted transparency. For enlarged separations (for three-color gum, etc.) mount the scale next to the transparency as shown in Figure 180.

Enlarging. Here is a way to set exposure times using Kodak Super-XX.

FIG. 180
35-mm color transparency and homemade transmission gray scale placed together in a plastic, double-glass slide binder. Trim off the sprocket holes on one side of the transparency. Cut a larger opening in the binder with a sharp knife.

Place the color transparency in the enlarger with the *emulsion side up.* Adjust the magnification and focus for the desired image size.

Remove the transparency, and, with the lens wide open, measure the amount of light at the plane of focus on the easel. To do this, turn off all the lights except the enlarger. Place a Kodak Neutral Gray Card on the easel, white side up, and take a reflected-light reading. Set the meter for ASA 400 and close down the aperture of the enlarging lens until the meter gives a reading of 1/25 second at f/4 or its equivalent. If you use an incident-light meter, set the ASA to 400 and adjust the enlarging lens to give a reading of 1/10 second at f/22 or equivalent. (In both cases, this equals 3 foot candles of illumination at the plane of focus.) When using an incident-light meter, you will have to raise the enlarger head to compensate for the distance between the plane of focus on the easel and the incident sphere on the meter. After taking the reading, lower the enlarger to its original position.

Replace the transparency in the enlarger, emulsion side up. Refocus if necessary, and then close down the lens 1⅔ additonal stops. With the enlarger at this setting, use the exposure times given below. Note that different filters than those given above are used.

No. 29 (red) *25 sec.*
No. 61 (green) *15 sec.*
No. 47B (blue) *30 sec.*

Turn off *all* the lights in the darkroom and make the separation exposures on Kodak Super-XX, each time with the correct filter placed in front of the lens. Place each sheet of film in the identical position in the enlarging easel for each exposure. This will make it easier to register the negatives when you print them. For identification, use a scissors to clip off *one* corner of the *green*-filter negative after the exposure and *two* corners of the *blue*-filter negative. You will develop all three together.

Developing. Develop in Kodak HC-110 (dilution B) at 20°C (68°F). Use a *fresh* tray of developer for *each set* of separations. The developing times given by Kodak for color separa-

tion seem too long for most of the three-color processes described in this book. Reduce these suggested times 20% to 30%. Use the times given below as a starting guide.

DEVELOPING TIME IN MINUTES IN HC-110
(DILUTION B)

Filter	Red	Green	Blue
Suggested times for trial	3⅓	3⅓	5¼
Kodak suggested times	4½	4½	7

Set the timer to 5 minutes 15 seconds and immerse the blue-filter negative in the developer. Develop with constant agitation. At 3 minutes 20 seconds, immerse the red-filter and green-filter negatives and continue development by shuffling the films carefully and continuously. When development is complete, place the films in the stop bath together, then fix, wash, and dry.

Check the balance of the negatives by laying them on a light table and examine their gray scales. All three scales should match. If they do not, adjust exposure and development times as necessary. The exposure should be adequate to give the deepest shadow details in the negative a density of at least 0.35.

After you have gone through the above procedure a few times you can usually dispense with the gray scales and depend on standard exposure and development times—at least when working with transparencies of approximately equal density range. If you have a transparency requiring a change in exposure times, use a transmission gray scale to be sure the effect of the change is equal for all three separation negatives.

The blue-filter negative requires a longer developing time because contrast depends in part on the wavelength of the light to which a film is exposed. Blue light gives a less contrasty image than either red or green light, and so more development is necessary.

Separation by Contact. Set the enlarger illumination as described above and follow the same exposure times for each filter. Place the *unmounted* transparency in the contact-printing frame with its emulsion side facing the glass. If you have more than one transparency, but all are close in density and contrast, you can expose them together on the same sheet of film. To avoid fumbling with the transparencies in the dark, tape them to the glass along with the transmission gray scale (made as directed above) or a Kodak No. 2 Step Tablet.

Printing

Whatever the printing process, use the blue-filter negative for the yellow printing, the green-filter negative for the magenta printing, and the red-filter negative for the cyan printing. Print the yellow first, then the magenta, and the cyan last. You can anticipate the effect of adding more of a color by referring back to the illustration for the subtractive primaries. Adding magenta, for instance, will darken green and cause cyan to shift toward blue, and yellow to shift toward red. Adding cyan will darken red and cause yellow to shift toward green, and magenta to shift toward blue. Adding yellow will darken blue, cause magenta to shift toward red, and cyan to shift toward green.

Four-Color Printing. If necessary, a black printing can be included in addition to the color printings to increase the density in the shadows. For the black-printer, expose the film through a No. 9 (deep yellow) filter. With tungsten enlarger light, use the exposure time for the No. 29 (red) filter, decreased by two stops. You will need a well-developed negative if you want the black-printer to affect only the shadows.

Masking for Color Correction

The outline above should be enough to get you started in three-color work. It contains all you really need to know for experimenting with three-color gum, a process in which precisely accurate color reproduction is not likely to be your goal. It is also all you need to worry about for three-color carbro, at least at the start. Nevertheless, for accurate color reproduction with carbro or any other subtractive printing process, some additional problems must be solved. They occur because of the imperfections inherent in the pigments or dyes used to produce color images. (See Plate 53.)

The subtractive primaries, which should ideally absorb only wavelengths of light corresponding to their complementary colors, also absorb some light of other wavelengths. This must be compensated for if accurate reproduction is to be possible.

- Of the subtractive primaries, yellow presents the least problem. Yellow absorbs blue light as it should and freely transmits red as it should; but instead of also freely transmitting green, it absorbs a little green. The amount is small enough, however, so that for most purposes no correction is required.

- The cyan is a different story and causes far more difficulty. Cyan absorbs red light as it should; but, instead of transmitting blue and green freely, cyan also absorbs some blue and an even greater amount of green.

- The magenta, for its part, absorbs green as it should; but, instead of freely transmitting blue and red, magenta also absorbs some red and an even greater amount of blue.

The green absorbed by the cyan and the blue absorbed by the magenta are the core of the color-correction problem. If left uncorrected, the blues and greens in the print will appear too dark.

- Since the cyan absorbs green, the cyan in effect acts as if it contained some magenta (magenta is supposed to absorb green). This is corrected by reducing the amount of magenta printed in those parts of the image where cyan is also printed.

- The magenta, by absorbing blue, acts as if it contained some yellow (yellow is supposed to absorb blue). This is corrected by reducing the amount of yellow printed in those parts of the image where magenta is also printed.

This sort of correction is what masking procedures are designed to do. A step-by-step explanation of masking is beyond the legitimate scope of this book.

The Early History of Photomechanical Printing

Heliography

One of the outstanding achievements of 19th-century technology was the discovery of ways to reproduce photographs by means of the printing press. It was not until the 1850's and 1860's that techniques for printing photographs in ink really began to be workable, but the idea of using photography to supply the press was explicit in the earliest experiments in photography undertaken in France.

Working before both Daguerre and Talbot, Joseph Nicéphore Niépce was the first to obtain permanent images by photographic means. Niépce took up lithography in 1813, in company with his son, Isidore. Niépce could not draw well, and so he relied on Isidore to draw on the lithographic stones, or sometimes on pewter plates, prior to the chemical treatment necessary for printing. Isidore left his father to join the army in 1814. Niépce, now deprived in one swoop of both son and draftsman, began to look for ways to produce images by means of light-sensitive substances. He tried plates coated with light-sensitive varnishes, then in 1816 began to experiment with paper sensitized with silver chloride and exposed to light in a *camera obscura*. Judging by his letters to his brother, Claude, it seems that he did get images in the camera that year but found no satisfactory way to fix them or to convert the negative image into a positive one. Niépce continued experimenting, turning again to materials other than silver.

Niépce had his first real success in 1822. A year or two earlier he had discovered that a type of asphalt known as bitumen of Judea becomes insoluble when exposed to light. Niépce coated a

FIG. 181
Niépce's house at Gras, near Chalon-sur-Saône.

glass plate with bitumen thinned with oil of lavender. He laid over it an engraving he had oiled to make transparent (it showed Pope Pius VII), and put it out in the sunlight. After an exposure of several hours, the coating on the glass became insoluble in the parts under the clear areas of the engraving. Niépce developed the image by washing the plate with oil of lavender and turpentine. This dissolved the still-soluble bitumen out of the areas protected from the hardening action of the light by the lines of the engraving. The insoluble bitumen remained in place.

Over the next few years Niépce experimented with bitumen on pewter and on zinc in order to prepare plates that could actually be inked and printed. He had his best results in 1826 with an engraving of Cardinal d'Amboise. Following the same procedure as above, but using a pewter plate instead of glass, Niépce contact-printed the

engraving, dissolved out the still-soluble bitumen, and then put the plate in an acid bath. The hardened areas of the bitumen acted as a resist, so that the acid etched only the uncovered metal in the lines left by the engraving. He made two such intaglio *heliographic* plates of the Cardinal's portrait and sent them off in 1827, with several other plates, to an engraver, who deepened the lines and made proofs. This was the first succcessful attempt at photomechanical reproduction.

Also in 1826, Niépce made the first permanent photograph from nature, a view looking out the third-floor window of his house at Gras. It was made, like the contact-printed copies of the engraving, on a pewter plate covered with

FIG. 183

JOSEPH NICÉPHORE NIÉPCE, *View from the Window at Gras,* light-sensitive bitumen on pewter.

Made in 1826, this is the first permanent photograph from nature. Stored in a trunk in 1917, it was forgotten until rediscovered in 1952 through the efforts of Helmut and Alison Gernsheim.

(Gernsheim Collection, Humanities Research Center, University of Texas at Austin)

FIG. 182

JOSEPH NICÉPHORE NIÉPCE, *Cardinal d'Amboise,* print on paper from a pewter heliographic plate.

The plate was made in 1826, the print in February 1827.

(Gernsheim Collection, Humanities Research Center, University of Texas at Austin)

bitumen of Judea, but this time exposed in a camera. The exposure was about eight hours. The areas not affected by light were dissolved away in the oil of lavender and turpentine, and so the image was a direct-positive—the light parts were bitumen, the darks, the pewter plate.

In 1829, after a series of cautious letters and contacts during the three previous years, Niépce formed a partnership with Louis Jacques Mandé Daguerre. When Nicéphore Niépce died four years later, Isidore took his father's place in the partnership. The heliographic and daguerreotype techniques were made public together in 1839, but the latter immediately captured most of the attention. Heliography did not amount to much next to the daguerreotype, especially since it could not really show the steps of the tonal scale. Yet Daguerre's technique, although remarkable in its ability to record details and tone, was not a means of reproduction.

FIG. 184
Partners Niépce (left) and Daguerre, exchanging secrets in 1829.

Etched Daguerreotypes

In an effort to solve the problem of reproduction, experimenters almost immediately began to search for ways to transform the daguerreotype directly into a printing plate. The first to manage this with some success was Alfred Donné, who in October of 1839 displayed at the French Academy of Science a daguerreotype etched by treatment in nitric acid.

An "aquatint grain" is necessary to produce a tonal scale in an etched plate (the principle behind this is discussed in the chapter on Photogravure). To a certain extent the daguerreotype provided its own aquatint grain, since the image already consisted of separate, tiny dots of mercury amalgam. Donné showed that these dots acted as their own resist to protect the silver lying beneath: The acid etched only the bare silver, which made up the shadows of the image. Because the etch was not deep and therefore could not hold much ink, Donné's prints were light and only forty or so could be pulled before the plate became too worn for use.[111]

The following year Joseph Berres, of Vienna, used a similar process, but on solid silver plates that could be etched more deeply than the silver-coated copper plates normally used for the daguerreotype.[112] Berres protected the highlights with a varnish, so that the longer etching times necessary for more shadow depth would not affect them. With this process it eventually became possible to print as many as 500 impressions from a plate. Berres published a pamphlet about the process, *Phototyp nach der Erfindung der Prof. Berres in Wien,* in 1840. The edition was 200

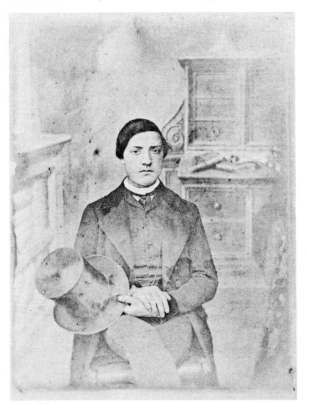

FIG. 185
HIPPOLYTE FIZEAU, print from a lightly etched daguerreotype, early 1840's.
(New York Public Library)

FIG. 186 HIPPOLYTE FIZEAU, print from an etched daguerreotype of cutout figures, early 1840's. See Fig. 59.

copies, each illustrated with five prints made from etched daguerreotype plates. This was the first photomechanically illustrated publication.

Hippolyte Louis Fizeau, of France, had the most success in etching daguerreotypes. Fizeau

FIGS. 187-188
HIPPOLYTE FIZEAU, etched daguerreotypes, proof and final print from *Excursions Daguerriennes,* early 1840's.

It is not clear whether these are from two separate plates, or show two states of the same plate. The shadows are in the same position in each, so if the prints are from two plates the subject actually daguerreotyped could not have been the building itself, but only another print.
(New York Public Library, International Museum of Photography/George Eastman House)

first boiled the daguerreotype in potassium hydroxide. According to the British patent (1843, No. 9957), this caused the mercury to be "better and deeper amalgamated with the silver under it, so that many imperceptible prints [points?] of the amalgam are effected [sic] in such a manner that the acid has no action upon them."[113] Fizeau then etched the plate in nitric acid and afterward wiped it over with linseed oil in such a way that the oil filled the etched parts, while the highlights were wiped clean. He then electroplated the daguerreotype with gold. This affected only the highlights because the linseed oil protected the etched shadow parts. Next, Fizeau removed the oil and etched the plate again. Because the gold plating gave the highlights additional protection against the acid, a deeper etch was now possible. Often handwork was done on the plate with engraving tools to reinforce details and dark areas. Selective etching, too, was done, by dusting the plate with an aquatint grain, then "stopping out" certain areas with a protective varnish in order to etch more deeply in other areas. After the final etching, Fizeau gave the plate a coating of copper, deposited by electroplating. The copper gave a

FIG. 189
Porte de la Bibliothèque, Louvre, aquatint copied from a daguerreotype for *Excursions Daguerriennes.*

The tonal scale in an aquatint was richer than that possible from an etched daguerreotype.
(National Gallery of Canada, Ottawa)

harder surface than bare silver, so that many more prints could be pulled than was possible with Berres's process. When the copper wore down, the coating could be restored simply by electroplating it again.

Two of Fizeau's prints were published in the second volume of Lerebours's *Excursions Daguerriennes, vues et monuments les plus remarquables du globe* (1842). The other illustrations in *Excursions Daguerriennes* were aquatints copied from daguerreotypes entirely by hand. Human figures, which the daguerreotype was still too slow to catch in motion, were added to the images. Oddly, some of these illustrations tend to look more "daguerrean" in tonality than do those printed directly from the daguerreotype plates prepared by Fizeau. (See Fig. 189.)

Other Early Attempts to Reproduce Photographs

The methods for transforming daguerreotypes directly into printing plates never proved commercially viable. It was left to the negative-positive process to make reproduction practical. Theoretically, at least, an infinite number of positive prints could be made from a calotype negative; but actually there remained many problems to solve before the mass production of photographic images could become a reality.

The first important attempt at mass production of photographs was Talbot's *The Pencil of Nature.*[114] Although all copies of *The Pencil of Nature* are dated 1844, the publication actually came out in six parts, the last appearing in 1846. Talbot wrote of the "difficulties innumerable in the first attempt at photographic publication . . ."[115] One problem was the considerable time necessary for exposing each print, especially when weather conditions were unfavorable. For example, it required months to print the more than 7,000 images necessary to supply each copy of the June 1, 1846, issue of *The Art Union* with a specimen calotype print. But even more distressing, especially to the potential customer, was the discovery that silver prints were likely to fade. Sir

William Stirling Maxwell's *Annals of the Artists of Spain,* one of the first books on art illustrated by photography and Talbot's last major attempt to use calotypes for book illustration, contained an insert explaining that faded prints could be exchanged for fresh ones, on request.

After the collodion and albumen processes came into use in the 1850's, the mass production of photographic images became much easier; yet it still took time and considerable work to reproduce photographs in quantity. Mass communication through photographic images was at this stage what an economist would call "labor intensive." Printing concerns like E. & H.T. Anthony, in New York, or the London Stereoscopic Company employed large staffs and assembly-line techniques. Sensitizing, printing, toning, mounting, and coloring of images were usually done by different individuals—skilled operations by men, the rest by women and young boys so that wages could be kept low. There was usually a delay between the date a negative was made and the date there were enough prints ready for issue.

FIG. 190
Production line for stereoscopic photographs, circa 1860.

The number of prints that could be produced over any given time depended on the hours of sunlight available and on the size of the image. Mass-production photographic printing was usually done with copy negatives consisting of a repeated image on a large collodion plate. The smaller the copy image, the more could fit on a plate; thus, the faster they could be multiplied. Given this basic restriction, it is easy to see why the two types of photographs reproduced most in the 1850's and 1860's were stereos and cartes-de-visite—both small images. They could never have achieved the popularity they did had their size not made mass production—or rather mass reproduction—possible. For a time in 1861, at the start of the American Civil War, the Anthonys were printing 1,000 cartes daily of a portrait taken by George S. Cook of Major Anderson, the heroic defender in the April 12 attack on Fort Sumter. The figure might have been exaggerated, but still gives an idea of how quickly small prints could be produced when public demand made the effort worth while. The same year, the June issue of The American Journal of Photography contained a more extreme example—a photograph which, it was claimed, could be printed from repeated-image copy plates at the astounding rate of 50,000 an hour. It was a portrait of Colonel Ellsworth, the first Union soldier to die in combat, but it measured only half-an-inch square.

Although (within the limitations described above) the problem of mass production of actual photographic prints had been solved by about the middle of the 1850's, there remained the need to devise an efficient way to insert photographic images into the texts of books and periodicals.

The first tentative solution was found by adapting photography to the production of wood engravings. In the technique of wood engraving, the nonprinting areas were cut away from a wood block with a knife, leaving a relief printing surface that could be set in a press on the same level with raised type and therefore printed at the same time. This gave wood engravings an enormous technical and economic advantage over photographic prints—which, among their other problems, had to be mounted in the text individually —and also over the competing and more elegant graphic reproduction techniques of aquatint, engraving, and lithography—for the same reason that prints from these media had to be printed separately from the text and individually mounted or bound with it.

Beginning in the late 1840's, the new illustrated weeklies had begun to use photographs as the source from which to copy their wood engravings. In the 1850's, techniques were developed for printing the photographic negative directly on wood, so that the block could be cut without having to trace or to draw an intermediate sketch. Actually, this was more in the line of a rediscovery of something done earlier. In 1839, in its April 27 edition, The Magazine of Science and School of Arts had printed three wood engravings cut from photogenic drawings that had been made by sensitizing the wood itself and then contact-printing lace and botanical specimens on top.

The technique of printing directly on wood saved time and allowed the engraving to be made with greater accuracy. But no matter how carefully done, the wood engraving could never come close to reproducing the tonal scale of a photograph or its fine detail, and the engraver was perfectly free to add or subtract details as he saw fit in the interests of time, composition, and his own assumptions about pictorial reality. The photographic image had to be translated by hand into a traditional kind of printmaking syntax before the image could be mass produced.

As shown in this brief sketch, the basic problems that provided the stimulus for photomechanical experiments from the 1840's on were: first, the need for efficient mass production of images, and second, image permanence. Significant improvements were made in the use of actual photographs, yet neither problem could really be solved this way. The solution lay in finding a process by which the image could be printed quickly on a press and in permanent ink. But then two new problems appeared: how to produce an ink reproduction that maintained the tonal precision of a photograph, and how to accomplish this while printing the photographic image along with the

type. Obviously, something better than the wood engraving had to be found.

The chapters that follow describe three major and a few minor attempts to solve these problems. The *photogravure*, the *collotype*, and the *Woodburytype* were the most important and the most beautiful of the photomechanical printing processes that preceded the dot-halftone processes used in commercial printing today. They were excellent solutions to the problem of reproducing photographic tonality. Unfortunately, none of them (except for a modification of gravure called *rotogravure*) allowed the image to be printed on the same press at the same time as type. This, along with difficulties in manipulation, eventually spelled their commercial downfall. They were replaced by type-compatible methods which, as generally used, are much their inferiors in the quality of the printed image.

FIG. 191 *Vue d'une Cour à Tunis,* albumen print and a handmade lithographic copy with figures added. Both appeared in Pierre Tremaux's *Parallèle des Edifices Anciens et Modernes de Continent African,* early 1860's.

(National Gallery of Canada, Ottawa)

Photogravure

The problems Talbot encountered in trying to produce permanent photographs for illustration led him to experiment with intaglio methods of printing photographic images in ink. Talbot had studied Fizeau's process for etched daguerreotypes. Unfortunately, none of the known Talbot manuscripts contains mention of the specific experiments that led directly to the technique Talbot patented on October 29, 1852, (British Patent No. 565) and announced in 1853, in an article that appeared on April 30 in *The Athenaeum*.[116]

The process he described was, as he carefully made clear, still in its infancy. Nevertheless, it involved two very important discoveries. First, Talbot had found that gelatin sensitized with po-

FIG. 192
TALBOT, a print from a plate exposed under a photographic veil, early 1850's.
(New York Public Library)

FIG. 193
TALBOT, ferns printed using a photographic veil, early 1850's.
(New York Public Library)

tassium dichromate became insoluble when exposed to light, and that it could be used as an *etching resist* much as Niépce had used bitumen of Judea.[117] This property of light-induced insolubilization ("hardening") of dichromated gelatin and of certain other dichromated colloids was to become the basic working principle behind virtually all the photomechanical and pigment processes that followed Talbot's work.

The second discovery was the use of a *screen* of black gauze or crepe to break up the image and provide the "shoulder" needed to print halftones. Later, as he improved his process, Talbot apparently abandoned the screen in favor of the *aquatint grain* described below. But the screen idea eventually reappeared, in modified forms, in the service of other photomechanical techniques.

Talbot coated a steel plate with gelatin sensitized with potassium dichromate. Then, he covered the plate with the screen of gauze or crepe, folded obliquely (he called this his *photographic veil*). He exposed the plate to the sun for two or three minutes. The result was that the gelatin exposed *between* the lines of the screen became insoluble. Talbot removed the screen and placed a flat object, such as a leaf, over the plate and again exposed it to light. This made the gelatin insoluble in the entire area not covered by the object. Talbot then washed the plate with water to rinse out the soluble, unexposed gelatin. He etched the plate in a solution of platinic chloride, which attacked those areas where the soluble gelatin had been washed away. As a result, a pattern of tiny lines representing the image of the object was formed in the plate.

The plate was inked and printed like any other intaglio plate. Talbot covered it with ink, then wiped it to force the ink down into the etched

FIG. 194 TALBOT, *Grass from the South of France,* 1850's. This print was made without a veil or aquatint grain.
(New York Public Library)

areas, in the process wiping the unetched areas clean. He laid a sheet of paper, already soaked in water to soften its fibers, over the plate and sent the combination through a press. The pressure forced the paper's fibers into the etched areas, pulling out the ink.

Five years later, in the October 22, 1858, issue of *The Photographic News,* Talbot announced an improved and newly patented version of this technique (British Patent No. 875, April 21, 1858). He called it *photoglyphy.* The first publish-

FIG. 195

TALBOT, photoglyphic engraving, 1858 or 1859.

The unevenness is typical of Talbot's results with the process.

(International Museum of Photography/George Eastman House)

ed examples of the new technique, architectural views taken by the French photographers Clouzard and Soulier, were inserted as supplements to the November issue of the same publication. Each copy contained one of the seven different views that were printed. The following September, *The Photographic News* contained a photoglyphic print of the Tuileries palace in Paris.

In working his new process, Talbot first coated a copper plate with gelatin sensitized with potassium dichromate and exposed it to light in contact with a positive transparency. This resulted in the hardening of the gelatin in proportion to the amounts of light passed through the different areas of the positive.

After exposure, and without first washing out whatever soluble gelatin remained, Talbot dusted the plate with gum copal powder to make an aquatint grain. He melted the copal powder by holding the plate over a spirit lamp; on cooling, the copal stuck fast to the surface. He then etched the plate in a solution of ferric chloride. The solution penetrated the gelatin in the spaces left open between the copal grains, and diffused through the gelatin to the metal beneath at a rate that depended on the exposure the gelatin layer had received. In the areas corresponding to the shadow tones, where the gelatin, protected by the dense areas of the positive, had received only slight exposure, the ferric solution penetrated quickly to the metal and began to etch it. In the highlights and middle tones, where the gelatin had received more exposure, the solution took longer to reach the metal. Consequently, the highlights were etched less deeply than the shadows. Talbot found that he could control the rate of etch by using ferric chloride baths of different specific gravities.

After etching, Talbot was left with an intaglio printing plate full of tiny, etched pockets, the depths of which—and thus the volume of ink each pocket could hold—corresponded to the tonal scale of the original positive.

The results Talbot obtained with this process were not very good, compared with those of later gravure techniques or even with the best etched daguerreotypes of more than a decade before. Despite this, the potential value of the process was

recognized immediately. According to *The Photographic News:*

> It appears to us that the importance of Mr. Talbot's invention—which it is impossible to over-estimate—chiefly consists of its applicability to the engraving of plates for the illustrations of books, at such a low rate, that even the cheap publications which, with one or two exceptions, are now obliged to content themselves with engraved wood blocks, may, instead of these, give an engraving which would be mathematically correct as regards perspective and the scale of the objects represented. For the illustration of books of natural history of animals, as well as of flowers and plants, this invention is invaluable; and even the most minute microscopic animalculae (such as the parasite of the bee described in a recent number) can be reproduced by photography in the camera, with the correctness no human hand could give. The paintings which form the pride of our National Gallery, the existence of which is unknown to the mass even of those who reside in this city, may be made familiar to the most remote peasant, by means of photographs engraved by this process.... When we consider the immense number of landscapes and *genre* paintings, the contemplation of which has given hours of pleasure to a limited number of individuals, we cannot but wish that a similar pleasure should be within the reach of our poorer brethren who lack our advantages. Surely, if the taste of the masses is to be raised by a contemplation of the beautiful, this invention offers the most ample means for accomplishing that object.[118]

Photogravure

Although the photogravure process has its origin in Talbot's work, the technique as we now know it was actually devised in 1879 by Karl Klič, a Viennese printer who had also had a career as a newspaper illustrator and caricaturist.

Klič first dusted a copper plate with resin, then melted the resin with heat. This produced the aquatint grain. Next, he sensitized a sheet of gelatin-coated pigment paper (much like the tissue used for carbon printing) with dichromate and exposed it to light in contact with a positive. After briefly soaking the pigment paper in water he laid it, gelatin side down, on the copper plate and smoothed it into firm contact. Stripping off the paper backing, Klič washed the gelatin (now transferred to the copper plate) with warm water, thus removing the soluble gelatin and leaving a coating of insoluble gelatin—thicker in the highlights than in the shadows (See Figure 147) —to act as the resist for the subsequent ferric chloride etching baths.

From here on, the process was much the same as Talbot's. When Klič etched the plate in ferric chloride, the solution quickly penetrated the thin areas of the gelatin—the areas corresponding to the shadows of the image—and began to etch. It took longer for the ferric chloride to reach the copper beneath the highlights, since the gelatin in those areas was thicker. As a result the shadows were more deeply etched than the highlights. Klič inked and printed the same way Talbot did.

In essence, this is the process for which directions are given here. This technique of photogravure, using an aquatint grain to break up the image, is often called *grain gravure* to distinguish it from the *screen* or *rotogravure* described later.

Grain gravures are easy to identify. There is usually an indented *plate mark* surrounding the image. Under roughly 15x magnification the image appears grainy, but the grain is soft in character—not sharp, as in a collotype—and it often

FIG. 196
Photogravure, magnified detail from Plate 36. The printing plate was worked over with engraving tools to deepen the outlines and shadows.

seems lost within the texture of the paper. There is no dot-halftone pattern such as appears in the offset reproductions in this book.

At first Klič kept the details of his process secret. He exhibited gravure prints at the Vienna Photographic Society in October of 1879 and again in November of the following year. He also began to produce prints on order and to prepare etched plates for other printers to use. His prints appeared in *Photographische Korrespondenz* and in 1881 the first one appeared in England in the *Yearbook of Photography,* a portrait of Mongo Ponton. In the early 1880's, Klič licensed the process to a number of printing firms on the condition that none divulge the method. Even so, sufficiently detailed accounts did leak out and were published in the photographic press.[119]

FIG. 197
A gravure screen, greatly magnified.

Rotogravure

The rotogravure process was invented in 1890 by Klič but, again, he kept silent about the details. The first to publish details for rotogravure was Adolf Brandweiner, who developed the process independently and described it in 1892. Rotogravure is still practiced today.

Two features of rotogravure set it apart from grain gravure: Instead of using an aquatint grain to break up the image in order to print intermediate tones, a cross-line screen is used; and printing is done from a rotating copper cylinder, inked mechanically.

Figure 197 shows an example of a gravure screen. It consists of transparent lines and opaque squares. To prepare the cylinder for printing, a sheet of gravure pigment paper is first sensitized with dichromate and then exposed in contact with the gravure screen. As a result the gelatin beneath the lines of the screen becomes insoluble through almost its entire thickness. The screen is removed and the pigment paper exposed once again, this time in contact with a transparent positive of the image. The gelatin layer is then transferred onto the printing cylinder and developed in warm water.

When the cylinder is etched, the ferric chloride solution penetrates the gelatin layers between the lines and etches the copper to depths corresponding to the tones of the positive. The copper protected beneath the thick insoluble lines formed by the exposure to the gravure screen is not etched at all. (NOTE: This is just the opposite of what occured in Talbot's original screen technique. There, the exposure beneath a gauze screen made the gelatin *between* the lines insoluble, so that the actual printing was done from the *lines* and not from the spaces in between, as in the later method.)

After etching, the copper is plated with chrome to give it a hard surface for printing.

The basic design of the rotogravure press is shown in Figure 198. The cylinder receives ink from a reservoir. As the cylinder rotates, excess ink is removed from its surface by a device called a *doctor blade.* You can see from the illustration that the function of the screen pattern is to create the "shoulder" that keeps the doctor blade from scraping the ink from the etched pockets. The printing paper is fed to the press in separate sheets or from a continuous roll, or *web.* As it is forced against the cylinder, it picks up the ink.

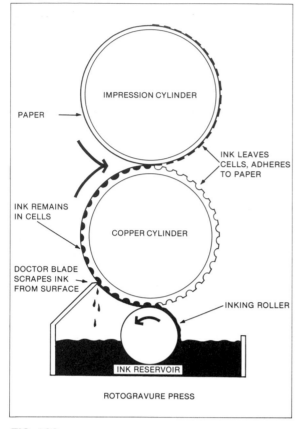

IMPRESSION CYLINDER

PAPER →

INK LEAVES
CELLS, ADHERES
TO PAPER

INK REMAINS
IN CELLS

COPPER CYLINDER

DOCTOR BLADE
SCRAPES INK
FROM SURFACE

INKING ROLLER

INK RESERVOIR

ROTOGRAVURE PRESS

FIG. 198
Rotogravure press.

Rotogravure is usually employed today only when a large print run is planned—the expense of preparing a cylinder makes it too costly for small runs. Rotogravure is used for a range of printing jobs from low-quality newspaper advertising inserts to high-quality illustration (*The National Geographic Magazine* is now mostly printed by rotogravure.)

You can easily identify a rotogravure print by looking at it under a magnifying glass: The surface will be covered by a fine grid of white lines, with ink of various densities in the spaces in between. When the press is run too fast, the ink is forced to one side of the etched pockets. This makes the print look grainy.

Print Quality

The tonal scale of a gravure print depends basically on the depth of the ink pockets formed during etching, though the choice of paper and ink—and, in flat-plate grain gravure, of inking and wiping techniques—also provides important control.

One advantage gravure has over other photomechanical techniques is that the gravure plate can transfer more ink to the shadow areas of a print. In conventional halftone printing (offset or letterpress) the density of the shadows depends on the size of the dots, and once halftone dots achieve their maximum size the only way to gain a denser black is to run the print through the press a second time to put additional ink in the dark areas of the image. Compared with conventional halftone reproduction, gravure puts much more ink in the dark areas with one printing. Since the ink can blend together in the deepest tones and obscure the grain, or gravure-screen pattern, the shadows of a well-made gravure print have a velvety richness. Because the gravure plate consists of ink depths that create real grays—rather than dots of various sizes that give only an optical illusion of gray—the tonal scale of a gravure print can contain subtleties almost impossible to convey with a dot-halftone image.

Photographers and Photogravure

Most grain-gravure prints are not as sharp as actual photographs. Peter Henry Emerson admired this softened image, and he also liked the delicate tonal scale possible with gravure. He felt the technique was the photomechanical equivalent of the platinum print. Emerson started the idea, later popular among a number of photographers, that gravures should be thought of as original prints and not merely as reproductions. He published his first gravure, *Gathering Waterlilies,* in May of 1886. It was printed in London by the Autotype Company. Five books or portfolios illustrated by gravure followed, their printing closely supervised by Emerson. Then, in 1890, he studied gravure under W.L. Colls. After that he etched and printed his own plates.[120]

From the beginning, Emerson made sure his gravures were printed in a "naturalistic" style. There were no deep shadows and the tonal scale was compressed—just as it was in his platinums.

In 1888, Emerson supplied twenty-six illustrations for the 100th edition of Izaak Walton's *The Compleat Angler*. Twenty-four others came from George Bankart, who was president of the Leicester Photographic Society. The book demonstrates two rival theories of gravure printing: Emerson's are printed in the naturalistic style; Bankart's in a standard style; the shadows deep and the tones more clearly separated (Figure 199).

Alvin Langdon Coburn, a famous member of the Photo-Secession, was another photographer who worked directly in gravure and regarded gravures as original prints. He studied the process two nights a week for three years during visits to London, and in 1909 began to produce a series of books printed by grain gravure.[121] The first were *London* (1909) and *New York* (1910). Coburn prepared his own plates and inks and made proofs for his pressman to follow in printing the editions. Coburn's sense of color, as expressed in his choice of inks, was excellent. By 1911 Coburn and his pressman had produced 50,000 gravure impressions. Coburn illustrated H.G. Wells's *The Door in the Wall, and Other Stories* (1911) with ten gravures, then came out with his own *Men of Mark* (1913).

Camera Work, the quarterly magazine published by Alfred Stieglitz from 1903 to 1917, is probably the single best-known example of gravure printing. During its lifespan, *Camera Work* published some 544 illustrations, 416 of which were printed by gravure. The prints were attached, or *tipped*, into the volumes by hand, sometimes first tipped onto cards and then onto the pages. Stieglitz also considered gravures as original prints. He had gained considerable practical experience in printing while a partner in the Photochrome (originally Heliochrome) Engraving Company in New York from 1890 to 1895. During its mostly unprofitable career, the company provided halftone letter-

FIG. 199 PETER HENRY EMERSON, *The Black Pool, near Hoddesdon,* photogravure in "naturalistic" tones, 1887.

press, gravure, and color printing for *The American Amateur Photographer,* which Stieglitz edited from 1893 to 1896, and for the *Police Gazette* and other publications. From 1897 to 1902 Stieglitz edited the Camera Club of New York's publication, *Camera Notes,* and employed the Photochrome Company (from which he had already retired) to print gravures for that magazine, as well.

On the whole, the style of gravure printing in *Camera Work,* as supplied by Photochrome and other companies, is unlike that of Stieglitz's earlier publications. The *Camera Work* gravures are often flat. The gravures in *The American Amateur Photographer* and in *Camera Notes* had generally been closer to commerical standards of tonality. *Camera Work* was an attempt to simulate the tonal and tactile qualities of the Pictorialist photographic printing style. It should be viewed in this light and not taken as demonstrating the inevitable qualities of gravure prints. This simulation was so effective that in 1904, when the Photo-Secession contribution to the exhibition of the *Société l'Effort* in Brussels failed to arrive on

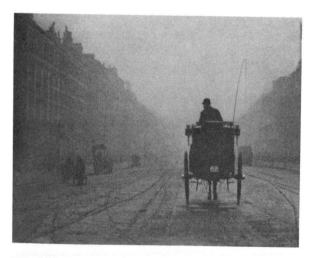

FIG. 200
ALVIN LANGDON COBURN, *Portland Place, London* (1906). Frontispiece to *The Novels and Tales of Henry James,* vol. 24, London, 1907-1909.
(Rodger Kingston Collection)

time, the exhibition committee framed thirty reproductions from *Camera Work* to hang in the show. They were a great success, and apparently it did not become generally known until the show was over that they were gravures and not photographic prints.[122]

If you want to study the gravure process, try to find gravures produced before the Pictorialist influence became strong, or which escaped it. This influence shows itself in some unexpected places. For example, Edward Curtis's magnificent twenty-volume work of descriptive anthropology, *The North American Indian*, was printed in grain gravure in a predominantly close-toned, Pictorialist style, perhaps an unfortunate decision in light of the documentary importance of the images.

One of the most interesting pre-Pictorialist examples of grain gravure is *The Old Closes and Streets of Glasgow,* a book published in 1900 in an edition of only 100 copies by James MacLehose and Sons, under commission by the Glasgow City Improvement Trust. It contains fifty gravures, many of them images from the original volume of carbon prints by Thomas Annan mentioned in the section on carbon printing. It also includes photographs made between 1897 and 1899 by the firm of T. & R. Annan (Thomas Annan had died in 1887). The firm had purchased from Klič a license to work the gravure process and introduced it to Great Britain in 1883. Some of the prints in *The Old Closes and Streets of Glasgow* show a good deal of handwork, done either on the positive or directly on the printing plate; but others have a wonderful clarity and richness of tone, not at all like most of the gravures in *Camera Work.*

James Craig Annan (Thomas's son) was the firm's expert on gravure, having been the one tutored in the process by Klič. It was James Annan who was responsible for the reappearance of the work of Hill and Adamson, which he reprinted in gravure and carbon. He published a portfolio of his own work, *Venice and Lombardy: A Series of Original Photogravures*, in 1898 in an edition of seventy-five copies. Annan belonged to the group of British Pictorial photographers called *The Linked Ring* and was also a close friend of Stieglitz and a member of the Photo-Secession. He con-

tributed to *Camera Work* a number of gravures, printed by himself.

Historically the last, and possibly the most outstanding, example of grain gravure is Paul Strand's *Photographs of Mexico*, a portfolio of twenty gravures first issued in an editon of 250 in 1940 by Virginia Stevens (who later became Strand's wife) and printed at the Photogravure and Color Company in New Jersey. In 1967, the Da Capo Press reissued the portfolio in an edition of 1,000 under the title, *The Mexican Portfolio*. By that time Charles Furth, who had printed the first edition, was dead and the Photogravure and Color Company was no longer printing grain gravures.[123] The second edition was printed by Albert De Long of the Anderson Lamb Company of Brooklyn,

New York. De Long had been with Anderson Lamb for fifty-eight years. In both editions the same plates were printed by possibly the best gravure pressman then living. The two editions are subtly but noticeably different. Strand thought the second edition the superior one. The interested reader should try to find examples of both editions and compare them firsthand. This is a pilgrimage that anyone who seriously plans to learn the gravure process should undertake at some stage. A great printmaking tradition came to an end with this work. It would be a fine sight to see it come alive again.

(NOTE: The first color section of this book contains a number of gravures that document the exhibitions held by the Photo-Club of Paris. They are from four volumes published by the Club from 1894 to 1897. Judging from an advertisement that appeared in the Club's regular exhibition catalog in 1898, a fifth volume may also have been produced. The volumes were splendidly printed and are an invaluable record of the growth of international Pictorial photography in the 1890's.)

The Technique of Hand Photogravure

Here is the process in brief: A film positive is made from the original negative or from a copy negative. The positive is printed in contact with gravure pigment paper sensitized with dichromate. The gelatin on the pigment paper becomes insoluble in proportion to the amount of light that reaches it. The pigment paper is then squeegeed gelatin side down on a copper plate, which has already been given an aquatint grain, and the backing paper removed. (A cross-line gravure screen can be used in place of the aquatint grain.) The soluble gelatin is then washed away, leaving insoluble gelatin on the plate to act as an etching resist. The plate is etched in ferric chloride baths of decreasing specific gravity. It is inked and proofed in an etching press. After proofing, the plate should be steel-faced by electroplating to harden its printing surface.

FIG. 201
PAUL STRAND, *Man: Tenancingo,* 1933.

The gravures from The Mexican Portfolio *(1967) have great physical presence. The printing ink is practically transformed into the particles of an adobe wall or the dirt on a peasant's tunic.*

Preparing the Positive

Use Kodak Gravure Positive Film (available from those photo dealers who have a Kodak graphic-arts franchise), Kodak Professional Copy Film, or Kodak Commercial Film to make the positive.

Expose the film to give a highlight density of about 0.35 (equivalent to approximately the third step, counting up from the base, on a Kodak No. 2 Step Tablet). This should place the lighter values on the straight-line section of the film's charactersitic curve. Using the developer recommendations given by the manufacturer, develop the film to give the deepest shadow value a density of about 1.65 (twelfth step on the No. 2 Tablet). This gives a total density range from end to end of about 1.30. Do not exceed this. It is much easier to work from a flat positive than from a contrasty one.

Mask the edges of the positive with red lithographic tape or Goldenrod paper (nonactinic paper available from graphic-art suppliers). This will provide an unexposed, and therefore soluble, border around the gelatin image when the pigment paper is developed on the copper. The soluble border prevents the edges of the image from puckering up and frilling off the plate. It is best to mask the positive with only a thin strip of tape or paper (about 6mm—¼ in.—or less). This will make it easier to trim the exposed pigment paper and to align it correctly on the copper plate. Figure 208 shows the suggested relative sizes of positive, mask, pigment paper, and plate.

The Copper Plate

Because the depth of the ink pockets used in gravure is minute, it is possible to print with very thin plates. The standard 16-gauge (0.64) photoengraving copper, usually recommended in current accounts of the gravure process, is actually much thicker, and so more expensive, than necessary. Copper is priced by the pound. As of April 1979, the price charged by one of the principal manufacturing suppliers, Bridgeport Engravers Supply Company, 30 Grand Street,

Bridgeport, Connecticut, was $3.18 per pound (roughly .45kg). A 16-gauge 18x36-inch (46x81cm) sheet of photoengraving copper weighs about 13.5 pounds (about 6 kilograms). The same size in the *thinner* 18-gauge (0.49) weighs about 10.3 pounds (about 4.7 kg). Thus, the price for the 16-gauge copper is $42.93; for the 18-gauge, $32.75. Six 9x13-inch (23x33cm) plates could be cut from a sheet this size. With 16-gauge, the price per plate works out to $7.15; with 18-gauge copper, $5.46. If you were to buy the same size plate precut in an art store, the price would be about double.

If you use photoengraving copper, the most economical plan is to buy the 18-gauge variety. Bridgeport Engravers Supply prefers to sell it by the case (30 sheets per case for 18-gauge copper) but will supply it in smaller lots for an extra charge per sheet. (Bridgeport has sales offices in Atlanta, Boston, Chicago, Cleveland, Dallas, Denver, Houston, New York City, Tampa, and Tulsa, all listed in the *Yellow Pages* under "Engraving Equipment & Supplies.")

If you do not have a guillotine plate cutter use a bandsaw, or else score the copper deeply with an engraver's draw tool (Fig. 202), then snap the plate back against the edge of a table.

Photoengraving copper comes coated on one side with an enamel resist. The working side is smooth, brightly polished copper that needs only minor treatment before printing.

PULL THE DRAW TOOL OVER THE CUTTING LINE REPEATEDLY UNTIL THE PLATE IS CUT HALFWAY THROUGH. THEN FLEX THE PLATE BACK AND FORTH ALONG THE LINE UNTIL IT SNAPS APART. IF NECESSARY, RUN THE PLATE THROUGH THE PRESS AFTERWARD TO FLATTEN IT OUT.

FIG. 202

A draw tool for scoring copper.

There is a less expensive alternative to photo-engraving copper, but it must be polished before use. It is 16-ounce (per square foot) cold-rolled roofing copper. Roofing copper is available in large sheets from local copper and roofing supply companies, and presently the cost works out to about $2.10 per 8x10-inch sheet, depending on cutting charges. You can easily cut 16-oz copper yourself with metal shears or even with a standard blade-type *paper* cutter.

If your supplier will let you go into his stockroom, try to select copper as free of scratches as possible. Do not drag the copper from stock—that is one way it becomes scratched. Lift it first, then pull it out. Be sure you are not given soft copper. Unlike soft copper, the copper you choose should spring back after being bent slightly in a broad arc.

You can get an idea of the depth of the scratches by running the tip of your fingernail across the surface of the copper and noting when you feel it catch. After cutting the copper to size, work down the lighter scratches with crocus cloth or 4/0 emery paper, using firm pressure, followed by finer-cutting 6/0 emery paper. Then polish the entire plate with Brasso. For deeper scratches use a burnisher first, as shown in Figure 203, and then the abrasive cloths or papers and the Brasso. To use Brasso, wrap a cloth around your finger and moisten the cloth liberally with the polish. Polish

FIG. 204
Polishing with Brasso.

the surface of the plate with a circular motion and as much pressure as you can manage, using enough Brasso to keep the plate constantly covered and lubricated. When you think you have been at it long enough, rub off the Brasso with a fresh cloth and check the shine. You should be able to see your face reflected clearly in the bright copper surface. A bit of tripoli compound scraped into the Brasso will increase its cutting power, saving time. All these materials are available from jeweler and metal-craft supply stores.

Polishing with successively finer abrasives replaces the original scratches with scratches of successively smaller size and depth. Eventually the surface becomes smooth. An absolutely perfect surface is not necessary for gravure, but carry the polishing to the point where the innumerable tiny lines left on the plate will have become too superficial to hold ink. At the end of the operation you should be able to draw your fingernail or the corner of a sheet of paper slowly across the surface of the plate without feeling it catch. You can also check the plate by examining it under 10x magnification.

After removing the Brasso, degrease the plate by rubbing it with a cotton swab or a soft cloth saturated with a 2% sodium hydroxide (caustic soda) solution. Use this warm. *Wear rubber gloves* or *keep your hands out of the solution.* Rinse the plate afterwards with plenty of hot

FIG. 203
Smooth scratches with a burnisher. Move it side to side, not back and forth.

water. There is still grease on the plate if the rinse water beads on its surface. The plate is clean when the water flows off in an even sheet. The gelatin resist will not adhere to greasy areas on the plate.

Next, rub the plate briefly with cotton or cloth saturated with

Water . *100 ml*
Sodium chloride *10 grams*
Glacial acetic acid *10 ml*

This forms weak hydrochloric acid, which dissolves tarnish and neutralizes the small amount of alkali still present after degreasing and rinsing. Use this solution on the plate for only a few seconds. Rinse the plate thoroughly with hot water, squeegee it, and *immediately* wipe it dry with a lintless cloth. The McGraw Colorgraph Company (supplier for gravure pigment paper) cautions against using proprietary cleaners, wetting agents, detergents, or chlorines for final cleaning of the plate.

Photoengraving copper should have no scratches as supplied. If there are scratches, follow the polishing steps described for roofing copper. If there are none, simply polish the plate briefly with Brasso, degrease, treat in the weak acid, and dry, as described above.

Dusting the Plate. Either asphaltum or rosin can be used to give the plate the grain necessary to print halftones. I prefer asphaltum because it gives a finer grain and is easier to fire (too much heat can cause the rosin grains to melt and run together). Since alcohol dissolves rosin, the alcohol treatments described below *cannot* be used with rosin-grained plates.

Dusting can be done in a large cardboard box as illustrated in Figure 205. One way to construct a box is to build a wooden framework, as shown. The plate will rest on the two parallel slats on the bottom. Cover this framework with cardboard, secured with tape along the edges. Cut a door to open downward, as shown. Make sure that the door closes tightly and that all edges are completely sealed to keep dust from escaping.

Place one cupful (250 ml) of powdered asphaltum (available from most art stores) in the bottom of the box. (This quantity is about right for the size

of box shown.) Close the door and turn the box upside down about six times to shake up the asphaltum. Set the box down and tap the sides and top to dislodge any large particles of asphaltum. Place the copper plate on a sheet of cardboard and lay a sheet of paper next to the plate. After the box has remained stationary for about 45 seconds, open the door and slide this in. Take care not to dislodge any large asphaltum particles still clinging to the sides of the box by jarring it.

After 2 minutes, carefully pull out the cardboard carrying the plate and the paper. The asphaltum is difficult to see against the copper, which is why the paper is there—against the white paper the grain pattern shows clearly. As to *amount,* the dusted paper should be about 50% covered. Check the grain with a magnifier. From a distance the paper should have a tone equivalent to about Zone 6 reflectance. This will give a fine, almost imperceptible grain in the printed image.

The texture of the grain will depend on the interval between setting the box to rest and putting the plate inside, and also on the time it remains inside.

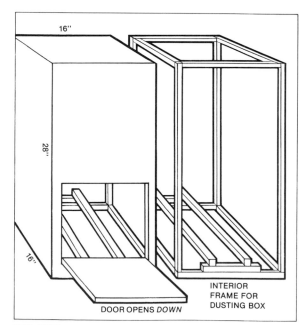

FIG. 205
Design for a dusting box.

The times depend on the size of the box and the amount of asphaltum and can be found only by experiment. The rule is that the sooner the plate is placed in the box, the thicker and coarser the resulting deposit. The largest clumps and particles of asphaltum fall first, followed by particles of increasingly finer size: A longer wait means a thinner and finer deposit. If the dust is too fine, though, the shadows will be undercut during etching and show reversed tones in the print. See Figures 206, 207.

FIG. 206
Two grain patterns, after firing. The plate on the right was given twice the time in the box.

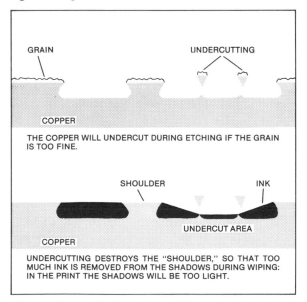

FIG. 207
Cross sections showing undercutting.

Sometimes objectionably large particles or clumps of asphaltum will fall on the plate, resulting in white spots on the print. This is likely to happen if the asphaltum becomes damp. Remove the clumps with fine tweezers or brush the plate completely clean, then have another try at dusting. If necessary, remove the old asphaltum from the box, scraping it from the interior walls, then add new asphaltum.

Firing the Asphaltum. Asphaltum fires at a relatively high temperature, but too much heat will burn it and possibly cause it to flake off the plate. Heat the copper plate over a gas flame or directly *on* the coils of a hotplate set at "High", moving it if necessary to distribute the heat. Use a hand vise or pliers with padded jaws to hold the plate. The moment the asphaltum begins to smoke, remove it from the heat.

To test whether the asphaltum has fired properly, allow the plate to cool and then scrape gently along its borders with the pointed end of a slip of paper. Hold the plate at eye level as you do this and examine the dusted surface against the light. If the asphaltum has fired properly the paper will not dislodge it. Just to be sure, check each border of the plate. Store the plate in a dust-free place.

The Etching Resist

Preparing the Pigment Paper. Gravure pigment paper consists of a porous backing paper coated on one side with gelatin mixed with a microscopically fine iron oxide pigment (to aid in judging development). The McGraw Colorgraph Company (175 West Verdugo, Burbank, California 91503) is now the only American manufacturer of gravure pigment papers. Type 37 is the best choice for grain gravure. At present it is available in rolls and in sheets, cut to size on order. Sheets are recommended because they are easier to handle and because the gelatin coating tends to crack when rolls are opened. The best storage temperature for the paper is 20 °C (68 °F) or lower, at 55 % to 60 % relative humidity.

Trim the pigment paper slightly larger than the masked positive, taking care not to touch the gelatin surface with your fingers.

Sensitize it in a 3.5% potassium dichromate solution cooled to 13°C (55°F). Increasing the concentration of the dichromate will increase the sensitivity of the paper but decrease its contrast. Decreasing the concentration of the dichromate will decrease sensitivity but increase contrast. (See page 204 for precautions in using dichromates.) Under tungsten light, place the pigment paper face up in the solution, brush away air bubbles, and keep it submerged with agitation for 3½ minutes.

Drain the paper and then lay it gelatin side down, middle first, on a sheet of stiff, clean Plexiglas, dropping the corners last to avoid catching air bubbles between the gelatin and the plastic. Squeegee the excess sensitizer from the back of the paper. Set the plastic on edge and position a fan to blow air at 21°C (70°F) and approximately 60% relative humidity across—but not directly on—the backing paper. Finish drying in the dark. The paper should dry and separate from the Plexiglas in two hours or less. Plexiglas is used rather than glass or ferrotype plate because the gelatin will separate from it without needing a wax or powder parting layer (which could come off along with the gelatin and impair its adhesion to the copper plate).

Another drying method is to strip the tissue immediately after squeegeeing (in this case glass or ferrotype tin can be used), and then simply hang it up to dry. It will dry faster this way, although it may curl (weight it with clothespins on the bottom).

Sensitized pigment paper becomes less soluble during storage. This *dark reaction* is equivalent to a gain in printing speed and a loss in contrast. According to McGraw Colorgraph, the dark reaction first becomes noticeable eight hours after drying when the tissue is stored at 21°C (70°F), and continues at a rate of a 7% gain in speed per day at that temperature. The dark reaction slows down as the temperatures decreases. There is only a 7% gain after four weeks at 5°C (41°F), and no gain after one year at −18°C (0°F).

For refrigerated storage, place the sensitized paper in polyethelene or foil envelopes, tightly sealed to prevent dehydration of the gelatin and to protect it from condensation when brought to room temperature. Allow the paper to come to room temperature before opening the container. When the paper warms up, the dark reaction will resume at the normal rate after the first eight hours.

Remember to protect the sensitized paper from daylight and ultraviolet light at all times up to the development of the gelatin image on the copper plate.

Exposure. Expose the pigment paper in firm contact with the masked positive. Set the positive against the sensitized gelatin with the same left-to-right orientation you want in the final printed image. Expose to ultraviolet light, taking care that the gelatin does not become overheated.

Start by making text strips, transferring and developing them out (as described below) on a polished but ungrained copper plate kept for this purpose. Do the test strips on copper rather than on glass or plexiglas. The gelatin becomes superficially hardened by contact with the wet copper

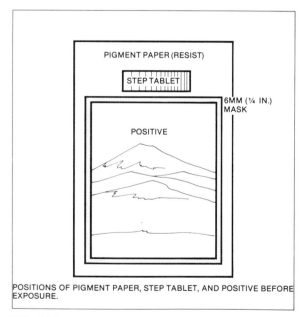

POSITIONS OF PIGMENT PAPER, STEP TABLET, AND POSITIVE BEFORE EXPOSURE.

FIG. 208

FIG. 208, 209, 210
Exposure, trimming, and laydown of the pigment paper. This system makes it easy to center the resist properly on the plate.

surface and this effect must be included in test strips. This hardening produces a "fog" which tends to lower shadow contrast.

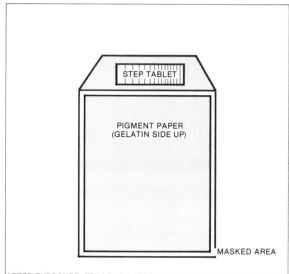

AFTER EXPOSURE, TRIM THE PAPER AROUND THE OUTSIDE EDGE OF THE MASK, AS SHOWN HERE.

FIG. 209

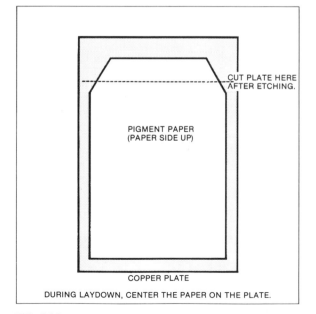

DURING LAYDOWN, CENTER THE PAPER ON THE PLATE.

FIG. 210

The exposure is correct when you can just make out detail in the deep shadows of the transferred and developed gelatin resist. Two minutes in front of a 275-watt sun lamp 38cm (15 in.) from the printing frame is about right.

If you have a densitometer or if you print with a Kodak No. 2 Step Tablet, refer to page 149 for a method of making exposure calculations.

Once you have found the correct time, expose the entire positive. It is a good idea to place a step tablet next to the positive. This will produce a series of density steps to use as a guide when etching. You can trim the plate afterward so that the tablet does not show up in prints.

EXPOSING WITH A GRAVURE COPY SCREEN

There are two basic types of gravure screen: the gravure *copy screen* and the *magenta screen*. The latter is used in "halftone" gravure, a technique in which pocket width and depth of etch both vary. The pockets are full-sized in the shadows but smaller in the highlights. For hand gravure, use a copy screen, as shown in Figure 197.

A point source or collimated-light source is recommended for exposure, because a diffuse source can cause the lines to widen wherever the screen is not tight against the pigment paper. Where this does occur, the tones becomes uneven and too light. A 150-line screen gives good results, and the lines are not visible to the naked eye in the final print.

First, use test strips to find the correct exposure for the positive. Next, expose the screen alone in contact with the pigment paper *for 30% longer* than that time. Remove the screen and expose the positive alone in contact with the pigment paper.

A supplier of gravure screens is DS America, Inc., 18110 Euclid Street, Fountain Valley, California 92708. The 1977 price for a 150-line screen, 41x56cm (16x32 in.) was $177.00.

Laydown. Fill a tray with at least an inch of gas-free (see below) water at 21°C (70°F). Place the dusted copper plate face up in the bottom of the tray and carefully brush off any air bubbles clinging to its surface. Slide the exposed paper face up under the water and brush away bubbles.

As the paper begins to flatten out, turn it face down, taking care to avoid trapping air bubbles between it and the plate. *As soon as* the paper begins to bend backwards, center it on the plate and lift them both out of the water together. This should happen no more than 40 seconds after the paper first becomes wet (both undersoaking and oversoaking the gelatin will result in poor adhesion to the plate).

Place the combination on a flat surface and squeegee together, working first from the center of the paper out, then from side to side with increasing pressure. Blot the excess water from the edges and set the plate aside to dry for 15 minutes, protected from daylight and ultraviolet light.

In addition to the dark reaction, there is a *continuing action* characteristic of dichromated colloids. This results in a continued gain in insolubility after the exposure, even if the tissue is stored in the dark. According to McGraw Colorgraph, the rate of gain for pigment papers is greatest right after exposure and then gradually decreases, becoming very slow by the end of an hour. For this reason it is best to complete the laydown procedure immediately after the exposure, or at least to standardize the interval between exposure and laydown. Like the dark reaction, the continuing action is sensitive to temperature and can be prevented by refrigerated storage.

Dissolved gases in the laydown water can cause gas bubbles to become trapped between the gelatin and the copper plate, resulting in uneven etching and in dark spots on the print. For this reason the water should be as gas-free as possible. Most distilled water intended for drinking is bubbled to eliminate an otherwise flat taste. You may find problems in etching that suggest the presence of bubbles lodged between the

gelatin and the copper, in spite of careful laydown and squeegeeing. If so, next time boil the laydown water to force out the dissolved gases; let it cool to 21°C (70°F) before use.

Developing. Wet the backing paper with full-strength denatured isopropyl alcohol (Isopropanol or rubbing alcohol). This conditions the paper so that the developing water can penetrate more quickly and uniformly to the gelatin.

About 20 seconds after pouring on the alcohol, slide the plate paper side up into a tray of water at 32°C (90°F). For efficient agitation, the tray should be at least one size larger than the plate. Add warmer water to the tray and bring the temperature up to 46°C (115°F). Agitate gently. The backing paper will begin to loosen as the warm water melts the soluble gelatin between it and the hardened areas of the image. After approximately 1½ minutes at 46°C (115°F), slowly strip the backing paper away by peeling it from one corner. Stop immediately if you feel resistance and wait for the gelatin to melt before continuing. Discard the paper.

There should now be an amorphous layer of gelatin left on the copper plate. This will be the *resist.* Develop it at 46°C (115°F) for 10 minutes after removing the backing paper. A longer development time at that temperature will

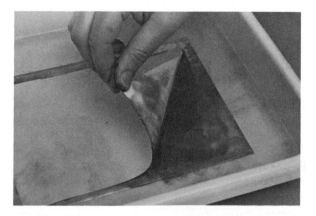

FIG. 211
Stripping the backing paper from the transferred resist.

do no harm but should be unnecessary. Use constant agitation and be careful not to touch the delicate gelatin. Change the water when it becomes cloudy. The final developing water should be clear.

Add cold water to the tray to bring the temperature down to about 15.5 °C (60 °F). After the plate cools, drain it, then flow over the resist a solution of

Isopropyl alcohol 3 parts
Water . 1 part

Drain this into the sink, then put the plate in a fresh 3:1 alcohol solution for 4 minutes with frequent agitation. Pour off the solution and flood the plate with straight alcohol, leaving it in this new solution for about 1 minute, with agitation. The purpose of the alcohol is to displace the water in the resist, so that it will dry more uniformly and rapidly.

Afterward, set the plate on edge to dry in a current of air at about 21 °C (70 °F). Turn it over periodically to let the high side become the low side. Drying with heat is *not* recommended because it can shrink the resist, making it pull from the plate. The plate will be ready for etching in about two hours, depending on the humidity in the drying area.

Before etching, coat the back of the plate and the borders around the image with liquid asphaltum, thinned if necessary with paint thinner. This will protect them in the etching baths. You will not need to coat the back if photoengraving copper is used. If you want a straight border around the image, apply the asphaltum with a ruling pen and straightedge and then fill in with a brush. Use a pointed brush to fill any pinholes in the resist.

Principles of Etching

Exposure of the sensitized gelatin to light causes it to become insoluble. This actually consists in raising its melting point. In the case of the McGraw pigment paper, insolubilization raises the melting point from approximately 35 °C (95 °F) to more than 93 °C (200 °F). The insolubilization starts on the surface of the gelatin and penetrates to depths proportional to the amount of exposure. After the gelatin is transferred to the copper and developed, the result is a relief image. The relief is thin in the shadows and thicker toward the highlights.

Gelatin that has been made insoluble will form, on drying, a surface that is surprisingly tough but still capable of absorbing water and swelling, at least to a limited extent. Insoluble gelatin will also absorb the ferric chloride etching solution used in gravure. It does so, however, at a rate that depends on the solution's specific gravity. Stock ferric chloride etching solution usually has a specific gravity of 48° Baumé (Baumé is a measurement of specific gravity). Adding more water to the solution lowers its specific gravity and at the same time increases the rate at which the solution can be absorbed into the gelatin. The absorption rate of 48° Baumé ferric chloride is so slow that it is always diluted for use.

When the layer of insoluble gelatin absorbs the etching solution, it begins to swell. When the swelling reaches its maximum, the etching solution begins to diffuse through the gelatin and attack the copper. Thin layers of gelatin reach their maximum swelling point much faster than thick layers. Consequently, the etching action starts first beneath the thin layers, which correspond to the shadows in the image.

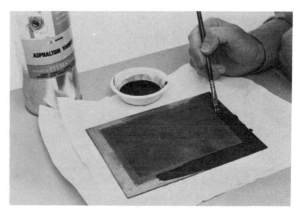

FIG. 212
Before etching, coat the exposed copper with liquid asphaltum.

If the plate is put in a bath of 45° Baumé ferric chloride, in a few minutes the solution will have worked through the lowest shadow values and slowly begun to etch the copper. Gradually the solution will work its way through the thicker gelatin and begin to etch the next-lighter values. In appreciably thick areas of gelatin, though, the rate of penetration will be so slow that the copper will not be affected. So in order to etch the lighter tones the plate is transferred to a bath of lower specific gravity, perhaps 43° Baumé. This more dilute solution penetrates the gelatin at a faster rate. As a result, new areas of gelatin are penetrated and the copper beneath them attacked. In a few minutes the plate is transferred to a still lower Baumé bath, and then to another if necessary, each time beginning to etch under a thicker area of gelatin. In this way the tonal scale of the positive is etched into the plate.

Once penetration of the gelatin is complete and etching has started, the depth of etch is approximately proportional to the etching time, regardless of Baumé. (Lower Baumé baths have slightly greater rate of etch once they reach the copper, but the difference is not important.) The traditional practice of etching is based on this. The idea is that equal differences in density should begin to etch at equal intervals of time. If you print a Kodak No. 2 Step Tablet next to your positive, for example, the steps in the tablet should begin to etch one after the other at approximately the same interval. If you wish to etch ten steps of the tablet (assuming the density range of the positive corresponds to ten tablet steps) and decide for reasons described below that the total etching time should be about 15 minutes from the moment the deepest shadow tones begin to etch, then in order to produce a smooth tonal scale each step in the tablet should begin to etch about 1.5 minutes after the previous step began its etch ($\frac{15}{10}$ = 1.5). The progress of the plate through the etching baths should be regulated with this in mind.

Here is how the tonal scale can be modified in the etching baths. Since etching depth depends on time (at a given temperature, with constant agitation), prolonging the interval between the start of etching of any two successive tones will in-

crease the contrast between them. Thus if you want to increase the printing contrast of the plate, you should favor the higher-Baumé baths, let the shadows etch deeply, and then pass the plate quickly through the lower-Baumé baths. Decreasing the interval between the start of etching of successive tones will decrease the contrast.

In actual practice it is easier to increase the contrast of a plate (compared with the tones of the original positive) than to decrease it. This is why low-contrast positives are preferred.

SINGLE-BATH ETCHING

An alternative to multiple-bath etching is the single-bath method, in which only one bath of constant Baumé is used. The practical difference between the two is that the single-bath method is designed for commercial applications, standardized working conditions, and standardized positives—consequently, it gives standardized results. The benefit of the multibath method is that it allows the beginning etcher to learn to control his results, handle special cases, and exercise a certain amount of personal judgment in using gravure as a creative process. The McGraw Colorgraph Company will send information on single-bath etching on request.

Sometimes the term *single-bath etching* is used to refer to the technique of adding small amounts of water to a single ferric chloride bath in order to lower its specific gravity while the plate is etching. This is a shortcut that makes it possible to use only one bath, but it cannot be recommended as a way to learn etching because it does not allow the etcher to keep exact track of Baumé ratings.

Preparing the Ferric Chloride Etching Baths

Hunt Blue Label Rotogravure Iron Solution is a ferric chloride solution of 48° Baumé specially prepared for gravure etching. It comes in 60-pound (27 kg) collapsible containers from any branch of the Philip A. Hunt Chemical Corporation, whose main address is Roosevelt Place, Palisades Park, New Jersey 07650. When you order, ask for the technical bulletin describing its use.

Using plastic or glass containers, prepare baths of 45°, 43°, 41°, and 39° Baumé strengths, following the dilution chart in Figure 213. These should be checked with a Baumé hydrometer (available from any laboratory supply company). Place the hydrometer in a hydrometer jar or in a tall, narrow graduate and add the solution until the hydrometer floats. Read the specific gravity in degrees Baumé at the point where the stem of the hydrometer breaks the surface of the solution.

Starting with 48° Baumé, dilute as follows:

Required Baumé	(Specific gravity)	Water (ml) added to each liter (1,000 ml) of 48° Baumé iron.
45°	(1.444)	108 ml
44°	(1.430)	148 ml
43°	(1.420)	193 ml
42°	(1.408)	238 ml
41°	(1.396)	283 ml
40°	(1.385)	333 ml
39°	(1.373)	380 ml
38°	(1.360)	430 ml
37°	(1.347)	480 ml

Because of the chemical changes that take place when a ferric chloride solution is diluted, these figures can only be approximate. If possible, allow the solution to stand overnight and then adjust Baumé as necessary.

FIG. 213
Ferric chloride dilution chart.

When a solution of ferric chloride is diluted with water it becomes hot, with the result that a period of time is necessary before the Baumé stabilizes. It is best to let the solution stand—overnight if possible—after the initial dilution from stock, and then make adjustments by adding more water or more ferric chloride stock. Since even a small amount of water can change the Baumé, be sure trays and containers are dry before pouring the solution into them.

During etching, the ferric chloride is reduced to ferrous chloride, while cupric chloride enters the solution as the copper dissolves. The etching characteristics of the bath tend to improve after the initial use; but eventually the concentration of ferric chloride decreases and the copper concentration increases to the point where the solution will penetrate the gelatin more rapidly but will be less able to etch the copper. It is hard to know when to discard the bath. Cartwright (see recommended readings) suggests throwing it away before it becomes a dirty greenish-brown. He advises throwing out the weakest Baumé bath, diluting each of the remaining baths down one step, and then preparing a new first bath.

Etching the Plate

Bring the temperature of the baths to 21 °C (70 °F). A small increase in temperature will quickly increase the rate of penetration and to a minor extent also the depth of etch for a given etching time. For this reason, temperature standardization is important.

Control the relative humidity in the drying and etching area if possible at 60% and the temperature at 21 °C (70 °F). The "dry" resist takes in or gives up water until it reaches equilibrium with the atmosphere. As the moisture content of the resist increases, so does the rate of penetration of the etching baths. The resist should be uniformly dry across its surface so that penetration will be uniform and not uncontrollably rapid.

Etching schedules, such as the one below and those is in the standard texts on gravure, are by no means exact. They should be thought of only as general guides. The type of resist, the exposure it

is given and consequently its thickness, the moisture content of the resist, the hardness of the copper, the condition of the etching baths, and the texture of the aquatint grain all affect the etching procedure. Because of this the etcher has to modify the procedure as necessary and cannot simply rely on rote procedures given in texts.

Place the film positive on a light table where it can be referred to during etching.

Always use constant agitation during etching. The agitation rate does not affect penetration time; but an increase in agitation willl increase the rate at which the copper is etched once penetration is complete.

FIG. 214
Etching a plate.

ETCHING SCHEDULE

45° Baumé: Agitate the plate in this bath until the deepest shadows are penetrated and etching starts. The copper will darken as it begins to etch—each step of the tonal scale darkening in turn. When the shadows begin to etch, transfer to the 43° Baumé bath. If etching does not begin in the 45° Baumé bath within about 4 or 5 minutes, transfer to the 43° Baumé bath.

43° Baumé: Depending on the exposure given the resist, most of the etching will take place in this bath. The plate should remain in it as long as the tones continue to come in at approximately even intervals. The time in this bath usually averages 10 minutes. When the penetration of higher steps begins to slow down, transfer to the 41° Baumé bath.

41° Baumé: This bath will generally be necessary to etch highlight tones. If further etching is required, transfer the plate to the 39° Baumé bath. Add a small amount of water to lower the Baumé, if necessary. Areas that are to print white should remain unetched, or they can be etched lightly and later worked down with the burnisher.

If at any point etching starts to rush and tones come in too quickly, return the plate for no longer than about 30 seconds to the previous (higher) Baumé bath, then place it again in the lower bath and proceed as usual. When you judge etching to have reached the proper stage, immediately rinse the plate under a stream of hot water and rub the gelatin off with your fingertips. Dissolve the asphaltum on front and back by wiping the plate with a rag soaked in paint thinner.

Further Points

Grain Size and Etching Time. The removal of copper during etching proceeds to the side as well as downward, with undercutting of the grain in the shadows as a possible result. (Figure 207). Undercutting is most likely to occur on fine-grained plates. Such plates should be sent through the etching baths rather rapidly, bringing in the middle and lighter tones soon enough to prevent undercutting the shadows. Plates with a coarse grain can stand considerably more etching.

The effect of undercutting is a reversal, or lightening, of the shadow tones—because the wiping rag drags the ink out of the shadow pockets. The problem is greatest when deep shadow values cover broad areas of the plate.

Undercutting in narrow and confined areas can usually be tolerated. A plate that must hold deep shadow values over broad areas should be given sufficiently heavy grain to prevent undercutting.

Devils. Most of the problems likely to be encountered in etching can be diagnosed using the information given above. One frequent difficulty is the occurrence of "devils." These are places where the etching solution penetrated the resist rapidly and spread sideways between the resist and the copper, resulting in dark areas from which a pattern of lines often radiates.

Devils are more of a problem in grain gravure than in screen gravure because of the uneven texture of the grained plate. Devils can be due to grease on the plate, to improper laydown procedures resulting in bubbles between the plate and the resist, or to an excessive concentration of free acid in the etching bath. The acid increases the rate of penetration and softens the gelatin. Hunt Blue Label Roto Iron contains a very low concentration of free acid. Less acid can be tolerated in grain than in screen gravure.

If devils occur, despite care in cleaning and in laydown, neutralize the 48° Baumé ferric chloride as follows: While stirring constantly, add to 60ml of stock ferric chloride a solution of 60ml ammonia and 240ml water. A precipitate of ferric hydroxide will form. Allow this to settle for 30 minutes, then decant the solution and add the *precipitate* to each gallon (3.785 liters) of ferric chloride stock. It will neutralize acid. Allow this to stand a day before use.

The dissolved copper in an etching bath lowers its acidity, which is one reason why a bath works better after the first use. The presence of ferric hydroxide slows down the penetration time of the etching baths, and may make a lower Baumé series of baths necessary.

Silvering. As mentioned, the surface hardening of gelatin in contact with the copper tends to decrease shadow contrast. This can be prevented by applying a thin coating of silver to the copper. The procedure generally can be used only with rosin aquatint or screen gravure because the temperature necessary to fire asphaltum will oxidize silver.

Distilled water *1 liter*
Silver nitrate *0.5 gram*
Potassium cyanide *0.5 gram*
Dissolve the silver first, then add the cyanide and stir until the precipitate dissolves.

Swab the solution over the degreased and acid-rinsed copper plate for about 2 minutes. The copper will take on a visible coating. Rinse the plate with water and then quickly dry it.

CAUTION: *Potassium cyanide is a deadly poison.* Wear rubber gloves and handle the solution and the potassiuim cyanide crystals with *great* care.

Beveling. If photoengraving copper is used, bevel the edges of the plate with a metal file, as shown in Figure 215, and smooth them with a burnisher. Round off the corners. This will keep the edges from cutting the printing paper and the press blanket. When the plate is steel-faced, the facing will be less likely to chip if the edges of the plate are smooth. Roofing copper does not require beveling, although it may be necessary to smooth the edges with the burnisher.

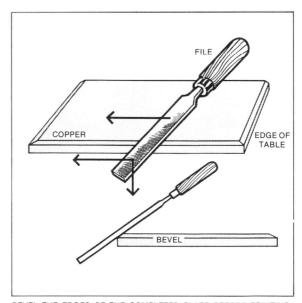

BEVEL THE EDGES OF THE COMPLETED PLATE BEFORE PRINTING: PUSH THE FILE FORWARD AT THE SAME TIME AS YOU PUSH IT DOWN.

FIG. 215
Beveling.

Preparing for Printing

Inks. It is easy and economical to grind your own printing inks (for instructions, see almost any textbook on etching), but in the beginning it is simplest to use the inks made for etching (*copperplate ink*) and sold in collapsible tubes. Also have on hand a pint of medium copper-plate oil (*burnt* linseed oil) or *raw* linseed oil for thinning the ink when necessary. The following copper-plate oils are listed in order of increasing viscosity:

Raw linseed oil (cold-pressed)

Light copper-plate oil (burnt linseed)

Medium copper-plate oil (burnt linseed)

Heavy copper-plate oil (burnt linseed)

Do not use *boiled* linseed oil. Boiled oil will cause the ink to stick to the printing plate.

The Etching Press. Etching presses are normally rigged with three blankets: two cushion blankets on top, next to the roller, and a thinner, smoother, fronting blanket beneath, in contact with the printing paper and the bed of the press. When the press is not in use, run the bed to one side so that the printing area of the blankets is not under pressure. Otherwise the blankets can harden and lose the flexibility necessary to force the printing paper into the pockets on the plate.

The blankets should be washed when they become hardened by repeated pressure or, in the case of the fronting blanket, from sizing picked up from the damp paper. Soak the blankets in warm water with a little ammonia, rinse, gently press out the water, and dry flat on newsprint—the blankets can stretch out of shape if wrung out or if hung up to dry. Sometimes just a gentle massage will soften the blankets enough for printing.

The pressure of an etching press is adjusted by the regulating screws at the opposite ends of the cylinder. Modern presses sometimes have gauges fitted to the screws to make balancing and resetting of pressure easier. Once you have found the right pressure by trial and error leave the adjustments alone, especially on presses without gauges where accurate resetting could be a prob-

lem. When small increases in pressure are necessary, you can make them by inserting sheets of paper between the bed of the press and the printing plate.

Paper. Many papers are suitable for gravure. Andrews-Nelson-Whitehead is the principal supplier. Among the 100% rag papers are Rives, Rives BFK, Arches Cover, German Etching, and English Etching. Less expensive are Copperplate Deluxe (75% rag), Domestic Etching (50% rag), and Copperplate (33% rag).

Soaking. Soak the paper in water before printing. This softens the fibers and raises the hairlike fibrils so that when it is passed through the press the paper will conform to the ink pockets and pull out the ink.

Etching papers are only slightly sized, or are left unsized (*waterleaf* paper). Copperplate, a soft, unsized paper, is almost like blotting paper. It absorbs water very quickly and can be soaked for a minute, then placed between sheets of blotting paper to remove excess water before printing. Compared to Copperplate, Rives BFK is a harder-surfaced paper. It prints well if soaked for 30 minutes or so and then blotted. The rule is that the more calendered or sized the paper is the longer the soaking time needed. Hot-pressed papers usually require so much soaking that they are not practical for gravure.

Another way to prepare the paper for printing is to dampen each sheet on both sides with a sponge and then stack them between two sheets of heavy plate glass. They should stay that way for 6-to-12 hours. If done on the evening before printing, the paper will be ready by morning and can be carefully pulled apart for use. You can seal the perimeter of the glass sandwich with plastic wrap to keep the edges of the paper from drying out.

For printing, the paper should be uniformly damp but free of surface water. Paper that is too dry will not go into the ink pockets deeply enough to pull out the ink. Often the printing quality of a hard or undersoaked paper can be improved by working it over gently with a brush to raise the knap.

Inking the Plate

Inking is an enjoyable—but messy—operation. It is a good idea to wear an old shirt or smock to protect your clothes and provide a convenient place for wiping your hands.

Squeeze the ink out onto a sheet of glass. Using a palette knife, scrape the ink together and then press it out against the glass. Repeat this a half-dozen times. You will begin to feel the ink loosen. If the ink is particularly stiff, add copper-plate oil (generally medium oil), drop by drop, and mix it thoroughly into the ink with the palette knife. You will have to learn from experience when oil is necessary.

While preparing the ink, warm the gravure plate on a hot plate. If the hot plate has coils (instead of a flat metal surface), place a large sheet of scrap copper between the coils and the gravure plate to distribute the heat. Set the hot plate on "Low". The gravure plate should become distinctly warm, but not hot to the point of being uncomfortable to hold with bare hands.

Etchers usually apply ink to plates with a leather-covered dabber (using a rocking motion to force the ink into the plate) or with a soft rubber roller (or *brayer*). You can dispense with both and use the edge of a piece of scrap cardboard or bristol board to wipe the ink across the surface of the warmed plate—but be careful, because this is one way plates can get scratched. Apply just enough ink to cover the surface with an even, opaque layer. The ink will soften in contact with the warm plate.

Wiping. The plate is wiped with a special gauzelike material called *tarlatan*. Before using new tarlatan, massage and crush it until it softens. Fold it into a ball, holding it with the ends tucked in and with a smooth exposed surface, as in Figure 216. Wipe the warm plate with a circular or linear motion—whatever feels right. This first wiping forces the ink into the pockets and just begins to remove some of the excess. As the tarlatan becomes filled with ink, take a second piece, fold it into a ball, and continue wiping. This will lift off more of the ink and begin to uncover the image.

FIG. 216
Initial wiping with tarlatan.

Continue wiping, with a fresh tarlatan if necessary, until the image is clear.

Be sure not to let the tarlatan pick up grit from the work area. This can result in scratches on the plate. So can wiping the plate with an old tarlatan on which the ink has become too dry and hard.

For subsequent plates, use these now-inky tarlatans in the same order as above: Start wiping with the rag most charged with ink, then use cleaner and still cleaner rags to bring out the image. When the exposed portions of the pad become loaded with ink, fold a fresh layer of tarlatan around the outside. Press it down so that the new layer becomes partly filled with ink from below. When the first tarlatan becomes too clotted with ink for use, throw it away and move up the second rag to its place.

After the tarlatan wiping there will be a slight ink tone in the highlights on the plate. Most of this *plate tone* is from ink on the unetched copper surface above the pockets. You can clean up as much of the plate tone as you want by wiping the plate with a nylon rag (close-woven nylon will pick up more of the remaining ink than will the open-weave tarlatan) and/or by *hand-wiping* the plate. To do the latter, place the pad of your hand between wrist and thumb on the plate, as in Figure 217, and wipe with sweeping or circular motions—a little experimenting will show you the

best method for the plate in question. If you rub a bit of whiting (calcium carbonate, chalk) against the side of your hand to dry up perspiration, more ink will be taken up from the plate. Hand-wiping will remove some or all of the plate tone and lighten the highlights.

Finally, wipe the borders and edges of the plate clean with a rag. Put the plate on the hot plate momentarily to rewarm the ink. The plate is now ready for printing.

Contrast. Wiping can give considerable control over the tones of the print. Thin inks produce lower-contrast prints than thick inks. Brown inks produce lower contrast than black inks. A plate

FIG. 219
The first proof.

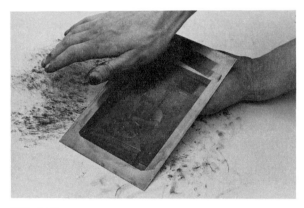

FIG. 217
Hand-wiping to remove the plate tone.

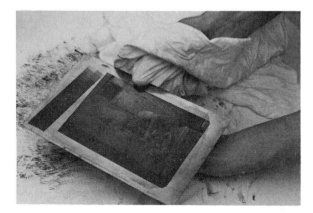

FIG. 218
Wipe the edges of the plate before printing.

wiped warm will give up ink more easily during wiping than one wiped cold. A plate printed warm will give a darker print than one printed cold.

Printing

Place the warm, inked plate on the press bed, checking first that both the bed and the bottom of the plate are clean. You may need to place a larger sheet of paper under the plate to keep the overlapping margins of the printing paper clean.

By this time your hands will be covered with ink; so use print tongs or folded strips of paper to remove the dampened paper from the blotters. Lower the paper carefully over the plate and then drop the blankets on top.

Run the paper through the press with a slow, even, nonstop motion. There should be enough pressure to make the impression in one back-and-forth pass. Lift the paper from the plate and inspect the plate mark around the image. It should have an even depth all around. If not, the pressure is greater on one end of the roller than on the other.

Re-ink the plate after each printing. When you are through printing, clean the plate with turpentine or paint thinner, using an old, soft toothbrush to scrub out the ink.

Steel Facing

After the plate has been proofed once or twice it should be faced, otherwise its surface will wear down in printing and be easy to scratch. The plate can be sent to a commercial plater, but be sure to find one familiar with intaglio printing plates. One such outfit is the Impressions Workshop, 27 Stanhope Street, Boston, Massachusetts 02116. (Plates can be sent by mail. The charge for steel-facing as of January, 1977 was 15¢ per square inch (6.5cm²), plus an additional charge if the plate has to be cleaned first.) An inquiry at a college printmaking studio or among artists or in the phone book will turn up similar services in other parts of the country.

The steel-facing process is the application of a thin coating of iron by electro-deposit over the copper surface. This is done by passing an electric current through a vat of ammonium ferrous sulfate. The current is supplied through a rectifier, a device that converts the alternating current from the wall source into direct current.

The vat can be of slate, earthenware, or heavy plastic. It should be roughly twice the overall size of the largest plate to be faced and about a foot (30cm) wide. Fit three *brass* rods or heavy strips across the top of the vat in the long dimension (See Figure 220). Suspend a plate of *mild* steel, several inches smaller than the bath in both vertical and horizontal dimensions, by *steel* hooks from the center rod. Hang the printing plates by *brass or copper* strips soldered to their backs and bent to form hooks. Suspend them in the plating solution from the two outside rods, printing side facing inward.

The rectifier should have an output sufficient to provide 0.03 amps per 6.5 square centimeter (1 sq. in.) of copper printing surface. It should have an ammeter for reading the amperage and a variable resistance for controlling amperage output. Use a heavy-duty automobile jumper cable to connect the positive pole of the rectifier to the rod holding the steel plate, as in Figure 220. Connect the negative pole of the rectifier by similar cables to the rods holding the copper plates.

CAUTION: *Be sure the rods cannot slip together and cause a short.* The steel plate is called the *anode,* the copper plate, the *cathode.*

The plating solution consists of

Water . *3.8 liters*
Ammonium ferrous sulfate *800 grams*

An alternative solution can be prepared with

Water . *3.8 liters*
Ammonium ferrous chloride *453 grams*

If the chloride solution is used, it should be mixed and the current passed through it in the vat for several hours to saturate the solution with iron. During this, connect the *positive* pole of the rec-

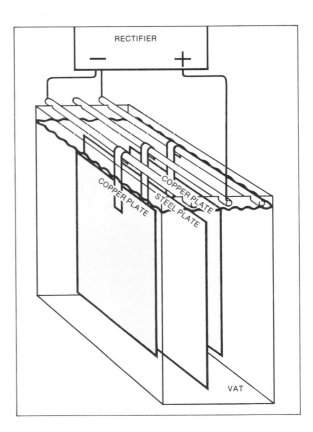

FIG. 220
Design for a steel-facing vat, showing positions of plates and electrical connections.

tifier to the rod carrying the *steel* plate and the *negative* pole to a *copper* strip suspended in the solution.

Keep the plating bath covered with a plastic film to prevent oxidation when it is not in use. Let the sediment settle to the bottom and remain undisturbed. From time to time decant the solution, clean out the vat, and bring the solution back to level by adding more ferrous salt and water according to the formulas given. Dry the steel plate and cover it with petroleum jelly (Vaseline) or asphaltum to prevent rust between use.

The printing plate must be perfectly clean before being faced. First, solder the copper or brass hanger to the back of the plate. Then clean the ink from the plate with a brush and a 5% solution of sodium hydroxide and a little whiting. This can be heated to boiling and used hot if necessary. Afterwards, rinse the plate in water, dip it for several seconds in a 5% hydrochloric acid solution, then *immediately* place it in the plating solution. At 0.03 amps per square inch, about 20-to-30 minutes will be enough to face the plate. After facing, wipe the plate dry with a rag and then dry it over heat. Cover it with a film of petroleum jelly or asphaltum to prevent rust. Re-cover the plate before storing between printing runs. If it rusts, remove the facing as described below and then reface.

The plated surface should be clean and bright. If it is dull, the current was too high. The faced plate should be good for more than 1,000 impressions. If the facing wears off quickly, probably the copper was not perfectly clean.

When the plated surface wears down, reface it, but first remove the old plating in a 10% sulfuric acid solution.

Plating with chrome will provide a surface that should withstand several thousand impressions before it has to be refaced.

Collotype

History

When Alphonse Poitevin took out the patent on his carbon process in 1855 (see page 69) he also patented a technique for printing with lithographic ink from photographically prepared surfaces (British Patent No. 2815).

Poitevin coated a lithographic stone with albumen sensitized with potassium dichromate. He exposed this to light in contact under a negative, causing the albumen to harden in the areas where the light passed through. Poitevin then dampened the coating with water, wiped it surface-dry, and inked it with a greasy lithographic ink.[124] The ink took to the dry, hardened albumen representing the shadows of the image but was repelled by the water-swollen, unhardened highlights. The process could also work with colloids such as gelatin or gum arabic, and on other surfaces. Poitevin preferred albumen. He chose lithographic stone so that after the initial inking he could "etch" the stone and print with normal lithographic techniques.[125]

Poitevin used the colloid coating only to prepare the lithographic stone. The stone itself then became the actual printing surface. F. Joubert, a French engraver working in London, was the first to have practical success in printing true collotypes—that is, printing *directly* from the colloid surface. The June issue of *The Photographic Journal* for 1860 contains an example of his work. Unfortunately, Joubert turned to other photographic pursuits and never disclosed the details of his process, having been unable to find anyone willing to pay him enough to do so.

In 1865, C.M. Tessié du Motay and C.R. Maréchal coated copper plates with gelatin sensitized with potassium dichromate, then exposed the plates, dampened them, and printed directly from the gelatin, using lithographic ink. Fairly good prints were made from these plates, though the middle tones were poor and the gelatin had a tendency to strip from the copper, leaving them useless after fewer than 100 impressions.

Three years later, Joseph Albert, a Bavarian, exhibited at the Third German Photographic Ex-

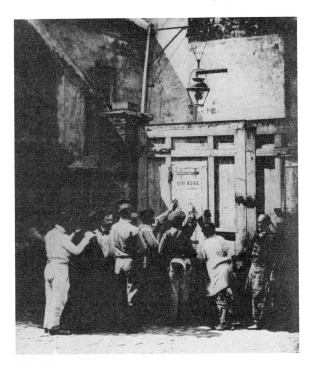

FIG. 221

CAMILLE DE SILVY, *Proclamation of the Army for Italy,* 1859. Collotype printed by F. Joubert for *The Photographic Journal,* 1860.

(Gernsheim Collection, Humanities Research Center, University of Texas at Austin)

position prints made by a gelatin process that he was not too shy to christen *Albertype*. Albert had discovered a method for coating the gelatin onto glass plates; he was able to prepare plates from which more than 2,000 prints could be run, and which had excellent middle tones.[126]

Within a few years Albert's process and the variant techniques introduced by other workers had become popular throughout Europe. In his own plant, Albert introduced the first cylinder presses for high-speed, large-edition collotype printing in 1873. A comment in the prospectus of the Albert-type (their spelling) Printing Company of Boston, which bought the New England rights to the process in 1872, suggests the extent of Albert's personal success. The Boston company asserted that "the inventor has realized during the past two years over three million Thalers, equivalent to about $2,000,000 in

gold." Each new modification of the process spawned a new commercial name. In addition to *collotype*, from the Greek *kolla*, meaning *glue*, *Albertype* or *Albert-type*, the German *lichtdruck*, and the French *phototypie*, the list came to include *artotype*, *phototint*, *heliotype*, *photogelatin*, *hydrotype*, *ink photo*, and even *autogravure*.

The Woodburytype process wins first place among photomechanical techniques for producing prints most easily mistaken for actual photographs. Second place goes to collotype. Collotype prints made on smooth paper were often given a coating of gelatin size and then varnished to make them appear to be photographic prints. But collotype printing demanded much less manpower than Woodburytype and unlike Woodburytypes, which had to be trimmed to size after printing and then mounted individually,

FIG. 222 LEONE RICCI, *La Danseuse de Corde,* 1890's. Collotype printed by W. Otto.

FIG. 223
Detail of eye from Fig. 222.

collotypes could be printed on signature-size sheets of paper for folding and binding directly into books.

Collotype and photogravure eventually replaced Woodburytypes for fine printing. Because the glass printing plates were inexpensive, collotype also became popular for many general printing jobs gravure was too expensive to handle. Collotype prints of celebrities were published, and a look at almost any collection of pre-World-War-One postcards will turn up a number of collotype prints. When H. Baden Pritchard visited Albert in his Munich printing plant in the early 1880's, he found the inventor at work printing reproductions of a "huge painting of a Munich beer-girl—a lively young person indigenous to the soil, who trips among her patrons with half-a-dozen foaming tankards in each hand."[127] In the 1930's and 1940's collotype was often used for posters in color, especially movie posters.

Collotype printing began its decline after the introduction of halftone zinc etching and rotogravure, and finally gave way to offset printing. The only American concern still doing collotype is the Trident Press in New York City.

The Collotype Look. The best way to identify a collotype is to examine it under magnification. The image has a wormlike reticulation pattern, much sharper than the grain of a gravure. Often considerable magnification is necessary before the pattern can be seen. The sharpness of the pattern gives the print an overall sharpness that is generally so distinctive that with a little experience one can identify a collotype without magnification, sometimes even while standing across the room.

New Work

The crisp, precise image quality possible with collotype appealed mostly to commercial printers. Photographers in the past never considered collotype anything but a reproduction process, while grain gravure had appealed to many as a direct medium. The use of collotype as an expressive, direct printing means for creative photography is quite recent and is really due to one person, Todd Walker, an instructor in photography at the University of Florida. In 1971 he received a grant from the National Endowment for the Arts to do research on collotype. For the last several years the process has been slowly catching on among photographers who work with photomechanical techniques. Walker's work exploits the manipulative possibilities of the collotype process and is genuinely unlike anything done in the medium before.

The Technique of Collotype

Gelatin. Collotype is based on the properties of gelatin. Gelatin is insoluble in cold water but dissolves in warm water at a temperature of about 29 °C (85 °F), depending on its type. However, gelatin will *absorb* cold water and will swell to a thick, sticky mass. When the temperature is raised the mass dissolves, and on cooling it will form a gel (if the gelatin concentration is at least 1 %). Heated a second time, the gel will redissolve, and on cooling it will again gel. Because of its easy change of state between solution and gel, gelatin is known as a *reversible colloid,* and in this respect it is superior to other colloids. In the gel state it will absorb water and swell until the osmotic forces that attract the water are balanced by the elasticity

of the gel structure. As the water evaporates, the gel will contract. Repeated melting of the gel or prolonged or excessive heating of the solution, especially if made strongly acid or alkaline, will destroy its ability to set. Do not heat gelatin solutions much above 54 °C (130 °F).

Gelatin is classified as *soft, medium,* or *hard.* The designation refers to the strength of a standard gel (made by dissolving a standard percentage of gelatin in water and allowing it to set) as measured by the force necessary to crush it. The strength is rated by a test system known as the *Bloom scale*, with harder gelatins having higher *Bloom numbers.* Soft gelatin absorbs water easily and quickly, and the gel sets and dissolves at relatively low temperatures. Hard gelatin sets and dissolves at higher temperatures; it absorbs water slowly but ultimately will absorb more water than a soft gelatin will. A soft gelatin will absorb as little as four times its weight of water; a hard gelatin, as much as ten times its weight.

How Collotype Works. In the first step of the process, a sheet of glass is coated on one side with a chemically hardened substratum of gelatin and sodium silicate. This forms a receptive base for a second layer of sensitized gelatin, from which the actual printing is done. In the past, dextrine, albumen, and even stale beer or ale were used in substratum formulas.

When the substratum has dried, the plate is coated with a layer of gelatin sensitized with ammonium dichromate and then dried in an oven for several hours at a temperature of about 52 °C (125 °F). After the plate has cooled, it is ready for exposure in contact with a negative. The exposure hardens the gelatin in proportion to the amount of light passed through the various densities of the negative. As in the carbon transfer process, this hardening, or *insolubilization,* starts on the surface of the gelatin and works down toward the substratum. In the deepest shadows the coating is hardened all, or almost all, the way through; in the middle tones part way through, and in the highlights, only superficially hardened.

A normal gelatin coating dried on a sheet of glass at room temperature will tend to swell perpendicularly to the glass if soaked in cold water. The gelatin is kept from swelling laterally (parallel to the surface of the glass) because of its adhesion to the glass. Under these conditions the gelatin can swell and contract any number of times without much permanent change to its surface. The treatment of the gelatin coating on a collotype plate, however, produces a situation that makes the surface reticulate.

Reticulation is partly caused by drying the gelatin at high temperature. At a certain point as its temperature is lowered, a gelatin solution will solidify, passing from the liquid to the gel state. This gelling point depends on the gelatin's type: It is higher for "hard" gelatin than for "soft." Suppose that, for test purposes, a gelatin coating is dried at a temperature *below* its gelling point and is then stripped from its glass support. When dampened, it will swell mostly perpendicular to its plane, even though its lateral motion is no longer limited by the glass. But if the coating is dried at a temperature *above* its gelling point and then stripped from the glass and dampened, the gelatin will swell about equally in *all* directions.

This is what happens on the collotype plate. Drying at a temperature above its gelling point increases the gelatin's tendency to swell laterally. But this lateral swelling is then restricted on the glass side by the adhesion to the hardened substratum and on the exposed side by the dichromate layer, hardened to various depths according to the light passed through the negative. When the plate is soaked in water after the exposure, the gelatin will swell and immediately begin to buckle under the varying constraint of the dichromate's hardening and the uniform constraint of the substratum, and will form a wormlike pattern of reticulation. The hardened gelatin becomes concentrated along the reticulation lines (or valleys, as they appear in cross-section—see Figure 224), while the soluble gelatin swells into the bumps in between.

For printing, the plate is dampened, surface-dried, and then inked. The ink takes to the hardened reticulation valleys but not to the water-swollen bumps. When you examine a collotype print under magnification, you see that the ink lines deposited on the print from the reticulation

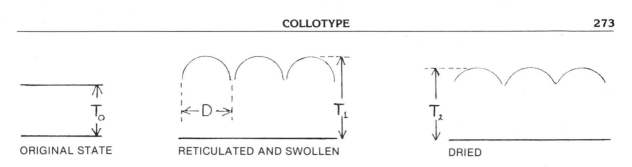

ORIGINAL STATE RETICULATED AND SWOLLEN DRIED

FIG. 224 Cross section of reticulated gelatin *(The British Journal of Photography,* August 12, 1949, p. 372).

lines are narrow in the highlights and become wider toward the shadows. This is what gives a collotype print the appearance of continuous tone. (Figure 223). Careful handling of the inks and rollers during printing is necessary, however, to bring out the tonal scale. It is not automatic.

Equipment and Materials

The most useful sorts of paper, inks, and printing presses are described later under *Printing.* First, some preliminaries.

Drying Oven. An oven is necessary for drying collotype plates. It can take any convenient form as long as it is light-tight, ventilated, maintains a constant temperature, and can support the glass plates in a perfectly level position while they dry.

In the 19th century drying ovens were complicated arrangements of gas pipes and water pipes, with sandpits to hold the heat and an apprentice to stand by to keep track of the temperature. Electric thermostats and heaters have made things much easier. The thermostat must hold the temperature inside the oven at close to 52 °C (125 °F). Thermostats made for chicken brooders are adequate and relatively inexpensive. They can be purchased through feed stores, but —since the urban chicken population is not what it once was—in most cities they are now hard to find. The Sears, Roebuck & Co. *Suburban Farm and Ranch Catalog* lists, under "Poultry," an inexpensive thermostat (32 HF 88022) that might be suitable for collotype. Honeywell, Inc., makes a more expensive thermostat that is excellent for collotype: Its catalog number is T-631C. Look in

the *Yellow Pages* under "Thermostats" for a supplier.

The heat source itself can be either electrical heating tape, the light-socket type of screw-in heating coils, or a hot plate. Most hardware stores carry the kind of heating tape designed for heating gutters and pipes. Use tape rated for 300 watts and *follow the safety directions* supplied. Most hardware stores also carry screw-in heating coils, as well as porcelain light sockets to hold them. Two heating-coil elements wired in parallel will provide plenty of heat. Hardware or electrical appliance stores also carry insulated wire safe for use at high temperatures. Be sure to use wire of this type for *all* electrical connections inside the oven. Figure 225 shows the wiring diagram for the thermostat and heating elements.

Figure 226 shows a drying oven. It is usually made of plywood. Its dimensions will depend on the number of plates to be dried at one time. A small oven capable of holding four 20x25cm (8x10 in.) plates might be 61cm (2 ft) wide, 61cm (2 ft) high, by 76cm (2½ ft) long. If you cannot build the oven yourself, you can usually find a wooden box to adapt by looking in the *Yellow Pages* under "Boxes."

The cover of the oven is a simple frame with six or more layers of lintless black cloth stretched over it. The cloth keeps the oven light-tight but allows moisture to escape. If it is more convenient, the top can be solid plywood, ventilated with several holes (each about 10cm [4 in.] square) and made light-tight with black cloth. If the oven has a solid top, water may sometimes condense on the underside and drip back down onto the

plates. Control this by slanting the top or by tacking absorbent lintless material to its inner side.

Attach two strips of wood on opposite sides down the length of the oven. Put them in at the same height, about two-thirds of the way up. These strips will support aluminum crossbars (available at most hardware stores), which run across the width of the oven. The bars hold the glass plates while they dry. Drill the crossbars at intervals and insert leveling screws. If you cannot manage to have the holes threaded for screws, glue nuts over the holes and then screw bolts in from below.

Give the oven a test run for light-tightness: Place it in a darkened room and put a light inside. Wherever light shows through, patch with opaque tape.

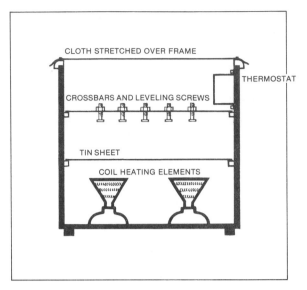

FIG. 226
Suggested design of collotype oven.

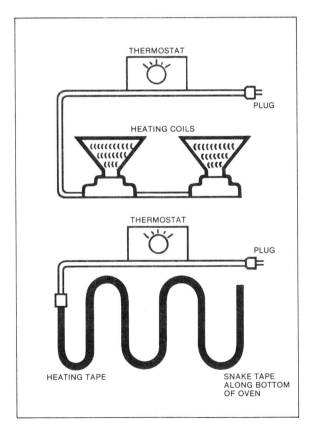

FIG. 225
Wiring for collotype oven.

Attach the thermostat to the inside of the oven with its temperature coil at the *same height* as the glass plates.

If you use heating *tape,* snake it along the bottom of the box, spread for even temperature throughout. Support it an inch or so above the bottom with insulating material. If you use heating *coils,* fit a tin sheet across the interior of the oven, about a third of the way up from the bottom, to make sure of even heat distribution.

Gelatin for Collotype. The best gelatin for collotype is medium hard—a Bloom number of about 175. Harder gelatins are difficult to ink. Softer gelatins ink more easily but tend to form coarse reticulations and will not stand up to repeated printings. The J.T. Baker Chemical Company of Phillipsburg, New Jersey, manufactures a gelatin with the correct Bloom for collotype. It is Gelatin 2124, U.S.P. Powder, Type A, Bloom 170–180, and is available from most chemical supply houses.

Glass for Collotype. Because the glass can break under pressure during printing, plate glass about a quarter-inch (6mm) thick is safest for collotype, but with care thinner glass, down to

eighth-inch (3mm), can also be used. Clean the glass with ammonia. Rinse it thoroughly with hot water. The plate is clean when the water flows off in an even sheet, without leaving droplets behind. To prevent spots, rinse it again with a wetting agent like Photo-Flo or with distilled water. Stand the glass on edge to air-dry or dry it in the oven. Any grease left on the plate can keep the substratum from sticking.

Grinding. Most of the traditional instructions for collotype say the glass should be ground to a matte surface with emery powder to help the gelatin coating adhere. This was essential with long commercial printing runs, especially on power presses; but it is not usually necessary when the plate is to be used for small editions printed by hand. The gelatin should adhere through several hundred impressions to properly prepared plain glass. If necessary, though, grinding can be done as follows: Spread a liberal amount of 220-grit

FIG. 227
TODD WALKER, early collotype from a 1966 negative. Print made by hand, without a press.

Carborundum over the glass, pour on a little water and then rub up the powder until it is *thoroughly* wet (the glass will be scratched if any powder remains dry). Place another sheet of glass on top of the first and then grind them both together with a figure-eight motion, first with light and then with increasing pressure. A suction cup is a great help as a handle for the top sheet. After grinding with 220-grit, rinse the plate and switch to 180-grit Carborundum. Give the glass a final rinse under running water and scrub the powder off with a brush.

Preparing the Plate

The substratum consists of gelatin (hardened with alum) and sodium silicate.

SUBSTRATUM

Distilled water at about
 21°C (70°F) *100 ml*
Gelatin *1 gram*
Allow the gelatin to swell for 10 minutes, then add
Distilled water 52°C (125°F) *380 ml*
Potassium alum *1 gram*
Then add
Sodium silicate *20 ml*
Filter the warm solution with fast filter paper or coffee filter paper or, even better, with a filter pump.

Dust off the glass plates and set them on a level surface, or level them in the drying oven by using the adjusting screws (three to a plate) and a carpenter's spirit level. Pour the warm substratum solution over the plates and spread it either by tilting the plates or by guiding it across the surface with a brush or a glass rod. You can dry the plates with low heat in the oven, or simply air-dry them at room temperature. Protect the wet surface from dust and do not touch it with your fingers. The plates will keep until ready for use. The substratum solution will stay good for several weeks, after which it becomes cloudy and must be thrown out. Use the solution warm each time.

FILTER PUMP

Solutions containing any significant percentage of gelatin are difficult to filter. They must be kept warm while filtering, but this is not easy to do because the gelatin solution passes through filter material very slowly. The easiest way to filter gelatin solutions is to use a filter flask and a Chapman filter pump, available from most suppliers of chemical glassware. This equipment, illustrated in Figure 228, uses atmospheric pressure to force the solution through the filter. It is not expensive and it is a good investment and a time-saver for all kinds of photographic filtering, especially of colloidal solutions.

FIG. 228
Filter flasks and Chapman filter pump. The metal flange screws onto a water faucet. A vacuum forms inside the flask when the water is turned on.

Sensitizing. When the substratum is dry the plate is ready for the sensitive gelatin coating. Do not attempt to rush the drying—in fact, the substratum will improve after a few days' storage. Since dichromated gelatin solutions do not have good keeping qualities, prepare only enough sensitizer to coat the plates you will use right away. Use metal containers for easier temperature control.

SENSITIVE COATING

Distilled water at about
21°C (70°F) 100 ml
175-Bloom gelatin 6 grams

Allow the gelatin to swell for at least 10 minutes. Meanwhile, prepare

Ammonium dichromate 1 gram
Distilled water 25 ml

When the gelatin has swollen, place its container in a larger container holding water hot enough to bring the gelatin up to 49°C (120°F). Add the dichromate and filter the solution. If you do not have a filter pump, filter just a small amount of the solution at a time. Keep both the filtered and the unfiltered portions warm in water bath.

While the gelatin is warming up, dust off the plate prepared with substratum and level it in the drying oven. Set the thermostat to 52°C (125°F). Leave the oven's top open slightly so that the plates will not sweat as they warm up. Pre-warming the plate keeps the gelatin fluid and makes coating easier.

Pour the warmed, filtered, sensitized gelatin over the substratum, leading it across the surface with a rod or the edge of a sheet of paper or tilting the plate to direct the flow. You may find to your chagrin that it takes practice to get the gelatin coating even and completely free of bubbles.

With the formula given above, the plate should be coated with 1 ml of solution for every 5 square centimeters (2 in.2) of surface. If the coating is too thick it will dry to a coarse grain and a wavy surface. If it is too thin the reticulations may be so fine that the plate will be difficult to print—although in the hands of an experienced printer beautiful results are possible from finely reticulated plates.

Dry the plate in the oven for 3 hours, then let it cool gradually, still in the oven with the top closed. The oven must not be moved or even subjected to vibrations. It takes just a slight motion to cause the gelatin to dry to an uneven surface.

A sensitized plate should keep for several days if protected from light and stored under cool and dry conditions. Place the coated surfaces face to face or in contact with sheets of glass to protect them from moisture. Be careful not to scratch the sensitive coating or to touch it with your fingers.

Exposing

Collotype plates print best with negatives that are normal to slightly soft. A long density range is not necessary. The final image will be reversed in terms of the original scene unless the plate is exposed with the *base* side of the negative in contact with the gelatin coating. If you want a white border around the print, mask the negative with lithographic tape.

Use a hinged-back contact-print frame or vacuum frame. Often the standard wooden frames will not take the additional thickness of the collotype plate but they can be modified with a little ingenuity.

Expose to an ultraviolet source until a brown printing-out image with slight detail shows in the highlights. You can judge the progress of printing more easily if you hinge the negative along one side of the plate with tape. Then you can lift the

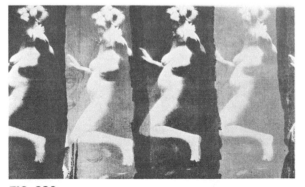

FIG. 229
TODD WALKER, collotype.

FIG. 230
TODD WALKER, collotype.

negative (after removing the entire combination from the contact frame) without worrying about registration.

An exposure with a 15-amp single carbon arc light 76cm (2½ ft) from the printing frame may take about 15 minutes. The exposure does not have to be precisely timed. Printable plates will result from a fair range of exposures, but a uniform exposure practice allows standardization of, and greater control over, the actual inking and printing of the plate later on. If the exposure is too short the plate will take up too little ink, resulting in loss of highlight detail and the premature breaking up of the gelatin image. If the exposure is too long, the plate will take up too much ink.

The percentage of dichromate in the sensitizing formula is relatively low, and so collotype plates are less sensitive than other dichromate printing materials such as gum, carbon, or oil. Even so, after exposure and until the plates are washed, handle them in tungsten light, away from daylight or ultraviolet light sources.

Washing. Wash the plate in running water at about 15.5 °C (60 °F). The plate immediately loses its sensitivity as the free dichromate washes out. The temperature of the wash will influence the size of the reticulation pattern, warmer water producing a more pronounced grain. Wash until the dichromate stain is completely gone and the printing-out image has disappeared except for a faint trace in the deepest shadows.

After washing, gently blot the excess water from the surface and set the plate on edge to dry. You can hurry the drying by placing a fan in front of the plate, but *do not use heat.* Drying strengthens the gelatin coating and must be completed before the plate is dampened and printed.

Printing

Paper. Smooth papers are best for collotype. A hot-pressed or a coated paper will pick up all or most of the ink from the plate after an impression, while textured papers leave some ink behind. Any smooth-surfaced paper used for offset printing, such as Warren's Cameo Dull, will print well with collotype.

Presses. A special press is not necessary for collotype work. You can use a typographic proofing press or a lithographic press. On an experimental basis, you can make do with a sturdy flat surface, a rubber roller, and your own muscles.

In all cases it is important to give the plate a uniform support with no dirt or grit underneath that could cause the glass to crack when pressure is applied. You can fix the plate firmly to the bed of a press with plaster of Paris or set it down on several sheets of blotting paper, dampened so that the plate will not slip.

The scraper on a lithographic press tends to wear down the gelatin; so adjust it carefully to the minimum pressure necessary.

Dampening the Plates for Printing. If you examine the collotype plate at this stage under about 8x magnification, you will see the reticulation pattern. The coating now consists of hardened gelatin along the reticulation lines and unhardened gelatin in the little bubbles in between. The hardened gelatin will not absorb water (except for a very small amount) and, by remaining dry, will accept a greasy lithographic ink. The unhardened gelatin will absorb water and repel the ink. The plate is dampened with a solution of glycerin and water.

Put the plate on a level surface and then cover it with

Glycerin . *3 parts*
Water at 20°C (68°F) *2 parts*

Be sure to mix the glycerin and water together thoroughly.

Add a drop or two of phosphoric acid to each 500 ml of the dampening solution: This increases the water absorption of the gelatin slightly and tends to keep the highlights from scumming over with ink.

Dampening takes anywhere from 5 minutes to 30 minutes, depending on the exposure of the plate and on the proportion of glycerin to water in the dampening solution, and also, on the humidity in the room in which the plate was stored. Adding a larger proportion of glycerin will result in less swelling and an increased tendency for the plate to accept ink. Decreasing the glycerin has the opposite effect, letting the plate absorb more water and so tend to reject ink.

When the plate is ready for printing, gently wipe off the dampening solution with a sponge and then blot the plate with several sheets of newsprint to remove the surface moisture.

Inking the Plate. Use a stiff lithographic printing ink. With a palette knife, spread a line of ink along one edge of an inking slab (a sheet of plate glass will do), using only as much ink as is necessary for a smooth, thin deposit. Shave off the excess ink and return it to the can. Press a brayer or a lithographic roller (a leather lithographic roller is best) onto the ink and then roll the ink out across the slab. At first the slab will be covered by a series of parallel lines. After each pass, give the roller a twist to set a new portion of its surface back down on the ink. Continue rolling until the slab is covered with a smooth, even deposit, and the roller is evenly charged (see Figure 231).

Place the collotype plate on a sheet of white paper (this makes it easier to judge inking) on a firm, smooth surface. Make sure the support and the bottom of the glass are both smooth and clean. Any irregularities can break the glass under the pressure of printing.

Roll the ink onto the collotype plate with a steady, even motion. *Slow rolling with firm pressure builds up the ink deposit and decreases contrast. Fast rolling with light pressure removes ink from the plate, clears up the highlights, and improves separation in the shadows.* See Figures 174-176 in the chapter on Oil and Bromoil. If the plate has been properly dampened it will take ink slowly at first but begin to fill out after several passes.

If you do not have a press, strike a proof by laying a sheet of paper over the plate, placing a cover sheet on top, and pressing them into contact with a hard-rubber roller and firm pressure.

It will take several inkings and printings before the quality of the plate can be known. At first the plate will take ink up all over; but with faster, lighter rolling the highlights should clear and the shadow tones begin to deepen and separate. Most of the ink should transfer to the paper. If the highlights remain muddied, blot off the ink with newsprint and re-swell the gelatin with the

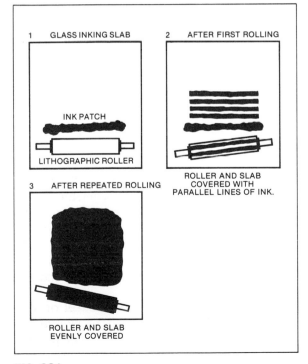

FIG. 231
Charging the inking roller.

FIG. 232
TODD WALKER, collotype.

glycerin-and-water solution. Sponge this off after a few minutes and ink the plate again. If the highlights persist in remaining muddied, either the plate was overexposed or the ink is too thin.

Normally, once the plate is printing properly it will not need redampening after each printing. Redampen it only when the highlights begin to block up with ink.

After printing, use benzine (naphtha) or gasoline to remove the ink from the plate. Blot the plate with plain newsprint.

Controls

There are many different ways to ink a collotype plate, and most of the control the printer has over the final image comes in at the inking stage. Each combination of gelatin, rollers, ink, and paper requires its own special treatment. The range of effects possible with collotype is amazing. A fine-grained, carefully inked collotype made on a coated paper can look remarkably like a photographic print. The sharpness of the reticulation pattern can give collotype a remarkable crispness. It is also possible to go in the opposite direction and make obviously manipulated prints that call attention to the printmaking process itself.

The stiffer the ink, the more it will be repelled by the water-swollen highlights on the plate. The result is apt to be a contrasty print if only a stiff ink

is used. Inks can be thinned slightly with lithographic varnish to take more easily to the highlights and give lower-contrast results.

Magnesium carbonate powder mixed into the ink (with a palette knife) will stiffen it and increase printing contrast. Oleic acid will make the ink more fluid, but also more greasy, and consequently will increase contrast.

To print the full tonal scale of the plate, it may be necessary to apply a stiff ink first, for shadow depth and contrast, and then go over the plate again with another roller with a thinner ink for highlight detail. You can achieve a two-toned effect in this way from a single printing by using two different colors of ink, thinned to different consistencies. Apply the stiff ink first; otherwise, the stiff ink will pull the thin ink off the plate.

Usually you can increase the printing contrast of the plate by *not* removing the ink before reapplying the dampening solution. With the shadows protected by the ink, the dampening solution will affect only the lighter tones. The plate can be dampened locally with a brush to lighten specific areas of the print.

Other Photomechanical Process

Here are brief descriptions of three historically important processes.

This process was invented by Paul Pretsch, who had been manager of the Austrian Imperial Government Printing Office in Vienna before moving to England in 1854. On November 9 of that year he took out a British patent (No. 2373) on photogalvanography.

Pretsch first coated a sheet of glass with gelatin containing dichromate (the coating also included silver nitrate and potassium iodide, which encouraged reticulation). When the coating was dry he printed it in contact with a transparent positive, then washed it in cool water. This treatment caused the gelatin to swell and reticulate. Figure 233 shows what probably happened. Looked at in enlarged cross section, the reticulated gelatin had the appearance of a landscape of hills and valleys. The valleys were wider apart in the shadows than in the highlights, the hills higher in the shadows than in the highlights.

The next step was to make a mold of the reticulated gelatin in gutta-percha, a resinous latex substance that could be made to conform to the hills and valleys. Pretsch then removed the mold and coated it with an electrically conductive material, which allowed him to electroplate a layer of copper over its hills and valleys. The copper was then separated from the gutta-percha, leaving Pretsch with a copper plate that duplicated the original reticulated gelatin. Pretsch called this the *matrix.* Finally, he made an electroplate over the matrix, separated the two, and was left with an intaglio printing plate that could be inked and printed like any etching. The sunken reticulation pattern had wider and deeper lines in the shadows than in the highlights: This produced the tonal scale.

The process was even more time-consuming than it sounds. Because the available methods of electroplating were quite slow, it took about six weeks to make a plate, and it was usually necessary to do a good deal of handwork on the plate afterwards. Pretsch pointed out, however, that six weeks was not very long compared to the year or more required to complete large steel engravings of the sort then being used to reproduce popular paintings. The real drawback was that the coarse reticulation and frequent handwork made many of the prints—especially early ones—look distinctly unphotographic.

Early in 1856, Pretsch formed the Photo-Galvano-Graphic Company, and in November published the first issue of *Photographic Art Treasures.* It contained four photogalvanographic

FIG. 233

Hypothetical cross section of the reticulation in photogalvanography.

FIG. 234
PAUL PRETSCH, detail of photogalvanographic reproduction of *Richmond on Thames,* by R.F. Barnes. *Photographic Art Treasures,* June 1857.
(Smithsonian Institution, Washington)

prints of work by Roger Fenton, who had taken a job as a manager of Pretsch's photographic department. The company was not a success and closed down in 1858. Pretsch could not even afford to renew the patent when its term expired in 1860. He returned to Vienna in 1863, a sick man, considerably the worse for wear.

Gravure Heliographique

Charles Nègre, whose work was mentioned in the earlier portion of this book, was not only an excellent painter and photographer but also an important experimenter in photomechanical techniques. Nègre's heliographic process was based on one worked out by Abel Niépce de St. Victor (inventor of albumen negatives), which was in turn derived from the seminal experiments of his cousin Nicéphore Niépce, Daguerre's original partner. Niépce de St. Victor coated steel plates with bitumen of Judea, which hardened on exposure to light under a positive. He dissolved out the unhardened bitumen in the unexposed shadow areas and then etched the plate in nitric acid. The remaining, hardened, bitumen acted as a resist to keep the highlights from etching. The trouble with the process was that it could not produce much in the way of middle tones.

The available accounts of Nègre's procedure are somewhat vague and contradictory, but it appears that his principal method was as follows:

Nègre first coated a steel plate with bitumen or, alternatively, with dichromated gelatin. He exposed this beneath a negative (some accounts say a positive, but this seems incorrect) and afterward dissolved out the unexposed portions of the coating. Then he connected the plate to the negative pole of a battery and electroplated a layer of gold over its surface. The highlights were more or less completely covered with the gold plating, the middle tones partly so, and the shadows least of all. Nègre then covered the plate with a rosin grain and etched it in nitric acid. The gold acted as a resist. Presumably, the resulting etched pockets were deeper and wider in the shadows than in the highlights. Nègre took out a French patent (No. 28802) on the process in 1856.

The process was tricky and the plates often failed to achieve proper middle tones. Yet the successful ones were remarkable for their time—and much better than Talbot's photoglyphic engravings. During the 1850's Nègre produced a number of large heliogravures of French cathedrals.

Along with Paul Pretsch and Alphonse Poitevin, Nègre was one of the finalists in the competition sponsored by the Duc de Luynes in 1856 for the best method of photomechanical printing.(At the same time, the Duc announced a competition for the best method for making permanent pigment-based photographic prints—see page 70.) The prize for photomechanical work was not awarded until 1867. Poitevin won it for his method of

FIG. 235
CHARLES NEGRE, *Reproduction from Nature.* Test plate for the Duc de Luynes competition, 1860's.
(National Gallery of Canada, Ottawa)

photolithography (See the introduction to the chapter on collotype). Nègre's method gave a better image, but he lost because his process was too difficult for practical commercial use.

Goupil Gravure

Walter B. Woodbury, the inventor of the Woodburytype, asserted that the Goupil process was based on a suggestion made by him to the French printing and publishing house of Goupil & Cie. around 1870.[128] Woodbury was miffed at the company's unwillingness to acknowledge this, but perhaps there was no reason they should have. According to Donald Cameron-Swan, the technique was based on his father's patent of 1865 (British Patent No. 1791).[129] Swan's father was Joseph Wilson Swan, inventor of the carbon process. It is impossible to resolve the issue because Goupil, realizing it had a good thing, never thought it prudent to broadcast the details.

In any case, it is known that the printing plates were made by electrotyping from gelatin reliefs, the relief probably produced by carbon transfer. The electrotype cast was the reverse of the gelatin relief, the shadows deeper than the highlights. The grain necessary for intaglio printing was created either by Woodbury's method of adding certain pigments (containing chromates?), which caused the gelatin to "granulate," or by Joseph Swan's method of dusting the negative with opaque particles before printing the carbon tissue.

The lack of technical details on the Goupil process is upsetting because the method was so exquisitely good. The overall excellence of a Goupil gravure—the density of black, the separation of tones, and the clear, crisp quality of the image—was never surpassed by any other gravure method. Part of this can be attributed to the careful handwork done on the plates to deepen lines and tones and correct defects; yet the praise is deserved, nonetheless.

Goupil and its successor, Boussod, Valadon, & Cie., used the process extensively for art reproduction, less frequently for printing original photographs.

Fig. 236
Goupil gravure, detail of Plate 44 from *Voyage dans La Haute Egypte,* Paris, 1878.

Woodburytype

Specific working details for the Woodburytype process will not be given in this book, but the process deserves special mention because of its historical importance and because Woodburytype prints are remarkably beautiful.

Its inventor was Walter B. Woodbury (not to be confused with Walter E. Woodbury, author of *The Encyclopedia of Photography* and *Photographic Amusements*). Woodbury was born in Manchester, England, in 1834. At the age of 18 he left home to try his luck in the gold fields of Australia. He did not strike it rich, but after trying various sorts of work became a professional photographer. In 1859 he moved to Java, where he photographed extensively despite the difficult tropical conditions and made a series of stereoscopic views that were published in Great Britain by Negretti and Zambra. Woodbury returned to Manchester with his Javanese wife in 1863.

In 1864—the same year Swan patented his carbon process—Woodbury patented a method for printing from intaglio molds (British Patent No. 2338).

Woodbury first flowed a solution of collodion over a clean sheet of glass. After the collodion dried Woodbury poured over it a solution of warm gelatin, sensitized with potassium or ammonium dichromate. He laid the glass level until the gelatin dried. Next he stripped the collodion/gelatin film from the glass and exposed it with the collodion side in contact with a negative. Since exposure was through the collodion base, the hardening of the gelatin began at the base and proceeded out to the surface (see Figure 147). Woodbury developed the image by dissolving the unexposed, soluble, gelatin in warm or hot water. The result, when dry, was a relief image in tough, insoluble gelatin, thick in the shadows (about .13mm—or .005 inch) and progressively thinner in the middle tones and the highlights—in other words, the thickness of the gelatin corresponded to the tones of the original scene.

To make the printing mold, Woodbury placed the gelatin relief in a hydraulic press. The press

FIG. 237
JOHN THOMPSON, *The London Boardman.* Woodburytype from *Street Life in London,* 1877.

forced the relief into a lead plate with a pressure of nearly five tons per square inch.[130] This caused the soft lead to become indented by the contours of the gelatin, forming an intaglio mold. One gelatin relief could be used to make as many as six molds.

Woodbury transferred the lead intaglio mold to the bed of a specially designed hand press for printing. He greased the mold lightly and poured into the center a small amount of warm, pigmented gelatin solution. He then laid a sheet of paper over the mold and brought the top of the press down on the paper. This forced the gelatin into the contours of the mold and the excess gelatin out along the sides. After allowing the gelatin about a minute to cool and set, Woodbury opened the press and pulled out the paper, which now carried the gelatin image. In effect, the image had been cast on the surface of the paper. He then soaked the print in an alum solution to harden the gelatin and finally trimmed off the dirty edges and mounted it.

An especially smooth paper was necessary for the process. It was first varnished with shellac, then coated with a solution of gelatin and gum benzine, and finally pressed smooth between the rollers of a calendering press.

The Woodburytype Look. Since the Woodburytype print does not have grain or halftone dots, it looks much like a regular silver photograph. In certain ways it looks better.

FIG. 238
Hydraulic press for making Woodburytype molds.
(International Museum of Photography/George Eastman House)

FIG. 239
Woodburytype press with mold in place.
(International Museum of Photography/George Eastman House)

There are several reasons for the surprising quality of a Woodburytype print. The first is the straight-line characteristic curve exhibited by dichromated gelatin. This allows a remarkably exact transformation of the tonal scale of the negative into an equivalent relief image in the printing mold. Another reason is the transparent nature of the pigmented gelatin. Because of this transparency, one does not so much look *at* the shadows of the print as *into* them, and this gives them an almost liquid quality. The gloss on the surface of the print is in direct proportion to the density of the image (that is, unless the print received an overall coat of varnish or gelatin afterward, as was sometimes done). This gives the highlights the softness characteristic of matte papers, while the shadows have the contrast and separation that come only from a glossy surface.

Once you have seen a few Woodburytypes you will find it easy to tell them apart from silver prints, but distinguishing between a Woodburytype and a carbon print is more difficult. In both, the image consists of the same material: pigmented gelatin. Here are some clues: Woodburytypes were usually preferred for illustration work involving large print runs, and in most cases the process is named, either below the print or on the title page,

if in a book. Often you can see an actual relief on a Woodburytype, especially on early ones, if you hold the print at an angle against the light and look closely at the edges where shadows and lighter tones meet. This relief is rare in carbon transfer prints, although it does occur. Woodburytypes also tend to have a slight blurring of the image in the lighter areas—blurring that is obviously not the result of an aberration in the lens used to make the negative. Because of the pressure required to make the lead mold, the practical limit on the size of a Woodburytype print was about 7x9 inches; if the print in question is larger than this it is probably carbon. The Woodbury Permanent Printing Company did have a press for making 14x10-inch molds, but it required a pressure of 500 tons and may have been the only one of its kind.

Woodburytype Printers

Woodbury sold the French patent rights to his process to Goupil in 1867.[131] They used the process with great success to print art reproductions and portraits for the thirteen-volume *Galerie Contemporaine,* a series published in Paris between 1876 and 1885. The French name for the process was *photoglyptie.* The British rights went to Disdéri & Co., but in 1869, when Disdéri failed to pay the fee, the rights reverted to Woodbury and his newly formed Photo Relief Printing Company. This was taken over in turn by the Woodbury Permanent Photographic Printing Company in 1878. Meanwhile, John Carbutt had bought the American rights in 1870 and started a printing plant in Philadelphia.

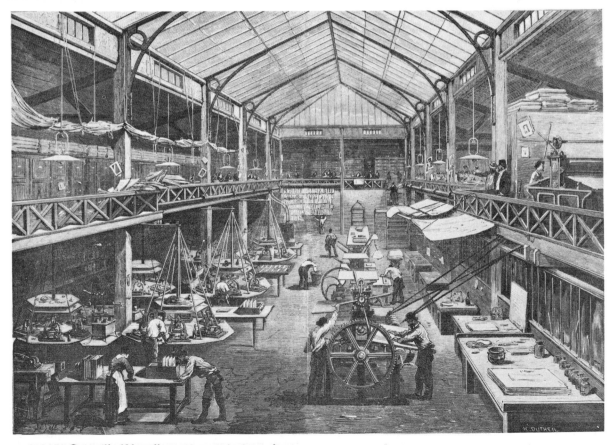

FIG. 240 Goupil's Woodburytype printing plant.
(International Museum of Photography/George Eastman House)

Technical Problems

The Woodburytype process had several practical drawbacks that finally caused it to give way in the 1890's to more efficient, if less beautiful, methods of printing. One problem was that each print was made on a hand-operated press, and so considerable manpower was needed to put out an edition. H. Baden Pritchard visited the Woodbury Permanent Photographic Printing Company one day in the early 1880's when the staff was busy printing an edition of portraits of Miss Genevieve Ward, an actress, in costume for her role in *Forget-Me-Not*.

FIG. 242
Collotype printed by Obernetter, also from *Traité Général de Photographie.*

FIG. 241
Woodburytype printed by Goupil, from Désiré van Monckhoven's *Traité Général de Photographie,* 1899.

He reported that 30,000 portraits were printed that day—but to do it took eight printers, each working seven presses (arranged on revolving tables for convenience), with four printing molds in each press.[132]

Another problem was the impossibility of making prints with clean white borders because of the excess pigmented gelatin forced out along the sides of the mold during printing. Consequently, each print had to be trimmed and then mounted, which called for still more labor and time.

FIG. 243
Magnified detail of Fig. 241. The white dots are highlights reflected from the surface of the gelatin.

Modifications

Considerable capital was needed to set up a Woodburytype printing plant equipped with the necessary hydraulic presses. Woodbury hoped his *stannotype* process (Latin *stannum,* meaning *tin*) would solve the problem. In the stannotype process the gelatin relief was made from a positive transparency, producing a reversed relief with the highlights higher than the shadows. The relief, backed by a sheet of glass, was sent through a mangle press in contact with a thin sheet of tinfoil. This forced the foil to conform to the shape of the relief, forming on the exposed side of the foil a mold that could be used for printing in the regular way. The stannotype process, however, never achieved commercial success.

Woodbury-gravure was another modification, introduced in 1891, after Woodbury had died. Instead of being mounted in the regular way, the Woodbury-gravure was trimmed, then its gelatin side was pressed onto the page and its original backing paper stripped off. This process of transfer mounting, in spite of its name, had nothing in common with actual photogravure.

In the years after his return to England, Woodbury took out twenty patents on a variety of inventions, including optical lanterns, techniques for printing from intaglio molds, stereoscopes, kaleidoscopes, barometers, hygrometers, equipment for ballon photography, musical railway signals, and more. In his time he was one of the best known and most respected photographic inventors. Even so, he never made a fortune from his inventions, and what he did make was soon invested in new projects. He was bankrupt when he died, from an overdose of laudanum, in 1885.

FIG. 244
Magnified detail of Fig. 242.

Part III

Conservation and Restoration

Mounting and storage of any image on paper come under the category of *conservation*. The materials and methods used should protect the artwork against chemical contamination and against physical damage. The science of photographic conservation has received much overdue attention in the last several decades. Even so, it is still an imperfect science, and its procedures have to be revised constantly as new information comes to light. The basic principles, however, are firmly set. They include proper fixing and washing of the image, the use of acid-free papers and adhesives, control of humidity and temperature in the storage and display areas, and protection against atmospheric pollution and ultraviolet radiation.

Mounting

The best way to mount a print is behind an over-mat, as shown in Figure 245. Attach the print to the mount with tabs, or use folded corners, as explained below. This way, the print can be removed easily if some form of treatment is needed in the future or if the mount gets damaged or turns out to contain harmful substances. Use only acid-free boards and tape. (Sources of supply for mounting materials are listed at the end of this chapter.)

Hinges. Hinge the overmat and the mounting board together on the long side with gummed Holland Tape, a sulfur-free linen library tape. You can also use hinges made from Japanese paper or Permalife paper (both are acid-free), glued with the wheat-starch Primary Paste given below or with a synthetic polyvinyl acetate adhesive emulsion such as Jade No. 403. *Do not use* masking tape, brown wrapping tape, regular transparent

tape, or synthetic adhesives (other than polyvinyl acetate) for hinging the boards together. Never use them—not even polyvinyl acetate—in direct contact with the print.

Tabs. Attach the print as illustrated, using tabs of Permalife (made by the Hollinger Corporation) or Japanese paper glued with wheat-starch Primary Paste. It is considered permissible to use

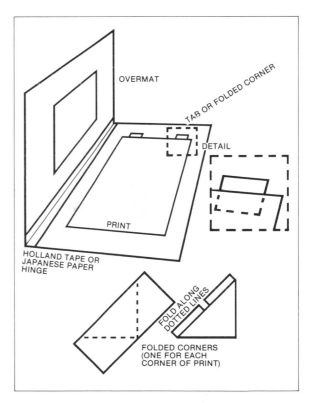

FIG. 245
Recommended mounting system for prints.

tabs made of Holland Tape or Scotch Magic Tape instead of paper. Their adhesives are chemically safe—but damage can result if the tapes are removed.

Corners. Folded corners, as illustrated, are an alternative to tabs. Make them from acid-free paper; tape or paste them to the mount board. The corners should give full support but be loose enough around the edges to allow the print to expand when an increase in humidity makes its cellulose fibers swell; otherwise, the print will buckle.

Adhesives. Many of the standard adhesives contain sulfur, which can oxidize to sulfuric acid and cause discoloration and embrittlement of paper. They might also contain other unstable and potentially harmful additives. Many adhesives tend to be particularly hygroscopic, collecting moisture that can accelerate chemical decompositon or encourage the growth of mold.

The following is called *Primary Paste* by conservators. It is safe for use in direct contact with works of art. The basic formula has been used for generations. It is not acidic, and its long-term effects are known. Its drawbacks are that it has limited shelf-life and that it takes time to prepare.

PRIMARY PASTE

Distilled water *150 ml*
Wheat starch *30 grams*
Thymol (saturated solution) *10 drops*

Put the 150 ml of water in the upper part of a double boiler and soak the starch in it *without heat* for about 30 minutes, stirring at intervals. Then bring water in the lower part of the double boiler to *slow* boil and cook the starch over this for about 20 minutes with more-or-less-constant stirring. The starch will become stiff at first and then more fluid as the cooking nears completion. Add the thymol and pour the paste into a jar that has first been disinfected by swabbing on the inside, including the lid, with the thymol solution. Allow the paste to cool before sealing the lid on the jar. This stock paste will keep for about a week in the refrigerator.

CAUTION: *The thymol is a poison and should be handled with care.*

To use, dilute the paste as necessary with a combination of distilled water and magnesium bicarbonate water (prepared according to the instructions given below under *Neutralization and Buffering*). This should produce a slight alkaline reaction (pH 7.5–8.0) when tested with pH paper. If a large amount of paste is needed it can be mixed easily in an electric blender. The combined paste will keep about 12 hours, then starts to become watery.

Framing. Metal frames are best. Wooden frames should be thoroughly sealed with a coat of acrylic as a barrier against volatilization of substances harmful to prints.

The print should never touch the covering glass or Plexiglas: When the ambient temperature drops, condensation can form on the inside surface of the glass; if this touches the print it can speed up chemical activity and mold growth. Plexiglas is more easily scratched than glass and more prone to attract dust electrostatically, but it is a better thermal barrier and makes condensation less likely. Plexiglas is available with additives that do not affect its color or transparency but that filter out near-ultraviolet radiation more effectively than glass does. This is especially important with pigment processes if the pigment is likely to fade in ultraviolet light.

The effect of ultraviolet radiation on photographs is not fully understood. It would be a safe policy to limit this form of exposure if possible, except in the restoration technique given below. Certain modern resin-coated papers appear to be particularly sensitive to ultraviolet radiation. It weakens the surface of the print, making it easier to scratch and abrade. The often objectionable blueish cast of many resin-coated papers is caused by a brightener activated by ultraviolet radiation. Placing the image behind glass or Plexiglas will absorb the radiation before it reaches the print and eliminate the blueish cast.

Figure 246 shows a suggested arrangement for framing a print.

Storage. Store prints in boxes made from acid-free paper or in metal boxes (stainless steel, anodized aluminum, steel with nonplasticized baked-on synthetic resin lacquer). Do not use

wooden boxes constructed with bleached or resinous wood unless the boxes are specifically designed for archival storage. Bleached wood can release peroxides harmful to prints. To prevent mold growth, store prints at temperatures lower than 21 °C (70 °F) at a relative humidity of 40% to 55%.

Never use glassine paper as a cover sheet for prints in storage. Glassine is acidic and contains harmful volatile additives. Instead, use acid-free paper or Mylar Type S. The latter is the most chemically inert flexible plastic currently available. Apparently, the only dangers from direct contact of the print with Mylar are entrapment of moisture or possible "ferrotyping" of the image if the Mylar is pressed tightly against it.

Use Mylar sleeves or acid-free envelopes for storing negatives. Do not use glassine. The glues used along the seams of envelopes tend to attract moisture, so envelopes with seams along the edge are best. If the envelope has a center seam, insert the negative or print so that the backing, not the image or emulsion, is against the seam. In recent years storage envelopes made with alkaline-buffered papers (Permalife) have come on the market. The pH of such papers can be as high as 8.5 initially but tends to decrease with time. At present, it is not known what the maximum permissible pH for permanent storage of negatives and silver prints might actually be, although it would seem that the benefits of slight alkalinity would outweigh the risks. Cyanotypes probably should not be stored in alkaline containers or in contact with alkaline papers because alkalinity can fade them.

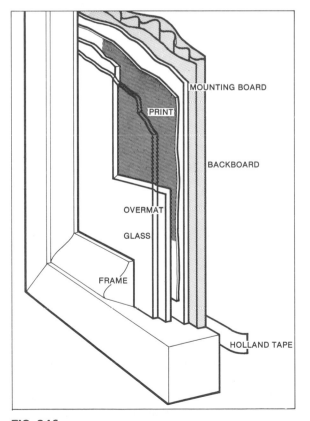

FIG. 246
Cross section of a framed print.

Restoration

Restoration is a delicate art learned only through practice. It should be thought of as a last resort. While its techniques can often halt, slow down, or even reverse, the deterioration of an image, their effects can be difficult to predict and their application always carries the risk that the image will suffer even further damage.

For the inexperienced, the best plan in caring for a valuable photograph or other work of art in need of repair is to consult a competent professional. Before any attempt is made to clean or restore it, a valuable item should first be copied photographically so that there will at least be a record of the image in case of damage.

Daguerreotypes

The procedure that follows will remove tarnish (oxidation) on daguerreotypes. Use it instead of older formulas containing potassium cyanide. Remember that the surface of a daguerreotype is fragile and should not be touched unless absolutely necessary. If it is necessary, use a soft, fine brush to remove dirt from the surface of the plate

as it lies under water (see step **1**. below). Work gently, testing the edges first. *Never* brush a *dry* daguerreotype.

1. Remove any surface dirt by rinsing the daguerreotype in distilled water and Photo-Flo or Alconox (available from chemical supply houses), following standard dilution. Rinse clean in distilled water.

2. Place in the solution given below until the discoloration disappears.

Distilled water 250 ml
Thiourea 35 grams
Phosphoric acid (85% solution). . 8 ml
Photo-Flo 1 ml
Add distilled water to make 500 ml

3. Immediately place the daguerreotype in distilled water, then in a fresh solution of Photo-Flo or Alconox and rinse thoroughly.

4. Flood the surface of the daguerreotype with ethyl alcohol or methanol and dry with low heat.

This cleaning method dissolves a slight amount of silver; so plan to avoid repeating it, if possible. To slow down any future oxidation of the image, replace the mat and the cover-glass and seal the edges airtight with archival paper and polyvinyl acetate or Primary Paste. Treat leather daguerreotype cases with a potassium lactate and p-nitrophenol leather preservative, if necessary.

Collodion Images

About all one can do with a collodion image is clean it gently with a Photo-Flo or Alconox solution made with distilled water and then flush it with distilled water. Even this treatment can be risky. Test a corner of the image first. The collodion on an unvarnished plate may wash right off. If the collodion has begun to separate from the plate, do not try to wash it. If possible, lift the loose collodion by gently sliding the edge of a sheet of paper between it and the glass. Using a brush, coat the exposed portion of the plate with a 15% solution of gelatin containing a drop or two of Photo-Flo, and use this to glue the loose collodion back in

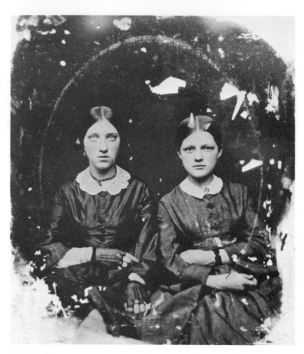

FIG. 247
Ambrotype with damaged backing.

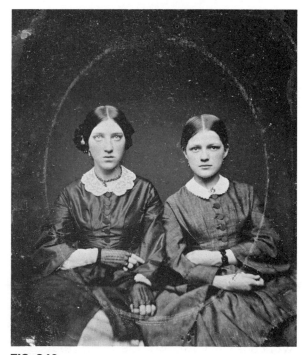

FIG. 248
Same image restored.

place. If necessary, place a sheet of glass over the collodion surface and tape it to the plate around the edges to prevent further loss.

With ambrotypes, often the black backing will be in worse shape than the image. Scrape off the loose backing and recoat the plate with black lacquer.

If a tintype shows signs of rust, do *not* wash it: Bear in mind that collodion images can be fragile, and sometimes even light wiping with a cotton swab can damage them.

Gelatin Plates and Films

Gelatin is a nutrient for mold. Mold can cause the image to fade or discolor and can weaken the gelatin emulsion, sometimes to the point where it will dissolve in water. Copy the plate or film (using Kodak Direct Duplicating Film SO-015) before attempting to clean it. If you think mold may be present, first treat in a thymol cabinet (see below), then clean in a *nonaqueous* solution such as Kodak Film Cleaner.

If there are no signs of mold you can clean the emulsion surface with ammonium hydroxide. The ammonium hydroxide softens gelatin, so first treat the emulsion in

HARDENING BATH SH-1

Water . *250 ml*
Formalin (37% formaldehyde
 solution) *5 ml*
Sodium carbonate
 (monohydrated) *3 grams*
Water to make a total volume of *500 ml*

Treat in SH-1 for 3 minutes. Follow this by a rinse in water, then 5 minutes in a fresh acid fixing bath, and a final wash.

Now you can begin treatment with the ammonium hydroxide solution:

Ammonium hydroxide (30% solution). . *15 ml*
Distilled water. *85 ml*

Work one small area at a time, testing the edge of the image first. Rinse with distilled water before going on to another area. Afterwards, rinse the negative in distilled water with a few drops of Photo-Flo added.

Nitrate Film. Cellulose nitrate was used as a base for films from 1888 until as late, in some cases, as 1951. Cellulose nitrate decomposes, becomes brittle, and is dangerously flammable. High temperatures in film-storage areas can cause spontaneous combustion, although the exact conditions that cause this are not completely understood.

These films are not always marked, but occasionally the word *nitrate* can be seen on the edge. One way to identify unlabeled nitrate film is to cut a bit from the edge of a negative and set fire to it in a ashtray *out of doors.*

WARNING: *Be careful not to inhale the fumes—* nitrate fumes are deadly.

If the film burns quickly, it is nitrate based. Non-nitrate *safety*-based film will merely darken and wrinkle.

Store nitrate-based films apart from other negatives and prints, in a cool place and with enough ventilation to remove the gaseous by-products of nitrate decomposition. As soon as possible, copy them with Kodak Professional Duplicating Film SO-015. If containers are closed, open them every month or so to let trapped gases escape. If the emulsion becomes tacky and soft, it is deteriorating and should be disposed of—but *NOT incinerated.* Call your local fire department for advice if you have a large amount to deal with.

Silver Prints

Here are the basic causes of fading and discoloration of silver images: (1) Incomplete fixing or use of an exhausted fixer; (2) incomplete washing after fixation; (3) exposure to harmful atmospheric gases; (4) contaminants in the paper itself or in the mount.

1. Sodium (and ammonium) thiosulfate fixing baths act on the unexposed silver halides, forming soluble salts that can be washed away. As the fixing bath is used, the concentration of dissolved silver in it increases. At a certain point, the concentration in the bath

becomes great enough so that various relatively insoluble silver compounds are formed in the image—compounds that cannot be removed by washing. The point at which the silver concentration in the fixing bath becomes dangerous is lower for papers than for films. These silver-and-fixer compounds eventually can decompose, resulting in a yellow-brown stain in both the image and the nonimage areas.

2. If the image is not washed adequately after fixing, thiosulfate remaining in it can combine with the silver, forming silver sulfide in the image areas, in time causing the image to fade. This is the problem most often encountered in old prints.

3. Atmospheric gases that can cause fading and discoloration include sulfur dioxide, peroxides, hydrogen sulfides, nitrogen oxides, ozone, and a variety of chemically active organic and inorganic particles. The salt in sea air is hygroscopic and can speed up chemical activity and the growth of mold. Vapors from solvents and fresh paints can be harmful. Much of this pollution can be eliminated from storage and display areas by efficient systems for air conditioning and filtration.

4. Acid in the paper can cause embrittlement and discoloring. Alum, a source of acidity, was used indiscriminately in papers in the 19th century (see the chapter on *Papers*). Unfortunately, not much chemical data is available on 19th-century photographic papers (see footnote 21). Nineteenth-century mounting boards were often acidic. The hygroscopic pastes often used tended to draw in moisture, which speeds up chemical deterioration, especially along the edges of prints.

The Problem of Mounted Prints. Chemical treatments that call for immersion can only be done on unmounted prints. Trying them on mounted prints will result in warping and wrinkles and in partial separation of the print from the mount.

Most adhesives used in the 19th century for wet-mounting prints were water-soluble, and so it is usually possible to soak mounted prints in water to soften the adhesive and then gradually peel the picture off the mount. This can be a risky procedure, though. For instance, no attempt should be made to soak a gelatin print that shows signs of mold growth. This could dissolve the weakened gelatin. Also, in cases where a print containing silver sulfide has been exposed to high temperature and humidity for many years, the silver *sulfide* can oxidize gradually to silver *sulfate*. Silver sulfate is light in color and water-soluble—water treatment could wash the last remains of the image away. Most conservators will not attempt to separate a print from a mount unless there is an excellent reason—only if chemical treatment is essential or it is clear that the inferior materials of the mount itself pose such a threat to the print that the risk is justified.

If you must separate them, soak the print and mount in water for as long as necessary to soften the adhesive to the point where removal can be accomplished without undue force. Sometimes a spatula or a palette knife can be used to help lift the print, or a stream of water can be made to flow between the print and the mount as the print is slowly pulled away. Afterward, lay the print face down on a blotter and use wet towels to wipe or blot the remaining adhesive from the back. It can be hard to get all the adhesive; but try to remove as much of it as you can.

Refixing. If faded prints or those stained by silver-hypo compounds can withstand a soaking, they should be refixed.

Soak the print in water at 20 °C (68 °F) for l minute. Then treat it in two baths of fresh fixer, agitating the print for 2-to-3 minutes in each. (In the case of gelatin prints, treat them first for 3 minutes in Hardener SH-1, as already described.) Rinse for about 1 minute. Treat in Kodak Hypo Clearing Agent for 2 minutes. Wash for 10 minutes.

The hypo-clearing agent will accelerate the rate at which the fixer can be washed from the print; but, even with a prolonged wash, it is still not possible to remove all of the fixer. For this reason the print should also be treated with Kodak Hypo Eliminator HE-1, which reduces the hypo to sodium sulfate. Sodium sulfate is thought to be

harmless to the silver image and also is readily soluble in a final wash.

HYPO ELIMINATOR HE-1

Water . 250 ml
Hydrogen peroxide (3%) 60 ml
Ammonia solution 50 ml
 (1 part 28% ammonia to 9 parts water)
Water to make total volume 500 ml

Mix this just before use. The solution produces gas, so **do not put it in a stoppered bottle.**

Treat prints in Hypo Eliminator for 3 minutes at 20°C (68°F), then wash in running water for at least 10 minutes.

Intensification. Faded silver prints will often respond to intensification, although some change from the original image color and contrast should be expected. Intensification is a last resort and should not be tried unless the image is useless in its present state.

First test for residual silver. If an exhausted fixer was used originally or if the print was not fixed long enough, there will be silver remaining in the light areas of the print, and this will darken during intensification. Unfortunately, these silver compounds cannot be completely removed by refixing the print before intensification.

RESIDUAL SILVER TEST: STOCK SOLUTION

Water . 100 ml
Sodium sulfide (anhydrous) 2 grams

For use, dilute 1 part of the stock solution with 9 parts of water. The diluted solution will not keep longer than a week; the stock solution not longer than 3 months.

To make the test, place one drop of the solution on a highlight area of the print—along the edge, if possible. Let it stand 2 minutes, then blot dry. If the spot turns yellow—deeper than a just visible cream tint—residual silver is present and the image should not be intensified.

The problem with this test is that the result in one area of the print might not be valid for another area.

If you decide to attempt intensification, refix the print as directed above. (Remember that gelatin prints will need hardening first.) Then use Kodak Silver Intensifier IN-5, following the directions on the package or in the Photo-Lab-Index.

Bronzing. Gaslight papers like Velox often show a metallic luster in the shadows. This can be removed by treating the print in the ammonium hydroxide solution described above under *Gelatin Plates and Films.*

Mold

Mold can grow on paper and on emulsion surfaces when the relative humidity rises above about 60%. Mold makes paper acid, and therefore weaker. The most frequent type of mold growth is called *foxing* and appears as reddish-brown spots surrounded by lighter filamentary halos. The color is thought to be the result of a reaction between the organic acids released by the mold and traces of iron salts that exist in most papers. Other colors are also possible (see Plates 48-50).

Mold sometimes produces a general stain that on first sight can be hard to distinguish from stains caused by improper fixing or washing. Take a strong magnifying glass and look for *filamentary* edges—purely chemical stains tend to have *diffuse* edges.

FIG. 249
Mold growth known as *foxing.*

Sizing materials such as starch and gelatin act as mediums for mold growth. Mold can weaken a gelatin or albumen emulsion and fade the image.

Placing the affected object under proper storage conditions will retard or halt the growth of mold but will not kill the spores by which it reproduces. The method for eliminating mold most often followed by conservators consists of exposing it to the fumes of thymol. There is some question whether thymol is a safe treatment for silver photographs; but the process has been used on silver photographs without evidence of harm. Sometimes it discolors paper slightly.

A *thymol chamber* can be built of wood or adapted from an old cabinet or refrigerator. Fit the chamber with racks of plastic window screen to hold the papers to be treated. Position a tray below the racks to hold the thymol and, below the tray, wiring for a 40-watt lightbulb. Spread the thymol crystals over the tray, using about 1.5 grams of thymol for every cubic foot of interior space.

Put the mold-affected print in the chamber and then seal to make it airtight. Turn on the light for about three hours a day for four days. The light-bulb will give off enough heat to vaporize the thymol. Four days should be enough to kill both live mold and spores.

CAUTION: Prolonged exposure to thymol vapors is harmful to human beings as well as to mold. This is one reason why the treatment chamber should be airtight. It is also best to place the chamber in a *ventilated, unoccupied* area.

After treatment, store the print under proper temperature and humidity conditions, keeping it apart from other mold-infected papers that have yet to receive thymol treatment. Except for a short period afterwards, thymol treatment in itself will not prevent future mold growth.

Often mold stains can be removed by means of ultraviolet light, as described below.

Removing Stains

Here is a stain-removal method, devised by a leading professional conservator, David Kolody (proprietor of The Fixed Image, 169 Newberry Street, Boston, Massachusetts). It goes against the conventional wisdom of never exposing works to concentrated ultraviolet radiation. In this case, however, the benefits outweigh the risks. The method will remove—or at least lighten—most stains caused by mold or by contact with wooden backings ("wood burn"), and also water stains and scorch marks. It does not appear capable of removing stains caused by rubber cement, Scotch tape, or masking tape, or mold stains that are black in color. The ultraviolet kills live mold; its effect on mold spores is not yet known.

Fill a tray with water at room temperature (distilled or de-ionized water is preferred) to a depth of about 19mm (¾ in.). A pH lower than 7 will make a longer treatment time necessary. Add ammonium hydroxide to raise the pH to between 7 and 8 for best results.

FIG. 250
Salted-paper print with *wood burn* caused by contact with a wooden backing. The left side was exposed to ultraviolet light to remove the stain.

Immerse the print in the water face up. It should rest at least 13mm (½ in.) below the surface. You can weight it down along the edges with strips of glass. Suspend a sunlamp or, depending on the size of the object being treated, a bank of sunlamps about 10cm (4 in.) above the water. Turn on the lamp. In most cases the ultraviolet radiation will remove the stain in 1-to-3 hours. Change the position of the glass strips at intervals (glass allows only a small portion of the ultraviolet to pass through).

NOTE: This procedure can sometimes cause the silver to print-out on photographs and can intensify a faded image. It might fade certain pigments.

Neutralizing and Buffering

In recent years considerable attention has been paid to the practice of treating acidic papers in various alkaline solutions to neutralize the acid and give the paper a buffer against acid in the future (refer to pages 140-141). Buffered papers are now commercially available, but the techniques of neutralizing and buffering earlier papers —that is, post-treatment of art objects and documents on paper—are still at an uncertain stage. There are questions about which neutralization procedure is best and what the long-term effects might be on different paper types.

At present, neutralization is not recommended for *silver* photographs of any type. It can weaken gelatin and albumen emulsions. It can also weaken the colloidal surfaces of carbon prints, Woodburytypes, and multiple-gum prints. It will fade cyanotypes.

Neutralization treatment would seem advisable, though, with *platinum* or *gravure* prints or *photomechanical* prints if they show definite signs of deterioration due to acidity.

One neutralization and buffering technique consists in soaking the print in a magnesium bicarbonate solution.

The best way to prepare the solution is with a standard CO_2 cartridge soda-water siphon bottle. Cut an inch (2.5 cm) off the tube that descends into the siphon bottle, so that the tube's opening will be above any undissolved sediment that might settle on the bottom. Put distilled water, magnesium carbonate and the *open* siphon bottle in a refrigerator to chill for several hours. They must all be cold if the maximum amount of carbonate is to go into solution.

NEUTRALIZING SOLUTION

Distilled water *300 ml*
Magnesium carbonate *6 grams*
Dissolve the carbonate and pour the solution into the siphon bottle. Do this quickly to keep things cold.

Cap the siphon bottle, then place a carbon dioxide cartridge in the handle and charge the solution. Put the bottle in the refrigerator overnight. Next day decant the clear portion. Quickly rinse out the bottle, pour the clear solution back in, and store in the refrigerator until needed. Use it right from the refrigerator.

Soak the print for 20 minutes in the solution. Then, *without rinsing,* dry it between acid-free blotters.

Magnesium bicarbonate water has a short tray-life. Like a carbonated drink, it goes flat and should be thrown out after use in a tray. It keeps well in the closed siphon bottle.

Materials for Conservation and Restoration

The best source of all is TALAS (Technical Library Associates), 104 Fifth Avenue, New York, New York 10011. Send for their excellent catalog.

Permalife papers for mounting and storage can be purchased in larger quantities from the manufacturer, the Hollinger Corporation, 3810 South Four Mile Drive, Arlington, Virginia 22206.

Footnotes

[1]*Journals of Ralph Waldo Emerson*, Boston, 1912, vol. VI (1841-1844), p. 101.

[2]*Creative Camera International Yearbook 1977*, London, p. 164.

[3]*The Times* (London), Oct. 4, 1823.

[4]*The Atlantic Monthly*, July, 1861, p. 16.

[5]M.T. Talbot, "The Life and Personality of Fox Talbot," *The Photographic Journal*, Sept., 1938, pp. 546-549.

[6]J. Dudley Johnston, "William Henry Fox Talbot, F. R. S.: Materials Towards a Biography," *The Photographic Journal*, Jan., 1947, pp. 3-13; Dec., 1968, pp. 361-371.

[7]*Journal of the Royal Institution*, vol. I (1802), pp. 170-174.

[8]W.H.F. Talbot, "Some Account of the Art of Photogenic Drawing . . .," *The Athenaeum*, Feb. 9, 1839, p. 115.

[9]*Ibid.*, p. 114.

[10]Talbot, *The Pencil of Nature* (1844), pp. 11-14.

[11]*Ibid.*, p. 14.

[12]"Some Account . . .," p. 16. In "Some Account," Talbot tells of making his first photomicrographs in 1834; but in a letter to *The Journal of the Society of Arts*, May, 1853, p. 292, he gives the date as "early in 1839."

[13]Talbot, "Photogenic Drawing," *The Literary Gazette, and Journal of Belles Lettres*, Feb. 2, 1839, p. 74.

[14]*Comptes Rendus des Séances des l'Académie de Sciences*, vol. IX, pp. 250-267. See also: "The Daguerre Secret," *The Literary Gazette*, Aug. 24, pp. 538-539.

[15]Helmut and Alison Gernsheim, *The History of Photography*, New York, 1969, p. 78.

[16]*Proceedings of The Royal Society*, March 14, 1839, pp. 131-133; March 5, 1840, pp. 205-210. Herschel, "On the Chemical Action of the Rays of the Solar Spectrum on Preparations of Silver and Other Substances . . ." *Transactions of The Royal Society*, vol. 130, 1840. Among Herschel's more bizarre, if unsuccessful, experiments was the one in which he tried to sensitize paper using a 15-year-old urine sample from a boa constrictor. (*Transactions*, p. 8.) See also: A. Brothers, *A Manual of Photography*, London, 1892, pp. 285-289.

[17]Beaumont Newhall, *Latent Image*, Garden City, 1967, p. 62. Talbot's letter was printed in *Comptes Rendus,* vol. VIII, p. 341, 1839.

[18]Talbot, *London, Edinburgh, and Dublin Philosophical Magazine*, July 1841, pp. 88-92. Letter to the editor. Talbot gave the dates of the discovery in Gaston Tissandier's *A History and Handbook of Photography*, 2nd ed., 1878, p. 359.

[19]*London, Edinburgh, and Dublin Philosophical Magazine*, July 1841, p. 89.

[20]It was introduced by P.E. Mathieu, according to Louis Désiré Blanquart-Evrard, *La Photographie, ses origines, ses progrès, ses transformations*, Lille, 1870, p. 182.

[21]Thomas Malone, "Amateurs' Column," *The Liverpool and Manchester Photographic Journal*, Dec. 15, 1857, p. 270; Jan. 15, 1858, pp. 23-24. This is full of information on early printing. See also "Amateurs' Column: Paper for Photography," July 15-Nov. 1, 1857, in the same publication.

[22]Gernsheim, *op. cit.*, p. 81.

[23]*Pencil of Nature*, p. 17.

[24]*The New York Star*, Oct. 14, 1839. Quoted in Newhall's *The History of Photography*.

[25]Translated in *The Literary Gazette*, Jan. 19, 1839, p. 43.

[26]Van Deren Coke, *Art in America*, vol. XLIX, no. 3, 1961, p. 68. Gives no source.

[27]*The Literary Gazette*, Jan. 12, 1839, p. 28.

[28]Richard Rudisill, *Mirror Image*, Albuquerque, 1971, p. 38.

[29]Marcus Root, *The Camera and the Pencil*, Philadelphia, 1864, p. 391.

[30]Gernsheim, *op. cit.,* 84-87.

[31]Robert Hunt, *A Manual of Photography*, London, 1853, pp. 88-90, 288-298. Contains much information on direct-positive papers.

[32]James Borcoman, *Charles Nègre*, Ottawa, 1976, pp. 18-21.

[33]*Bulletin de la Société Française de Photographie*, April, 1930. For the opposite opinion, see: "French Discovery—Pencil of Nature," *The Literary Gazette*, Feb. 2, 1839. (Paragraph four: "These works of light want light . . . There is an absence of vivacity and effect.")

[34]Edward Lind Morse, *Samuel F.B. Morse, His Letters and Journals*, Boston, 1914, p. 144.

[35]"Two Prints," *The Witness*, Edinburgh, June 24, 1843.

[36]*London, Edinburgh, and Dublin Philosophical Magazine*, July, 1841, pp. 89-90.

[37]"The Calotype. Invented by Henry Fox Talbot, Esq., F.R.S.A." Article reprinted, with the exception of the last two paragraphs, in: Hugh Miller, *Leading Articles on Various Subjects*, Edinburgh, 1870.

[38]Letter of Jan. 17, 1848, to a Mr. Bicknell, quoted in: Beaumont Newhall, *The History of Photography*, New York, 1964, p. 37.

[39]Gernsheim, *op. cit.*, pp. 187-188.

[40]*Comptes Rendus*, May 27, 1850.

[41]John Towler, *The Silver Sunbeam*, New York, 1864, pp. 173-178.

[42]*La Lumière*, May 18, 1851, p. 58.

[43]James Borcoman, *Charles Nègre, op. cit.*, p. 35.

[44]*Comptes Rendus*, 1848, p. 637.

[45]British Patent No. 12,906 (Dec. 19, 1849); No. 13,664 (June 12, 1851).

[46]Gernsheim, *op. cit.*, pp. 200-201.

[47]Frederick Scott Archer, "Origin of the Collodion Process," *The Liverpool and Manchester Photographic Journal*, June 15, 1857, pp. 121-122.

[48]Jerome W. Harrison, *A History of Photography Written as a Practical Guide and an Introduction to Its Latest Developments*, New York, 1887, p. 45.

[49]*Ibid.*, pp. 45-56. Dry processes using tannin or beer functioned on the principle of "halogen acceptance."

[50]*The Athenaeum*, London, May 11, 1839, p. 358.

[51]Oliver Wendell Holmes, "Doings of the Sunbeam," *The Atlantic Monthly*, July, 1863.

[52]*Comptes Rendus*, May 27, 1850; Thomas Sutton, *Photographic Notes*, 1856, p. 63; Sutton, "Description of the Printing Process Employed by Blanquart-Evrard," *The British Journal of Photography*, June 28, 1872, pp. 308-309.

[53]By adding nitric acid to the fixer for prints sensitized with ammonium silver nitrate: *The Liverpool and Manchester Photographic Journal*, Jan. 15, 1858, p. 24.

[54]London Quarterly Review CI (1857), pp. 241-255. Reprinted in part in Beaumont Newhall, *On Photography, A Source Book of Photohistory in Facsimile*, Watkins Glen, 1956.

[55]*La Lumière*, Feb. 23, 1851, pp. 10-11.

[56]*La Lumière*, March 23, 1851, p. 27.

[57]*La Lumière*, Aug. 7, 1852, p. 130.

[58]A.H. Wall, "Rejlander's Photographic Art Studies—Their Teachings and Suggestions," *The Photographic News*, August 27, 1886, p. 549. First part of this article begins July 30, p. 483, continues through September. Also in 1855, Berwick and Annan exhibited at the British Association in Glasgow a print from two negatives, showing the figure of a woman in a landscape: *Journal of the Photographic Society*, Sept. 21, 1855, p. 233.

[59]O.G. Rejlander, "On Photographic Composition with a Description of 'Two Ways of Life'," *Journal of the Photographic Society*, April 21, 1858, pp. 191-196.

[60]James Borcoman, "Notes on the Early Use of Combination Printing," in Van Deren Coke's *One Hundred Years of Photographic History*, Albuquerque, 1975, pp. 16-18.

[61]A.H. Wall, *op. cit.*, p. 549.

[62]Henry P. Robinson, "On Printing Photographic Pictures from Several Negatives," *The Photographic and Fine Art Journal*, April, 1860, pp. 113-114.

[63]American edition, 1881, p. 76.

[64]Late in his career, prompted by the publication of *Naturalistic Photography*, Robinson said, "This absolute impossibility of representing with the lens alone what the eye sees is made easily possible by combination printing." This was in *The British Journal Almanac for 1889*. Reprinted in Nancy Newhall, *P.H. Emerson*, New York, 1975, pp. 57-58.

[65]Gernsheim, *op. cit.*, pp. 168-169.

[66]William Lang, "The Cyanotype Reproduction of Seaweeds," *The Photographic News*, Dec. 5, 1890, p. 948.

[67]Nancy Newhall, *A Portfolio of Sixteen Photographs By Alvin Langdon Coburn*, George Eastman House, 1962, p. 3.

[68]*Punch, or the London Charivari*, vol. XII (1847), p. 143.

[69]*Journal of the Photographic Society*, Nov. 21, 1855, p. 251.

[70]J.M. Eder, *History of Photography*, New York, 1945, p. 119.

[71]J. Waterhouse, "Alphonse Louis Poitevin and His Work," *Penrose's Annual*, vol. 17 (1911-1912), pp. 49-53. Best biographical source on Poitevin.

[72]Edward L. Wilson, *The American Carbon Manual*, New York, 1868, pp. 83-100. Detailed history of carbon processes.

[73]Eder, *op. cit.*, 555-556.

[74]*Ibid.*, p. 561.

[75]*Journal of the Photographic Society*, Dec. 11, 1858, pp. 90-94. This may have been the most raucous meeting in the history of the Society. Much indignation.

[76]*The Photographic News*, Dec. 3, 1858, p. 154.

[77]*The Photographic News*, Nov. 23, 1860, title page.

[78]Reprinted in Peter Bunnell, *Nonsilver Printing Process*, New York, 1973.

[79]Robert Taft, *Photography and the American Scene*, New York, 1964, pp. 356-357.

[80]*Photographic Notes*, Nov. 15, 1856, p. 235.

[81]Peter Henry Emerson, *Naturalistic Photography*, 3rd. ed., 1899, p. 119.

[82]Sir William Newton, "Upon Photography in an Artistic View," *Journal of the Photographic Society*, March 3, 1853, pp. 6-7. See also: June 21, 1853, pp. 74-78.

[83]H.P. Robinson, *Picture-Making by Photography*, 2nd ed., 1889, pp. 127-138.

[84]*Ibid.*, pp. 128-129.

[85]P.H. Emerson, *Naturalistic Photography for Students of the Art*, pp. 119-120.

[86]*Ibid.*, pp. 116-117.

[87]Nancy Newhall, *P. H. Emerson*, New York, 1975, p. 79.

[88]Philip H. Newman, "Some of the Tendencies in Photographic Art," *The Photographic News*, Dec. 19, 1890, pp. 983-984.

[89]Some people prefer to confine the use of the term *Pictorialism* to movements in artistic photography that occurred after roughly 1910, and they also give it a perjorative meaning. But that leaves us without a label for the years 1890-1910, years when the leading photographers were not hesitant to refer to themselves as "Pictorialists."

[90]George Davison, "Impressionism in Photography," *The Photographic News*, Dec. 19, 1890, pp. 990-991; Dec. 26, 1890, pp. 1009-1010; Jan. 2, 1891, pp. 10-11.

[91]*Ibid.*, Jan. 2, 1891, p. 10.

[92]Aaron Scharf, *Art and Photography*, 1974, pp. 165-209.

[93]Rudolf Arnheim, *Art and Visual Perception*, University of California, 1954, 1971, p. 320.

[94]Peter Bunnell, "Photo-Aquatint, or the Gum Bichromate Process," *Nonsilver Printing Processes*, pp. 42-47.

[95]*Ibid.*, reprint of second edition.

[96]Robert Demachy, "On the Straight Print," *Camera Work*, No. 19, July 1907, pp. 21-24. All Demachy quotations are from this article.

[97]Clive Holland, "Artistic Photography in Great Britain," *Art in Photography: Special Summer Number of the Studio*, 1905, p. GB4.

[98]*The Amateur Photographer*, Nov. 15, 1904, p. 396.

[99]F.C. Tilney, "Hopes and Fears for Oil Printing," *The Amateur Photographer*, Dec. 6, 1904, p. 451.

[100]H. Snowden Ward, F.R.P.S., ed., *Photograms of the Year 1909*, London, p. 21. This annual publication came out in

London and New York from 1895 on.

[101]From *Twice-A-Year*, 1942, Dorothy Norman, ed., Reprinted in Nathan Lyons, *Photographers on Photography*, Englewood Cliffs, New Jersey, 1966, p. 121.

[102]Edward Steichen, "New York: Stieglitz and the Photo-Secession," *A Life in Photography*, New York, 1963.

[103]Peter Bunnell, "Photography as Printmaking," *Artist's Proof* IX, 1969, pp. 24-34.

[104]Joseph T. Keily and Alfred Stieglitz, "Improved Glycerine Process for the Development of Platinum Prints," *Camera Notes*, April 1900, pp. 221-238.

[105]George Bernard Shaw, "Some Criticisms of the Exhibitions," *The Amateur Photographer*, Oct. 16, 1902, p. 305.

[106]Weston Naef, *The Collection of Alfred Stieglitz*, New York, 1978, pp. 443-468. Naef thinks that some of the Steichen copies are Artigue prints, which he calls "gelatin carbon." Naef may be right, but the assertion is difficult to confirm. Not enough is known about the Artigue process. See the entry on Artigue in E.J. Wall's, *The Dictionary of Photography*, Boston, 1937, p. 46; also, Henny and Dudley, *Handbook of Photography*, New York, 1938, pp. 493-497. Fresson printing, a modification of the Artigue process, is still being done by a descendant of the Fresson family in France. His prints tend to be grainy.

[107]Waldo Frank et al., *America and Alfred Stieglitz: A Collective Portrait*, New York, 1934, p. 107.

[108]Dorothy Norman, ed., *Twice-A-Year*, 1938, p. 110.

[109]*British Journal of Photography*, vol. 70, pp. 612-615. Reprinted in Lyons, *Photographers on Photography*, pp. 144-154.

[110]Steichen described his early work to Robert Taft as "technical aberrations." Taft, *Photography and the American Scene*, p. 497.

[111]*Comptes Rendus*, Oct. 14, 1839, pp. 485-486; June 15, 1840, pp. 933-934.

[112]*The Athenaeum*, May 23, 1840, pp. 418-419.

[113]Antoine Claudet acted as agent in gaining the patent. See also, *Comptes Rendus*, July 8, 1844, pp. 119-121.

[114]The first publication illustrated by calotype was a booklet in memory of Catherine Mary Walter. See: *Times Literary Supplement* (London), Dec. 23, 1965, p. 1204.

[115]Gernsheim, *The History of Photography*, p. 171.

[116]Eugene Ostroff, "Etching, Engraving, and Photography," *The Journal of Photographic Science*, Vol. 17, 1969, p. 78.

[117]*The British Journal of Photography*, Oct. 21, 1864, pp. 412-413.

[118]*The Photographic News*, Nov. 5, 1858, p. 97.

[119]*Ibid.*, 1884, p. 67; 1887, p. 49; *Year Book of Photography* (1888), p. 171.

[120]Nancy Newhall, *P.H. Emerson*, New York, 1975, pp. 83, 260-263. Emerson's *Naturalistic Photography* contains chapters on photogravure.

[121]*Alvin Langdon Coburn, Photographer*, New York, 1966.

[122]*America and Alfred Stieglitz*, New York, 1934, p. 83.

[123]See the text accompanying the Da Capo edition.

[124]Poitevin was not the first to ink a plate in this way. Paul Pretsch had described a similar method in British Patent No. 2373 (1854).

[125]"Alphonse Louis Poitevin and His Work," *Penrose's Annual*, Vol. 17 (1911-1912), pp. 49-53.

[126]For historical information, see: Gernsheim, *The History of Photography*, pp. 547-549.

[127]H. Baden Pritchard, *The Photographic Studios of Europe*, London, 1882, Reprinted by Arno Press, 1973.

[128]*The British Journal Photographic Almanac* (1874), p. 106.

[129]Donald Cameron Swan, "Pioneers of Photogravure," *The Imprint*, Jan.-June 1913, p. 387.

[130]Woodbury's Patent No. 2338 (1864) described making molds by electrotyping or casting in plaster. The technique of forcing the gelatin relief into a lead plate was a later modification and became standard procedure.

[131]For historical information see: Gernsheim, *The History of Photography*, pp. 340-342; J.S. Mertle, "The Woodbury-type, The Most Beautiful Photographic Reproduction Process Ever Invented," *Image* (George Eastman House), Sept. 1957, pp. 165-170. There is an excellent technical account in Walter E. Woodbury, *The Encyclopedia of Photography*, New York, 1898, pp. 469-470, 522-523. See also the entry "Woodburytype" in Albert Boni, *Photographic Literature*.

[132]H. Baden Pritchard, *The Photographic Studios of Europe*, London, 1882.

Recommended Reading

General Technical Works on Historical and Nonsilver Processes.

ABNEY, W.
Instruction in Photography. 11th ed. London: Iliffe & Sons, 1905.

ANDERSON, PAUL L.
"Special Printing Processes," in Henny, Keith, and Beverly Dudley. **Handbook of Photography.** New York; Whittlesey House, 1939.

————.
The Technique of Pictorial Photography. New York: J.B. Lippincott, 1939. Originally published as **Pictorial Photography, Its Principles and Practice.** New York: J.B. Lippincott, 1917.
Anderson was the authority on historical and nonsilver printing methods. "Special Printing Process" in particular is an excellent source of information.

BROTHERS, A.
Photography: Its History, Processes, Apparatus, and Materials. London: Charles Griffin, 1892.

BUNNELL, PETER C.
Nonsilver Printing Processes. New York: Arno, 1973.
Contains reprints on photogravure, gum dichromate, platinum, and oil and bromoil.

BURBANK, W.H.
Photographic Printing Methods. 3rd ed. New York, 1891. Reprinted, New York: Arno, 1973.

BURTON, W.K.
Practical Guide to Photographic and Photomechanical Printing. London: Marion and Co., 1887.

CLERC, LOUIS-PHILIPPE
Photography, Theory and Practice. London: Issac Pitman & Sons, 1930.
Good sections on platinum, carbon, gum, and various pigment processes.

DUCHOCHOIS, P.C.
Photographic Reproduction Processes. London: Hampton, Judd, 1892.
Good source of formulas.

EATON, GEORGE T.
Photographic Chemistry. 2nd ed. Hastings-on Hudson: Morgan & Morgan, 1965.
Excellent and readable introduction to photographic chemistry.

JONES, BERNARD EDWARD
Cassell's Cyclopedia of Photography. London: Cassell: 1911. Reprinted, New York: Arno, 1974.
Another important source of formulas.

JONES, CHAPMAN
An Introduction to the Science and Practice of Photography. 2nd ed. London: Iliffe & Sons, 1891.

KOSAR, JAROMIR
Light Sensitive Systems. New York: John Wiley & Sons, 1965.
Not a how-to text, but the major book on the chemistry of nonsilver processes.

LEAPER, CLEMENT
Materia Photographica. London: Iliffe & Sons, 1891.
Information on photographic chemicals. Usefully arcane.

LIETZE, ERNEST
Modern Heliographic Processes. New York: D. Van Nostrand Company, 1888. Reprinted, Rochester: Visual Studies Workshop, 1974.
Full of information, but written for draftsmen and engineers interested in line reproduction rather than continuous tone reproduction. First 1,000 copies of original edition contain specimen prints.

NEBLETTE, C.B.
Photography: Its Principles and Practice. New York: D. Van Nostrand, 1927.
The second and third editions (1930, 1938) are the best for historical processes.

TISSANDIER, GASTON
A History and Handbook of Photography. New York: Scovill, 1877.

TOWLER, JOHN
The Silver Sunbeam. New York: Joseph Ladd, 1864. Reprinted, Hastings-on-Hudson: Morgan & Morgan, 1969.
Went through nine editions, the last dated 1879. New material was added to each edition but original material left unchanged.

WADE, KENT E.
Alternative Photographic Processes. Dobbs Ferry: Morgan & Morgan, 1978.

WALL, E.J.
The Dictionary of Photography. 14th ed. Boston: American Photographic Publishing Co., 1937.
Very useful.

WALL, E.J., and FRANKLIN I. JORDAN
Photographic Facts and Formulas. 4th ed. Garden City, New York: American Photographic Publishing Co., 1975.
This is a re-edition of a book which first came out in 1924. Though valuable, the text has some problems. Certain formulas are inaccurate, and a number of others are less than fully practical. Not the best text for beginners, but should be examined at a later stage.

WILSON, EDWARD L.
Wilson's Cyclopedia of Photography New York: Wilson, 1894.

WOODBURY, WALTER E.
The Encyclopaedic Dictionary of Photography. New York: Scovill & Adams, 1896.
Excellent source on nineteenth-century technique.

Photographic Emulsions

BAKER, T. THORNE
Photographic Emulsion Technique.
Boston: American Photographic Publishing Co., 1941.

WALL, E.J.
Photographic Emulsions. London: Chapman & Hall, 1929.

For additional references see:
BONI, ALBERT
Photographic Literature. 2 vols. New York: Morgan & Morgan, 1962, 1972.

Paper

BRITT, KENNETH, ed.
Handbook of Pulp and Paper Technology. New York: Reinhold, 1964.

HARDMAN, H. and E.J. COLE
Paper-Making Practice. Toronto: University of Toronto Press, 1961.

HUNTER, DARD
Papermaking, The History and Technique of an Ancient Craft. 2nd ed. New York: Alfred A. Knopf, 1967.

STRAUSS, VICTOR
The Printing Industry. Washington: Printing Industries of America, Inc. pp. 525-579.

SUTERMEISTER, EDWIN
The Story of Papermaking. New York: Bowker, 1954.

Salted Paper

ABNEY, W. and H.P. ROBINSON
The Art and Practice of Silver Printing. London: Piper & Carter, 1888. Reprinted, New York: Arno, 1973.

ADAMS, W. IRVING
Twelve Elementary Lessons on Silver Printing. New York: Scovill, 1887.

CLERC, LOUIS-PHILIPPE
Photography, Theory and Practice. London: Issac Pitman & Sons, 1930. pp. 327-334.

TENNANT, JOHN A.
"Albumen and Plain Paper Printing," **The Photo-Miniature,** December, 1900.

Ambrotype

BOOKSTABER, DENNIS
"The Ambrotype," **Camera 35**, July, 1975, pp. 34-35.

BUNNELL, PETER
The Collodion Process and the Ferrotype, Three Accounts. New York: Arno, 1973.

BURGESS, N.G.
The Ambrotype Manual. New York: D. Burgess, 1856.

————.
The Photography and Ambrotype Manual. New York: Hubbard, Burgess, 1861.

ESTABROOKE, EDWARD
The Ferrotype and How to Make It. Cincinnati: Gatchel & Hyatt, 1873. Reprinted, Hastings-on-Hudson: Morgan & Morgan, June, 1972.

TOWLER, JOHN
The Silver Sunbeam. New York: Joseph Ladd, 1864. Reprinted, Hastings-on-Hudson: Morgan & Morgan, 1969. pp. 51-153.

Cyanotype

BROWN, GEORGE E.
Ferric and Heliographic Processes. London: Dawborn & Ward, 1899.

CLERC, LOUIS-PHILIPPE
Photography, Theory and Practice. London: Issac Pitman & Sons, 1930, pp. 381-385.

JONES BERNARD EDWARD
Cassell's Cyclopedia of Photography. London: Cassell, 1911. Reprinted, New York: Arno, 1974, pp. 66-68, 397-398.

KOSAR, JAROMIR
Light-Sensitive Systems. New York: John Wiley & Sons, 1965.

TENNANT, JOHN A.
"The Blue Print and its Variations," **The Photo-Miniature.** January, 1900.

Platinum and Palladium

ANDERSON, PAUL L.
"Hand Sensitized Palladium Paper," **American Photography,** 32: 457 (1938).

————.
"Palladium vs. Silver for Photographic Prints," **Photo Technique,** August, 1940, pp. 58-61.

————.
"Special Printing Processes," in Henny, Keith, and Beverly Dudley. **Handbook of Photography.** New York: Whittlesey House, 1939.

GOODMAN, DEVARA
Instruction and Troubleshooting Guide for Platinum and Palladium Photoprinting. Wilmington, Delaware: Elegant Images, 1976.

KEILEY, JOSEPH T., and ALFRED STIEGLITZ
"Improved Glycerine Process for the Development of Platinum Prints," **Camera Notes,** April, 1900. pp. 221-238.
Contains some interesting reproductions of glycerin prints.

PIZZIGHELLI, G., and BARON ARTHUR HÜBL.
Platinotype. London: Harrison and Sons, 1886. Reprinted, Bunnell, Peter. **Nonsilver Printing Processes.** New York: Arno, 1973.

TENNANT, JOHN A.
"Platinotype Processes," **The Photo-Miniature,** October, 1899.

————.
"Platinotype Modifications," **The Photo-Miniature,** July, 1902.

THOMSON, JAMES
"A Silver-Platinum Printing Paper," **American Photography,** November, 1915, p. 630.

WALL, E.J.
"The Platinotype Process," **British Journal of Photography** 49, pp. 531, 570, 612, 630 (1902).

WALL, E.J., and FRANKLIN I. JORDAN
Photographic Facts and Formulas. 4th ed. Garden City, New York: American Photographic Publishing Co., 1975.
Formula on page 284 (4th ed.) should read 0.26 grams potassium chlorate, not 0.026.

WARREN, W.J.
A Handbook of the Platinotype Process of Photographic Printing. London: Iliffe & Sons, 1899.

WILLIS, WILLIAM
British Patent No. 2011, June 5, 1873; **British Patent No. 2800,** July 12, 1878; **British Patent No. 1117,** March 15, 1880.

Kallitype

BROWN, GEORGE E.
Ferric and Heliographic Processes. London: Dawborn & Ward, 1899.

CLERC, LOUIS-PHILIPPE
Photography, Theory and Practice. London: Issac Pitman & Sons, 1930, p. 38.

EASTMAN KODAK
Photographic Sensitizer for Cloth and Paper. Kodak Publication No. AJ-5.

JONES, BERNARD EDWARD
Cassell's Cyclopedia of Photography. London: Cassell, 1911. Reprinted, New York: Arno, 1974, pp. 314-316.

THOMSON, JAMES
"Kallitype," **The Photo-Miniature,** December, 1904; September, 1907; January, 1922.

Carbon and Carbro

ANDERSON, PAUL L.
"Special Printing Processes," in Henny, Keith, and Beverly Dudley. **Handbook of Photography.** New York: Whittlesey House, 1939.

BURTON, W.K.
Practical Guide to Photographic and Photomechanical Printing. London: Marion & Co., 1887.
Contains information on making carbon tissue.

CECCARINI, ORLINDO. O.
"Color Printing," in Henny and Dudley, **Handbook.**

DUNN, CARLTON E.
Natural Color Processes. 3rd ed. Boston: American Photographic Publishing Co., 1940.

GREEN, ROBERT, M.D.
Carbro, Carbon. 2nd ed. rev. Fort Wayne, Indiana: Gallery 614, 1975.

MARTON, A.M.
A New Treatise on the Modern Methods of Carbon Printing. Bloomington: 1905.
Information on making carbon tissue.

NEWENS, FRANK R.
The Technique of Color Photography, Boston: American Photographic Publishing Co., 1931.

TENNANT, JOHN A.
"The Carbon Process," **The Photo-Miniature,** No. 17, 1900.

WALL. E.J.
Practical Color Photography. Boston: American Photographic Publishing Co., 1922. pp. 60-74.

WALL, E.J., and
FRANKLIN I. JORDAN.
Photographic Facts and Formulas. 4th ed. Garden City, New York: American Photographic Publishing Co., 1975. pp. 318-334.
Contains information on making carbon tissue.

Gum Printing

ANDERSON, PAUL L.
"Special Printing Processes," in Henny, Keith, and Beverly Dudley. **Handbook of Photography.** New York: Whittlesey House, 1939.

MASKELL, ALFRED, and
ROBERT DEMACHY
The Photo-Aquatint, or the Gum-Bichromate Process. 2nd ed. London: Hazell, Watson, & Viney, 1898. Reprinted, Bunnell, Peter. **Nonsilver Printing Processess.** New York: Arno, 1973.

NEBLETTE, C.B.
Photography, Its Principles and Practices. 2nd ed. New York: D. Van Nostrand, 1930. pp. 481-493.

WALL, E.J.
The Dictionary of Photography. 14th ed. Boston: American Photographic Publishing Co., 1937. pp. 329-337.
Contains an interesting entry, "Gum-Printing on Bromides," a process in principle similar to nontransfer carbro.

WAUGH, F.A.
"Gum-Bichromate Printing," **The Photo-Miniature,** January, 1901.

WHIPPLE, LEYLAND
Manuscript on gum and three-color gum printing at the George Eastman House, Rochester, New York.

Oil and Bromoil

ANDERSON, PAUL L.
"Special Printing Processes," in Henny, Keith, and Beverly Dudley. **Handbook of Photography.** New York: Whittlesey House, 1939.

HAWKINS, G.L.
Pigment Printing. London: Henry Greenwood & Co., 1933.

MAYER, EMIL
Bromoil Printing and Bromoil Transfer. Boston: American Photographic Publishing Co., 1923.

MORTIMER, F.J., and
S.L. COULTHURST.
The Oil and Bromoil Processes. London: Hazell, Watson, & Viney, 1909. Reprinted, Bunnell, Peter. **Nonsilver Printing Processes.** New York: Arno, 1973.

NEBLETTE, C.B.
Photography, Its Principles and Practice. 2nd ed. New York: D. Van Nostrand. pp. 494-519.

TENNANT, JOHN A.
"Oil and Bromoil Printing," **The Photo-Miniature,** March, 1910.

————.
"Bromoil Prints and Transfers," **The Photo-Miniature,** No. 186, 1922.

WHALLEY, GEOFFERY E.
Bromoil and Transfer. London: Fountain Press, 1961.

Three-Color Printing

HUNT, R.W.G.
The Reproduction of Color in Photography, Printing, and Television. 2nd ed. New York: John Wiley & Sons, 1968.

ZAKIA, RICHARD D., and
HOLLIS N. TODD
Color Primer I & II. Dobbs Ferry: Morgan & Morgan, 1974.

The History of Photomechanical Printing

GERNSHEIM, HELMUT, and ALISON
The History of Photography. New York: McGraw-Hill, 1969, pp. 55-64, 539-552.

JUSSIM, ESTELLE
Visual Communication and the Graphic Arts: Photographic Technologies in the Nineteenth Century. New York: R.R. Bowker, 1974.
An important book, in large part a criticism of Ivins's theories.

TOWLER, JOHN
The Silver Sunbeam. New York: Joseph Ladd, 1864. Reprinted, Hastings-on-Hudson: Morgan & Morgan, 1969, pp. 286-307.
Shows the state of the art in 1864.

Photogravure

BENNETT, COLIN N.
Elements of Photogravure. 2nd ed. London: Technical Press, 1935. Reprinted, Bunnell, Peter. **Nonsilver Printing Processes.** New York: Arno, 1973.

BLANEY, HENRY R.
Photogravure. New York: Scovill, 1895.

CARTWRIGHT, H. MILLS
Photogravure. Boston: The American Photographic Publishing Co., 1939.
This is the most useful book for the student of photogravure.

————.
Rotogravure, A Survey of European and American Methods. London: Mackay, 1956.

DENISON, HERBERT
A Treatise on Photogravure. London, Iliffe & Sons, 1895. Reprinted, Rochester, New York: Visual Studies Workshop Press, 1974.

KRAFT, JAMES N.
An Historical and Practical Investigation of Photogravure. Unpublished MFA thesis, University of New Mexico, 1969.

LILIEU, OTTO M.
History of Industrial Gravure Printing up to 1900. London, 1957.

ROTHBERG, SAMUEL W.
Photogravure Handbook. Chicago: Rye Press, 1976.

Any good general textbook on etching and engraving will contain useful information for the beginning gravure printer.

Collotype

BROTHERS, A.
Photography: Its History, Processes, Apparatus, and Materials. London: Charles Griffin, 1892. pp. 98-104.

BURTON, W.K.
Practical Guide to Photographic and Photomechanical Printing. London: Marion and Co., 1887.

SCHNAUSS, JULIUS
Collotype and Photo-Lithography Practically Elaborated. London: Iliffe & Sons, 1889.

WILKINSON, W.T.
Photo-Engraving, Photo-Litho, Collotype, and Photogravure. London, 1894.

WILSON, T.
The Practice of Collotype. Boston: American Photographic Publishing Co., 1935.
By far the best reference on collotype.

Gravure Héliographique

BORCOMAN, JAMES
Charles Nègre. Ottawa: The National Gallery of Canada, 1976.

Photogalvanography

HANNAVY, JOHN
Roger Fenton. Boston: David Godine, 1976.

Journal of the Photographic Society, June 21, 1856, pp. 58-63.

Photographic Notes, November 15, 1856, pp. 235-237.

See the entry under Pretsch in Boni, **Photographic Literature** *for additional listings.*

Conservation and Restoration

CLAPP, ANNE F.
Curatorial Care of Works of Art on Paper. Oberlin: Intermuseum Conservation Association, 1973.

DOLLOFF, FRANCIS, and ROY PERKINSON
How to Care for Works of Art on Paper. Boston: Museum of Fine Arts, 1971.

OSTROFF, E.
Conserving and Restoring Photographic Collections. American Association of Museums, 1976. Available from the American Association of Museums, 1055 Thomas Jefferson St., N.W., Suite 428, Washington, D.C. 20007.

WEINSTEIN, ROBERT A., and LARRY BOOTH
Collection, Use, and Care of Historical Photographs. Nashville: American Association for State and Local History, 1977. Distributed by Morgan & Morgan.
Contains useful information and basic bibliography.

WILHELM, HENRY
Preservation of Contemporary Photographic Materials. East Street Gallery: 1408 East Street, Grinnell, Iowa 50112 (1975).

TALAS (Technical Library Associates) 104 Fifth Avenue, New York, New York 10011, carries a full line of books on conservation and restoration.

Sources of Supply

ALABAMA

Sargent-Welch Scientific Co.
3125 7th Avenue North
Birmingham 35201
205 / 251-5125

ARIZONA

VWR Scientific
50 South 45th Avenue
Phoenix 85001
602 / 272-3272

VWR Scientific
601 East 24th Street
Tucson 85717
602 / 624-8371

CALIFORNIA

Sargent-Welch Scientific Co.
1617 East Ball Road
Anaheim 92803
714 / 772-3550

VWR Scientific
1363 South Bonnie Beach Pl.
Los Angeles 90023
213 / 265-8123

VWR Scientific
P.O. Box 1391
San Diego 92112
714 / 262-0711

VWR Scientific
P.O. Box 3200
Rincon Annex
San Francisco 94119
415 / 469-0100

Curtin Matheson Scientific Co.
470 Valley Drive
Brisbane 94005
415 / 467-1040

Curtin Matheson Scientific Co.
18095 Mt. Shay
Fountain Valley 92708
714 / 963-6761

Fisher Scientific Company
2225 Martin Avenue
San Francisco 95050
408 / 249-0660

COLORADO

VWR Scientific
4300 Holly Street
Denver 80216
303 / 388-5651

Sargent-Welch Scientific Co.
4040 Dahlia St.
Denver 80207
303 / 399-8220

CONNECTICUT

Brand-Nu Laboratories, Inc.
30 Maynard Street
Meriden 06450
203 / 235-7989

DELAWARE

John G. Merkel & Sons
807 No. Union Street
Wilmington 19805
302 / 654-8818

FLORIDA

Curtin Matheson Scientific Co.
7524 Currency Drive
Orlando 32801
305 / 859-8281

Fisher Scientific Company
7464 Chancellor Drive
Orlando 32809
305 / 857-3600

GEORGIA

Curtin Matheson Scientific Co.
5800 Bucknell Avenue S.W.
Atlanta 30336
404 / 349-3710

VWR Scientific
890 Chattahoochee Ave., N.W.
Atlanta 30325
404 / 351-3872

Estes Surgical Supply Co.
410 W. Peachtree Street, N.W.
Atlanta 30308
404 / 521-1700

Fisher Scientific Company
2775 Pacific Drive
Norcross 30071
404 / 449-5050

HAWAII

VWR Scientific
P.O. Box 9697
Honolulu 96820
808 / 847-1361

ILLINOIS

Sargent-Welch Scientific Co.
7300 N. Linder Ave.
Skokie 60076
312 / 267-5300

A. Daigger & Co.
159 West Kinzie Street
Chicago 60610
312 / 644-9438

LaPine Scientific Co.
6001 South Knox Avenue
Chicago 60629
312 / 735-4700

Macmillan Science Co., Inc.
8200 So. Hoyne Avenue
Chicago 60620
312 / 488-4100

SGA Scientific Inc.
2375 Pratt Boulevard
Elk Grove Village 60007
312 / 439-2500

Technical Industrial Products
1990 East Washington Street
East Peoria 61611

Wilkens-Anderson Co.
4525 West Division Street
Chicago 60651
312 / 384-4433

Curtin Matheson Scientific Co.
1850 Greenleaf Avenue
Elk Grove Village 60007
312 / 439-5880

Fisher Scientific Company
1458 N. Lamon Avenue
Chicago 60651
312 / 379-9300

INDIANA

General Medical of Indiana
1850 West 15th Street
Indianapolis 46202
317 / 634-8560

KENTUCKY

Preiser Scientific Inc.
1500 Algonquin Parkway
Louisville 40210
304 / 343-5515

LOUISIANA

Curtin Matheson Scientific Co.
621 Celeste Street
New Orleans 70123
504 / 524-0475

MARYLAND

Curtin Matheson Scientific Co.
10727 Tucker Road
Beltsville 20705
301 / 937-5950

VWR Scientific
6601 Amberton Drive
Baltimore 21227
301 / 796-8500

MASSACHUSETTS

Doe & Ingalls, Inc.
25 Commercial Street
Medford 02155
617 / 391-0090

Curtin Matheson Scientific Co.
100 Commerce Way Bldg.
Woburn 01801
617 / 935-8888

Healthco Scientific
250 Turnpike Street
Canton 02021
617 / 828-3310

SciChemCo
P.O. Box 250
Everett 02149
617 / 389-7000

VWR Scientific
260 Needham Street
Newton Upper Falls 02164
617 / 969-0900

Fisher Scientific Company
461 Riverside Avenue
Medford 02155
617 / 391-6110

Mallinckrodt Laboratory
Harvard University
12 Oxford Street
Cambridge
617 / 495-4011

MICHIGAN

Curtin Matheson Scientific Co.
1600 Howard Street
Detroit 48216
313 / 964-0310

Curtin Matheson Scientific Co.
2440 James Savage Road
Midland 48640
517 / 631-9500

Rupp & Bowman Company
10320 Plymouth Road
Detroit 48204
313 / 491-7000

Sargent-Welch Scientific Co.
8560 West Chicago Avenue
Detroit 48204
313 / 931-0337

Fisher Scientific
34401 Industrial Road
Livonia 48150
313 / 261-3320

MINNESOTA

Curtin Matheson Scientific Co.
2218 University Avenue, S.E.
Minneapolis 55414
612 / 378-1110

Leriab Supply Co.
4th Avenue W. & Grant Street
Hibbing 55746
218 / 262-3456

Physicians & Hospital Supply Co.
Scientific & Laboratory Division
1400 Harmon Place
Minneapolis 55403
621 / 333-5251

MISSOURI

Curtin Matheson Scientific Co.
3160 Terrace Street
Kansas City 64111
816 / 561-8780

Curtin Matheson Scientific Co.
11526 Adie Road
Maryland Heights 63043
314 / 872-8100

NEW JERSEY

Ace Scientific Supply Co., Inc.
1420 Linden Avenue
Linden 07036
201 / 925-3300

Amend Drug & Chemical Co., Inc.
83 Cordier Street
Irvington 07111
201 / 926-0333
212 / 228-8920

J. & H. Berge, Inc.
4111 South Clinton Avenue
South Plainfield 07080
201 / 561-1234

Beckman Instruments Inc.
Route 22 at Summit Road
Mountainside 07091
201 / 232-7600

Curtin Matheson Scientific Co.
357 Hamburg Turnpike
Wayne 07470
201 / 278-3300

Macalaster Bicknell of N.J., Inc.
Depot & North Street
Millville 08332
609 / 825-3222

Sargent-Welch Scientific Co.
35 Stern Avenue
Springfield 07081
201 / 376-7050

SGA Scientific Inc.
735 Broad Street
Bloomfield 07003
201 / 748-6600
212 / 267-9451

Seidler Chemical & Supply Co.
16 Orange Street
Newark 07102
201 / 622-4495

Fisher Scientific Company
52 Fadem Road
Springfield 07081
201 / 379-1400

NEW MEXICO

VWR Scientific
3301 Edmond Street S.E.
Albuquerque 87102
505 / 842-8650

NEW YORK

Albany Laboratories, Inc.
67 Howard Street
Albany 12207
581 / 434-1747

Ashland Chemical Co.
3 Broad Street
Binghamton 13902
607 / 723-5455

Berg Chemical Co.
441 W. 37th Street
New York 10018
212 / 563-2684

Kem Chemical
545 So. Fulton Avenue
Mt. Vernon 10550
914 / 699-3110

New York Laboratory Supply Co.
510 Hempstead Turnpike
West Hempstead 11552
516 / 538-7790

Riverside Chemical Co.
871 River Road
N. Tonawanda 14120
716 / 692-1350

VWR Scientific
40 Greenleaf Street
Rochester 14609
716 / 288-5881

NORTH CAROLINA

Carolina Biological Supply Co.
2700 York Road
Burlington 27215
919 / 584-0381

OHIO

Curtin Matheson Scientific Co.
12101 Centron Place
Cincinnati 45246
513 / 671-1200

Curtin Matheson Scientific Co.
4540 Willow Parkway
Cleveland 44125
216/883-2424

VWR Scientific
2042 Camaro Avenue
Columbus 43207
614 / 445-8281

Sargent-Welch Scientific Co.
10400 Taconic Terrrace
Cincinnati 45215
513 / 771-3850

Sargent-Welch Scientific Co.
9520 Midwest Avenue
Garfield Heights
Cleveland 44125
216 / 587-3300

Fisher Scientific Company
5481 Creek Road
Cincinnati 45242
513 / 793 -5100

Fisher Scientific Company
26401 Miles Avenue
Warrensville Heights 44128
216 / 292-7900

OKLAHOMA

Curtin Matheson Scientific Co.
6550 East 42nd Street
Tulsa 74145
918 / 622-1700

Melton Company, Inc.
Labco Scientific Division
20 West Main Street
Oklahoma City 73101
405 / 235-3526

OREGON

VWR Scientific
3950 N.W. Yeon Avenue
Portland 97210
503 / 225-0400

PENNSYLVANIA

Arthur H. Thomas Company
Vine Street at Third
Philadelphia 19105
215 / 627-5600

Bellevue Surgical Supply Co.
126 North Fifth Street
Reading 19601
215 / 376-2991

Fisher Scientific Company
585 Alpha Drive
Pittsburgh 15238
412 / 781-3400

Fisher Scientific Company
191 South Gulp Road
King of Prussia 19406
215 / 265-0300

Bowman-Mell Co. Inc.
1334 Howard Street
Harrisburg 17105
717 / 238-5235

Dolbey Scientific
P.O. Box 7316
Philadelphia 19101
215 / 748-8600

Para Scientific Co.
Tyburn Road & Cedar Lane
Fairless Hills 19030
609 / 882-4545

Reading Scientific Co.
2200 North 11th Street
Reading 19604
215 / 921-0221

Scientific Equipment Co.
3531 Lancaster Avenue
Philadelphia 19104
215 / 222-5655

RHODE ISLAND

Eastern Scientific Co.
267 Plain Street
Providence 02950
401 / 831-4100

TENNESSEE

Durr-Fillauer Surgical Supplies, Inc.
936 E. 3rd Street
Chattanooga 37401
615 / 267-1161

Nashville Surgical Supply Co.
3332 Powell Avenue
Nashville 37202
615 / 255-4601

TEXAS

Curtin Matheson Scientific Co.
1103-07 Slocum Street
Dallas 75222
214 / 747-2503

Curtin Matheson Scientific Co.
4220 Jefferson Avenue
Houston 77023
713 / 923-1661

Sargent-Welch Scientific Co.
5915 Peeler Street
Dallas 75235
214 / 357-9381

Capitol Scientific
2500 Rutland Drive
Austin 78757
512 / 836-1167

VWR Scientific
7230 Mykawa Road
Houston 76133
713 / 641-0681

VWR Scientific
6980 Market Avenue
El Paso 79915
915 / 778-4225

Fisher Scientific Company
10700 Rockley Road
Houston 77001
713 / 495-6060

UTAH

VWR Scientific
650 West 8th Street, South
Salt Lake City 84104
801 / 328-1112

VIRGINIA

General Medical
319 Mill Street N.E.
Vienna 22180
703 / 938-3500

General Medical Scientific
8741 Landmark Road
P.O. Box 26509
Richmond 23261
804 / 264-2862

Fisher Scientific Company
Seaboard Building
3600 West Broad Street
Richmond 23230
804 / 359-1301

WEST VIRGINIA

Preiser Scientific
900 MacCorkle Avenue, S.W.
Charleston 25322
304 / 343-5515

WASHINGTON

VWR Scientific
600 South Spokane Street
Seattle 98134
206 / 447-5811

WISCONSIN

**Genetec Hospital Supply Co.
Division of McKesson & Robbins**
250 North Water Street
Milwaukee 53202
414 / 271-0468

Drake Brothers
N. 57 W. 13636 Carmen Avenue
Menomonee Falls 53051
414 / 781-2166

CANADA

EDMONTON, ALBERTA

Canadian Laboratories Supplies, Ltd
10989—124th Street
403 / 454-8531

HALIFAX, NOVA SCOTIA

Canadian Laboratories Supplies, Ltd
5614 Fenwick Street
Halifax
902 / 429-3806

MONTREAL, QUEBEC

Canadian Laboratories Supplies, Ltd
8655 Delmeade Road
Town of Mt. Royal 307
514 / 731-9651

TORONTO, ONTARIO

Canadian Laboratories Supplies, Ltd
80 Jutland Road
Toronto 550
416 / 252-5151

VANCOUVER, B.C.

Canadian Laboratories Supplies, Ltd
1240 S.E. Marine Drive
Vancouver 15
604 / 327-8321

WESTON, ONTARIO

**Sargent-Welch Scientific
of Canada, Ltd.**
285 Garyray Drive
416 / 741-5210

WINNIPEG, MANITOBA

Canadian Laboratories Supplies, Ltd
535 Marjorie Street
204 / 774-1945

Practically all of the distributors listed above will ship chemicals, subject to regulations governing dangerous substances. Two shipping companies that maintain large stocks are listed below.

ICN Life Sciences Group

121 Express Street
Plainview, New York 11803
516 / 433-6262

2727 Campus Drive
Irvine, California 92664
714 / 833-2500

26201 Miles Road
Cleveland, Ohio 44128
216 / 831-3000

1956 Bourdon Street
Montreal, Quebec H4M lVl

**Ventron Corporation:
Alpha Products**

P.O. Box 159
Beverly, Massachusetts 01915
617 / 922-0768

2098 Pike Street
San Leandro, California 94577
415 / 352-4077

1500 Stanley Street
Suite 405
Montreal 110, Quebec
514 / 845-9280

Here is a firm that sells kits for a number of the processes described in this book, plus an extensive line of chemicals. An excellent source; request their catalog.

Photographers' Formulary, Inc.
P.O. Box 5105
Missoula, Montana 59806

Index

INDEX

317

Flatter no man, but spare not generous praise to really good work.
 PETER HENRY EMERSON

Weights and Measures Conversion Tables

In American photographic practice, solids are weighed by either the Avoirdupois or the Metric system and liquids are measured correspondingly by U.S. Liquid or Metric measure. The following tables are all the equivalent values required for converting photographic formulas from one system to the other:

AVOIRDUPOIS TO METRIC WEIGHT

Pounds	Ounces	Grains	Grams	Kilograms
1	16	7000	453.6	0.4536
0.0625	1	437.5	28.35	0.02835
		1	0.0648	
	0.03527	15.43	1	0.001
2.205	35.27	15430	1000	1

U.S. LIQUID TO METRIC MEASURE

Gallons	Quarts	Ounces (Fluid)	Drams (Fluid)	Cubic Centimeters	Liters
1	4	128	1024	3785	3.785
0.25	1	32	256	946.3	0.9463
		1	8	29.57	0.02957
		0.125	1	3.697	0.003697
		0.03381	0.2705	1	0.001
0.2642	1.057	33.81	270.5	1000	1

CONVERSION FACTORS

Grains per 32 fluid oz multiplied by 0.06847 = grams per liter
Ounces per 32 fluid oz multiplied by 29.96 = grams per liter
Pounds per 32 fluid oz multiplied by 479.3 = grams per liter

Grams per liter multiplied by 14.60 = grains per 32 fluid oz
Grams per liter multiplied by 0.03338 = ounces per 32 fluid oz
Grams per liter multiplied by 0.002086 = pounds per 32 fluid oz

Grams per liter approximately equals ounces per 30 quarts
Grams per liter approximately equals pounds per 120 gallons
Ounces (fluid) per 32 oz multiplied by 31.25 = cubic centimeters per liter
Cubic centimeters per liter multiplied by 0.032 = ounces (fluid) per 32 oz

cm × .3937 = inches inches × 2.5400 = cm

Temperature Conversion Scale

°Fahrenheit / °Centigrade

125 —
120 —
115 —
110 —
105 — 40
100 —
95 —
90 —
85 — 30
80 —
75 —
70 — 20
65 —
60 —
55 —
50 — 10

50 (top of Centigrade scale)

NOTES

NOTES

NOTES